HOLY
TERRORS

HOLY TERRORS

Latin American Women Perform

EDITED BY DIANA TAYLOR AND ROSELYN COSTANTINO

Duke University Press Durham and London 2003

©2003 Duke University Press
All rights reserved
Printed in the United States of
America on acid-free paper ♾
Designed by Amy Ruth Buchanan
Typeset in Melior by Tseng
Information Systems, Inc.
Library of Congress Cataloging-
in-Publication data appear on
the last printed page of this book.

Contents

List of Illustrations

Preface

Writing about performance is all well and good. Necessary, even. But there is something in performance that resists writing. It strains against the confinements of textual two-dimensionality, and challenges the authority and permanence vested in the stable script. Whether we're talking about performance art, in which the artist uses her body as the stage, or political demonstrations that physically put the body on the line, performances reveal the power of embodied practice. As they critique normative values, performance artists usually work outside, and in opposition to, dominant systems of representation. Activists, trying to change sociopolitical systems of power and domination, intervene unexpectedly in the public arena. The kinds of performances included in this collection rely on presence and interaction. They refuse to be tied down. They respond to ongoing events, and need to be flexible, relatively spontaneous, and open-ended. The artist plays with the audience, addressing it directly, admonishing it to get the joke, decipher the gesture, take note, and bear witness. The audience is therefore a vital player, part of a moment that demands interactivity.

So the problem is simple. How do we convey some of the vitality of these performances in a book?

Roselyn Costantino and I had thought of including a CD in the book in order to add an audiovisual dimension to these texts. But that would still have limited and fixed the materials we could provide. We decided instead to create a website, *Holy Terrors: Latin American Women Perform* <http://hemi.nyu.edu/eng/cuaderno.shtml>, that we could update and keep active. Created by Alexei Taylor and me with the help of the

Hemispheric Institute of Performance and Politics, the site offers performance videos, music, original texts in Spanish, additional texts, interviews, photos, bibliographies, and other materials of interest to artists and scholars. We will continue to add sections, and other Latin American women performers, and I hope will one day expand this to a broader Americas performance site.

While the website offers more audiovisual files, it clearly does not capture the "liveness" of the performances, their immediate force, their compelling humor and presence. Nothing can, except the liveness itself. That's the problem with performance, as well as its incredible strength and reason for being.

Diana Taylor
New York University

Unimagined Communities

DIANA TAYLOR AND ROSELYN COSTANTINO

This volume brings together a divergent group of women artists involved in some of the most important aesthetic and political movements of Latin America.[1] In one sense, these women don't have a lot in common either ethnically or artistically. Diana Raznovich, a feminist playwright and cartoonist born in Argentina in 1945, is descended from Russian Jews who fled the pogroms at the turn of the nineteenth century and boarded the wrong boat (they thought they were going to the United States). Griselda Gambaro, Argentina's most widely recognized playwright, was born in 1928 and is of Italian origin. Denise Stoklos, author, director, and Brazil's most important solo performer, was born in 1950 in the south of Brazil, and is of Ukrainian extraction. Diamela Eltit, born in Santiago, Chile in 1949, has a Palestinian grandfather. Astrid Hadad, performer, singer, director, and manager of her show, born in the southern Mexican state of Quintana Roo in 1957, is of Lebanese heritage. Jesusa Rodríguez, director, actor, playwright, entrepreneur, and feminist activist, born in 1955, is of Mexican indigenous and European ancestry. Also born in 1955, Sabina Berman, playwright, director, poet, novelist, and screenwriter, is of Polish Jewish extraction. Petrona de la Cruz Cruz and Isabel Juárez Espinosa, cofounders of the Fortaleza de la Mujer Maya (FOMMA) in Chiapas, Mexico, both born in the 1960s, are Tzotzil Mayan and Tzeltal Mayan, respectively. El teatro la máscara (the Theatre of the Mask), a woman's collective from Cali, Colombia, which started in the early 1970s, includes women of diverse ethnic origins. Teresa Ralli, a founding actor, director, and writer of Peru's foremost theatre collective, Grupo Cultural Yuyachkani, is a *limeña* of mixed ethnic origin. Teresa Hernández, from

Puerto Rico, is a fair-skinned mix of African, indigenous, and Spanish ancestry that characterizes the *mestizaje* of the island. The same is true for Tania Bruguera, born in 1968, a Cuban performer who explores the long history of extermination and political repression and intervention through her work. These backgrounds attest to the racial and ethnic diversity of Latin America, and make visible a complicated history of Spanish and Portuguese colonialization, mestizaje, slavery, migration, and political turmoil that has often resulted in displacement and exile.

Yet there are many reasons—cultural, economic, political, military—why all these women identify as "Latin American." All of them—whether from the highlands of Chiapas or the far reaches of Europe—undergo profound processes of identity (re)formation by participating in the "imagined community" of Latin America. For some, the process began hundreds of years ago when preconquest ethnic identities came into violent contact with European colonial systems. From the sixteenth to the eighteenth centuries, highly ambivalent structures of ethnic identification both flattened and highlighted difference. While all native groups were simplified to "Indians," terms such as *mestizo, mulatto, zambo,* and many others came to designate the racial by-products of miscegenation. Nineteenth- and twentieth-century nationalisms privileged national over ethnic identity, even as they based nationalist policies in racial distinction. While several countries, especially Peru and Mexico, continue to celebrate their glorious native past and invoke a nation evolving from preconquest empires, they nonetheless exploit and disparage contemporary "Indians." Some of the authors and activists included here, especially Petrona de la Cruz Cruz, Isabel Juárez Espinosa, Jesusa Rodríguez, and Teresa Ralli, fight to give native peoples their rightful place in the here and now of a heterogeneous Latin America. For groups whose population spreads out over different countries, ethnic identity does not necessarily dovetail with national identity. The Mayas, for example, extend over three modern nations—Mexico, Guatemala, and Belize. Tania Bruguera, to posit a radically different example of the same phenomenon, envisions a "greater Cuba" that spans both sides of the Caribbean to transcend recent political chasms. For Teresa Hernández, an artist from a "Tiny Country . . . the only pre-state country in existence," the struggle has been to define herself as "Puerto Rican" and, by extension, Latin American, rather than accept a colonial status as a second-class citizen of the United States. Puerto Ricans, who endure the ambiguous status of U.S. colonial subjects, are often missing from the Latin American political and geographic map.[2] For others, the identification with Latin America involves exile and migration from the poverty or terrors of their coun-

tries of origins. For each artist in this volume, "Latin American" proves more a negotiated political, ethnic, and cultural positioning than a genetic or racial identity—that is, a political, rather than biological, matrix.

For each, moreover, Latin America proves quite different—for some, it consists of huge metropolitan centers like Mexico City, São Paulo, Lima, or Buenos Aires. For others, it's the indigenous communities in the highlands of Chiapas or the Andes. If the differences and divergences prove so great, and if *Latin America* does not have a clear explanatory power, to what degree does the term provide a useful framework for discussion?

Amérique Latine, like *America*, are European constructions—the first coined in mid-nineteenth-century France to refer to countries in the Americas colonized by Spain and Portugal, the second in honor of Italian explorer Amerigo Vespucci, who first argued that the newly "discovered" landmass was not, in fact, Asia. There is no general consensus about how many countries make up Latin America: does Puerto Rico count as a country or as a U.S. commonwealth? Does the term include French-speaking countries such as Haiti and Martinique, or English-speaking or Dutch-speaking countries such as Trinidad or Surinam? Nonetheless, for all the problems with the term, it does have some virtues for Latin Americans themselves. In the nineteenth century, Simón Bolivar labored to unite Latin America under one political banner, convinced that only by uniting could these countries defend themselves from external political and economic pressures. At the end of the nineteenth century, José Martí wrote "Nuestra América" (Our America) to urge Latin Americans to wake up and get to know each other before the giant from the north with the big boots crashed down among them. The current economic treaty among nations in the southern cone, MERCOSUR, basically echoes the belief that political and economic independence lies in unity. For all the disparities of ethnic background, class, and racial privilege among them, the women in this book share certain histories of social engagement that allow us to think about them as Latin American artists. Geopolitical identity has less to do with essence than with conditions of (im)possibility and opposition. *Latin American* gains its political edge through negation: not European, not U.S., not "First World." These artists have commonalities in practices and strategies, tackling systems of power that date back to colonial times—church domination, imperialism and neo-imperialism, political oligarchy and dictatorship, and the pervasive sexism and racism encoded in everything from education to eugenics efforts, to theories of mestizaje and progress. Each, in her own way, uses performance—broadly understood here to include theatre, performance art, cabaret, and political performance interventions—as a means of contest-

ing a sociopolitical context that is repressive when not overtly violent. Some make their political intervention through writing—whether it's a manifesto, a cartoon, or a play. Others participate in embodied performances that signal a break from accepted practice by forming a feminist collective, building an installation, engaging in self-mutilation, or abandoning traditional dress. Yet, these women are not activists who turn to performance as a means of making a statement. Rather, as Denise Stoklos asserts in an interview on the Holy Terrors web *cuaderno*, the political thrust of their work is the inevitable consequence of their living conditions: "It's all very present. It's a kind of work where you don't have to first think about the issues and then try to respond to them. They are with you because you live with them." The force of these works comes from the urgency of the intervention.

This volume represents three generations of artists that grew up and worked in periods of extreme social disruption—whether it was Argentina's "Dirty War" (1976–83), or the Brazilian military dictatorship (1964–84), the Pinochet dictatorship (1973–87), the decades of civil conflict and criminal violence in Colombia, the divided Cuba that resulted from Castro's revolution, the 1968 massacre of students at Tlatelolco and the 1985 earthquake and recent student strikes in Mexico City, or the civil violence between the Peruvian military and Sendero Luminoso (Shining Path) of Peru in the 1980s and 1990s.

While female artists and activists have played a pivotal role in human rights and social justice movements in Latin America—we need only think of the Mothers of the Plaza de Mayo or Rigoberta Menchú—the very limited possibilities for women have dictated that their strategies of intervention were always predetermined by their sex. The Mothers could only intervene as mothers (Taylor, *Disappearing Acts*, 183–207). Rigoberta Menchú insists in her writings that she wielded the same power and authority as her male counterparts, only to reveal again and again that she was able to gain authority in spite of the fact that she is a woman. Female activists had to fight not only the "enemy" but the men in their organizations as well. Petrona de la Cruz Cruz describes how she and Isabel Juárez Espinoza were expelled by their male colleagues from Sna Jtz'ibajom, a Mayan theatre collective, even though the group had received substantial new funding. Because these women had faced extraordinary personal and social hurdles in exerting their right to participate in a theatre group, they decided to form their own group, FOMMA, to highlight the gender and racial violence they experienced.[3] Their theatre work has helped them fight the fierce discrimination visited on indigenous peoples in Mexico. From not being allowed to walk on the sidewalks

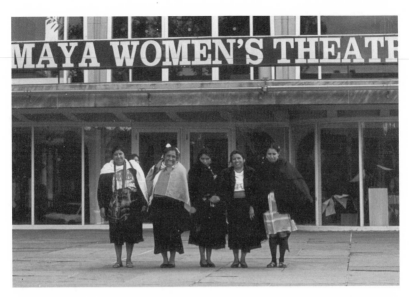

1. Petrona de la Cruz Cruz, second from left, and Isabel Juárez Espinosa, second from right, and other FOMMA members at Dartmouth College, N.H., 1996. Photo by Joseph Mehling.

in Chiapas, they are now celebrated as guest artists around the world (figure 1). Diana Raznovich (like many artists) returned to Argentina from self-imposed exile to participate in the Teatro abierto movement. Teatro abierto brought together hundreds of artists who had been blacklisted during the military dictatorship to stage a repertoire of twenty-one short plays in defiance of the governmental prohibition. Still, even within this "open" liberatory movement, Diana Raznovich was chided for being "frivolous." How could her play, *El desconcierto*, which depicted a female pianist who tried in vain to wrestle sound out of a silent piano, have anything to say about the culture of silencing associated with the "Dirty War?" She was asked by her male colleagues to withdraw her contribution to the event. Denise Stoklos, though an internationally acclaimed artist, works at the periphery of the theatrical establishment. Her solo performances and authored texts get little more than a passing reference in histories and overviews of contemporary Brazilian theatre. Astrid Hadad has generated such controversy and disdain from the establishment that some male practitioners threatened to withdraw from events that featured her work. El teatro la máscara in Colombia has been in existence longer than most collective theatre groups. Nonetheless, it remains virtually unknown because, members claim, people simply don't care about "women's issues." Jesusa Rodríguez, a legendary artist who is con-

sidered to be "the most powerful woman in Mexico" (Weiner A4), still survives on the margins of Mexico's artistic and intellectual communities. And so it goes for most of these women.

For these artists, then, political intervention (in the broadest sense) takes on many forms and many fronts, including national and ethnic political movements, human rights activism, antidictatorship battles, anticapitalism, anti-imperialism, and struggles around issues of gender, sexual, and racial equality. Often these struggles involve the Catholic Church. Since the implementation of the Holy Inquisition in the sixteenth century, the Catholic Church has often supported civil authorities in the repression of disenfranchised groups—Jews, Native Americans, African Americans, and, of course, women. During the various "dirty wars" in Latin America, the Catholic hierarchy usually sided with the dictators. They blessed the military's weapons with holy water and turned in "subversives" who revealed their dissidence during confession. Liberation theologists were either targeted for murder or forced out of their positions. The church continues to meddle with issues pertaining to women. The Vatican has ruled against birth control, divorce, and equal opportunity and access for women in a number of areas. It opposed the Platform for Equal Rights for Women presented at the Fourth World Conference on Women at Beijing in 1995 and has continued to try to dismantle the gains made in the fields of reproductive rights, civil liberties, and education. As women working in deeply entrenched Catholic societies, these artists have become "holy terrors," taking on not only the authorities, but the systems of belief that demand that they behave like obedient, subservient creatures. They fight for cultural participation— access to space, to resources, to authority, and to audiences—on local, national, and international levels. Most of them have forged their own space —physical and/or professional—to stage their aesthetic and political acts of resistance. Some clearly needed to find their own ways of working, having been closed out or expelled from existing groups or organizations.

Jesusa Rodríguez and her partner Liliana Felipe, an Argentine musician, singer, and performer, started their first cabaret/performance space, El Cuervo (the Crow), in 1980, and then El Cábito (the Habit) cabaret and El Teatro de la Capilla (the Chapel Theatre) in 1990. Rodríguez, like Astrid Hadad, began training at the Center for University Theatre of Mexico's National Autonomous University (UNAM)—one of Latin America's major centers for the production and promotion of world-class theatre. Like Hadad, she was repulsed by the male-run and artistically limited and limiting nature of Mexico's theatrical and cultural institutions. Both Rodríguez and Hadad recount mean-spirited comments

hurled at them by well-known male directors who are still active today. Hadad was told she was wasting her talent by pursuing her style of performance, which wasn't theatre at all, and Rodríguez was told she had no right to be onstage because she was too ugly. Both left before finishing the program and moved into the margins to work independently.

At El Hábito, the audience of lefties, lesbians, gays, and intellectuals can always expect to find new political satires and other kinds of outrageous performances by Rodríguez and Felipe; El Teatro de la Capilla typically features full-length plays. Though coming from the margins, Jesusa Rodríguez's influence has grown to such a degree that her comments, ideas, and performances become front-page news in Mexico's leading newspapers. Photos of her wedding to Liliana Felipe have circulated, to the horror of many and the delight of a few (figure 2).

El Teatro la máscara has also founded its own space in which to work in Cali, Colombia—assuring the women from La máscara access to a performance space and the development of their own audience. Part of the wave of collective theatres that sprang up during the 1970s based on Marxist ideals of collective social responsibility, El Teatro la máscara drew from an ethos of group creation (figure 3). Over the decades, the theatre has struggled to adapt to changing social and economic pressures. Interestingly, the theatre forms part of the women's home, intimately connecting their work to a personal fight for survival and social acceptance. Nonetheless, the group undergoes constant transformation as members come and go in their efforts to earn a living.

Grupo Cultural Yuyachkani, a group of nine artists, works from Casa Yuyachkani, a theatre and cultural center it has run for the past decade (figure 4). The group, another collective, appeared on the Peruvian scene thirty years ago, using theatre to support workers during a violent mining strike. Issues such as gender inequality did not figure in Yuyachkani's early work, based as it was on Marxist precepts that privileged class, anti-capitalist, and anti-imperialist struggles at the expense of gender conflict. Not surprisingly, popular theatre groups in Latin America during the 1970s and early 1980s ran the risk of reducing deep-seated cultural differences to class difference. In Peru and other countries with large indigenous and mestizo communities, the "proletariat" in fact consisted of indigenous and mestizo groups who lived on the margins of a capitalist society for various reasons—including linguistic, epistemic, and religious differences not reducible (though bound into) economic disenfranchisement (Taylor, *Archive*). While Yuyachkani started addressing these cultural issues early in their development, questions of gender inequality emerged later. Teresa Ralli, Ana Correa, Rebeca Ralli, and Deborah Cor-

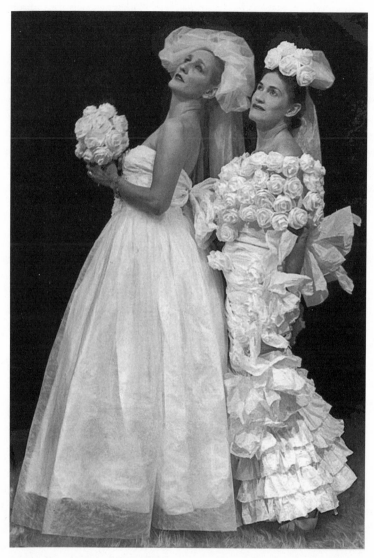

2. Wedding photo of Liliana Felipe, left, and Jesusa Rodríguez. The dresses were made of papier-mâché by artists friends of the couple. Photo by Gabriela Saavedra.

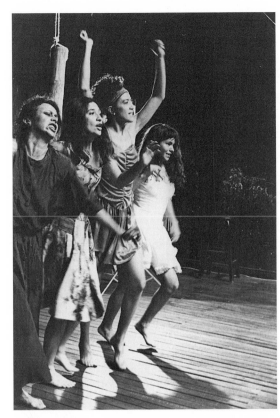

3. Teatro la máscara. Photo courtesy of Marlène Ramírez-Cancio.

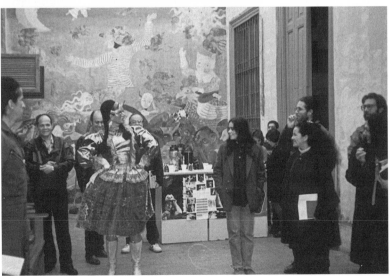

4. Patio, Casa Yuyachkani. Edmundo Torres, their longtime mask maker, dances the role of the *China diabla*, July 1996. Photo by Diana Taylor.

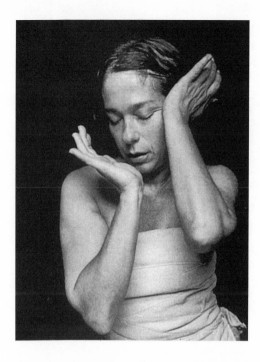

5. Teresa Ralli in *Antígona*. Photo courtesy of Grupo Cultural Yuyachkani.

rea, the four female members of Yuyachkani, began to focus on how gender issues affected everything from professional options, to group performance, to political violence. They organized and ran workshops for women, and started developing their own plays and solo performances, even as they remained vital members of the group. Ralli describes this process in a video interview, available for viewing at the web cuaderno developed for this book. Ralli developed *Antígona*, fragments of which are included here, based on interviews she conducted with the mothers and widows of the disappeared in Peru. Unlike African American artist Anna Deavere Smith, who bases her performances on the words spoken by the people she interviews, Ralli sought to transmit a repertoire of their gestures (figure 5).

Petrona de la Cruz Cruz and Isabel Juárez Espinosa founded FOMMA, a cultural center primarily for Mayan women and children. They conduct trilingual workshops to help women in their community deal with the many problems they face both in the local and national arena. Through theatre, FOMMA addresses issues of cultural identity, displacement, and domestic violence, as well as gender, racial, and economic discrimination. The space allows Mayan women to assert their views and civil rights in a society that has doubly excluded and silenced indigenous women— they are marginalized by the mestizo society around them, and silenced by the men in their own communities.

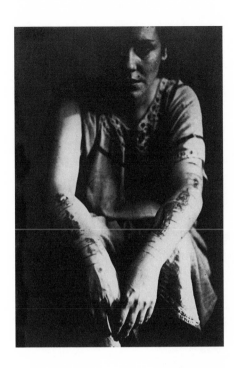

6. Diamela Eltit cuts herself as she reads from her novel *Lumpérica* in a brothel in Santiago de Chile. Photo courtesy of Diamela Eltit.

But even artists who don't control their own physical space have found ways to control their interventions. Astrid Hadad, who manages her own show and always performs with her band Los Tarzanes (the Tarzans), has worked hard to develop her own circuit of festivals and national and international performance opportunities. Denise Stoklos, a solo performer who writes and directs her own productions, has done likewise, managing herself and publishing her own books. Diamela Eltit uses her body as the site of violent confrontation. During Pinochet's dictatorship, she transgressed all boundaries by reading from her fragmented performative novel, *Lumpérica* (E. Luminata) in a brothel as she cut herself (figure 6). Ema Villanueva and Katia Tirado, two young performance artists that Antonio Prieto discusses in his essay in this volume, erupt unexpectedly on Mexico's political scene—Ema Villanueva started her work by performing a one-woman demonstration in response to the student strike at UNAM. She invited spectators to write on her body their views of the political situation (figure 7). She has since gone on to create performances that highlight the little-discussed practice of political disappearances in Mexico and has joined forces with human rights organizations. Katia Tirado, dressed as a wrestler, takes her performance of sexual and gender identity into very popular spaces in Mexico—from the famous market of La Merced to the performance space, Ex Teresa Arte Alternativo (figure 8). Sabina Berman, a self-employed playwright, has created a

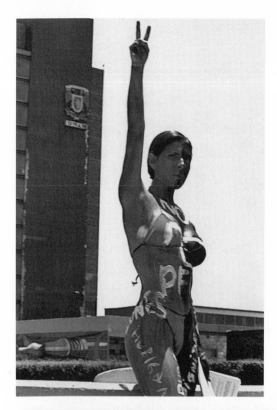

7. Ema Villanueva asked passersby to write their opinions of the student strike at the UNAM on her body. Photo by Eduardo Flores.

8. Katia Tirado and Patricia Castellanos in "Exhivilización: Las perras en celo." Ex-Teresa Arte Alternativo, October 1995. Photo by Mónica Naranjo. Courtesy of Antonio Prieto.

space for herself within the Mexican theatre establishment. Having won recognition as one of the foremost Mexican dramatists, she now enjoys visibility and status both nationally and internationally, and serves as a member of the board of the Mexican writers' union, SOGEM. Diana Raznovich, as a dramatist and cartoonist, works mostly by herself in Madrid, having recently left her native Argentina. Griselda Gambaro has gained major recognition and is consistently produced in Argentina's most prestigious theatres. But for all her success, she has until recently been the only woman to be included in any project. Hers is usually the only female name in Latin American theatre festivals and anthologies. It's been hard and it's been lonely, she admits with her usual love of understatement.

While their artistic goals, media, and strategies vary—one thing remains constant: these women unsettle. Through their use of humor, irony, parody, citationality, inversions, and diversions, their art complicates and upsets the dogmas and convictions that dominant audiences hold near and dear. This is the art of the "outside." These artists, holy terrors, take on the sacred cows. They fight for the freedom to act up, act out, and call the shots. Denise Stoklos rails openly against those whom she feels participate in the continuing travesty of Brazilian politics. Sometimes with humor, sometimes with raw indignation, she makes sure she gets her views across. In *500 Years: A Fax from Denise Stoklos to Christopher Columbus*, she explores the role of the artist, the intellectual, the theatre, and the audience in the tragic history of her country. "Read it," she says, "it's all in the books." Later, once the audience fully comprehends the magnitude of her critique, she has the house lights turned up: "The doors of the theatre are open for those who want to abandon this ship in flames" (Stoklos 9, author's translation; figure 9).

Diana Raznovich uses the "minor" mode—the cartoon—as well as her "frivolous" theatre to call attention to the acts of everyday violence that women endure through socialization. Women are not allowed to laugh, to giggle or snigger, to chuckle or cackle, to grin or guffaw (figure 10). In *Manifesto 2000 of Feminine Humor*, Raznovich points out that women's right to pleasure is no laughing matter, according to those who would advocate the position that "women should not laugh, it threatens the world with total moral decomposition." Women should stifle their laughter, swallow it, block it, turn it into a cry, a perpetual and dismal "ay ay ay." Jesusa Rodríguez and Liliana Felipe, whose aesthetic inspiration draws from cabaret and nineteenth-century *revista* (revue theatre), likewise turn their formidable talents to making fun of repressive social systems and the audience's complicity with them. "Mexico's elite has never had it so bad," as Tim Weiner puts it. And after a night of political satire, non-

9. Stoklos in *500 Years*: A *Fax to Christopher Columbus*. Photo by Bel Pedrosa; courtesy of Denise Stoklos.

stop *directas e indirectas*, they remind their audience: "Seremos cabronas, pero somos las patronas." This is their space, their art, their turn, and they have no intention of giving it up.

Though committed to the disruption of oppressive norms, these artists share no aesthetic position. While we use the term *performance* broadly to refer to their work, this is not a word many of them would use to describe what they do. Some poke fun at the term. "PerFOR-what?" asks the bewildered woman in Diana Raznovich's cartoon (figure 11). *Performenzos* (*performnuts*) is the word Jesusa Rodríguez uses for those of us crazy enough to dedicate ourselves to this practice. Liliana Felipe asserts she doesn't understand the term, and suspects no one else really does either. Teresa Ralli uses *acciones* (actions) to describe some of her street performance, while Astrid Hadad calls herself a *todóloga* (an everythingist) who combines singing, political critique, acting, stage design, and body art in her productions. While the term *performance* finds no satisfactory equivalent in either Spanish or Portuguese, many of these same artists subscribe to the overlapping practices it signals. *Performance* has commonly referred to "performance art," and in certain places (like Mexico) it comes out of the visual arts rather than theatre. Translated simply but nonetheless ambiguously as *el performance* or *la performance*, a linguistic cross-dressing that invites English speakers to think about the sex/gender of *performance*, the word is beginning to be used more broadly to talk about social dramas and embodied practices. In spite of charges that *performance* is an Anglo word, scholars and practitioners are starting to appreciate the multivocal and strategic qualities of the term. While the word may be untranslatable, the debates, decrees, and strategies arising from the many traditions of embodied practice and corporeal knowledge are deeply rooted and embattled in the Americas. *Performance*, then, signals overlapping practices: theatre, conceptual art, solo performance or *uni-personales*, performance art, installations, body art, and acciones—political happenings or interventions.

These performers nonetheless belong to a long line of outspoken women performers and artists. Their performances pay tribute to, and often cite, the paths of trailblazers in various arts in the twentieth century throughout Latin America: singers such as Mercedes Sosa, Elis Regina, La Lupe, Chabuca Granda, Lucha Reyes, and Chavela Vargas; artists such as Frida Kahlo, Bekis Ayon, Ana Mendieta, and Pita Amor; actresses such as María Felix and Dolores del Río; playwrights such as Rosario Castellanos, Elena Garro, and Alfonsina Storni, to name a few. These earlier artists had already challenged the limits and restrictions imposed on them by the racist, misogynist, and homophobic world in which they worked.

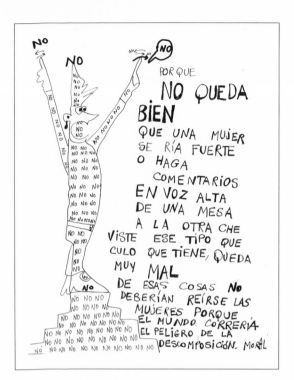

10. The female body is the zone of prohibition. Cartoon by Diana Raznovich.

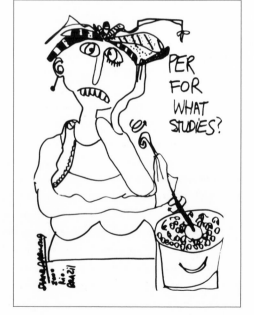

11. PerFORwhat studies? Cartoon by Diana Raznovich.

Singers like the *puertorriqueña* La Lupe had defiantly answered her male, homophobic critics in her songs: "According to your point of view/ I am the bad one." Chavela Vargas was notorious in Mexico for picking up female admirers in the clubs and shooting a pistol to get the attention of the audience. Chabuca Granda, from Peru, has reworked the famous song "Adelita" to question the quietism of contemporary women: "¿Dónde estás, Adelita? ¿Dónde estás, guerrillera?" [Where are you, Adelita? Where have you gone, woman warrior?]. Liliana Felipe updates these traditions in her song "Mala" (Bad), which concedes, "¡mala, pero bonita, caray!" [bad, but beautiful, damn it!].

In addition to citing some of the great women performers of the mid-twentieth century, these recent performers also draw liberally from popular theatre styles of the late nineteenth and early twentieth centuries known as *teatro frívolo* or frivolous theatre. These traditions have served not only the "frivolous" artists—such as Diana Raznovich, Astrid Hadad, and Jesusa Rodríguez—but the more "serious" ones as well. Sabina Berman's plays, Griselda Gambaro's one-act pieces, and Teresa Ralli's *Antígona*, for example, look like traditional Western theatre. But a study of the content and tone of these works reveals nontraditional treatment of a broad spectrum of "universal" and Latin American themes. In some of these plays we find elements of street theatre, indigenous theatre based on oral tradition, and soap-opera melodrama, an important part of Latin America's cultural production.

Teatro frívolo is important to our study not only because of its popularity among the women under discussion here but because of the resurgence of interest in its forms on the part of new generations of practitioners. Artists then and now, liberated from state-controlled spaces and academic rules of production, take advantage of the various forms and styles of teatro frívolo such as cabaret, sketches, *teatro de revista*, *teatro de carpa* (itinerant theatre, literally, under a tent), and street theatre. These short works, usually lasting less than an hour, stage a series of comic, satirical dramatizations based on real events, past or present (Dueñas and Escalante 12). Revista incorporates music and dance scenes, and offers portraits of customs, fashions, and traditions. Sketches, so called because of the outline form of the open-ended scripts, and carpa both promote the open participation of the spectator. As in revista, the parody, satire, and humor of the sketches and carpa provide ample opportunity for artists and citizens to express themselves and their criticism of all aspects of life—political, economic, social, and cultural. These works stress communication with the audience rather than mimetic representation.

From the 1880s until the 1930s, audiences from the burgeoning semi-educated populations in the urban centers and provinces of Latin America mingled and participated in some local version of teatro frívolo. Performers drew their material from daily events, transmitting news and information through skits and songs, voicing sociopolitical criticism, and creating a sense of nationhood and of ethnic or national identity. Realistic and stock characters—including the street vagrant, the revolutionary, fancy cowboys, the innocent virgin, the prostitute, the rancher, students, dancing skeletons, politicians, the cabaret diva, and the drunk—were constructed through iconic gestures and spoken through popular language characterized by the use of *albures* and *lunfardo*, plays on words and puns with double meanings, often with sexual connotations. The play between performer and audience highlighted the rich oral traditions of popular sectors that prided themselves on an agile sense of humor and strategies of one-upmanship. The intentional use of local words and expressions insisted on the importance of local meaning and community. These performances were always in situ, always a response to immediate circumstances. Lyrics of songs such as *boleros*, *corridos*, *rancheras*, and *tangos* also transmitted histories and conflicts about love, gender roles, claims to geopolitical space, and heroic resistance to encroaching hegemonic forces. Thus, all of these elements converged and helped crystallize the images that audiences had of themselves as a people. Benedict Anderson's concept of "imagined community" describes the processes through which geographically dispersed and heterogeneous populations began to conceive of themselves as a community through print culture. Popular performances, however, allowed for a different form of transmission. They allowed the predominantly semiliterate audiences of teatro, corrido, and carpa—that is, the *unimagined* community of common people or pueblos left out of print culture—to rehearse and enact the imaginings binding them.

Not surprisingly, producers of elite art forms—the prominent men often caricatured and criticized on revista's stages—disapproved of these performances and tried to resignify the term *popular* as vulgar. Yet the critics seem to have had little effect on the popularity of revista, carpa, and cabaret. Unlike classic theatre, which dominates most histories of theatre, these popular forms were generated by the need for representation, expression, and communication of the population whose tastes and realities they reflected. Nonetheless, teatro frívolo began to fade in the late 1920s and early 1930s due to cultural trends gaining currency in the various countries, the rise of the cinema perhaps most particularly. Teatro frívolo never disappeared, of course. Even when the shows them-

selves seemed to lose popularity, the style and humor and intent, as well as some of the routines, lived on in other forms and in other places. Cantinflas, Mexico's brilliant humorist and the people's philosopher, moved from carpas to film. And the carpa tradition, which migrated north to the United States as part of Mexican American popular culture, went on to inspire other kinds of popular theatres—most notably Teatro Campesino in the 1960s.

Within the formulaic, frivolous, and flexible framework of this short art form, then, artists have found a broad range of possibilities—from the merciless critique by Griselda Gambaro to the more playful, yet equally trenchant attack by Jesusa Rodríguez and Astrid Hadad. Gambaro, for example, uses the *teatro grotesco*, a mordant and incisive genre related to the short teatro frívolo, to convey the grotesque character of the Dirty War. *Strip*, the one-act play offered here, is an example of the adaptability of this genre—as capable of entertaining and playing with its audience as of critiquing its frivolity. This short piece brutally depicts the escalation of violence during a period of political crisis, and the inanity, even irresponsibility, of the public's response. In this case, the short grotesco genre serves both to index and to critique certain aspects of teatro frívolo itself. For Jesusa Rodríguez, the teatro frívolo model provides a basic and flexible framework for much of her cabaret-type performance. In a 1999 piece, *Palenque político*, Rodríguez and Liliana Felipe staged a political horse race, with the candidates for Mexico's presidential election vying for the lead. In the midst of this, Chona Schopenhauer (Rodríguez) came onstage in folkloric dress, riding a wooden horse which she wore as a skirt held up with straps (figure 12). Her philosophical reflections, very much in the tradition of carpa and Cantinflas, elevate uncertainty to an existential condition: "We never know what's going to happen tomorrow," she reminds us. Life in Mexico is a crap shoot, as fickle and as arbitrary as *la lotería nacional*—a national game along the lines of bingo. At the end of the game, things end the way they always do in Mexico, with raucous accusations by actors and audience alike of corruption and fraud.

Astrid Hadad has taken up a variation of this form by staging her forceful political commentary within the traditional genre of a cabaret performance. Hadad particularly focuses on the politics of representation itself. In her performances, she takes on some of the most "Mexican" of icons. Mexico is only visible through cliché, she suggests, known solely "in translation." The parodic self-marking reads as one more repetition of the stereotype, one more proof of its fixity. Hadad plays with the anxiety behind these images of excess, pushing the most hegemonic of specta-

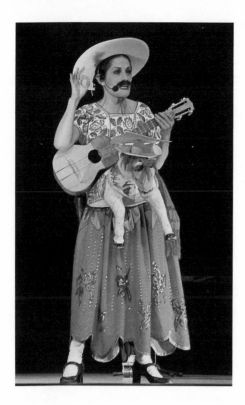

12. Jesusa Rodríguez as
Chona Schopenhauer.
Photo by Lorie Novak.

tors to reconsider how these stereotypes of cultural/racial/ethnic differ-
ence are produced, reiterated, and consumed. Hadad, in a *tableau vivant*
of a Diego Rivera painting, humorously bears the weight of stereotypical
accumulation and "anxious" repetition. She is all in one: the Diego Rivera
girl holding calla lilies, the *soldadera* (revolutionary fighter), the bejew-
eled Latina, loaded down with rings, bracelets, and dangling earrings, the
India with the hand-embroidered shirt, long black braids, and a bewil-
dered look about her (figure 13). These over-marked images of telegenic
ethnicity signal the rigid structuring of cultural visibility. Hadad suggests
that the stereotype can be used as a critique by those who are able to see
the violence of the framing.

In their various ways, these women have made important progress
in opening a greater discursive and representational space not only for
the issues they examine, but also for women's right to command pub-
lic attention. The reasons that women born in the 1950s and 1960s have
entered previously restricted public spheres are numerous. In the South-
ern cone, the long periods of military dictatorship strengthened the re-
solve and even militancy of many women who could not accept the in-
human restrictions imposed on them and their families. Even women

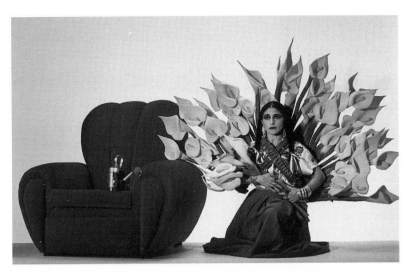

13. Astrid Hadad in *Heavy Nopal*, 1998. Photo Pancho Gilardi.

like the Mothers of the Plaza de Mayo, who had never thought of them-
selves as "political," took to the streets. The 1970s and 1980s saw the rise
of women's political mobilization in numerous ways: grassroots orga-
nizations, feminist groups, militancy. Other reasons for the increased
visibility of women throughout Latin America are economic crisis and
the subsequent migrations of male workers: more women have been
forced to work outside the home even though social mores continue to
stress that a woman's place is in the home. Concomitantly with new mar-
ket demands, women have increased access to education and thus the
professions. Foreign influences, omnipresent in mass media and tech-
nology, have also changed local perceptions and expectations. NAFTA,
MERCOSUR, and other global market initiatives facilitate access to con-
sumer goods and ideas. And, of course, people travel more than ever,
whether as tourists or as immigrants, destabilizing rigid borders and
identity markers. All these factors contribute—albeit slowly—to the en-
hanced visibility and activity of women throughout Latin America.

In the last decades of the twentieth century, then, we witness an
emergence of styles that draw directly on various popular forms and
emphasize the relation between performance and the visual arts. The
character of these performance styles, simultaneously intimate and pub-
lic, continues to interrupt social and aesthetic systems, and to motivate
and rehearse civic participation with the spectators. The artists also put
into visible circulation some of the traditions that characterize Latin
American cultures, imbued with global influences deriving from com-

plicated histories and social circumstances—in Néstor García Canclini's words, Latin America's "multitemporal heterogeneity" (3). The artists remind us that the glorification of the "indigenous past" elides the very present predicament of impoverished native communities relegated both to the "past" and to the economic margins. The colonial legacy of Hispanic and Roman Catholic institutions continues to exert its power, and specters of inquisitorial scrutinizing and prohibitions continue to haunt the present. Patriarchy permeates and structures all social formations at the macro- and micro-level. Meanwhile, the cultural imperialism of the United States threatens to relegate performance interventions into the off-off-off shadowlands of the third world produced by colonialism— poor Latin America, so far from God, so close to the United States, as the joke goes. Rather than accept that the "real" struggles are taking place offstage, these performers rail back. The conflicts are fought out in the here and now of each performance. During a production of *Heavy nopal* in Miami, Astrid Hadad sweetly asked her audience in broken English, "Do you understand Spanish?" When many in the audience shouted back, "NO!" she said, "Well, learn it!" and went on with her show in Spanish. Who's marginal now? While claims to access are constantly being denied to minority populations, this too can change. Diamela Eltit and Ema Villanueva shift the focal point—the performance act has moved from prestigious theatres to the streets and brothels, from representation to self-exposure and mutilation. These women assume the task of dismantling codes of signification that inscribe themselves on the individual and collective body. Each excavates "universal" and local sources to uncover and expose the structures of power at the base of their society. They recuperate and recirculate the visual, linguistic, symbolic, and, more recently, technological codes that circumscribe identities and modalities of seeing, representing, and knowing. In different ways, their performative styles simultaneously interrogate the politics of representation and the strategies of power written across the female body, which serves as both the message and the vehicle. They expose the social theatrics that circulate Woman and women as commodities in a landscape upon which capitalism, even more charged in the age of neoliberal economic treaties, so intrinsically depends. The normative habit of objectifying the female body is challenged through a variety of strategies, for instance by juxtaposing light and sound, contrasting visual and tonal elements, exposing the disembodied nature of the discourses of power, and capturing or framing the spectator within the gaze of the performer. The performances, in their own ways, disassemble the sacred national and religious iconography in which Woman has been traditionally portrayed as either

saint or sinner, virgin/mother or whore, but always passive and dangerous, in order to make explicit the iconography's constructed, not "natural," nature. These artists develop a repertoire through which ruptures and gaps produced by such representations generate spaces of critical potential. They experiment with reworking the scripted roles for women configured by masculinist systems at different historical moments, systems whose authority and endurance seem self-perpetuating.

Cultural revolutionaries and holy terrors, these performers are every macho's nightmare, every politician's headache, every clergyman's despair. Malas, pero ¡fabulosas caray!

Notes

1. The selection of the people included here is limited—there are far too many women artists, if we include singers, performers, playwrights, and directors, to present in a single volume. The editors see their work in this field, as well as the field itself, as very much in progress.

2. Puerto Ricans, although they hold U.S. citizenship and passports, are not allowed to vote in U.S. presidential elections.

3. As Cynthia Steele writes in "A Woman Fell into the River" (Taylor and Villegas, 239–56), "the two women's work with Sna has entailed great personal risk. Most pointedly, they have aroused suspicion among their townspeople regarding their sexual virtue. Many people, including some of the family members, assume that actresses are prostitutes. Both women reached the theatre as a result of traumatic personal histories involving considerable hardship and suffering, which took them out of their traditional societies and roles, to the city and roles as single mothers and servants. Juárez Espinosa's Chol husband was assassinated in the agrarian struggles of northern Chiapas while she was pregnant. She initially supported her son by working as a servant and cashier in San Cristóbal. De la Cruz Cruz survived an abusive home life during her childhood only to be kidnapped, repeatedly raped, and impregnated by a man from her community. She also supported her son, along with her sister, following their mother's death, by working as a servant in San Cristóbal. It was this ambiguous status as single mothers from fractured primary families that made it possible for them to become actors and playwrights" (251).

Works Cited

Costantino, Roselyn. "And She Wears It Well: Feminist and Cultural Debates in the Work of Astrid Hadad." *Latinas on Stage.* Ed. Alicia Arrizón and Lillian Manzor. Berkeley: Third Woman, 2000. 398–421.

———. "Performance in Mexico: Jesusa Rodríguez's Body in Play." *Corpus Delecti. Performance in Latin America.* Ed. Coco Fusco. New York: Routledge, 2000. 63–77.

Dueñas, Pablo, and Jesús Escalante Flores, eds. *Teatro mexicano: Historia y dramaturgia. XX Teatro de revista (1894–1936)*. Mexico: Consejo Nacional para la Cultura y las Artes, 1994.

García Canclini, Néstor. "Cultural Reconversion." Trans. Holly Staver. *On Edge: The Crisis of Contemporary Latin American Culture*. Ed. George Yúdice, Jean Franco, and Juan Flores. Minneapolis: University of Minnesota Press, 1992.

Holy Terrors: Latin American Women Perform. Ed. Diana Taylor and Alexei Taylor. Hemispheric Institute of Performance and Politics. <http://hemi.nyu.edu/eng/cuaderno.shtml>.

Hutcheon, Linda. *The Politics of Postmodernism*. New York: Routledge, 1989.

Stoklos, Denise. *500 anos: Un fax de Denise Stoklos para Cristóvão Colombo*. São Paulo: Denise Stoklos Produções Artísticas, 1992.

Taylor, Diana. *The Archive and the Repertoire: Performing Cultural Memory in the Americas*. Durham: Duke University Press, 2003.

——— . *Disappearing Acts: Spectacles of Gender and Nationalism in Argentina's "Dirty War."* Durham: Duke University Press, 1997.

Taylor, Diana, and Juan Villegas, eds. *Negotiating Performance: Gender, Sexuality, and Theatricality in Latin/o America*. Durham: Duke University Press, 1994.

Weiner, Tim. "Pummeling the Powerful, With Comedy as Cudgel." *New York Times* 15 June 2001: A4.

DIANA RAZNOVICH

(Argentina)

Diana Raznovich's trajectory as a playwright and cartoonist began in Buenos Aires when her first play won a theatre contest in 1967. Since then, she has written a dozen plays characterized by humor, intelligence, and unwavering defiance of delimiting social systems. She laughs at Argentina's authoritarian military dictatorships—"the military and their medals"—at coercive economic systems, and at the far subtler but nonetheless restrictive systems of gender and sexual formation. "An educated woman," as she writes in her *Manifesto 2000 of Feminine Humor*, learns lessons in repression. Throughout her work, she indicates how various systems interconnect in creating and manipulating desire even as they define, position, and control desiring bodies. In plays such as *Disconcerted, MaTrix, Inc., Inner Gardens, Rear Entry*, and *From the Waist Down*, Raznovich uses her art to critique and transgress the restrictions imposed by her society, which have been considerable to say the least, for a Jewish, bisexual, Oscar Wildesque woman coming of age during the time of the "Dirty War" (1976–83). Raznovich has won prestigious awards the world over, including a Guggenheim in the United States. Her works have been translated into English, Italian, German, and other languages.

Manifesto 2000 of Feminine Humor

DIANA RAZNOVICH

Translated by Marlène Ramírez-Cancio and Shanna Lorenz

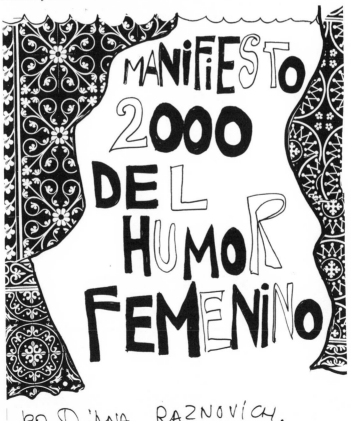

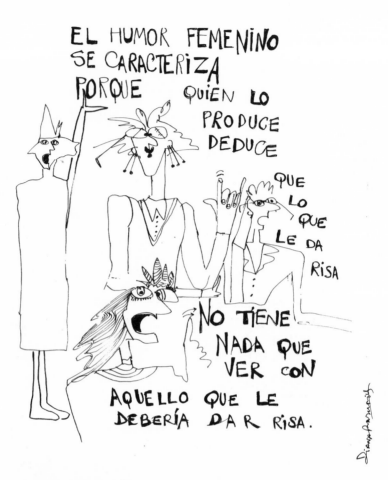

Feminine humor is characterized by the fact that
She who reproduces it
Deduces
that what causes laughter
has nothing to do with what should cause laughter.

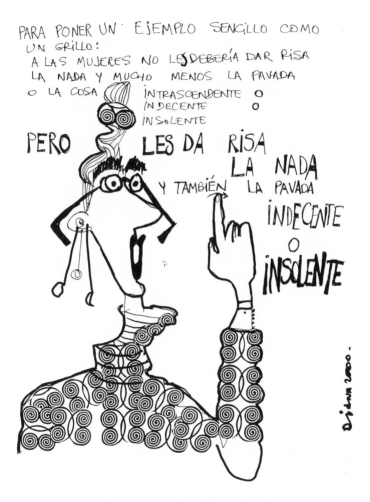

PARA PONER UN EJEMPLO SENCILLO COMO
UN GRILLO:
A LAS MUJERES NO LESDEBERÍA DAR RISA
LA NADA Y MUCHO MENOS LA PAVADA
O LA COSA INTRASCENDENTE O
INDECENTE O
INSOLENTE
PERO LES DA RISA
LA NADA
Y TAMBIÉN LA PAVADA
INDECENTE
O
INSOLENTE

To give an example that is as simple as a dimple:
Women should not laugh
at funny things, much less, at silly or risqué things,
nor at clever, sly, or witty things
or even silliness, silence or insolence.

To continue, there are several kinds of feminine laughter:
laughter just because
laughter just for us

giggles
chuckles
chortles
chortalinni

crazy laughter

that kind of laughter that you just can't stop

and, to speak bluntly, the cackles

that an educated woman should repress at all costs
because it really does not look good when a women cracks up
or makes lewd comments
across the table like:
"Girl, did you see that guy's ass?"
It looks very bad.
Women should not laugh at these things because
the world would run the risk of total moral decomposition.

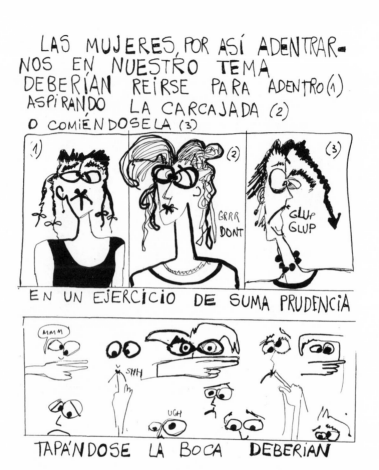

Women, to return to our topic, should laugh on the inside,
sucking in their chortles or eating them,
that ultimate test of prudence,
or covering their mouths,

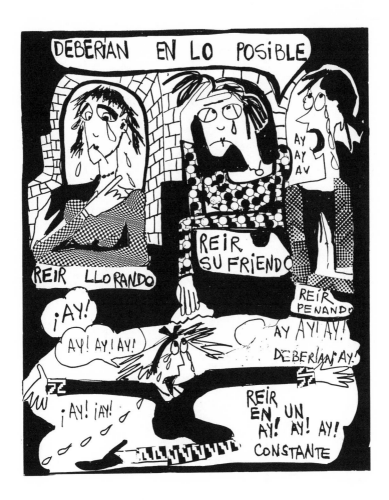

they should cackle in silence, choking back their laughter,
or, if at all possible, weeping, suffering,
that is to say, the proper way for women to laugh
is through the dignified tear,
the sob, the boo hoo hoo,

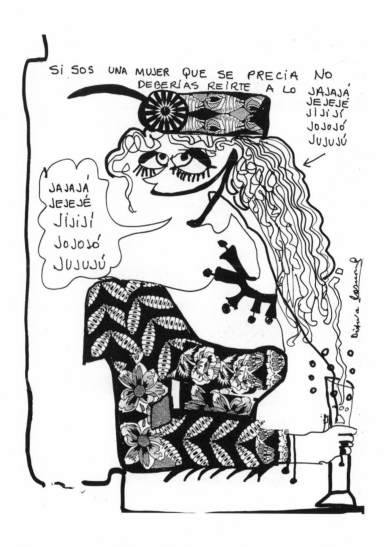

So,
if you are a woman who values yourself
don't even think of laughing like hahahaha hehehehe hohohoho
because it is not proper for the feminine sex to express such
 pleasure.
The more pleasure a woman feels,
the greater should be her punishment.

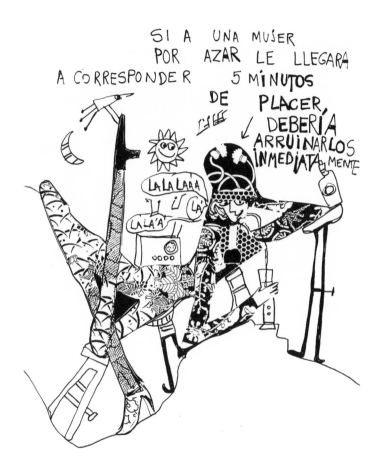

If a woman should happen to find
even five minutes of pleasure she should sabotage them
immediately.
When a woman's laughter exposes that she
is having a good time, she should call the police immediately and say:
"I am having so much fun" and turn herself in.
And if she's having a really, really good time,
if she's relaxed, delighted, fascinated, excited, interested, enraptured,
she should go to the mirror and beg forgiveness
in several languages because
the only thing ruining the end of the millennium

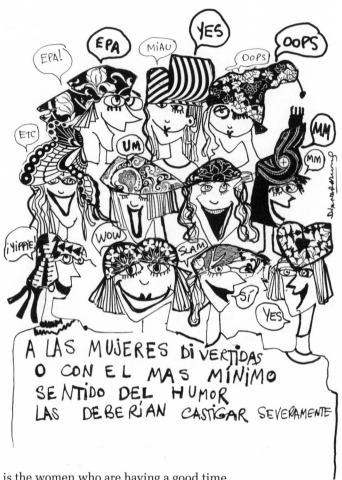

is the women who are having a good time.
Women who laugh, for example,
are a disastrous model for young girls,
who are just beginning to peek into the world.
Instead of a mother who screams and wails,
They see women enjoying themselves,
That is very bad.
Fun women or those who have even the slightest sense of humor
Should be severely punished.
Because what possible humor could there be in a soiled diaper
Or in a husband who wants to eat "NOW."
And what possible humor could there be in a cartoon by
Diana Raznovich.

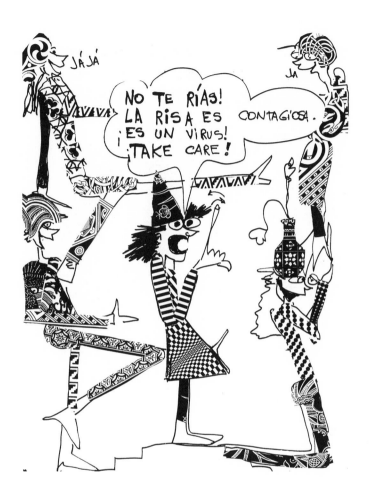

Don't laugh, laughter is contagious.
Be careful!

From the Waist Down

DIANA RAZNOVICH

Translated by Shanna Lorenz

From the Waist Down is dedicated to Diana Taylor who made it possible for this idea to become something resembling a work of theatre. I offer it to her, with all of my gratitude, as a celebration of our friendship.—Diana Raznovich, New York, October 1999

Characters:

ELEONORA: Beautiful and fiery, thirty-six years old.

ANTONIO: Forty years old. A pleasant, somewhat formal man. (Husband of Eleonora)

PAULINA: Sixty years old. Energetic and brilliant. (Mother of Antonio)

TRONCOSO: The sexologist. An ex-torturer. Well-built, forty years old.

PHOTOGRAPHER: North American from a magazine with a huge international readership. Twenty-five years old.

Act 1

It is three in the morning on a Friday in May in Buenos Aires. Eleonora and Antonio are installed in their matrimonial bed. Sitting in a beautiful new nightgown, she pathetically stares out into empty space. He sleeps deeply. Like a sort of musical duet, she occasionally sighs while he snores. Eleonora's lamp remains lit. In contrast, Antonio has turned

off his lamp. Beyond them the sound expands and fills the space, like a musical score of the mutual loathing that unites them.

ELEONORA: Don't snore, Antonio. *(She looks at him sadly, close to tears.)*

ANTONIO: *(Immobile. Sleeping. Talking while he dreams.)* I don't snore.

ELEONORA: *(She waits a few moments while in the thick silence of night her sighs combine with his snores.)* You're snoring! *(He doesn't respond. He keeps snoring. She briskly changes the position of his head so that he will stop snoring. This produces a short-lived effect. She feels satisfied with her work but a moment later he begins to snore again. Now the snoring is even stronger and combines two sounds that she responds to with a sigh that is so loud that it becomes transformed into a sort of shrill shriek. With this addition the combination of sounds becomes: two snores, a shriek, two snores, a shriek, (etc.). In the middle of this "chamber concert," she sadly opens the drawer of her bed table and takes out an enormous box of cookies. She intentionally opens the box noisily, and when she realizes that she hasn't managed to wake Antonio, she yells.)*

ELEONORA: I am informing you that you are still snoring!

ANTONIO: These are not snores, Eleonora. *(He continues snoring in double time. She lets out a desperate and discordant shriek.)*

ELEONORA: They are the same snores as always, as every night. The ones that make me desperate, my love. How can you dispute this. I am married to these glorious snores. *(She voraciously eats cookies. He snores. She shrieks. The shrieks are so loud that he groggily wakes and speaks again without opening his eyes.)*

ANTONIO: *(Sweetly and patiently)* My love, I never snore.

(Eleonora eats cookies with a rhythm and velocity that surpasses her ability to swallow them, and because of this, after a few moments her mouth is full of cookies and she is close to choking. With her mouth full of cookies, desperate, and crying, all at the same time, she speaks.)

ELEONORA: What do you mean you have never snored? What do you call these noises, Antonio? *(More and more loudly, spilling unswallowed cookie crumbs on the bed.)*

ANTONIO: They are the sounds of my soul. *(This sentence moves him so much that he sits up, meekly opens his eyes, and looks at the choking, crying, disfigured Eleonora.)*

ELEONORA: Couldn't you please ask your soul to dream more harmoniously?

ANTONIO: *(Complacent, he agrees.)* I am going to try. *(He lays down. Stunned, she watches how easily he falls asleep and begins snoring.)*

ELEONORA: *(She screams at the top of her voice.)* You are still snoring!!!

ANTONIO: *(He sits up, calmly. He opens his eyes. He speaks normally.)* You are going to wake me up, and that is a shame, because I am dreaming a beautiful dream.

ELEONORA: Tell me.

ANTONIO: Tomorrow. I can't dream and tell you at the same time.

ELEONORA: *(Relentless)* Tell me, Antonio.

ANTONIO: *(He prepares to tell her, agreeable as always.)* It was just starting to get interesting. Let me find out how it continues.

ELEONORA: Tell me. *(She eats cookies nervously.)*

ANTONIO: *(Meek. Tranquil. Romantic.)* It was a fantastic dream. It took place in the office of Public Records where a white-haired man named Monetary Circulation sat at a floating table. I entered, accompanied by two crooked employees.

ELEONORA: Where did you enter, my love?

ANTONIO: *(Thrilled and evocative)* I entered a platform covered with adjustable stock indices and converted them into a Regulated Free Rate. Free, Eleonora, free!

ELEONORA: Who was free, my love?

ANTONIO: *(Logically)* The Free Market.

(She chews and swallows and looks at him as if attempting to understand something profound that has escaped her. There is a weighty seriousness between them, as if their discussion were truly transcendental.)

ELEONORA: And?

ANTONIO: And two other employees came out.

ELEONORA: Crooked?

ANTONIO: Broken. They were each missing a hand. *(Pause)* I noticed that

they were waiting for me to ask a question. It was difficult. What would you have done in my place, what would you have asked them?

ELEONORA: The name.

ANTONIO: I dreamed about doing that, but it was not an adequate question.

ELEONORA: So what did you ask?

ANTONIO: *(Lyrically)* Transferable or nontransferable? And in unison, but with well differentiated voices *(He yells.)* they answered: Nontransferable and midterm adjustable. And then I saw it all clearly.

ELEONORA: What did you see clearly?

ANTONIO: I don't know, because you woke me up.

ELEONORA: *(On the verge of tears again)* Do you want a cookie?

ANTONIO: How can you offer me a cookie when you have interrupted the dreams of my soul? You should at least apologize. Don't you realize what you have destroyed?

ELEONORA: And do you realize that I have a new nightgown, Antonio?

ANTONIO: It does not seem very important to me.

ELEONORA: Look at it. I bought it especially for you.

(Antonio looks at the nightgown. He doesn't find anything that particularly catches his attention.)

ANTONIO: Was it very expensive?

ELEONORA: It was very expensive. I am always buying more and more expensive nightgowns. And you, nothing.

ANTONIO: Try to buy the cheapest ones. Maybe they will get an effect. Maybe the expensive ones don't do anything for me.

ELEONORA: Antonio, we have to talk about "something."

ANTONIO: We are talking about "something."

ELEONORA: I am referring to a specific topic, my love. *(She gives Antonio a cookie. He returns it. She eats it.)*

ANTONIO: Actually, if you don't mind, I would rather go back to my dreams. I am very intrigued with the story. A dream like this doesn't come every night.

46 Diana Raznovich

ELEONORA: And I do? I am something that is here every night.

ANTONIO: You are my wife.

ELEONORA: You say it as if you were saying "you are my hypodermic needle."

ANTONIO: Hypodermic needles hurt—you don't.

ELEONORA: I can't even hurt you! *(Eleonora sticks another cookie in Antonio's mouth. Almost forcing him. He speaks with a pleasant and almost tragic tone.)*

ANTONIO: If you don't mind, my love, I am going back to the Department of Public Records. *(He rolls over and goes to sleep.)*

(After a while, Antonio begins to snore in double time and Eleonora begins to sigh. Finally she jumps out of bed. While eating cookies she paces nervously around the room like a caged lion desperately looking for a way out.)

ELEONORA: *(Pausing)* Don't you realize that nights and nights are going by and nothing? Don't you realize that nothing ever happens in this room? *(She shakes him.)* Antonio, how long do you think it has been since something happened?

ANTONIO: *(He sits up in bed to defend himself.)* Well, we made love on my mother's birthday. Or don't you remember?

ELEONORA: Eleven months ago!

ANTONIO: So what, Mother's birthday is next month. You can start getting ready.

ELEONORA: My love, I am thirty-seven years old. You are forty. At the rate of once a year, in twenty years, when I am fifty-seven and you are sixty, we will only have made love twenty more times.

ANTONIO: It is a beautifully secure future. We won't be excessive, but neither will we lack for anything. *(He is pleased with the prognosis.)*

ELEONORA: *(Furious, inconsolable, pacing)* We don't lack anything? *(She pauses, hopelessly.)* Anyway, what is going to happen once your mother dies?

ANTONIO: *(Very superstitious)* How can you say such a thing? *(In a state of emotional shock)* You want to kill my mother. *(Now he gets out of bed.)* My mother! My good, peaceful mother, who is as captivating as she is

charming. What do you have against her? What dark feelings have caused your evil words? *(He returns to bed and pulls the blankets over his head.)* For this you have torn me out of the Department of Public Records? *(He is clearly desperate.)* What is going to happen when my mother dies? *(He pathetically gazes up towards the ceiling.)* Why does she put me in front of the cruel Supreme Moment, when you, Father, will take my mother away from me? *(He kneels in bed while she watches him from the armchair where she sits.)* Why, at this hour of the night, would you bring up the physical disappearance of a healthy woman who sanctimoniously sleeps at home in her solitary bed? What has possessed this woman of mine with her sexual speculations?

ELEONORA: *(Now it is she who remains calm.)* My love, since we always make love on your mother's birthday, it is not unreasonable to ask what will happen when she dies.

ANTONIO: Calling Death again!

ELEONORA: I am not calling Death, Antonio, I am calling Love. *(She yells.)* I want to make love!

ANTONIO: *(In a panic)* Now?

(Eleonora is ready and she quickly takes off her robe and nightgown and stands facing her husband with her back to the audience.)

ELEONORA: Of course now. Why?

ANTONIO: *(He covers his head with the pillow so that he doesn't have to look at her.)* Depraved woman!

ELEONORA: Why? *(She stays where she is.)*

ANTONIO: *(He peeks at her. He confirms that she is still naked and then covers his face with the pillow again. Finally he lowers the pillow and calmly speaks.)* Because today is not my mother's birthday.

ELEONORA: *(Unmoving and naked)* Can't we break with this Imaginary Tradition that you have imposed on us since we were married?

ANTONIO: Imaginary Tradition? My mother? Oh no. I am not going to allow this. At least put on your clothes to say her name.

(Eleonora puts on her nightgown and robe, a hat, a pair of boots, a scarf, and gloves.)

ELEONORA: Okay? Now can I say your mother's name?

(He looks at her without answering, reaches for the phone, and dials his mother's number.)

ANTONIO: Hi, Mom? It's me. *(Pause)* I wanted . . . wanted to know how you feel . . . You are sleeping I imagine, but . . . physically I mean . . . You don't have any symptoms of physical ailment do you? Nausea? Migraine? Heart palpitations? *(He pauses, listening.)* Sleeping, just sleeping. It is not an abnormal sleep, is it? It is not a lethal slumber, is it? Don't sleep, Mother, answer me.

ELEONORA: *(She grabs the telephone from him.)* Hi, Paulina? *(Stupefied)* She is snoring, just like you. *(She holds on to the receiver and from it come two snores which she answers with a shriek. This repeats two times until Antonio takes the telephone from his wife and yells.)*

ANTONIO: Mom. Forgive me but I need to know exactly what you are dreaming about. Yes, tell me! *(He listens. He hangs up, his face livid.)* Of course, her too. She was also dreaming that she went into the Department of Public Records, where a man with white hair named Monetary Circulation sat at a floating table.

ELEONORA: *(She is in anguish. She bundles up even more. She might put on an overcoat.)* It can't be.

ANTONIO: It's too much of a coincidence. We had the same dream on the same night. Something has cracked in our minds. And why? Because you called the most sacred thing Imaginary Tradition and carelessly invoked the Death of my mother.

ELEONORA: But I didn't want to invoke the death of your mother, just your love.

ANTONIO: Come here, lay down. *(Eleonora comes to bed with all of her clothes on, including her boots.)*

ELEONORA: I am afraid.

ANTONIO: *(Panicking)* There is nothing to be afraid of.

ELEONORA: *(Shaking)* Nobody has the same dream.

ANTONIO: How do you know, Eleonora? We can't call everyone on the phone to ask them what they are dreaming.

ELEONORA: Let's test it. Go to sleep and dream about something else.

ANTONIO: Eat some cookies. It puts me to sleep. It calms me. *(She eats cookies ostentatiously, which produces the desired effect. She looks at*

Antonio who sleeps and snores. This produces the duet: two snores and a shriek. Two snores and a shriek from Eleonora. Finally she shakes him. He wakes up.)

ELEONORA: What were you dreaming about?

ANTONIO: *(Sure about what he just dreamed)* The emergency room of an ancient hospital in the north.

ELEONORA: What north? There are so many norths!

ANTONIO: In my dream there was just one. Desperate people from a shantytown entered and asked me for white rice. I only had brown rice. A woman with a jar in her hand spilled out its contents which immediately transformed into a magazine with a huge readership.

ELEONORA: What else?

ANTONIO: I asked for you, but the woman with the jar and the shantytown people left. A lopsided blue chair remained on top of an ocean of dissipated ashes. And the subtle humidity impregnated twenty suspenseful minutes. Now call her and ask her what she was dreaming. This is a very complicated dream.

(Determined, Eleonora dials the number of her mother-in-law.)

ELEONORA: Paulina, pardon me for bothering you so many times in one night, but just now, what were you dreaming? *(Pause)* It doesn't matter if it is long. I'm listening. *(She listens. She repeats what Paulina is saying out loud.)* The emergency room. The emergency room of an ancient hospital in the north. Desperate people from a shantytown entered and . . . *(She hangs up, shocked. She crosses herself.)* You are not going to tell me that at this moment 50 percent of the world population is having this same dream.

ANTONIO: *(Panicking)* Something very serious is about to happen. *(He dials his mother's number.)* Mother, come over. *(He hangs up.)*

(The entrance of Paulina, Antonio's mother, happens instantly. She is neatly dressed, made-up, charming, and radiant, which seems strange because until just a moment ago she was at home, asleep.)

PAULINA: Yes, my love. What is it?

ELEONORA: *(Stunned, stupefied)* But . . . how could?

ANTONIO: Mom, what luck that you are here. *(He takes Paulina into his open arms.)*

50 Diana Raznovich

PAULINA: *(Covering him with kisses)* Son, my little son. What has happened? Who has hurt you?

ELEONORA: But how, how could you get here so quickly?

PAULINA: I am his mother.

ELEONORA: You're his mother but you live ten blocks from here. And you were asleep in your bed and he had hardly finished telling you to come and you were here.

PAULINA: *(She looks patiently at Eleonora.)* And what surprises you about this, Eleonora?

ELEONORA: I am surprised about the time . . . the speed.

PAULINA: But what do you imagine? That time is realistic? Don't you know that reality doesn't exist for this mother and son?

ELEONORA: No?

PAULINA: Not at all. We have never cultivated reality in our relationship.

ELEONORA: Yes, but there is real time between your house and mine, Madame.

PAULINA: You see that there is not. There just isn't. Was Einstein thinking about us when he spoke of the curvature of space? *(Contemptuous of her daughter-in-law)* Don't speak to us of time, Eleonora. It is a convention like any other. Just like space.

ELEONORA: But the reality is that you had to get out of bed, take off your nightgown, get dressed, put on your makeup, go out to the street, and traverse ten blocks. This is a real distance that takes a palpable time.

PAULINA: Between my son's heart and mine, distance and palpable time are nothing.

ANTONIO: My mother speaks so well. A great orator.

PAULINA: I always was but I prefer to write bestsellers. One earns more than as an orator.

ANTONIO: *(He hugs her.)* Mother, I don't want you to die. Your readers need you so much!

PAULINA: What an idea. How could I possibly die just as my last book is selling so well.

ANTONIO: Well, money isn't everything.

PAULINA: *(Shocked)* No? When a shirt manufacturer suggests that money isn't everything then something very grave must be happening in this house.

ELEONORA: It is simply that Antonio panicked. That is why we got you out of bed.

ANTONIO: Do you feel completely healthy, Mother? Did you do your daily gymnastics? Did you adequately supplement your diet? Is your urine clear? How long has it been since you had an electrocardiogram? How long since they checked your vesicular activity? And your liver? And for arthritis? And for arteriosclerosis? What about undiagnosed rheumatism? Insidious asthma? Pneumonia hidden in your chest?

PAULINA: *(She begins to stagger.)* I am starting to feel bad. I was perfectly healthy until seconds ago. Now my left shoulder is beginning to hurt.

ELEONORA: Paulina, please don't leave us. At least don't deprive us of your birthday.

PAULINA: My birthday?

ELEONORA: In this house your birthday is the spinal cord of eroticism.

PAULINA: Now my right shoulder also hurts.

ANTONIO: She's sick. She's sick. See how dilated her pupils are? *(He examines his mother's eyes.)* I see a yellow spot. *(In front of Eleonora with his mother in his arms)*

ELEONORA: Don't abandon this world, Paulina. If you didn't have birthdays, nothing would ever happen in this room.

PAULINA: What do you mean, nothing?

ELEONORA: The only time something happens between Antonio and me is on your birthday.

PAULINA: *(Enchanted. She kisses her son.)* You mean that I inspire you so much?

ANTONIO: Mother, it is a modest homage that I offer you each year.

PAULINA: *(A little worried)* And the rest of the year?

ELEONORA: Nothing.

(Suspense. Antonio looks at his mother, she looks at him, disenchanted.)

PAULINA: And you asked me if I was sick? Put me down, Antonio. I prefer firm ground. *(Antonio puts her down.)*

PAULINA: Do you give this boy enough nutrition?

ELEONORA: He eats like a horse.

PAULINA: *(To Eleonora)* And you, are you nice to him?

ANTONIO: Not at all.

ELEONORA: I am enchanting. I buy a new nightgown every day. In twenty years of marriage, considering that I was crazy enough to marry at seventeen, at a rate of 365 nightgowns a year, you calculate the price that I have paid to please him. *(Eleonora opens the closet and begins to violently take out hundreds of nightgowns which she scatters on the bed, and lets fall on Antonio and his mother and on herself.)* As you can see, we haven't been lacking for nightgowns.

PAULINA: It is clear that your eroticism does not go the way of nightgowns.

ELEONORA: He told me differently.

ANTONIO: I like nightgowns. They make me dream lushly. *(He puts one on.)* *(The three of them stand in a sea of nightgowns. Paulina is interested in what her son has to say.)*

PAULINA: It is true. With so many nightgowns you could dream lushly. *(She takes off her clothing and quickly puts on a transparent nightgown.)* If you don't mind, I love dreaming lushly. *(She gets into the matrimonial bed. In the middle.)* *(Eleonora looks at the scene, embarrassed. She jumps out of bed. They are hugging.)*

ELEONORA: The problem here is not you, Antonio, much less your mother. *(She tries to hang herself with a nightgown.)* I'm the problem here. You are happy, and I disturb your happiness. *(They are not listening.)* I am telling you that I have decided to leave you in peace. *(She tears off strips of nightgown and tries to hang herself.)* I am announcing that the intruder has decided to eliminate herself. *(Her attempts completely lack conviction. She does it to get attention. She finally gets it.)*

PAULINA: No, Eleonora: Without you there is no scene. You are indispensable. Stop trying to kill yourself and come to bed.

ELEONORA: I decline.

ANTONIO: *(He goes to get her.)* I need both of you. *(The three of them get into bed.)*

PAULINA: This is definitely bestseller material. It would sell out the first day. I know what I am talking about. I know my readers. We have succeeded in creating a scene without a symbolic level. And my readers hate the symbolic level. They like straightforward things. The woman on the left, the husband on the right, and the mother, like a goddess, in the middle of the bed.

ANTONIO: Your birthday is coming up, mother. Your birthday is the sacred festival that we transform into a profane rite.

PAULINA: How well my son speaks. I am also going to add that to my next bestseller. *(She takes out her notebook and writes.)* I have the complete story: it ends with my death.

ELEONORA: No, Madame, it ends with my death.

ANTONIO: You see, it's decided. Someone has to die. Well, if I have to choose, then let my wife die. *(He picks his mother up.)* I can marry again, but I will never have another mother.

PAULINA: Antonio is so strong. Have you noticed?

(Antonio strides like a hero. Eleonora watches them, resigned. Paulina speaks like a heroine rescued from death.)

PAULINA: So you only . . . make love on my birthday?

ELEONORA: It is the only thought that stimulates him.

PAULINA: Well, it is a great homage. *(Coy and proud)* It is not for nothing that he came out looking so much like me. *(She laughs. Eleonora is not even slightly amused. Paulina becomes serious as well.)*

ELEONORA: *(She follows them both around the room.)* You have to understand, Paulina, that things can't go on like this.

PAULINA: That is a shame.

(Antonio puts her down, returns to bed, and covers his head with a blanket as if he doesn't want to hear. Eleonora comes back to bed. After a moment, Paulina also comes back to bed and installs herself between the two of them, forcing them to move over. Eleonora and Paulina are on top of the blanket while Antonio is underneath the blanket. After a pause they cover themselves as well, although unlike Antonio, they don't cover their heads.)

ELEONORA: In this bed the nights are very long. And there are 365 nights in every year. Which leaves me 364 nights of nothing!

PAULINA: I am going to rescue you.

ELEONORA: How?

PAULINA: The moment to reveal the truth to Antonio has arrived.

(Antonio covers himself even more. He becomes a lump burrowing to the foot of the bed.)

ELEONORA: What truth, Madame?

PAULINA: I educated Antonio in the most strict and repressive system. When my husband died, I swore that I would not talk to Antonio about sex until he was forty years old. He lost his father but he never lacked for a good spanking.

(The lump that is Antonio becomes agitated.)

ELEONORA: Well, Antonio is already forty.

PAULINA: That is why I believe that it is time to tell him where children come from. What men and women do when they are alone. I am going to keep this marriage from falling apart. I am going to give my son the necessary education.

ELEONORA: Finally!! Do you need a chalkboard? Colored chalk, anatomy books?

PAULINA: Definitely. It is a culminating moment. My son will lose his innocence. *(Antonio emerges at the foot of the bed with a panicked expression.)*

ANTONIO: I don't want to lose anything, Mother.

(Lights out.)

Act 2

Two nights later in the same room. A screen has been installed on the far wall, above the bed. Antonio is dressed in a suit with a vest and looks like a studious schoolboy. His hair is slicked down and his shoes are shiny. His mother has on a teacher's uniform and holds a pointer in her hand. On the screen we see the first slide of an audiovisual presentation titled "The Sexual Education of Antonio." This audiovisual presentation, which opens the second act, was designed by Paulina especially for her son and consists of photographs alternating with humorous drawings that are particularly imaginative. The drawings will be simple, tender, and funny. There won't be anything lascivious or pornographic in

the images which must give the sense of being intended to reveal the origin of life and the act of sex to a six-year-old child. Paulina's voice is heard offstage, recorded especially for the audiovisual presentation, although both she and Antonio make live commentary onstage. With her pointer Paulina will signal whatever she considers to be the most graphic part of each slide. The audiovisual presentation begins with the titles: "The Sexual Education of Antonio, by the best-selling author, Paulina Mincens (his mother)."
(The lights come on. Antonio looks at his mother, embarrassed.)

PAULINA: Now you know everything. You are a man, my son. I am going to call your woman.

(Paulina exits. Eleonora enters, very sensual and enticing.)

ANTONIO: And my mother?

ELEONORA: She left, my love. We are alone. The world is ours. She told me that you are an excellent student, that you know everything now. *(She kisses him on the mouth.)* I am waiting for you to demonstrate your knowledge.

ANTONIO: The man has a flat chest. In contrast, the woman has two round swellings.

Eleonora, sexy, ready. He is stiff and didactic. He repeats like a good student.

ANTONIO: We can call them "boobs" if we want.

(Eleonora dislikes the word.)

ELEONORA: *(Furious)* Boobs . . . my beautiful breasts? *(Trying to recover her erotic mood)* What else did your mother show you?

ANTONIO: Notice that from the waist down, you will see something very different that hangs between my legs, the "rod."

ELEONORA: Rods and Boobs? Your mother taught you this?

ANTONIO: That, and that later the man's rod gets hard and he sticks it in the groove while they dance, or they get into a bathtub, or they bite each other's ears, or the best thing is when *(He repeats, rapidly.)* the man and the woman copulate, and the central moment arrives with a rush of unforgettable sensations, that drunken flood of happiness, that primordial pleasure of the flesh, also known as the "ORGASM." Have you heard of that before?

ELEONORA: Shall we go to bed?

ANTONIO: Won't you congratulate me? For learning my lessons so well, I mean.

ELEONORA: Well, I will congratulate you at the proper moment. You took the theoretical exam. It is time for the practice.

ANTONIO: No, Eleonora. I only learned the theoretical part.

ELEONORA: But theory is the complement of practice. *(She corners him; he shrinks back.)*

ANTONIO: *(Panicking)* There was no practical part. I swear it. They were very didactic drawings. Theoretically I am ready.

ELEONORA: And practically?

ANTONIO: I am going to practice disappearing. *(He gets inside the closet and shuts himself in. She tries unsuccessfully to open the door.)*

ELEONORA: *(Banging on the door)* Antonio, come out. Antonio, come out.

ANTONIO: Call my mother.

ELEONORA: Your mother? Enough with your mother. *(She grabs the phone and searches through the telephone book.)* Sexology. Sex therapy. Sex mania. Sexologist. That's it—sexologist. I am going to call a sexologist. *(Dials. Speaking into the phone.)* Hello, is this the sexologist? Look, wake him because this is an emergency. I have a husband stuck inside a closet.

Act 3

This scene transpires two days later in the same bedroom. Eleonora and Antonio wait impatiently for the sexologist.

ANTONIO: But why did we have to find some guy in the phone book, with so many friends that could recommend a sexologist with a good reputation?

ELEONORA: And the shame? Do you want me to tell my friend Mariana all about our lush private life? The next day all of our friends would be laughing at us.

ANTONIO: I would prefer that to putting ourselves in the hands of some stranger.

ELEONORA: And I prefer putting myself in the hands of a stranger to that.

ANTONIO: And why aren't we going to his office?

ELEONORA: The sexologist insists on coming to the place.

ANTONIO: What place?

ELEONORA: The place where the act transpires; the consultant prefers to appear in person.

ANTONIO: Why are you using this cold terminology?

ELEONORA: Those were his words: "I prefer to appear in person."

ANTONIO: I can't even stand the idea of his presence here.

ELEONORA: Well you'd better get used to it because he will be here any moment.

ANTONIO: Cancel. Call him. Let's try to copulate without having the consultant make his presence known in person. *(He lowers his pants.)*

ELEONORA: Vulgar! Insensitive! Crass!

ANTONIO: And the consultant, what is he?

ELEONORA: A man of science.

(The doorbell rings.)

ELEONORA: I am asking you to pull up your pants. And show a bit of decorum.

(Antonio swiftly pulls up his pants. Eleonora opens the door. A muscular man enters, wearing the uniform of the motorcycle police or something similar. His appearance is clearly militarized. He handles the space as if he were used to making raids. His presence inspires fear. They recoil.)

SEXOLOGIST: My service was requested?

(Antonio and Eleonora understand nothing. This is really not the type of person that they expected.)

ELEONORA: There must be a mistake.

ANTONIO: We expected a sexologist.

SEXOLOGIST: That's me.

(Bewilderment. Eleonora and Antonio stare, disconcerted.)

SEXOLOGIST: What's wrong?

ELEONORA: Well, we expected a different kind of person . . . I mean . . . more intellectual, with glasses, thin, I don't know how to say it . . . a psychologist or psychiatrist type.

SEXOLOGIST: But didn't you call for a sexologist?

ELEONORA: Yes, from the telephone book.

ANTONIO: You dialed the number of the police.

SEXOLOGIST: You dialed my number. Sexologist. *(He takes out a card.)*

ELEONORA: *(She reads it.)* Yes, it's true. The card proves it. *(She shows it to Antonio.)*

ANTONIO: But am I going to put myself in the hands of a card? Am I going to trust myself to a Saturn Troncoso?

SEXOLOGIST: You are wasting my precious time. And my time is worth a lot of money. And my patience is short. Let's get to the point. So things aren't working in bed. *(He mounts the bed and with great impunity hits it repeatedly with his billy club.)*

ANTONIO: Who said that?

ELEONORA: It's true. We can't lie to the sexologist, Antonio. They aren't working.

ANTONIO: I am not going to argue with the police!

ELEONORA: He is a sexologist!

SEXOLOGIST: Unemployed. We do what we can. We used to persecute psychologists. Now we persecute whoever comes our way. Democracy ruined us. But we said, "Boys, we will find new jobs." For example, now I destroy homosexuals. It's a good job. And recently people have begun to call me . . . people like yourselves.

ELEONORA: I need an aspirin. My head hurts a lot. Mr. Troncoso . . . so you are an ex-torturer? Or something like that?

SEXOLOGIST: There is no proof. Now I have a new ID. I go where I want, when I want, as happy as can be. Don't you see how happy I am? *(He laughs.)* Don't you see how free I am, in body and soul? *(He strikes the air with karate kicks.)* I sell hard sex. I help people amuse themselves by exploring their own repression. I was certified by a psychologist that we "worked over" several decades ago.

ANTONIO: I don't understand how this could have happened to us. During the worst of times we were innocent. No one bothered us. And now we have the paramilitary in our bed.

ELEONORA: History comes around?

SEXOLOGIST: She understands very well. Before sex was one thing, now it is another. *(He opens a briefcase filled with leather articles.)* If you haven't tried hard sex, you can't talk about sex. Sex is punishment. *(He gets on top of a piece of furniture and displays various articles like a traveling salesman on a bus.)* Sex involves the master and the slave. It involves the humiliator and the humiliated. It involves the tyrant and the subject. The king and the vassal. The macho and the terrified female. Who is the macho in this house?

ANTONIO: *(He raises his hand with some enthusiasm.)* Me, me!!!

SEXOLOGIST: Good boy! I congratulate you. You won the battle. It is much better to be the man than to be the woman.

ANTONIO: Do you think so?

SEXOLOGIST: How can you have any doubt? The man is superior at everything. Everything else is inferior. You have to get that into your head.

ANTONIO: What good news.

SEXOLOGIST: This is the suit of the macho dominator. *(He gives him an outfit exactly like his own. Antonio puts it on enthusiastically.)* Now things are starting to take shape.

ELEONORA: I am afraid that I made a terrible mistake. *(Very afraid)* The phone book was not the right place to look for a sexologist. Of course someone like you could turn up.

ANTONIO: *(Already in his character)* Inferior weakling! You don't even trust the telephone book!

SEXOLOGIST: Don't you feel better? Don't you feel truly supreme? *(He takes out chains.)* Madame, this is your slave outfit. It is the new way we legalize violence. Instead of exterminating you, you exterminate each other. Do you know the Marquis de Sade?

ELEONORA: I think that I saw him once at a party.

SEXOLOGIST: Then put on these chains and stop moving like a liberal woman. We can't stand independent women.

ANTONIO: We can't stand the ones who eat cookies either. *(Cracking his whip)* We are going to crush them.

ELEONORA: I refuse.

SEXOLOGIST: Great, this is how the party begins. The slave resists. The master gives her a good whack and domesticates her. Then the slave starts to like being beaten.

ELEONORA: Nobody is going to hit me.

ANTONIO: I feel so good. This is something else. You are a true man of science. How much do I owe you sir?

SEXOLOGIST: For the outfits, 700. For the consultation, 200. For the chains, 1,000.

ANTONIO: See how much your chains cost me, slave!!!

SEXOLOGIST: The suitcase with the torture devices, 900. Complete with instructions and a case, 4,500.

(Antonio pays him with a check.)

ANTONIO: This makes me happy.

ELEONORA: I am going to denounce him at the human rights tribunals!

SEXOLOGIST: If she resists, hit her harder. Don't soften up!

ANTONIO: I am going to destroy her. *(Swinging a whip)* No more cookies. The nightgowns are over. *(He prepares himself to punish her. She runs around the room.)*

SEXOLOGIST: I leave satisfied. I can see that they are going to have a good time. This couple's sexual problems, solved.

ANTONIO: *(Shakes his hand)* You are a genius, sir. Out of nothing you have made me a macho.

SEXOLOGIST: You are a fascist prodigy.

ANTONIO: *(The sexologist leaves.)* Slave, I am going to mess you up.

ELEONORA: *(With another whip in one hand and a chair in the other)* Try it and I will smash you like a toad.

(A ridiculous battle begins. They look like a trainer and a lion. They fight with everything they have.)

ANTONIO: On your knees in front of the macho. Chewer of cookies.

ELEONORA: You think that this has something to do with pleasure?

ANTONIO: I paid $4,500 for these erotic vestments; we have to use them.

ELEONORA: That is true, $4,500. We could have taken a trip. *(She puts on a chain.)*

ANTONIO: And now what do you say? Come here so that I can smash you, slave. Inferior. Barbarian.

(They return to their fight with fury. She fights back. They hit each other. They fight hand to hand while the lights dim and go out.)

Act 4

When the lights come up we see Eleonora and Antonio in their bed in body casts. They are beat up as a result of their sadomasochistic session. They each have a leg in a cast, suspended from the ceiling, bandaged heads, and various other parts of their bodies in splints or casts. Eleonora is visibly furious. Antonio tries to cheer her up by reading out loud from a biography of the Marquis de Sade.

ANTONIO: *(He reads.)* "Sade was born in 1740. He had the title of Marquis and belonged to a family from the highest echelons of the French aristocracy."

ELEONORA: My coccyx hurts.

ANTONIO: *(Unchanging)* "His life spanned the entire period of the French Revolution, and he died the same year that Napoleon abdicated . . ."

ELEONORA: I think that I am going to die right now if you don't stop reading.

ANTONIO: It is a way to get through the long tunnel that we have in front of us. In body casts. Immobile.

ELEONORA: Still, I would rather that you read about Troncoso. He is not a French marquis, but an Argentine torturer, who has much more to do with us.

ANTONIO: He is the high priest, and we his devotees.

ELEONORA: I am appealing to whatever bit of sanity you have left. If we have to stay in this bed for a prolonged period, please abandon your ridiculous posturing.

ANTONIO: But you actively resisted.

ELEONORA: What did you expect? That I would let myself be whipped to bits?

ANTONIO: That was the deal. What do you want to talk about? The limitless arrogance with which you returned every one of the sacred blows that I gave you?

ELEONORA: Yes, I love that topic. It makes me feel better.

ANTONIO: It isn't Troncoso who failed. It is we who have failed.

ELEONORA: *(She enthusiastically agrees with this idea.)* Definitely!

ANTONIO: On this we agree.

ELEONORA: Completely. Now we have to think about the future.

ANTONIO: What are you referring to?

ELEONORA: To our failure. We came to this experience together, but we leave separately, Antonio. Our lives have fallen apart. Our bodies are destroyed. There is nothing left to do but to say goodbye.

ANTONIO: *(He looks at her sadly.)* So this is the end.

ELEONORA: Twenty years of eating cookies and dreaming lushly. And making love on your mother's birthday.

ANTONIO: Now we don't even have that. The cookies were tasty. And the Department of Public Record, at whose floating table sat a man with white hair named Monetary Circulation . . . had its charm.

ELEONORA: Now it is all over.

ANTONIO: You brought Troncoso here.

ELEONORA: But you paid dollars to pose as the victorious macho.

ANTONIO: It was a beautiful outfit.

ELEONORA: Look what you did to me!

ANTONIO: You were no wallflower!

ELEONORA: I had to defend myself! *(They challenge each other.)* It's natural . . . "the survival instinct."

ANTONIO: Natural for you to break my leg? Is this natural in a couple?

ELEONORA: You broke my left hand.

ANTONIO: I don't want to know how many times you cracked my skull but every day I have fewer ideas.

ELEONORA: How can this go on? It's all over. I prefer a legal separation, dignified and without any grudges. We are young and we can rebuild our lives.

ANTONIO: Will you marry again?

ELEONORA: Probably, some day . . .

ANTONIO: So it is really over.

(Paulina enters, with various publications in her hand, as if she had been listening through the door.)

PAULINA: *(As if continuing the conversation)* I think that it is a ridiculous idea for you to break up just as you are getting so famous.

ANTONIO: Famous?

PAULINA: This has made you famous. There isn't a single newspaper that hasn't mentioned you. *(She shows them. Eleonora looks at them out of the corner of her eye.)* It was good that you told the doctors that your fractures had an erotic origin.

ANTONIO: The doctors . . . the police . . . my colleagues. I had to explain to all of them that we hadn't had an accident . . . Hard sex . . . I told them.

PAULINA: This made you famous. Now everyone admires you. Articles and more articles in all of the magazines. You are on the cover of this one in your new cast. Below it says: "The great macho sadist."

ELEONORA: *(Enviously)* And I am not in any of them?

PAULINA: You, too. "The great female slave at the moment she is pulverized." *(Eleonora looks at the magazine.)* I have a list of twelve reporters from the top media conglomerates who want to interview you. Nobody is talking about anything else besides what is going on in the sanctuary. If we manage the business well, we could make millions.

ANTONIO: It is too late, Mother. It's too late for success. It is too late for fame. Eleonora and I were breaking up.

ELEONORA: *(She reacts to this.)* You said it right. We "were breaking up." The verb is conjugated in the past tense.

ANTONIO: But didn't you say just five minutes ago . . .

ELEONORA: Five minutes ago I didn't know that we were famous.

PAULINA: I don't want to interrupt you, but it would be lovely if you would appoint me as your representative.

(Paulina leaves. Eleonora and Antonio are left alone.)

ELEONORA: *(Thrilled)* You are so brilliant, Antonio.

ANTONIO: A common man . . . Your ex-husband. *(Resentful)*

ELEONORA: Antonio . . . now I want to remain chained to you.

ANTONIO: *(He looks at her.)* You like that they imagine . . .

ELEONORA: It turns me on that they think that we were having a wild orgy. No wonder they looked at me in the hospital as if I were a Profane Goddess.

ANTONIO: *(Surprised)* They looked at you like that?

ELEONORA: *(She proudly confirms.)* Now I understand the adoring attitudes of the emergency room staff.

ANTONIO: Tell me about it.

ELEONORA: My darling, I adore you. You have never given me an orgasm, but you have given me so much prestige.

ANTONIO: You conceived of this giant leap. You are really a mythic goddess.

ELEONORA: But you brought it to its final conclusion.

ANTONIO: Do you know that mummy look is quite flattering on you?

ELEONORA: And do you know that your head bandage suits you marvelously well?

(They look at each other, enchanted and happy. In spite of how uncomfortable it is to do so, they kiss. Lights.)

Act 5

(The scene: the bedroom of Eleonora and Antonio, completely transformed into a temple of sadomasochism. The bed is hanging vertically, like a torture rack. Chains hang from the ceiling. On the walls are various instruments of erotic torture. They are all very bizarre and sophisticated. Outside, reporters struggle to get in. But Paulina, dressed in a leather

suit, oversees their access. When the lights come on, Eleonora, dressed in an Egyptian slave costume covered with golden scales, is tied to the vertical bed. Antonio is dressed in his leather equipment, and, with his whip in his hand, pretends to punish her. A photographer from a North American newspaper is taking pictures for an exclusive exposé. He is tall, blond, and is loaded down with numerous cameras. The scene is lit with special care and looks like a photographic set. There is a makeup person who draws red whip marks on Eleonora's body. Paulina, at the door to the bedroom, argues with a journalist. Meanwhile, assuming several clearly erotic postures, Antonio and Eleonora pose for the photographer.)

PAULINA: *(To the reporter who is outside)* No, sir. The interview that I agreed to give your newspaper is in two hours.

OFFSTAGE REPORTER: This schedule was confirmed for me, Madame.

PAULINA: Impossible. Right now they are being photographed for a North American exclusive.

OFFSTAGE REPORTER: What does that have to do with it? I just want to write a story. I just want to ask them questions.

PAULINA: No, sir. You will distract them. Your appointment is later.

OFFSTAGE REPORTER: I am going to make sure that people know about this, Madame!

PAULINA: What are they going to know?

OFFSTAGE REPORTER: That you privilege Yankee imperialism. Our sado-masochistic newspaper is domestic and popular. Haven't we had our own dictatorship? Argentine sadism is famous worldwide. Thirty thousand disappeared. Isn't that a big enough number? Do you need more? *(Pushing)*

PAULINA: But they pay in dollars.

(The reporter tries to push his way in. Paulina pushes him back the other way. There is a chain on the door that stops the progress of the reporter. Meanwhile, both the photographer and the makeup person continue working. The makeup artist stains Eleonora's mouth with iodine, as if it were bleeding.)

PHOTOGRAPHER: *(To Eleonora in English)* Please, Madame, moan!!!

ELEONORA: I don't understand what he is saying.

PHOTOGRAPHER: Please, Madame, moan!!! Simulate more suffering!!

ELEONORA: What is he saying to me, Antonio?

ANTONIO: Mother, come here.

(Paulina slams the door and comes in.)

PAULINA: What do you want, sir?

PHOTOGRAPHER: I need her to contort her face.

PAULINA: *(Translating)* He needs you to contort your face.

PHOTOGRAPHER: I need a crazy face.

PAULINA: He needs a crazy face.

(Eleonora tries to satisfy his demands.)

PHOTOGRAPHER: I need to photograph a mangled body.

PAULINA: He needs to photograph a mangled body.

PHOTOGRAPHER: As though a big missile had exploded her innards. *(Emphatic. Convincing. Demanding.)*

PAULINA: *(Having understood, she emphatically translates.)* As though a big missile had exploded your innards.

ELEONORA: What?

ANTONIO: *(Yelling at Eleonora)* As though a big missile had exploded your innards, darling!! *(He assumes the expression and pose of a torturer.)*

PHOTOGRAPHER: *(To Eleonora)* I want her to pretend to be a victim of a giant, sexual war machine which spouts deadly semen.

PAULINA: Aren't you exaggerating a bit?

ELEONORA: What does he want now?

PAULINA: He needs you to pretend to be a victim of a giant, sexual war machine which spouts deadly semen.

ELEONORA: Tell him I am going to try.

PAULINA: *(To the photographer)* She will try.

PHOTOGRAPHER: Excellent!!!

(Eleonora tries to pose under the pressure of these demands. She contorts herself. She writhes. Antonio, who is directed by the photographer, complements her by assuming the ridiculous postures of a torturer. The photographer takes a few shots like this. Banging at the door.)

OFFSTAGE PHOTOGRAPHER: For a politics of national sadomasochism!! In defense of patriotic sadomasochism!! *(He bangs on the door.)* For the opening of new tabloid press markets!!! For pornography that represents us!!! Open this door!!!

ANTONIO: Isn't there any way to get rid of that guy?

PAULINA: We can't fall out with the local tabloids. We have to cover all of the fronts. The national and the international.

ANTONIO: But must we have the national front there at the door bursting our eardrums?

PAULINA: He will tire himself out eventually.

PHOTOGRAPHER: *(To Paulina)* Give me delirious eyes. Let's see her nails torn off, her breasts ripped away, and her sex corrupted by metallic sounds. *(Mystically possessed by his own images)*

PAULINA: *(Translation for Eleonora)* He wants delirious eyes. He wants to see your nails torn off, your breasts ripped away, and your sex corrupted by metallic sounds. *(Impassioned)*

ANTONIO: And how are we going to manage that? *(Desperate)*

ELEONORA: I can make my eyes delirious, but I am not going to rip off my nails!

PAULINA: With as much as they pay us, we can buy you nails made of gold!!! Look at the contract. *(Businesslike)* But we can't waste time. There are too many interviewers waiting.

PHOTOGRAPHER: *(Excited)* I've come all the way to this unknown and undiscovered land and paid hard cash for some authentic South American suffering!!!

PAULINA: He says that he's come all the way to this unknown and undiscovered land and paid hard cash for some authentic South American suffering!!!

PHOTOGRAPHER: Please, I am asking you to give me authentic South American suffering!!!

ELEONORA: *(She screams.)* Ahhhhhhhhh. Is this authentic and South American enough for you?

PHOTOGRAPHER: More, Madame, more!!! *(The photographer takes more photos. She contorts herself. Antonio pretends to punish her. The photographer is finally satisfied. To create ambience he puts on warlike music. The sounds of machine guns.)* Okay, here we have the victim of a huge sexual war machine. *(He advances as if his camera were a war machine. He makes war sounds.)* Violence!! Death!! Blood!!

PAULINA: *(Translating)* Violence, Death, Blood!!!

(The makeup artist covers Eleonora with iodine. The photographer enthusiastically laughs, and with fervor, photographs the simulated scene of flagellation.)

PHOTOGRAPHER: *(Facing Antonio)* I need more sadism, man, I need to photograph a cruel and bloody scene.

PAULINA: More sadism, man. He needs to photograph a cruel and bloody scene.

PHOTOGRAPHER: I need to capture Satan's face as he smashes towns and nations and people and animals and plants.

PAULINA: He needs to capture Satan's face as he smashes towns and nations and people and animals and plants.

ANTONIO: I don't know how to do all of that.

(The photographer exaggerates the poses of Antonio. He sticks him in sadistic positions. He mounts him on top of a piece of furniture and puts a whip in his mouth which drips a red liquid. He asks for more noise to create atmosphere. Missiles and bombs explode. Afterwards he takes copious pictures with the active collaboration of the makeup artist.)

PHOTOGRAPHER: Ah, finally, some good sadism. *(He laughs.)*

PAULINA: Ah, finally, some good sadism. *(She laughs.)*

PHOTOGRAPHER: From South America to the rest of the world!!

PAULINA: From South America to the rest of the world!!

PHOTOGRAPHER: I love your brutality. It is totally absurd and primal!!!

PAULINA: I love your brutality. It is totally absurd and primal!!! *(Antonio beams with pride.)*

PHOTOGRAPHER: Now pretend to copulate with your despised slave.

PAULINA: Now pretend to copulate with your despised slave.

ANTONIO: Is that also in the contract?

PHOTOGRAPHER: Silence!! Shut up!! *(Ferocious)* I need you to fake brutality. I bought fake brutality.

PAULINA: Silence!! Shut up!! I need you to fake brutality. I bought fake brutality.

ELEONORA: He is absolutely right. He bought sacrilegious copulation. He wants you to pretend to stick barbed wire into my brutalized vagina. He wants to export a simulacrum of a fake sex scene between a South American sadist and an Egyptian slave born in Buenos Aires. He has traveled from afar for a close-up of a savage act of primitive humiliation between a macho, armed to the teeth with torturous chains, and a female reduced to the emptiness of fake pleasure, which is what we sell in this temple. Hit me with everything you've got, Antonio. But don't touch me. *(Mystical. Devoted.)*

PHOTOGRAPHER: Sí, sí, sí . . . That's what I paid for.

ELEONORA: He needs to take back a suitcase full of terrifying images of humiliation, so that the truck drivers of New York City can masturbate with his magazines. *(Happy to interpret for the photographer)*

PHOTOGRAPHER: That's it. *(He is enchanted by the understanding and malleability of Antonio and Eleonora.)* Okay, that's enough for me.

PAULINA: *(Untying Eleonora)* He is finished.

(Eleonora falls on top of Paulina.)

ELEONORA: Finished. Yes, finished.

(The lights fade and go out with this image.)

Act 6

Sadomasochistic posters of Eleonora and Antonio are projected on the far wall. They have a strong visual impact and appear very produced and generic. A few months have gone by. Antonio and Eleonora lay in bed, alone. He is in his underwear; she is eating cookies.

ELEONORA: Darling . . . couldn't we?

ANTONIO: You and me?

ELEONORA: Today is your mother's birthday, and we are missing it.

ANTONIO: Noooooo!!!

ELEONORA: It's time for our yearly love-fest.

ANTONIO: *(Unmoving)* Insatiable Eleonora . . .

ELEONORA: I miss our day of love . . . there was only one, but it was something.

ANTONIO: When one rises to a new position in life, one always has to give up something. Happiness, my love, has its price.

ELEONORA: Is this happiness? *(She anxiously eats cookies at top speed.)*

ANTONIO: Of course . . . this is happiness. Touch it, feel it, live it . . . *(He gets dressed to make it clear that nothing sexual is going to happen between them. He puts on party clothes. Formal attire.)*

ELEONORA: *(They touch.)* We are so happy. *(She cries.)*

ANTONIO: *(He cries.)* Crying out of happiness.

(They cry together.)

ELEONORA: Me too, I am crying out of happiness. *(She puts on makeup and gets all dolled up.)*

ANTONIO: Don't tell anyone that happiness makes us cry so much.

ELEONORA: Don't worry . . . It is such an intimate happiness. *(They cry together.)*

ANTONIO: It is such a perfect happiness.

ELEONORA: So happy.

(Someone knocks at the door. Antonio and Eleonora wipe away their tears and in unison draw shiny exaggerated smiles on their faces. Eleonora opens the door. It is Paulina. She comes in wearing a leather outfit, whips, and boots. Very flamboyant.)

PAULINA: Am I interrupting something? Since it is my birthday . . . I thought that . . .

ELEONORA AND ANTONIO: Happy Birthday! *(They hug her.)*

PAULINA: I know that today is the day . . . that I shouldn't bother you.

ELEONORA: Now we don't have any day . . . *(They both give her forced smiles.)*

PAULINA: I am so happy to hear that, darling . . . so you no longer . . . ?

ANTONIO: We are completely cured.

ELEONORA: We don't have our day anymore.

PAULINA: What lovely news . . . you have 365 days a year to dedicate yourselves to the demands of the free market!!!!

ANTONIO: Free!!!!! We are free. Now we don't have any sexual problems because we don't have sex.

PAULINA: This can't leave these four walls . . . it would be terribly damaging. I have brilliantly directed your careers . . . So . . . nobody has heard this confession . . . not even me . . . You are a model of happiness . . . for the entire society.

ANTONIO: Don't worry . . . no one will ever know.

ELEONORA: We were just talking about that . . . how happy we are.

PAULINA: We are the happiest beings on earth. *(They hug.)*

ANTONIO: We did everything so well . . . I am so proud of the three of us.

ELEONORA: I never believed that we would have such a happy ending.

ANTONIO: So . . . so happy . . .

ALL THREE: *(They cry.)* So . . . so happy! *(They stop crying. They laugh.)*

PAULINA: This is the best birthday of my life.

ELEONORA: You are so sensitive Paulina . . . thank you for helping us to achieve such happiness.

PAULINA: I am happy when you are.

ANTONIO AND ELEONORA: Just as we imagined.

(The three of them raise a toast with champagne. The lights go down.)

The End

What Is Diana Raznovich Laughing At?

DIANA TAYLOR

When Diana Raznovich presented her *Manifesto 2000 of Feminine Humor* at the Hemispheric Institute of Performance and Politics in Brazil in 2000, she adopted the role of a censoring shrew:

> Diana Raznovich is a dangerous woman.
> She spends her time laughing.
> What does Diana laugh at?
> Eh?
> Or, better put,
> What *doesn't* she laugh at?
> Diana laughs at all things serious, the military and
> > their medals, fuming politicians that
> > look like cartoon figures.
> Either she's out of focus, or we have to look
> > for focus elsewhere.

In her *Manifesto*, the feminist playwright/cartoonist answers her own question: "Diana laughs at all things serious." But her laughter is serious. Her writing has gotten her into trouble since she was a child. She tells, laughing, of the time she was six, in first grade in Buenos Aires. She was chosen to recite her poem to Evita Duarte on the First Lady's official visit to the school. As a reward, Evita gave Diana a bicycle, which the child proudly took home. Diana's parents, avidly anti-Peronist, made her get rid of the bike. She took the bike to a friend's house and continued to ride it secretly. Since then, art for her has always been linked to defiance.

Early in her career, Raznovich began defying Argentine theatrical

norms. She rejected the ponderous realistic style so popular among her fellow dramatists. *Plaza hay una sola*, her second production, was a performance piece comprised of eight different scenes taking place simultaneously in a public park. The audience walked around, encountering a series of situations—a woman about to commit suicide, another person giving a speech from a soapbox, and so on. The scene about the woman determined to commit suicide (a motif that runs from this first play to her most recent) illustrates the social forces that drive women to self-annihilation. A reporter, who follows her around the park videotaping her despair, tries to reassure her that life is worth living. He plays a heroic role in her ordeal until she starts believing him. As she decides that she can, in fact, go on living life, he realizes that he's lost his show. The question becomes how he can get her to commit suicide and still preserve both his show and his protagonist role in it.

Since the 1960s, Raznovich's work, both as a cartoonist and in the theatre, has been marked by her sense of humor and her love of disruption, inversion, and the unexpected. But her career as a playwright was stalled when repeated threats on her life by the Armed Forces pressured Raznovich into exile in 1975, shortly before the military coup that initiated the "Dirty War." She lived and worked in Spain, teaching dramaturgy in an independent theatre school until she returned to Argentina in 1981 to participate in the Teatro abierto (Open Theatre) festival.

Teatro abierto brought together dramatists, directors, actors, and technicians—all of them blacklisted and fearing for their safety—to produce a cycle of one-act plays that demonstrated that Argentina's artists had not succumbed to the dictatorship's silencing tactics. How could Raznovich resist the chance to participate in such an important act of collective defiance? Still, even within this oppositional solidarity, there were those who sought to control the range of "acceptable" defiance—several of the other playwrights found Raznovich's contribution (the one-act, one-woman play *El desconcierto* (Disconcerted) to the "open" theatre cycle inappropriate. Who could possibly be interested in a play about a female pianist who can't make sound come out of a piano in the context of the censorship and general silencing of the "Dirty War?" While Raznovich's intentions were (and are) always to challenge and transgress repressive limits, she has not always done this in a manner that her more openly political colleagues could understand or appreciate. Though she was asked to withdraw the play and submit another, she refused (Raznovich, interview, Dartmouth). The military reacted more violently not just to her work but to the entire project, burning down the Picadero Theatre on the night that *Disconcerted* was presented (Arancibia and Mirkin

21). Teatro Abierto moved to another locale, and continued to stage its productions in the face of growing governmental opposition and growing popular support. Yet some of Raznovich's fellow artists "started saying that I was frivolous. I took it as a compliment. There was no permission for my stance or style, and I found it wonderfully transgressive" (Interview, Buenos Aires).

Disconcerted, far from being frivolous, depicts a society caught up in the active production of national fictions—fictions that ultimately render all members of the population silent and complicitous. The pianist, Irene della Porta, is paid handsomely by her manager to play Beethoven's *Patetica* on a piano that emits no sound.[1] The audience buys tickets to watch Irene wrench sounds out of nothingness: "It is as if the woman and the audience, knowing that the Beethoven Sonata cannot be heard, were mysteriously capable of composing 'this other non-existent concert'" read the opening stage directions.[2] At the end of the play, the piano regains its sound as if by magic. But after so many silent concerts, Irene della Porta no longer knows how to make "real" music. Desensitized fingers produce harsh, discordant notes. Shocked and defeated by her ultimate failure as an artist, she rejoices when the piano once again becomes mute.

On the most obvious level, *Disconcerted* is a critique of Argentine artists and audiences alike who were willing to go along with the censorship imposed by the military dictatorship, convincing themselves that, in fact, they were engaging in meaningful communication. What draws the members of the audience into the theatre night after night is, in part, a sharing of collective complicity that they can interpret as resistance. Although they produce no sound, the reasoning seems to be that by their presence alone, audience members defy those who impose censorship and self-censorship.[3] The idea that public presence at a theatrical event was an act of resistance underlay the entire Teatro project. The fact that thousands of people lined up to see plays *bajo vigilancia*[4] (under surveillance) was interpreted by the military leaders and by the population at large as an oppositional move.

Disconcerted, however, seems directed at those Argentines who were complicitous with the dictatorship and whose passivity in the face of governmental brutality made a new social order—the culture of terror—possible. The "show," far from being oppositional, is produced by the power-brokers themselves. By their very presence and willingness to be part of the performance, the spectators contribute to the construction of a new community, one that is grounded in fictions. But the spectators do not recognize themselves in the scenario—they are blinded to their situation

and think that the drama (which seemingly eludes them as the sound eludes Irene) is taking place someplace else. Yet this silencing and displacement was precisely what the "Dirty War" was all about.

The performative process of communal binding/blinding depicted by Raznovich points to two forms of gender violence. On one level, "femininity" is a performance that Irene enacts on a daily basis. Clad in her low-cut, tight, red gown and dripping with jewels, she becomes the Other that the audience pays to see. She even speaks of herself in the third person, as Irene della Porta, as a commodity who has agreed to play along with her objectification and degradation because she gets tangible benefits out of it: "Agreeing to be Irene della Porta playing silently gave me endless years of comfort" (Raznovich, *El desconcierto* 46). Raznovich presents gender as performative, much along the lines developed by Judith Butler in her early writings: "gender is an act which has been rehearsed, much as a script survives the particular actors who make use of it, but which requires individual actors in order to be actualized and reproduced as reality once again" ("Performative Acts" 277).[5] Few roles available to women in patriarchy offer any visibility—the "star" being one of them. But, the star, as Irene explicitly notes, embodies the male spectators' desires. She becomes Woman as a projection of patriarchal fantasies that performs onstage. She no longer recognizes herself in the mirror—there is no "self" to recognize.

On another level, the project of community building undertaken by the junta is also gendered. From the beginning, the junta made explicit that state formation was inextricable from gender formation. In its first pronouncement, published in *La nación* on 24 March 1976, the day of the military *golpe*, the junta declared itself the "supreme organ of the Nation" ready to "fill the void of power" embodied by Perón's widow, "Isabelita," Argentina's constitutional president. The maternal image of the Patria was both the *justification for* and the *physical site of* violent politics. The very term *Patria*, which comes from padre or "father," does not mean "fatherland" in Spanish, but rather the image of motherland framed through patriarchy. There is no woman behind the maternal image invoked by the military. Yet the feminine image (Patria, Irene della Porta) serves a real function in community-building by uniting all those who imagine themselves bound or loyal to her. However, the "feminine" is only useful to the power brokers as long as she remains an image without real agency. As such, "she" gives the spectators their identity. Just as the Armed Forces defined "true" Argentines by virtue of their loyalty to the Patria (and by extension, to the Armed Forces as her defenders), Irene della Porta's fans form an "imagined community" through their relation-

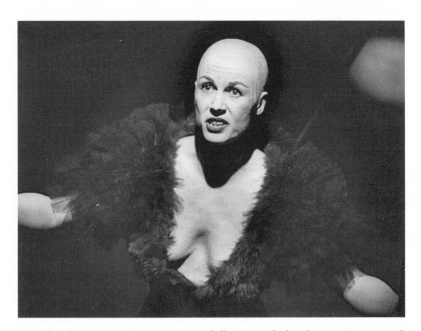

17. "What do you want from me?" Irene della Porta asks her fans in *Disconcerted*.
Photo courtesy of Diana Raznovich.

ship to her: "Who am I? Who are you?" The nature of this community-
building is circular—the feminine image is the creation of the patriar-
chal order, but she, in turn, gives birth to the nation's image of itself. So
too, Irene della Porta candidly admits that she is the creation of her fans:
"[they] have made me what I am today. But, who am I?" And yet, her tenu-
ous, rehearsed "identity" unites the audience.

While the woman disappears in the image of Patria, Raznovich will not
allow her audience to overlook the misogynist violence of this commu-
nity-building discourse. Her character makes it clear that what draws the
audience to the theatre is also the "show" of public humiliation that Irene
della Porta performs on a nightly basis. The themes of collective com-
plicity, silencing, and disempowerment are played out on the exposed
and humiliated body of Woman: "What do you want from me? (*Suddenly
she opens her dress and begins to undress.*) Do you want to unravel hid-
den truths? Do you want to see me without any more disguises? (*She un-
dresses down to her underclothes.*) . . . Now that you see me this way,
stripped down to my teeth, do you know more about me than before? . . .
Does my nakedness bring success? What is a naked woman? A skeleton
out in the open covered with a fragile vital membrane?" (47). As a femi-
nist, Diana Raznovich understood an aspect of the cultural production of

community and silencing that other playwrights reproduced but failed to recognize—that the social pact between power brokers and complicitous audiences is being negotiated (both in the military discourse and in "art") on the body of Woman. The audience searches for its identity in her bodily interstices and looks for "truth" on her naked flesh. Her body functions as a text on which the community's fate is inscribed.

Disconcerted paradoxically signals both the failure and the power of art in the context of the "Dirty War." The play's presentation of Irene della Porta's body as exposed rather than naked and of the grotesque sounds emanating from the piano defies the aestheticization of violence and the commodification of culture even as it portrays them. Raznovich decries the fetishizing even as Irene della Porta succumbs to it. Her play is a work of "committed art" even as it laments the nonexistence of such a thing. As Theodor Adorno noted in the late 1960s, "a work of art that is committed strips the magic from a work of art that is content to be a fetish, an idle pastime for those who would like to sleep through the deluge that threatens them, in an apoliticism that is in fact deeply political" (177). Diana Raznovich makes clear that noncommitted, evasive art during periods of social catastrophe helps constitute and cement a culture of terror in which people ultimately lose their capacity for real insight. Even if restrictions were suddenly lifted, and the piano magically regained its sound, those involved in the production of fiction would not be able to reestablish real communication.

Diana Raznovich's opposition to the limits imposed by the oppositional "left" itself, however, went beyond issues of her personal dramatic style. As a feminist, she objected to what she saw as the all-male nature of Teatro abierto, made evident not only in the content of the almost entirely male-authored and -directed plays, but in the decision to stage Teatro abierto at Tabarís after the burning of the Picadero. As before, Teatro abierto started early, at 6:30 P.M. At night, the Tabarís continued its regular programming—a cabaret featuring scantily dressed showgirls and misogynist jokes. When women in Teatro abierto complained about housing their politically "progressive" and oppositional theatre event in that location, they were overruled. The argument was that Teatro abierto would "subvert" the space and give it new meaning. But rather than subvert the space of feminine degradation, Teatro abierto decided to exploit it to ensure its own survival and continuity. The military males, who frequented the cabaret during its regular hours, would be less likely to destroy a space they associated with their own pleasure. This strategy of protecting political content within the context of female sexual exploitation was not new to the period.[6] But the consequence, of course, was

that gender inequality and sexual exploitation of women could never be the topics of analysis, since the transmission of the political message was seen as contingent on their continuing exploitation. Thus, Teatro abierto set up a situation in which theatergoers prepared to find a critique of their repressive society, would have to walk past the posters of half-naked women to get into the theatre. The juxtaposition of the political event against the seminude female body reproduced the visual strategies used by pro-military magazines (such as *Gente*) that superimposed headlines of the atrocious events of the "Dirty War" on the female bodies in bikinis that graced half of their covers. Again, the female was reduced to pure body and backgrounded as the site of violence and political conflict. The female subject could lay no claim to political participation or to nonexploitative representation—she served as the scenario on which the struggle between men—political agents—could take place.

The struggle for a feminist playwright in Argentina during the "Dirty War," then, was far more complicated than taking an antimilitary stand—dangerous and heroic though that was in itself. It meant taking on not just the brutal regime but the Argentine imaginary, that imagined sense of community that defines "Argentine-ness" as a struggle between men—fought on and over the "feminine" (be it the symbolic body of the Patria or motherland, or the physical body of a woman). The violence against women, both in fact and in representation, went beyond a straightforward "left"/"right" divide. Thus, to challenge that violence meant taking on the "progressive" authors who themselves depicted the construction of national identity as predicated on female destruction. Even plays by progressive male artists that were intended as a critique of the macho military male still needed the woman's naked body to express their objections and engage their audience.

In one of those examples of ironic inversions that Diana Raznovich is so fond of, the "Dirty War" ended, the military was more or less chastened, the rulers changed, and she still had plenty to laugh about. Unlike several important Argentine dramatists who could identify and address the evils of military dictatorship but who did not understand that the coercive system (not just the leaders) had to change, Raznovich had begun to write about oppression in relation to issues of gender and sexuality that had so totally eluded most of her colleagues. Her brilliant plays, *Inner Gardens* (Jardin de otoño 1983), *MaTrix, Inc.* (Casa Matriz 1991), and *Rear Entry* (De atras para adelante 1995), continue to explore the feminist premise that desire is created and constrained through the scopic and economic systems that supposedly only represent it, that gender and sexuality are performative, and that subjectivity is socially constructed.

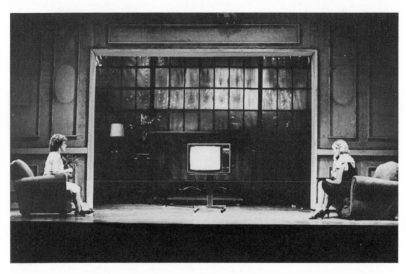

18. In *Inner Gardens*, Griselda and Rosalia spend every afternoon in front of the television passionately involved in the ups and downs of their adored hero, Marcelo-the-mechanic. Photo courtesy of Diana Raznovich.

Just as the star-role enacted by Irene della Porta was a product of a patriarchal system that profited both economically and politically from her ability to make a spectacle of her humiliation, the other roles and sexual choices available to women were similarly produced.

In *Inner Gardens*, Raznovich shifts her examination of these constraining systems of gender and sexual formation to the *telenovela* or "soap opera" so popular in Latin America. Soap operas, too, of course are in the business of producing fictions. Like the silent concert staged by Irene della Porta's manager, the telenovela is controlled by the power broker behind the scenes—here the odious Gaspar Mendez Paz, the producer. The consumers of these fictions, like the audience in *Disconcerted*, live with the fantasy that they are actually opposing those in authority by participating in some romantic battle against the status quo, even as they submissively surrender themselves to the screen. The main characters of the play—two middle-aged women named Griselda and Rosalia, who have lived together for twenty years, spend every afternoon in front of the television passionately involved in the ups and downs of their adored hero, Marcelo-the-mechanic. Though lowly, rough-speaking, and dressed in greasy overalls, he challenges the social barriers that separate him from the lovely, upper-class, and engaged-to-another Valeria, the girl of his dreams. And the women live the drama with him, consumed with passionate intensity. Will the girl's father have

him thrown in jail? Will he end up dying there? This, as one of the women points out, is a "modern" soap opera, which means that things could turn out badly for the hero—no happy endings guaranteed. The telenovela, like the silent concert, provides these spectators with the fiction that they are participating in a life of intensity that eludes their grasp.

On one level, though perhaps not the principal one, the play engages the debates surrounding the political dimension of popular culture. Do the soaps, one of the best examples of popular culture on a massive level of production and consumption, instill an antipopular ideology in its audiences, giving them values and worldviews that reflect the industry's interests rather than their own class interests? While the telenovela might not overtly intend to control its audience (unlike the concert in *Disconcerted*), the product bears the ideological stamp of its producers. As John Fiske puts it, "every commodity reproduces the ideology of the system that produced it: a commodity is ideology made material" (14). The simple David vs. Goliath plot of the soap opera seemingly confronts social bias (specifically class conflict). While the women cheer their idol on to triumph, and hope that social barriers will simply evaporate, they certainly are not going to *do* anything about the problem. They may not even be aware of class conflict as a social problem, especially when they personalize it by concluding that the rich girl's daddy is a "rotten old man" and that the rude producer "hates the viewers." The most they can do is call the producer and, as loyal viewers, demand that those in charge work out a satisfactory ending. Thus, the anti-soap argument goes, these programs encourage the working classes (who make up the bulk of the viewing audience for these shows) to dream about triumphing in a social structure that, in fact, is predicated on their exclusion.

Inner Gardens does not endorse this "antipopular" position outright. There is an element of playfulness in the way the women participate in the drama that supports Carlos Monsiváis's contention (shared by other analysts of popular culture such as Fiske, Rowe, and Schelling) that popular audiences find a way to resemanticize cultural materials provided from above. Monsiváis argues that "collectivities without political power or social representation . . . sexualize melodrama, extract satirical threads from black humor, enjoy themselves and are moved emotionally without changing ideologically . . . The subaltern classes accept, because they have no alternative, a vulgar and pedestrian industry, and indisputably transform it into self-indulgence and degradation, but also into joyful and combative identity" (qtd. in Rowe and Schelling 109).

Monsiváis's contention that the subaltern viewers can engage "emotionally" without "changing ideologically" is the problematic crux of the

issue—and the one Raznovich's play most lucidly dismantles. Griselda and Rosalia, the two "old maid" types, desire, long for, love, and feel intensely, but they have no adequate outlet for this love. Griselda writes poetry and talks to her plants; Rosalia goes to the fortune-teller, hoping against hope that some handsome man will appear in her future. Meanwhile, they spend the afternoons lusting for Marcelo-the-mechanic, kissing the screen, each wishing she were the adored woman in the picture. One day, they decide to kidnap Marcelo and live out their fantasy, even if they have to die afterward. So they do, and the play goes on to show their increased frustration as the star disappoints them. He is not the simple, good, honest, hardworking boy they've grown to love on the series. He is charming and nice, but far more complicated than they anticipated. He can't make passionate love to them, as they had dreamed, though the women can't figure out why. Maybe he's impotent, they suggest, maybe he's gay. Well, maybe he's not gay but rather homosexual. What's the difference, they wonder, though they feel there probably must be some. And on they go until they discover the star lightens and perms his hair and uses makeup. The "real" man is more artificial, the women decide, than the Marcelo on TV. So they turn the soap opera back on and let the actor find his own way home. The "real" is a poor substitute for fantasy. The women seem comfortable back in their world of safe, predictable, honest, "real" illusion. So, this, it seems, illustrates Monsiváis's point that the viewers can engage emotionally and disengage ideologically.

However, it seems to me that *Inner Gardens* is specifically concerned with the constraints imposed on emotional and sexual expression by dominant systems of representation that not only reproduce scenes of desire (Marcelo and Valeria) but also demarcate their limits. These systems of signification (for soap operas are not just products but systems) do not offer as much space for resemanticization as one might like to believe. The real love story going on here is not between Marcelo and Valeria but between Griselda and Rosalia. They live together; they love each other; they share a rich, funny, tumultuous domestic relationship; they cannot imagine life without each other. Yet, they have never been permitted to envision their relationship as anything beyond the banal labels that they have available: "a friend, a roommate, a boarder, let's say" (55). The idealized male soap-opera star serves to channel and contain the love and desire between them. Their desire circulates through him. Griselda's most acute sensation when she is watching "the best episode of the year," the one in which Marcelo kisses Valeria and admits he's "got it bad" for her, is the feeling of disappointment that Rosalia is not there to watch it with her (64). This love on the screen is to be shared by them,

even though they have momentary snits in which each claims the divine Marcelo for her own. Thus, the soaps, as a dominant system of signification, validate certain forms of love while making others unthinkable. Class barriers might be the subject matter of the telenovela, but it cannot (yet) question the barriers that make heterosexual love the norm. Griselda and Rosalia, not surprisingly, are as blind to the nature of their desire as the society that created them. They can say that they love each other, they can look at each other intently, hold each other, and admit they cannot live apart, but only the fantasy of heterosexual passion allows them to do so without assuming the weight and shame too often ascribed to homosexuality. The women simply displace their passion onto the handsome television star. The story of their lives isn't theirs—it's taking place on TV; their love for each other (which they allude to repeatedly) isn't theirs—it's happening between Marcelo-the-mechanic and the lovely, rich, engaged-to-another Valeria. The women can own their passionate intensity every afternoon precisely because they don't have to recognize it as *theirs*. Towards the end of act 1, in one of the saddest moments of the play, the women pray for forgiveness for the life they haven't lived:

Forgive me for what I haven't done.
Forgive me for what I haven't had.
Forgive me for what I haven't taken.
Forgive me for what I haven't felt.
Forgive me for not laughing enough.
Forgive me for not using up my tears. (73)

The plot of *Inner Gardens* illustrates that emotionally, as well as ideologically, social subjects are produced and delimited by the very systems that, in theory, are there to excite desire. But the play also inverts the paradigm that positions the feminine as the object of desire that serves to stabilize the male-dominated community that Raznovich depicted in *Disconcerted*. In that play, the audience becomes a community as it comes together to applaud Irene della Porta. In *Inner Gardens*, however, there is a more explicit sexual dimension to the mediation that, I have argued, is central to Argentina's social imaginary. Again, we see the case of the triangulation of desire—channeling of erotic intensity through a safe symbol of either feminine or masculine sexuality that allows for proximity without incurring the stigma of a society as homophobic as the Argentine one. Yet, that triangulation is pivotal, both to the lives of these two spinsters and to the gendering of the nation as a whole. As I submitted in *Disappearing Acts*, "The feminine nation, or Patria, mediated the autoeroticism of the military's performance. The armed forces obses-

sively conjured up the symbolic Woman to keep their homosocial society from becoming a homosexual one. The military men came together in the heterosexual language of 'love' of the Patria" (68–69). Whether it's the Patria, Irene della Porta, or Marcelo-the-mechanic, the discourse of passion circulates through a rigidly monitored economy of heterosexual love.

In her next play, Diana Raznovich extends her exploration of the "substitute" and the supposedly real (is Marcelo any more or less real to these women than the actor who plays him?) to the social enactment of roles in general. Coming as she does from a society that values the mother almost to the exclusion of all other women, it seems inevitable that she would choose that role to examine. *MaTrix, Inc.*, a full-length one-act play, depicts a "daughter," Gloria, who hires a "mother" from an agency specializing in that service. The two women rehearse a series of roles. They range from the traditional long-suffering mother so popular in much Latin American literature, to the professional mother who jets around the world; from the cold, rejecting mother, to the transgressive one who vies with her daughter for a lesbian lover. Each "mother," of course, elicits a different "daughter," and Gloria undergoes a series of transformations as she pouts, demands satisfaction, cries, begs for love, and orders the substitute mother to give her her money back. Motherhood, so long essentialized as the natural condition that alone justifies the existence of women in Latin America, is exposed not only as a patriarchal construct, but as a commercial one as well. When the substitute mother is asked to play "the long-suffering mother," for example, she states that this is her most sought-after role: "Everyone, absolutely everyone wants to see me in the most menial state of servitude" (119). The show of female submission, just as in *Disconcerted*, continues to be a best-seller. Yet, the brilliance of the play lies in the performative distance that Raznovich establishes between the enactment and that absent referent that one supposes to be the real. But even "the real" is destabilized through the highly theatrical nature of the iterations. As the substitute mother makes a show of crying that produces real tears, she asks her "daughter" to touch them: "You could not ask for a more tragic effect. I am the suffering Mother par excellence. Dressed in black, cleaning, crying . . . Look at my tears!" (121–22). Thus, the idea of "the real" only lends weight to the representation—and not the other way around. That is, the show does not represent the real—as in Aristotelian logic. Rather, "the real" is produced through these constant enactments. So, too, the substitute mother signals the constructed quality of the "real" mother, that woman whose claim to identity and visibility depends on her ability to be a quick-change artist—to be all things

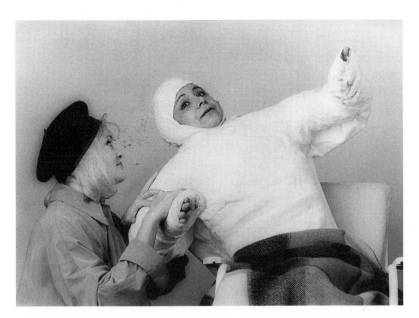

19. The two women in *MaTrix, Inc.* rehearse a series of roles. Photo courtesy of Diana
Raznovich.

to all people. The motherhood role so lucidly deconstructed by Razno-
vich is crucial because it has both severely limited *and* afforded visibility
to Argentine women as different as Evita (the "mother" of the Argentine
homeland) and the Mothers of the Plaza de Mayo. As *women* they had
no claim to power or redress but as *mothers*, symbolic or political, they
launched the most visible political movements headed by women of their
times. Only as mothers could they speak in a way that their fellow citi-
zens could hear. But Evita never had children; the Madres, privately ac-
cepting the death of their own children, claimed to be the mothers of
all the disappeared. Motherhood, thus, shifts from the realm of the bio-
logical to that of the sociopolitical. The efficacy of the role, then, lies not
in its "natural" essence but in its performance. And, in the "intimacy"
of the rental agency, Gloria pays the substitute to produce real anguish
and tears.

The economy of the substitute normally serves to bolster the real,
for what would a substitute mean, what possible function could it have
if it did not replace, stand in for, or somehow link up with the real?
But the notion of the real, so privileged by the deployment of the sub-
stitute, is exactly what becomes shaken in this enactment. The "real"
is produced through the capitalist market system that trades in desires
and emotions. Rather than allowing us to buy into the seemingly natu-

ral mother/daughter experience, to idealize it or psychologize it, Raznovich leaves all the performative strings showing. The set reminds us that the scene of the natural is highly produced, and that somewhere in the background of this (and perhaps every) fantasy, entrepreneurs continue to control the staging.

Nowhere is the complicated interconnection between the act and the real, between the performative and the so-called natural more highlighted, than in Diana Raznovich's *De atras para adelante*. Structured as a more conventional three-act comedy, this play is about a wealthy Jewish businessman, Simon Goldberg, who comes on hard times as his bathroom and plumbing industry goes bankrupt. Everyone is in a tizzy—the young wife, the married daughter, the son-in-law—as the business and the fortune seem, literally, to be going down the drain. Simon, who cannot bare strong doses of reality, crumples in a faint/feint. Mariana, the daughter, insists they contact Javier, her wealthy brother whom Simon threw out of the house a decade ago when he found him in bed with Mariana's fiancé. Help comes but, as always with Raznovich, not in the way that one recognizes or expects. Onstage comes the lovely Dolly—a.k.a. Javier, a transsexual, who is now a gorgeous and loving woman with a husband and three daughters. Dolly saves the business by convincing Argentines that they love colored toilet paper (and that their bottoms deserve no less), but she has more trouble convincing her homophobic father that she deserves his love and support as his transsexual son/daughter, Dolly—not as the Dolly whom Simon is prepared to adore only if she pretends that she is Javier's *wife*.

Clearly, the issues posed here go far beyond the ideas of gender as performative posited both by *Disconcerted* and *MaTrix, Inc.* Gender, of course, is still performative, still an act that the body comes to perfect over time, through the rigorous course of socialization. But the figure of the transsexual challenges the notion that sex (male/female) is ever a stable marker. What sex is Javier/Dolly? How can we even begin to think about, let alone define, sexual difference? Does difference lie in the reproductive organs (so that Javier "dies" as Dolly comes to life)? Or does it lie in the hormones, or in the DNA? Are women (as in the "Dirty War") no more than the "enemy" or "dangerous" *other* in a binary system founded on the sexual divide, part of a male/female *dialectic* as thinkers such as Simone de Beauvoir suggest? Or, as the figure of Irene della Porta implies, are women simply the projection of masculinist fantasies and prohibitions in a closed system whose only referent is male, a *monologic* system or singular phallic order that denies that there even is an *other*. If so, female subjects are forever linguistically absent and unrepresentable.

Does this absence signal the limits of discursive formations themselves and suggest perhaps the possibility of a negotiated existence between discourses, in the margins and fractures? Or does it put in doubt the material existence of real historical beings, situated in discursive formations that erase them? If subjectivity is produced by the entry into culture, as theorists such as de Beauvoir, Foucault, de Lauretis, and Butler have argued, then it is gendered and, more specifically, gendered from the monologic male position in a closed system of self-reference. There are many absences here—the discursive absence of the feminine in a masculinist imaginary; the absence of real, historical female protagonists in Argentina; the absence of the material bodies of the women who were permanently "disappeared" from the political landscape.

The disappearance of Javier inverts the system that erases women as linguistic and heroic subjects. Dolly becomes visible—and so does the seeming cultural impossibility: a man socialized in a masculinist society like Argentina's may in fact choose to be a "woman." Sex is not a static given. Javier will always be a part of Dolly, as perhaps Dolly was always a part of Javier. Sexual identity isn't simply an either/or—mark the M or the F. As Mariana says after she and Dolly go through their old costume box and perform some of the routines they acted out as children, "I think there are three of us, Mariana, Javier and Dolly" (172). There is no immutable real that engenders a series of acts—but a series of acts that construct the real. These performances including those linguistic performances that J. L. Austin refers to when he writes about speech acts that effect change. Social systems only give permission for two acceptable performances of gender to be seen, and these are marked as dominant (masculine) and subordinate (feminine) in a myriad of ways. Language (in this case Spanish) also genders all nouns, and also subsumes the subordinate into the dominant. The duo made up of Mariana and Javier was called "Los hermanos Goldberg" (the Goldberg *Brothers*), a name that erased distinctions between the two. Now, the male Javier has disappeared behind the feminine Dolly, erasing all visual traces of his presence in her as the "Goldberg Brothers" erased the presence of Mariana. Thus, identities disappear and reappear (more or less violently) through a whole series of systems—be they political, linguistic, or systems that dictate the appropriate enactments of gender and sexuality.

Raznovich's most recent play, *From the Waist Down* (1999), continues her ferocious ridicule of the construction of sexual identity and practice in Argentina. As night after night Eleonora sits awake, lamenting the lack of sexual activity in her marriage, her husband Antonio snores placidly and dreams of investments. Antonio represents those stereotypical Latin

American males whose bonds to their mothers run so deep that literally nothing separates them. The only night of the year that Antonio can make love to his wife is on his mother's birthday—an homage to her. As the three of them end up in bed together, Eleonora realizes that she is the intruder in the erotic relationship. Once again, the woman and her right to sexual pleasure disappear from the scenario. Eleonora's attempt at suicide, albeit ridiculous, underlines the fact that even after the fall of the dictatorship, she, like Irene della Porta, continues to perform in a space of impossibility. There is simply no room for certain kinds of women (independent, sexual, non-maternal) in the social imaginary.

In *From the Waist Down*, the set (Antonio and Eleonora's bedroom) links the six short acts, marking the interconnections between sex, capitalism, and militarism. In each scene, Eleonora, Antonio, and his mother Paulina try strategies either to enhance the couple's sexual activity or, failing that, the *illusion* of sexual activity. In act 2, Paulina takes charge of Antonio's overdue sexual education. Eleonora finds to her disappointment that Antonio's newly found theoretical grasp of sex does not involve a practical component. In act 3, the sexologist that Eleonora hired turns out to be an ex-torturer making a new profession for himself after the fall of the dictatorship. Antonio proudly dons the macho gear he bought from the ex-torturer and chases Eleonora, forced into the outfit of an Egyptian slave, around the room with a whip. In act 4, Eleonora and Antonio are back in bed, both in body casts from beating each other up. They discuss divorce as Paulina comes to inform them that they have become national sex symbols. A new business looms ahead, and Paulina asks to represent them. In act 5, the bedroom has transformed into a temple of sadomasochism. The bed is turned upwards, like a torture rack, and Eleonora, still in her slave outfit, hangs from the chains. Antonio pretends to brutalize her as an American photographer asks for gorier, more sadistic poses. Paulina keeps journalists from the national press from banging down the door as they demand access for their national, popular, and patriotic brand of sadomasochism. Wasn't the "Dirty War"—with its scenes of torture and rape—Argentine, after all? The closing scene, "Happy Ending," leaves Eleonora crying, though resigned to a life of celibacy. Even their annual lovemaking ritual in honor of Paulina has disappeared. Though their sex life is nonexistent, business is good. The fiction of erotic intensity proves more viable and marketable than any real sexual relationship possibly could. The final moment shows Eleonora, Antonio, and Paulina joined in their misery and success.

Once again, Diana Raznovich insists that the fantasies that sustain the social imaginary in Argentina continue to be deeply misogynist and

militaristic. While on the surface Argentina exudes an air of glittering prosperity and cosmopolitanism, from the waist down things remain the same. The prevailing politics of repression, which had so conveniently been located and contained in the "dictatorship," in fact go far deeper. The dictatorship is over, but the population has internalized the violence of a century of authoritarian domination. The childishness of the sexual education of Antonio depicted in the second act does not allow the viewer to conclude that this training is harmless. The words that Antonio associates with male and female anatomy—*rods* and *boobs*—have a militaristic overture, especially following the period of the "Dirty War" in which relatively innocent words became euphemisms for brutal practices. The violent fantasies that sustain the "macho" link him to the torturer. Instead of annihilating "others," the post-dictatorship torturer helps wanna-be machos annihilate their very own "others"—their partners. Now, however, in this newly re-democratized society that tries to distance itself from its past, the violence gets cast in terms of consent. Both partners, willing and armed, enter the fray. In reality, however, the consensual paradigm of S/M hides the same misogynist structure of power. Only now, the body of the violated woman, which sustained the military discourse during the "Dirty War," has gone global. National and international commercial and voyeuristic interests are being fought out on her exposed body. The photographer from the United States demands a dramatic show of violence, while the Argentine national press calls for equal access for "national and popular" sadomasochistic publications. The tortured body of Woman is one more commodity circulating in an increasingly global system of representations that creates the very violence it claims to denounce. While Diana Raznovich had called attention to the culture of fiction and displacement that reigned during the "Dirty War," this play shows that not much has changed. Women continue to function as "hinge" figures in all sorts of different scenarios that deny them subjectivity. Eleonora (like Irene della Porta) serves as the hinge between the male and his mother, the male and his homosocial society, the private and the public, eroticism and torture, love and business, the national and the international market. Little wonder that both Antonio and Paulina tell Eleonora to get back into bed. The fantasy can't function without her.

Is Diana Raznovich's representation of these violent systems appropriate? Perhaps the word *appropriate* sums up the normalizing code of admissible behavior that Diana Raznovich so riles, jokes, and warns against. The military junta imposed and enforced rules governing appropriate behavior; the opposition dictated the terms of appropriate resistance. Society demands that citizens act their gender and sex appropriately.

Economic systems—television, advertising, and so forth—tell us what sells and what doesn't, what cultural products can enter the market and which will be excluded (no censorship here, they say, they just aren't marketable). And the way the appropriate becomes the normalized relates to desire. One of the challenges that faces authoritarian governments is that they must teach the population to desire a nebulous higher good (national unity, or a passionate defense of the motherland, for example) so that people will accept civil restrictions (i.e., loss of personal liberties—the right to vote, organize, strike, protest, etc.). Those who refuse to desire what they've been asked to are figuratively or literally "disappeared" as citizens. Capitalist economic systems not only create desire and fulfill it by supplying the desired commodity but, as Marx argued, they erase the human labor that went into production. The worker disappears, leaving only the object whose worth lies not in its production value, but in its exchange value. Gender and sexual identities are produced and reproduced in similar economies. The male occupies the position of producer and consumer while the female's worth rests in her exchange value. As star and as torture victim, she embodies the male fantasy to the mutual benefit of producer and consumer. As the ideal mother, she performs her act of servitude—an act, as Raznovich observes, that is greatly in demand. As a "good" woman, she embraces denial and accepts life without sex, life without laughter. The efficacy of these enactments, of course, depends on their naturalization—that is, on people's willingness to see them as both normative and desirable. Those who fail to participate in this socially constructed desire also disappear into some other category reserved for the "deviants" and gender benders. And what is more violent, Diana Raznovich seems to ask in her humorous, provocative work—the self-inflicted violence of the one who tries to squeeze into appropriate norms? Or the other-inflicted violence (ranging from disappearance to ostracism) visited on those who fail to comply? There are different kinds of violence, different kinds of repression. A playwright like Diana Raznovich who sees the interconnection between the different kinds of systemic violence has her work cut out for her. To invert the normative, she turns to comedy. Humor is subversive; it is capable of challenging and unsettling the norm. "I wish people understood how subversive humor really is," Raznovich says. "You can say a lot more with laughter than with tragedy" (interview, Buenos Aires). So she goes on being "frivolous," defiant, and transgressive as she keeps on laughing.

Notes

1. I have written about this play extensively elsewhere, especially in *Disappearing Acts*. However, a brief overview of the play is important here to lay the basis for Raznovich's subsequent work.

2. All translations from Raznovich's plays are by Victoria Martínez, unless otherwise noted. *Disconcerted, Inner Gardens, MaTrix*, and *Rear Entry* all appear in *Defiant Acts*.

3. It is interesting to note that muteness and public silence were interpreted both as an act of complicity and as an act of resistance during the "Dirty War." On the one hand, those who did not speak out against government brutality enabled the criminal practices of abduction, disappearance, and torture to continue. However, *not speaking* was also seen as a heroic defiance against a system that demanded conformity, just as it was seen as defiance against the torturer who demanded information during the act of torture.

4. This is the term used by Miguel Angel Giella to describe Teatro abierto.

5. See also Butler's *Gender Trouble* and *Bodies That Matter*.

6. The eminent film maker Adolfo Aristarain, who directed *Time for Revenge* in 1981, admitted to doing the same. He included long and unnecessary sexual scenes in the film, he explained in an interview with Annette Insdorf, " 'so the censors took five days and questioned things—*not* politics or ideology, but sex. All I had to do was cut a few frames at the end of some scenes, like one of a strip-tease. It doesn't hurt the scenes—especially if you made them longer than they should have been,' he said with a knowing smile" (17).

Works Cited

Adorno, Theodor. "Commitment." *Aesthetics and Politics*. London: Verso, 1977. 177.

Arancibia, Juana A., and Zulema Mirkin. Introducción. *Teatro argentino durante el proceso*. Buenos Aires: Instituto Literario y Cultural Hispánico, 1992.

Austin, J. L. *How to Do Things with Words*. Cambridge: Harvard University Press, 1962.

Beauvoir, Simone de. *The Second Sex*. Harmondsworth: Penguin, 1984.

Butler, Judith. *Bodies That Matter*. New York: Routledge, 1993.

———. *Gender Trouble*. New York: Routledge, 1990.

———. "Performative Acts and Gender Construction." *Performing Feminisms: Feminist Critical Theory and Theatre*. Ed. Sue-Ellen Case. Baltimore: Johns Hopkins University Press, 1990.

de Lauretis, Teresa. *Alice Doesn't: Feminism, Semiotics, Cinema*. Bloomington: Indiana University Press, 1984.

Fiske, John. *Understanding Popular Culture*. London: Routledge, 1989.

Foucault, Michel. *Discipline and Punish*. New York: Vintage, 1979.

———. *The History of Sexuality*. Vol. 1. New York: Vintage, 1980.

Giella, Miguel Angel. *Teatro abierto, 1981: Teatro Argentino bajo vigilancia*. Buenos Aires: Corregidor, 1991.

Insdorf, Annette. "Time for Revenge: A Discussion with Adolfo Aristarain." *Cineaste* (1983): 16–17.

Raznovich, Diana. *El desconcierto/Disconcerted. Defiant Acts: Four Plays by Diana Raznovich/Actos desafientes: Cuatro obras de Diana Raznovich.* Ed. Diana Taylor and Victoria Martinez. Lewisburg, Pa.: Bucknell University Press, 2002.

———. Personal interview by Diana Taylor. Dartmouth College, September 1994.

———. Personal interview by Diana Taylor. Buenos Aires, 1994.

Rowe, William, and Vivian Schelling. *Memory and Modernity: Popular Culture in Latin America.* London: Verso, 1991.

Taylor, Diana. *Disappearing Acts: Spectacles of Gender and Nationalism in Argentina's "Dirty War."* Durham: Duke University Press, 1997.

GRISELDA GAMBARO

(Argentina)

Griselda Gambaro, who was born in 1928 in Argentina, is one of Latin America's most prolific and important playwrights. She scrutinizes the role of theatre and theatricality in Argentina's tumultuous recent history. In the 1960s, her plays, such as *The Walls* (1963), *Siamese Twins* (1965), *The Camp* (1967), already depicted the escalation of political violence that would become the grim reality of Argentina's "Dirty War" (1976–83). The plays' bizarre environment of victims and victimizers, abductions, and concentration camps, foretells the atrocities to come. In the 1970s, major works such as *Information for Foreigners* (1972) and *Strip* (1974), explored the role of the population living in a criminal society. The audience became the protagonist of *Information for Foreigners*—not the population of torturers and torture victims of earlier plays, but the audience of innocent bystanders, complicitous onlookers, and invisible members of the silent majority who had to make daily decisions about how to act and react in response to the brutality around them. Gambaro's work of the 1980s, such as *Decir sí* (Saying Yes 1981), and *Antígona furiosa* (1986) marks the population's gradual shift from passive participant to furious resister. In the 1990s, plays such as *Atando cabos* (Tying Loose Ends 1991) and *Es necesario entender un poco* (It's Important to Understand a Little 1995), show people trying to deal with the traumatic aftershocks of their recent experience. Throughout her career, Griselda Gambaro has been in tune with the political climate in her country. When she went into

exile in Spain during the "Dirty War," she gave up writing theatre. She needs her audience—but no more than her audience needs her. Gambaro is the most celebrated playwright in Argentina. Her works are produced in all the major theatres, and awarded every conceivable prize. She has won twelve national awards. She is also recognized internationally as Argentina's most important living playwright. In 1982, she was awarded a Guggenheim. Her works have been translated into English, French, and Italian, and staged in theatres such as Royal Court, Theatre de la Source, and Lugano Teatro in Europe.

Strip

GRISELDA GAMBARO

Translated by Marguerite Feitlowitz

Characters

WOMAN

YOUNG MAN

On the set—a table with magazines, a chair, a small armchair.

The WOMAN enters. Pretensions of elegance, skirt to mid-calf, blouse and a short cape. She is wearing earrings and expensive, but worn, high heels. She is carrying an ordinary handbag and a large envelope with her photos. She speaks facing front, smiling.

WOMAN: I know, I know, I'm early. But I'm in no rush, I'll wait. Thank you! *(To herself)* Idiots. Why do they bother setting appointments? They use your time as though it belonged to them. *(Looks around)* They could have a different set-up here, with all the money they make. Stingy bastards.

(She leaves her purse and the envelope on the table. Takes off the cape. Doubts. Puts it back on. Takes a few steps, considers, removes the cape. She folds it and places it on the armchair. Doubts. Drapes it over the back of the chair. She opens her purse, takes out her mirror, looks at herself.)

What eyes. One look and they fall to my feet. *(Thinks, sighs)* Well, not all of them now . . . *(Keeps holding the mirror)* Anyway, the pictures don't show the lines, or the miseries . . . You're lying. The pictures that bastard

took of me! He hated me. *(A low, little laugh)* I didn't pay for them. He deserved it. Forget the crow's feet, I came out a crow.

(She looks at the armchair and then at the chair, unsure as to where to sit. She chooses the armchair.)

But if I show up without pictures, they'll think I . . . came in off the street. They're awful, but they'll do: I've brought the original. *(She laughs.)* When a person like me comes with bad pictures it's practically good that they're bad, it points up the differences. I come out ahead. *(Suddenly disconcerted)* Right? "But, is that you in these pictures? They're not very flattering! No one would say that this girl . . . *(caving in)* this woman . . . is you. My, how you've changed!" *(She remains distracted for a moment. Suddenly stands up.)* I hope Joey doesn't come home early. I didn't leave him anything to eat, and he's so particular! Everything must be ready, everything must be just so. As though I were his servant. I don't know why I put up with it. *(Sincerely)* I love him, that must be it . . .

(The YOUNG MAN *enters. His behavior is impersonal, as though he were dealing with objects—including the* WOMAN—*of no interest to him. Without noticing that the* WOMAN *is smiling, looking at him suggestively, he approaches the table after spotting the envelope there, takes the envelope, and exits.)*

How rude! He could have asked for it! I hope they pay attention to the ones that flatter me, which ones flatter me? Practically all of them, I think. I was thinner then, no belly. *(Sucks in her stomach. Acid laugh.)* No belly, but crow's feet! Why did I bring these old pictures? All yellowed . . . To show I was someone else, without wrinkles, open. They'll see . . . how I've aged. I'm nervous, how dumb. Everything went wrong for me. Even Joey. Poor bastard.

(The YOUNG MAN *enters. She smiles instantly.)*

So? What did they think? Nice, aren't they? *(With a gesture left unfinished)* Did they notice the one by the sea, where I have my hand . . .

(The YOUNG MAN *stops a moment, takes the wide way around her and exits on the opposite side. She's left astonished, open-mouthed. She composes herself.)*

A go-fer. I always make the same mistake. I think just anyone is worth the trouble. Anyone decently dressed . . . I never learn! Too anxious. And what's called for is . . . *(can't find the word)* condescension.

(She smiles. Sits, crosses her legs, finds an attractive position. Hardens in the pose. Drops it. Opens her purse, searches.)

I don't have my cigarettes. What a pain. Maybe I should go get some . . . No, don't move. Others might come and I'd lose my turn. What could I say, I'm next? "Fuck off," they'd tell me. I could call an errand boy and get him to . . . *(Shrinks)* But then how do I tell him I smoke the cheapest brand? And . . . and I'd have to give him a tip.

(The YOUNG MAN *enters. She notices a second later. Quickly, she arms herself with her smile and elegant pose. The* YOUNG MAN *is looking for something, he ignores her. He spots the cape, takes it and carries it off. She looks at him amazed, then stands up.)*

What are you doing? How dare you? *(She follows him anxiously.)* Do you need it? Don't ruin it, please! It isn't mine!

(The YOUNG MAN *stops and observes her.)*

Of course it's mine, of course it is. I only said that so you'd be careful. Fold it, like so.

(Timidly, she takes the cape from the YOUNG MAN, *folds it, and gives it back to him.)*

It's still elegant. Very much in style. My friend always lends it to me. *(Corrects herself)* I always lend it to her. As though it were mine. Elegant, isn't it? What do you need it for?

(The YOUNG MAN *leaves without answering.)*

Idiot! Why did I apologize? Why did I explain? I will never learn to keep my mouth shut! I ought to cut out my tongue! I myself put it in his hands! It's all right, calm down, a little gentility won't turn them against me. On the contrary. I'm sure the director asked for it. He'll want to know how I'm dressed, what he'll be working with. A cape, not just anyone wears a cape. *(Contented, she hums, very badly.)*

Come, my heart is calling
Although my hopes are falling
Come, my dear I need you
If only *(hoarsely)* I could see you . . .

I sing so badly. And what a shame. It would be another asset. They gladly pay to have their ears greased. *(Hums briefly)* Except Joey will never let me sing. "Quiet, I've heard better horns on a car!" Frustrated, Joey is. Won't dance to the music, or let others . . . dance to the music. I wonder if

he's home yet. When will these people attend to me! After eleven o'clock, as though they didn't have to get up in the morning. What time can it be? I could ask. What's to lose? *(Dignified)* "Do you have the hour, please." *(Answers)* "Don't you have a watch?" *(Insecure)* I don't know what kind of impression that would make: not having a watch. They might think I'm some poor unfortunate. Like Joey, all you have to do is look at him and your soul drops to your feet. Poor man. He has no sparkle. I didn't iron his shirt, didn't leave him anything to eat. He's going to scream to high heaven. "What good are you if I can't even have a clean shirt?" As though that's what I was born for . . .

(Exhausted. Suddenly she opens her purse, takes out her mirror, looks at herself, touches her cheek.)

No, you can't see it. What a blow that bastard gave me. Practically did me in. All black and blue.

(She sits. Nervously, she applies a great deal of powder to her cheek. Holds the mirror at a distance, looks at herself.)

They'll think I don't know how to do my make-up. *(She rubs her face. Looks at herself, disconsolate.)* What a mess! But people don't search your face for bruises, they look in your eyes, searching for who you are and with these eyes . . . *(laughs)* I've won the battle! I've still got a pair of eyes that . . . When that creep comes back, I'll look at him like this *(a supposedly coquettish look)*, seductively and . . . knock him dead. "Ever see a look like this, you little brat?" No, don't say a word. No familiarity, no risk. *(The YOUNG MAN enters.)* But I can ask if they liked the pictures and . . . *(Crosses her legs, smiles. Lifts her skirt a little, swings her leg. Tries to give him an intense look. In spite of herself:)* Where's the cape? *(He doesn't answer.)* Bring me the cape, please.

(He goes to her, takes the shoe she was swinging from the end of her foot, and leaves with it. She's totally disconcerted for a moment, but quickly gets to her feet and follows him.)

What nerve! Come back here! How can they allow this?

(He exits, as though he hadn't heard her, leaving her absolutely perplexed.)

What if they call me now? What do I tell them? That I was sitting there swinging my leg and he took my . . . ? And what if he isn't there? What if he's in the bathroom? "I let him take my shoe, sir." It's too ridiculous! What does he take me for? No. I'm going to ask for it back.

(She limps toward the door. Stops, looks at herself and tucks in her blouse. She comes back, takes her purse, goes toward the other door and collides with the YOUNG MAN.*)*

Give me my shoe! I insist. They're new. I bought them to come here. And they cost me plenty! No. It doesn't matter. I have others, but at home. Does the director really need . . . to see my shoes? They're not all that fine, but . . . I liked them, bought them on a whim. You shouldn't think that normally I wear this kind of shoe. I have better ones, suede, pumps, sandals. I can give you these. They're not worth anything. Not now of course. But tomorrow I can bring them to you. *(Without conviction, painfully)* You must have a little girlfriend and . . . you want to . . . I understand. But you understand that I can't go barefoot, don't you? Except if Wardrobe has other shoes and they want me to wear them because they would go better with . . . *(Unmoving, the* YOUNG MAN *looks at her.)* Fine, you decide. That's why I'm here. *(Humbly)* Tell the director to see me.

(The YOUNG MAN *reaches toward her face as though to caress her. Although the action itself shows no emotion, she takes it for an unexpected gesture of friendship. She watches him, unsettled and in suspense. The* YOUNG MAN *keeps his hand immobile and then brusquely pulls off her earring. She cries out.)*

What are you doing! You hurt me! *(The* YOUNG MAN *leaves.)* If Joey were here! Joey! No, why did I scream? Serenity. He could have pulled off my ear. And what if they were gold! Eh? If they were gold? They'll realize they're fake. They look real, though. They could fool you. At least I should have told him that the real ones are at home or at the bank, in my safety deposit. But why don't they come out here and look at all of me? When it's my turn, the first thing I'm going to say is: That employee of yours is a brute, a brute with no manners. In my day . . . work was done . . . differently. Employees obeyed. None of this do-as-you-like, treat-people-like-garbage. Well not me, he won't. He's met his match. Serenity. They're testing you, Honey. Testing to see how far . . . Madam, they'll say, you are amazingly serene. We congratulate you. *(Perplexed)* But what do they need with serenity? I can act, I know how to move, no role is too big, or too small. And with the way I photograph! Even if they mess up the lights, my face is naturally luminous, my skin . . . *(She takes off her remaining earring, goes to put it in her purse. Unsure, she puts it back on.)* They don't know what they'll be losing, if they don't take me! I have so many ideas! When he comes back, I'm going to tell him, ideas blossom in me like flowers. Joey admires that. *(Doing Joey)* "Honey, you've got some imagination!" Another advantage in this job: they give me a script and I

make it shine. People are such slaves! But me! I fly! That story about the millionaire, you remember, Honey? The girl was going to marry a poor man because they, the idiots, thought love conquers all. With money love conquers better. So like an arrow I fly to the director, I know so much about life, and I tell him: No, she marries the millionaire, he leaves everything to be with her—house, family, position, everything, except his millions. And afterward they forgive her, his mother forgives her, calls her "my little girl," and when the grandchildren come! *(Sighs softly)* What a hit I was. The director gave me a kiss and said, "Honey, you're a gem!" That was the last time I was a gem for anyone. I remember how it was before, just a fluke I didn't land in the movies, a little bad luck. I did ingenues, girls in love. Until I got this "stoneface." The girls in the neighborhood would look from me to the magazine, from me to the magazine, and die laughing. Sluts! From ingenues to now . . . nothing. A few crumbs from Joey, a little love.

(The YOUNG MAN enters, looks at her.)

So you're back! Well? I'm waiting. Give me back my things! Everything! And you practically . . . tore off my ear! If you ruin, or lose, that cape, I'll . . . you'll know what I'm about! That cape cost a lot, and . . . it isn't even mine! Bring it to me, now! What are you? A bunch of crooks? What is this place? A den of thieves?

(The YOUNG MAN turns to leave.)

Get over here, you little . . . ! Answer me!

(The YOUNG MAN stops and looks at her. A pause. She is disarmed.)

I didn't mean to say that. I . . . I got carried away. You could be more polite, I'm not trying to be difficult, so why the abuse? I've been waiting patiently, you can see that. When it comes to work I can wait for as long as they like, time means nothing to me, I'll lend you the cape, yes, I'll lend it to you! But . . . when the director calls me, I want to be . . .

(She finishes with a gesture. Undaunted, the YOUNG MAN points to her skirt. She looks at him, then at her skirt.)

What do you want? You're insane! I'll scream. Get out!

(The YOUNG MAN turns and leaves.)

But what . . . *(Gets herself in check)* Oh my God, what have I done? I threw him out. Now what? I'm a fool to lose my head like that. Always the same. Always a disaster, I can never control my temper . . . But why

didn't they tell me they would need a . . . I don't know, a . . . a model. Fine, I have no objections! Work is . . . work, one must be . . . flexible. It's all right. They need a . . . model . . . But not naked! A model, not a . . . Oh, I can still show a little leg. *(She does so.)* But if Joey ever saw me. "Careful what you do, Honey. Bring me the pictures." It's easy for him to make demands. A dishrag . . . well not me so much, at least I still get some respect. I was right to yell at him. What do they think? That I have no backbone, that they can walk all over me? *(Smiles)* I remember that time, when Joey had beat me up so bad I couldn't get out of bed, the neighbors called the police and I said, "Nothing happened here, I fell down the stairs." *(Laughs)* That's what they get for butting in! Joey came and gave me a kiss. If I'd accused him, poor Joey! How humiliating! For him, for me. *(She's distracted for a moment.)* For me, humiliated already, letting myself be hit. *(Pause. Hums.)* Now magazines, that's a step up. The pay is better, that's for sure. *(Sings and dances clumsily)* If Joey sees, he'll slaughter me! *(Laughs)* I'll give him the name of some other magazine, he'll buy it, and not to worry. I won't be there. But what if it's postcards . . . Naked, no way! He'd murder me. He wants me to do the lady, the housewife, the mother of young girls. The grandmother! He never wanted me to pose naked, always checked my necklines, and now he's got a good excuse. *(Laughs caustically)* "You're too wrinkled to pose nude." Jerk. Why does he have to know? I can lie, to protect him . . . *(Suddenly opens her purse)* I need more make-up. What I'm wearing is too subtle and my skin is already . . . I'll come out all pale, anemic. *(Makes up, roughly)* What do I do about these bags? These blotches? They could take some proofs already and be done with it! What do they want? How am I supposed to behave? *(Shrinks)* Where do they tell you how to behave? Where?

(The YOUNG MAN enters. Rapidly, she puts everything in her purse, closes it. Stands, smiles.)

Forgive me. I was nervous. What time is it? No, it doesn't matter, I already told you. I can do any kind of role. I thought it was something more serious, well not serious. More in keeping with my age, not my age, my experience . . . I also dance! Sing, no! *(Laughs)* But, one doesn't sing in photographs, one doesn't . . .

(The YOUNG MAN approaches, tries to rip off her skirt.)

What are you doing! Get away! *(She resists.)* What are you trying to do? Let go! I'm telling you to let go!

(She moves away. Undaunted, the YOUNG MAN points to her skirt.)

Stop yanking things from me! Don't they teach you manners? Ask me for what you need. Who do you think I am? You could be nicer . . . more . . . delicate . . . What would it cost you? It wouldn't cost you anything. You simply say . . . the director is busy, he needs to know how you're dressed in order to decide if it's worth . . . if right this minute he can . . . if you should wait. And I would give it to you! Everyone has his own way of working. I don't know . . . Maybe your way is . . . faster, more efficient. Take it! I'm giving it to you. *(She takes off the skirt and hands it to him.)* You see? Friends. Why force me when with a little delicacy . . . *(As she's talking, the YOUNG MAN exits.)* we get along, work well together? Happily. On the other hand, when you dare to take things by force, I get enraged, don't know what I'm saying. I'm capable of . . . leaving. And that way you don't get anything. Believe me . . . But then I don't get anything either. *(Low)* What does it cost . . .

(She looks at herself, closes her blouse. Tries to be jocular.)

Now don't go thinking I'm . . . temperamental. What's happened is I've been out of training. *(Looks at her legs)* To keep in trim, that's the important thing. Docile. If I just had my cigarettes. *(Sits up straight)* Smoking looks good. It's chic. I'll have to send the cape to the cleaners, after so many paws have gone over it. If I give it back stained, she won't lend it to me anymore.

(She takes off her shoe, rubs her foot, puts her shoe back on.)

God, they pinch! *(Acerbic laugh)* They're at least a size too small. Let's see if they lose the other one. No, surely they'll bring more elegant ones from Wardrobe. I'll show them there's no role one can't face if one has . . . talent. *(Walks, laughs)* All I have left is talent. When I act for Joey, he's always amazed. "Do me the ingenue, Honey."

(Looks down, acts.)

"No, sir, no sir! Mother won't let me talk with strangers. What are your intentions?"

(Laughs. Looks down, falsely modest. Rocks pathetically. Stops moving.)

They want a model. What a shame. With the ingenue experience I have! I should have studied dance. If I'd known that was the ticket, I would have learned. I'm always missing the boat. I'll probably be late to my own funeral! *(Acid laugh)* Who knows! Maybe that'll be my lucky day. They'll have the hole all ready and waiting, and I'll fail to show up. Joey will get upset. "Honey, it's always the same! I wasted all that energy crying!

Willya die already!" *(Laughs)* And he'd be right. I should make the occasion, for once in my life. What was I expecting? That they'd call me for an ingenue? Not even if I were reborn could I be an ingenue . . . but I was an ingenue, everything we do leaves its trace, right? Joey will come home hungry, I should have left him an omelette. I shouldn't get so scared about work, they'll play music, they'll be nice. Will I be alone? Or will there be other girls? Younger, prettier . . . *(Smiles, with difficulty)* Competition. Why would they pick me? Why . . . me? A . . . an old lady who isn't even in trim? Wrinkled and . . . knock-kneed. And I threw him out! He had no reason to be offended, if people talk, dialogue, they get along. I wonder if he understood that? Was I clear? How could I be, in the face of such impertinence! I should have told him my ideas about movement. A model has to dance, wink, shake her bottom. I just got another brilliant idea! I'll leave them with their mouths open. After all, he can't complain about me. I myself put the cape into his hands, and the skirt. And if he'd said he wanted the earrings, well then, the earrings too! A savage. I'm accustomed to being treated differently. So I yelled. Why are they taking so long? A go-fer, that's what he is. None too nice, but then niceness doesn't pay the bills. With him insolence must be a habit. Of course, they think that with their two feet on the ground they won't fall. They don't want a model, maybe they want a wh . . . a prostitute. Well, so what! Posing as one doesn't make you one. They'll say, "Lady of leisure." And if that isn't it . . . they'll have another idea. They'll tell me. It doesn't matter. They make the contract, they take the pictures, they make sure the work comes out. Me, they give me a few directions, the script, and off I go! With my talent, my willingness. I can do anything—mothers, crazies, sweethearts, grandes dames. Joey will be waiting, I should have left him an omelette . . . They'll have me do a mother, then a grandmother, and then they'll realize that I'm young, and can do the young girl in love or the ingenue . . .

(She takes off her shoe, slowly rolls down her stockings.)

And then . . . then . . .

(The YOUNG MAN *enters and takes away the little table.)*

When he comes back, I'll look at him with these eyes of mine . . . He still hasn't noticed my eyes, but when he does, he'll be dazzled. And I'll tell him my imagination is inexhaustible. I take a script and make it shine, if they let me . . . I round it out. In this scene, I could give daddy a kiss, and then, I'm nude . . . and yet it's all . . . very tender, very moving. I have to act natural, innocent. *(Tries to laugh)* Innocence is the last thing you lose! When you have it, and I still do, no work is undignified. Work is

what's visible, what's outside, but inside . . . How must one be on the inside to do certain kinds of work? One has to be broken, or dead. But not me! Inside, I'm flowers! A child swinging in a hammock, as from a gallows, because I'm . . . happy. They'll have a good time with me, and that's already something, isn't it? Poor guys . . . all alone. Of course they don't lay a hand on you, in this kind of work no one gets . . . humiliated. Or turned on. They're so . . . used to it all. A woman they just photograph, alone or . . . accompanied, with children or old folks. I'll be the madam or . . . they'll put a beautiful young girl in bed and I . . . I'll be the mirror, the mirror where everything ends . . . No, no! I'm still good for . . . still beauti . . . *(Laughs. Claps her hand over her mouth.)* No, come now, I mustn't get down. What's with you, Honey? Get up on the wrong side of the bed? Where's your will to work? I can still . . . please . . . I can still make them crazy. They'll pay me well. For poses . . . that are agreeable. And there'll be a heater so one won't feel the cold . . .

(She sits down on the chair, and pathetically provocative, unbuttons her blouse, spreads her collar, opens her legs. The YOUNG MAN *comes in and takes away the armchair. She doesn't move, follows him with wide-open eyes and a stereotypical smile. Cheerfully:)*

I'm waiting!

(The smile petrifies, she bows her head, bursts into tears.)

Joey!

End

DIAMELA ELTIT

(Chile)

Born in 1949 in Santiago, Chile, Diamela Eltit examines the violent fracturing of postcoup Chile through novels, video, and performance art. She exposes and problematizes discrete social, artistic, and political boundaries by overlapping the issues of gender, class, and discourse. In a variety of contexts Eltit explores themes of confused identity, the body, and subjectivity. *Lumpérica* (1983), Eltit's first novel, represents a bizarre spectacle in which a protagonist mutilates her own body. Eltit herself performed an analogous expression in which she scarified her own arms and then read her manuscript in a brothel. This performance, in turn, engendered another "text," the video *Maipu*.

To date Diamela Eltit has published six novels: *Lumpérica* (1983), *Por la patria* (1986), *El cuarto mundo* (1988), *Vaca sagrada* (1991), *Los vigilantes* (1994), and *Los trabajadores de la muerte* (1998). *Los vigilantes* was awarded the Chilean prize Premio José Nuez for best novel in 1995. In addition she facilitated a "testimonial," *El padre mío* (1989), transcribing the words of a schizophrenic street person. Her other recent book, *El infarto del alma* (1994), is a collaboration with the photographer Paz Errázuriz. Eltit was awarded a Guggenheim grant in 1985 and a grant from the Social Science Research Council in 1988. She served as cultural attaché for the Chilean embassy in Mexico during the administration of Chilean president Patricio Aylwin, 1990–94.

Excerpts from *Lumpérica (E. Luminata)*

DIAMELA ELTIT

Translated by Ronald Christ

"From Her Forgetfulness Project"

The nails of her toes are to my nails unidentical twins with pinkish stains streaked by white lines.

Her toenails are to my nails twins in the gnawing of their tips.

They too are perfect thick scales as they mark the dimension of the toes that appear again at their edges. To the touch they seem granitic or eroded or diseased if one notes the spots that cross every nail, but each one of these curvatures restores the balance. Her toenails grow wider in accordance with the broadening shape of the toes, but each one of them preserving the preceding margin of flesh. That's why her smallest nails appear like infinitesimal hardnesses that do not protect the toes' flesh in all its magnitude.

Her toenails are to my nails twins in their identical functions, preserving for the touch certain mounds that imply their characterizing forms. Her toenails are to mine twins in keeping at bay fear of the lawn, in obstructing transparency.

Her toenails are to my nails twins in the disorderliness of their cut, in their run-down care. More than finery, her toenails are the element that mediates with the grass, that prevents the dissolution of the flesh of her toes which this way remain fragmentarily protected.

Her toenails are to my nails twins in their absurdity, in being an eyesore, demonstrating that way domestication of the gaze that does not stop to classify their functions.

Her toenails foretell the abandonment of her whole image which has been engraved in the multiple uneven cuts that bound their edges.

Her toenails are just like my nails, crusts.

The toes of her feet are to my toes twins in each joint that provides the mobility necessary for their being shown with the extreme slimness that defines them. This delicacy no doubt begins in their privileged skeletal formation, since despite the natural agglutination of her toes they do not look like discordant parts, keeping instead the definition of their color, which, whitish rose, they retain as a unit.

Her toes are to my toes twins in their texture, not a single blemish on the skin, their lack of erosion distinguishes them as unique and even the natural down ringing them is almost imperceptible except to the touch.

Resting on the ground they spread apart a little and that allows clearer confirmation of the beauty of each one of them in its outline. Her toes are to my toes twins in their sinking into the grass, in that decoration by color where pleasure manifests itself undisguised. That's why the lawn does not hinder the grazing by each one of her toes which tirelessly seek rubbing with the grass.

The soles of her feet are to my soles rough and arched, marked length-wise by multiple striations that stand out despite the hardened skin that frames them, but in spite of everything they maintain the curve that is measured in their resting on any floor. The soles of her feet are to my soles twins in their concealment and in the resistance, which lessened by the lawn, only there permits deferred rubbing against the earth.

Her eyes are to my eyes sufferers from the gaze, that's why they are the slight nexus that staves off abandonment. My eyes are to her eyes the con-stant that does not permit mistaking grass for branches.

Elucidating the abandonment, her eyes are to mine the sustenance of the pale people who cross the square and who when no longer in need of her twin eyes will lead their very own to the same irreversible failure.

Her eyes are to my eyes twins in their pigmentation, in the perpetual transparent moistness that protects them. Her eyes generate in my eyes the same twin gaze contaminated by so much of the city of Santiago re-duced to grass.

Her eyes are to mine guardians.

Her hands are to my hands twins in their smallness. With fingers so extremely pointed her nails appear limpid, filtering the rosiness of the flesh which that way accents its curvature.

Each one of her fingers is covered by multiple granulations, intractable lines that become inevitable over each joint which corresponds to the very thickness of the fingers and which mark, finally, the crease separating them from the next one.

Gazed at from the palm, her hands are to my hands sinuous.

Absolutely rose colored her palms are to mine the stage for palmistry and bear no destiny out of keeping with what goes on in the square. Her palms are to my palms the true foundation of pleasure.

Her hands are to mine twins in the absence of gold rings.

Naked, the fingers half open like the sun's rays when electric light does not illuminate the premature darkness in the public square.

Her arms are to mine twins in their symmetry. Perfectly slender they show in the skin's transparency the tracery of veins that encircles them. Covered with down, they assume in the exposure to light a different periphery that is confirmed in the delicacy of her movements cutting the void. Nevertheless, her arms are to mine twins in their failure, their absolute uselessness, in the want of arms that—perhaps—programmed for a fruitful destiny, are denied, and they touch the leavings intertwining them with the trees.

Not dependent on benches in the square, her arms are to my arms unaware on the grass, touching as the one and only skin her very own which even in itself avoids the rubbing.

Her arms are exactly like mine sensitive at the wrists so that no sort of life escapes through some hypothetical orifice. The wrists of her arms are for this reason obsessively watched over.

Her waist is to my waist the twin in its wearing away, different in its measurement. In any case irreducible, her waist becomes provocative in demarcating erogenous zones in the balancing that makes room for the torso and the shifting of the thighs. But nobody could find there any form of beauty because her waist is connoted by its amorphousness, nothing about it comforts the gaze or arrests it at that point and in not leading to the flight of imagination, her waist remains like mine unexplored.

Her waist is to mine the twin in its nonexistence.

.

Her waist is a final point of abandon.

Her waist is the penitentiary/ it is the ecstasy of the end.

Her waist is the twin to mine in its obstinate insistence on this life, it is margination.

Her waist—oh, her waist!—is the twin to mine in its transparency to the soul.

Her soul is material.

Her soul is being established on a bench in the square and choosing as the only true landscape the falsification of this same square.

Her soul is shutting the eyes when thoughts come and reopening them on the grass.

Her soul is this world and nothing else in the lighted square. Her soul is being E. Luminata and offering herself as another.

Her soul is not being called diamela eltit/white sheets/cadaver.

.

Her soul is to mine the twin.

"Dress Rehearsal"

D. R. 1

She moo/s/hears and her hand feeds mind-fully the green disentangles and maya she erects herself sha/m-an and vac/a-nal her shape.

D. R. 2

She anal-izes the plot = thickens the skin: the hand catches = fire and the phobia *d* is/members.

D. R. 3

She moo/s/urges round corp-oral Brahma her sig/n-ature ma lady man ual betrays her and she bronca Brahamas.

Horizontal direction betrays the first line or cut on the left arm.

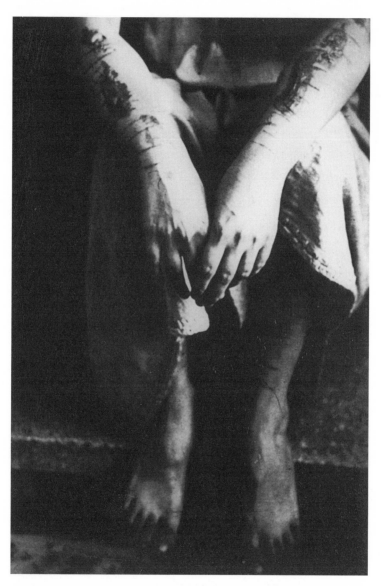

1. Diamela Eltit. From "Dress Rehearsal." Photo by Lotty Rosenfeld.

It is solely a mark, sign or writing that is going to separate the hand that frees itself by means of the preceding line. This is the cut by the hand.

Whereas—upward—the epidermis becomes bog/barbered barbaric baroque.

.

The second cut on the left arm is manifestly weaker. The blade has been sunk into the skin superficially. This second cut is ruled by the first on the left arm.

The distance that separates the two cuts is the surface of the skin that appears and emerges rigorously following the very shape of the wrist.

.

The third cut is flawed by interrupting in an oblique line the horizontal direction of the preceding lines.

It displays a wider swath of skin to the eye and the cut itself widens leaving obscured the birth or end of its trace.

The third line is discontinuous from the ones that precede it, despite preserving the straight direction.

The third line—gazed upon jointly with the others—betrays an erratum or rather the attempt to change course.

.

The first cut, if isolated, is the dress rehearsal.

Is it really a cut?

Yes, because it breaks with a given surface. On this same surface the cut sections off a fragment that marks a different limit. The cut should be seen as a limit. The cut is the limit.

Then, what is the border? The cut itself? No, it's scarcely even the signal. The first cut establishes itself as dress rehearsal in so far as the others are successively integrated. In that sense its isolation is resorted to only so as to show the first mark that is established. The first cut is a seizure—it is a theft—on the plane of the skin's surface which is divided by breaking its continuity. A line is given so that it may be acted upon.

.

(Concerning the photographic cut.)

Is the cut represented in itself as in the photograph itself? Rather it is fixed as such. The performance takes place to the degree that the cut is acted upon.

For example, the track of the cut is a furrow that is operated on by divulging it in that way as a signal. Yet, being like a furrow, it becomes a trench or breastwork behind which is protected or hidden a performance. As furrow, it is sunk beneath a surface that has been penetrated. If it is restored photographically it becomes flattened by the precision of a new surface, which will be broken only by the eye that cuts its gaze there.

And what about the eye then?

The eye that reads it, erratic, constrained only by its own contour, imprisons itself in a linear reading.

The eye that surveys the photograph stops at the cut (her cut)

and recasts the gaze when confronted by an annoying, unforeseen interruption.

The cut's like that too?

Trompe l'oeil.

.

Let's suppose:

That the surface was chosen by chance and on it the first cut was also made anywhere at all.

This way, the third cut could have been the first cut made. If the obliqueness of its track is observed, it is perfectly possible that that's how it was. On seeing that oblique result, it then could have been corrected by instilling horizontality in all the other lines. If that's how it was, then the first cut (which is the third) did not end up freeing the hand, rather it marked a limit, trace, border, trench, breastwork, between one part and another of the arm.

Solitary, isolated this third cut—the first actually—is scarcely graffiti on the skin of the arm that it enters upon obliquely like a signature on a painting. Because it's curious that this third cut should be the only one that changes its direction in relation to the strict horizontal course maintained by the others.

Is that perhaps why this third cut was the first and was made shakily?

That's not likely. The third cut—by the oblique straightness of its track—betrays no trembling course.

If it was the first cut, this deviation is explained only by the whole scene's change to the horizontal.

.

What exactly does this third cut mean?

If first, this third cut is really the dress rehearsal.

.

Between the first cut and the cut first (the third) there is—aside from the skin—a 2nd cut.

There is a second cut.

There's a second between cut and cut?

The interruption of a second between cut and cut?

Was there additionally a second after the cut? Was there?

.

The fourth line, on the other hand, is shorter than the previous ones, but returns to the horizontal direction sketched by the first and second cut on the left arm.

The track of the fourth line is briefly interrupted by a fragment of skin, which allows the supposition that:

a) The line was made in more than one stage.

b) The blade that made the cut was raised slightly.

The fourth cut on the left arm repeats the first and second marks, eliminating that way the oblique track which the third cut could have imposed.

.

The fifth cut on her left arm betrays its inlay over a new surface.

The surface on which it appears is modified by a burn on the skin. So this fifth cut is inscribed over (or under) the burned epidermis, which has in all certainty become bog/barbered, barbaric, baroque in its weave. The fifth cut as soon as it enters in relation with another form of attack, establishes the duality of the mark.

.

From the previous scenes it follows that:

Defining the various cuts in isolation turns out to be subterfuge in so far as they are articulated to the degree that each one is illuminating the course of the others.

(The efficacy of this broken surface is repeated gestural research.)

It's plausible to determine an objective staging on the basis of the marks on the skin:

Razed by the burn the down on her left arm disappears, the raised scab, bristled over the burned down is another set for the dress rehearsal.

.

The truth about the first five cuts plus the burns lies in thinking of them, say, as pose and pretexts.

.

About the previous fragments plus the sixth cut.

1. Archaic sounds are mixed in with their art: recognizable quotations. Also registers from an old track also on their archetypal plane: the blade on which is written the brand.

2. The utility of their fragmentary element: the metallic and fine set of instruments recedes from the photographic trace. Everyday material. From trivial objects a pose is fabricated.

It has gone through. Her sixth cut is the apathy of the others, the vertigo and the habit.

The surfeit of the sixth element is a loose thread of burns, obsessive and fleeting it is scarcely marked along their edges.

The in-cine-ration absorbs it and determines everything. It is appropriated from the linear space pushing, expelling the sixth cut.

Brutal seizure at the slash, but the skin blisters obscuring the sixth line.

The sixth line by its weakness is the rehearsal's surplus.

.

It's cold and maybe that alone is why she holds her pose in the square.

She sits down on the ground barefoot, her head bent slightly downward, she remains that way for a lapse of time and then raises her head and looks.

She keeps her sight fixed with quick blinks. The fingers of her right hand hold up the small sharp blade. Without looking she brings it toward her hide.

The Dress Rehearsal is going to begin.

Diamela Eltit: Performing Action in Dictatorial Chile

ROBERT NEUSTADT

A critical . . . reading is one that changes the representation into a performance which
exceeds the text.—Teresa de Lauretis

In this essay I trace the projection of Diamela Eltit's performance across
multiple genres, media, and texts. My reading of *Lumpérica*—Eltit's first
novel, in which a protagonist mutilates herself—and *Maipu*—a video of
a reading in a brothel in which Eltit did the same—suggests a continuum
that spirals between fictional, corporeal, and visual performances.[1] I use
the concept of *performance* not only in terms of theatrical or dramatic
representation, but also in the literal sense of accomplishment, achieve-
ment, and success. Consequently, a reading of Eltit's performance will
take into account how the work performs narratively as well as politi-
cally.

The context of the Chilean dictatorship imbues Eltit's work with
a sense of social and political urgency. Following the military coup
of 11 September 1973, anyone who even remotely supported Salvador
Allende's socialist Unidad Popular lived under serious threat of "disap-
pearance," torture, imprisonment, and murder. During the early years of
dictatorship, censorship gagged literary and artistic dissension, creating
a state of cultural blackout, *apagón cultural*. In addition to physical re-
pression, the regime fought to secure hegemony on ideological and dis-
cursive grounds. Women played a key role in this ideological struggle.
The military government organized groups of mothers and wives (Gen-
eral Pinochet's wife headed the most important national organizations)
who worked for the dictatorship by espousing the traditional values of

family and patriotism. On a day-to-day level, women were encouraged to serve the country by working as volunteers for charitable organizations that maintained familiar and ecclesiastical institutions. Socially, these women did not act as autonomous subjects, but rather they participated as auxiliary support within a hierarchical family paradigm.[2] Nuclear families were to support the great "national family," *la patria*, directed by the father figure Pinochet, who purportedly served the will of God. Ultimately, the *discurso pinochetista* projected an image of the ideal woman within the symbolism of the Catholic Church, the Madonna.

Eltit addresses these concerns with a particularly eclectic brand of artistic activism. Rather than delineating a clearly defined agenda, Eltit projects fragmented images of self-mutilating bodies. On one level, Eltit's narrative fragmentation evokes what one might call a realistic image of life under dictatorship. In his book *La mala memoria*, Marco Antonio de la Parra insists that any accurate representation of life during the dictatorship would have to be fragmented: "Every account from that time period that attempts to be linear is false . . . We have been fragmented by history, turned into splinters, we cling to personal history because public history has been blown into a thousand pieces" (111, my translation). One way to read Eltit's experimental style, then, would posit that she mimetically represents the confusion of a society that has been blown to pieces. This is a plausible scenario, though the resulting imbroglio raises serious questions about the political effectiveness of experimental art. One must ask whether the interpretive "difficulty" of these texts undermines their subversive power. What does it mean to mutilate one's own body while living under a military dictatorship? And why write a novel ostensibly devoid of plot and apparent meaning? My analysis twists together the formal and aesthetic elements of Eltit's experimentation with the political and literary notions of *representation*. From a strictly literary perspective, Eltit's style situates her in opposition to any and all formulations of realism. In other words, her neo-avant-gardism resists the traditional status quo rendering of the literary canon as well as the easygoing plot constructions of popular literature. She turns the dominant representation of a novel inside out, rejecting even the possibility of representing reality from a clear unbiased viewpoint. It is crucial to note, nevertheless, that her approximation of literary fragmentation is inextricably related to a political agenda.

By accentuating what René Jara has called the "limits of representation," Eltit discursively opposes the neo-fascistic sense of order imposed by the military dictatorship. The aesthetic, formal, and structural fragmentation that is so pervasive in Eltit's work articulates a paradoxically

coherent agenda of narrative obliteration. Through a process of narrative mutilation, Eltit displaces the narrative of national order.

In her essay "Going Public: Reinhabiting the Private," Jean Franco describes Eltit as a writer who is "obliged to separate the political from the aesthetic" (70). For Franco, Eltit's literary experimentation pursues a different, less blatantly political tangent:

> Consider, for example, the case of the Chilean writer Diamela Eltit. She actively collaborated with the *Por la vida* movement, which stages demonstrations to publicize disappearance; she wrote novels that are so hermetic they seem to baffle critics, and she staged public performances such as kissing a homeless man or reading her novel in a brothel in a poor section of Santiago. In this one author, we find a tangle of conflicting intentions: to act against the authoritarian state, to take literature symbolically into the most marginal of spaces, to work against the easy readability of the commercial text, to foreground the woman's body as a site of contention, to increase or exaggerate the marginality of art, and juxtapose literature's marginality to that of prostitutes, vagabonds, and the homeless. (70)

Franco's summary, while critically insightful of Eltit's agency, starts from what seems to me a misguided preconception. Rather than separating "the political from the aesthetic," Eltit explicitly conflates the two realms. Highlighting the aesthetic nature of politics, she actively politicizes her exceedingly experimental fiction. In my view, Eltit's "tangle of conflicting intentions" reveals an understanding of the political and the aesthetic as inextricably related both to each other, and, significantly, to narrative.[3] It is crucial to interpret Eltit performatively—to read not only what she "says" but what her work "does." Re-presenting authoritarian order through narrative confusion, Eltit produces antidisciplinary chaos in the regimes of literature and politics.

Eltit's rearticulation of the discursive body corresponds to a performance that also performs. Eltit's performance clears a critical space for critique and subsequent political/artistic performance. Obviously, "literature" did not topple the neo-fascist military regime in Chile. Nevertheless, Eltit's critical performance created a political opening, allowing for writers and artists (including herself) to express and perform political resistance in increasingly blatant defiance.

In spite of Eltit's infamous "hermeticism" many critics (including Nelly Richard, Julio Ortega, Eugenia Brito, and others) have rigorously and correctly interpreted her texts as polyvalent deconstructions of hegemonic power. At times, nevertheless, critics seem to isolate specific themes from her multifaceted critique. Her reinscription of the gendered

body cannot and should not be separated from her political re(dis)articulation of discourse, her post-structuralist awareness of language, nor the repression of the Pinochet regime. Her more recent books explore the dictatorial underpinnings that remain institutionalized in democratic Chile. My analysis aims to reconfigure these disparate interpretations (deconstructions of patriarchy, language, and political power) together within the wider context of cultural, narrative, and political performance.

Performance represents the common denominator of Eltit's work. Not only does spectacle play a key role in each of Eltit's "texts," but these respective performances dialogue intertextually. I do not claim that biographical analysis can "explain" *Lumpérica*, but Eltit's self-effacement, her public reading, and the video *Maipu* function as formative episodes for the mise-en-scène that culminates with the publication of *Lumpérica*. Key passages of the novel constitute significant components of Eltit's performance action. The ensemble of Eltit's work, like de Lauretis's conception of a critical feminist reading, "changes the representation into a performance which exceeds the text" (36). The bulk of this essay focuses on Eltit's texts, particularly *Lumpérica*, in relation to the technological, discursive, and political representation of her "performance." Of course, Eltit's complex mode of expression did not emerge spontaneously. Comprehending the ideological conflicts within the left, both before and during the dictatorship, establishes the theoretical framework of Eltit's political and artistic strategy.

Art Actions and Political Performance

Performance art was not a common means of expression in the Chile of the 1970s and '80s. Carlos Leppe was probably the first artist in Chile to use his body as a medium of performance with his "Happening of the Hens" (Happening de las gallinas) in 1974. Leppe gave a series of performances in galleries challenging the traditional concepts and taboos associated with the body, sexuality, and gender.[4]

Though drawn to the radical politics of performance, Eltit was never interested in performing in art galleries. Instead, while writing *Lumpérica*, she developed an approach to performing "art actions" (*acciones de arte*) in the streets of Santiago with an artists' collective known as the Collective of Art Actions (Colectivo acciones de arte; CADA).[5] In 1979 Eltit participated in the formation of CADA with poet Raúl Zurita, the visual artists Lotty Rosenfeld and Juan Castillo, and sociologist Fernando Balcells. By mounting theoretically complex art actions in public, CADA simultaneously denounced Pinochet's authoritarian regime and articu-

lated a critique of the traditional linear protest art of the orthodox left. CADA's actions were massive events—a parade of milk trucks, a squadron of small aircrafts from which 400,000 flyers were thrown, graffiti written on walls throughout Santiago—that denied the government sanctioned concept of art and, more importantly, forced dialogue and questioning. While CADA performed their actions collectively from 1979–85, several members of the group also carried out individual actions. Lotty Rosenfeld's 1979 action "A Mile of Crosses on Pavement" (*Una milla de cruces sobre el pavimento*), in which she converted traffic dividers on a street into + signs, is considered by many to be one of the most important works of visual art in postcoup Chile.[6] Eltit's performances—scarifying her arms, washing the pavement in front of a brothel, reading her manuscript in this brothel, and kissing a homeless man on video—function according to a similar logic as the group actions produced by CADA. The complex (neo-avant-garde) actions constituted a code with practical as well as theoretical consequences. This approach protected the artists from police reprisals and at the same time formulated a multifaceted critique of authoritarianism. The art actions engaged with the monological discourse promulgated by both the military government and the orthodox left. The strategy was to occupy Santiago's urban zones with arresting images that questioned conditions that had become habitual in the repressed environment of dictatorial Chile. Eltit's act of scarification and her reading of a text in the brothel play a key part of a larger performance that includes her novel *Lumpérica*. This performance, furthermore, played a part in what later became a massive pro-democracy movement in Chile.

Lumpérica: A Multimedia Performance Novel

Lumpérica was originally published in 1983 by a small independent publisher (no longer in existence) called Ornitorrinco. The novel has since been republished by progressively larger publishing companies (Planeta in 1993 and Seix Barral in 1998) and has also been translated into English and French.

Lumpérica is a virtually plotless novel in which a transient woman, L. Iluminada, spends the night staring at a neon sign in a Santiago plaza. The "action" primarily takes place on the level of narrative perspective and language. Third-person description alternates with first-person narration, ambiguous dialogue, and a kind of impersonal, often lyrical, textuality. *Lumpérica*'s fragmentation cannot be overemphasized. Not only does the novel fracture narrative continuity by employing frequent

stops and starts, but the prose itself radically distorts the narrative with (neo-)avant-garde word play. In spite of these experimental occlusions, reading between the fragments reveals a carefully coordinated structure. The novel amasses and superimposes a series of images of L. Iluminada in the plaza. This woman's presence in the plaza creates a spectacle during which she collapses, masturbates, smashes her head, burns her hand, makes love with a woman, and gashes her arms. *Lumpérica* not only blurs the point of view but also overlaps representations of L. Iluminada through diverse representational media. L. Iluminada's spectacle, in other words, constitutes a multimedia performance.

Early in the first chapter the narrator employs theatrical and filmic terminology: at this point it seems as if the novel's plot represents the process of making an experimental film. The text depicts cameras circling around a posing L. Iluminada in the plaza, then the narrative focus expands outward to include a level of metafictional criticism. The novel turns into a screenplay in which an implied director offers *comentarios, indicaciones*, and *errores* of the first three "scenes." From the first chapter, *Lumpérica* comprises three narrative stratum: text, presenting the image of L. Iluminada in the plaza; textualization, representing the process of filming L. Iluminada in the plaza; and meta-text, critiquing the performance and cinematography.

However, this narrative scheme only scratches the surface of *Lumpérica*'s representational strategies. In chapters 4 and 5, the visual image modulates into a specifically literary format: "The scene is no longer filmic but narrative . . . The image is completely different for he who reads it . . . Writing is like a zoom" (99).[7] In a later section titled "Ensayo General," this novel about a film becomes an essay that interprets a photograph included within the text. In essence, *Lumpérica* self-reflexively interrogates the process of image construction. The novel assembles a collage of interrelated texts and self-reflexive meta-texts. Each of these layers, in turn, embodies a narrative concretion, *mise en abyme*, that represents *Lumpérica*'s representation of L. Iluminada. But while L. Iluminada's identity seems to be in a continual state of flux, her situation remains relatively fixed. A changing image still remains an image, regardless of its format.

Situating L. Iluminada: The Empty Space Between the Signs

Lumpérica depicts the process of filming a voyeuristic spectacle in which L. Iluminada represents the obscene object of the gaze. The cameras film vagabond men (the "pallid ones") staring at L. Iluminada's perfor-

mance. Elsewhere, someone describes having scrutinized the film footage of L. Iluminada's fall. Ultimately the reader "watches" this entire matrix of reticulating gazes. This situation suggests a series of questions about the technical, aesthetic, and ideological foundations of spectacle, performance, filmmaking, and discourse.

In *Lumpérica*, the narrative montage revolves around L. Iluminada, a transient female figure placed at the center of a plaza, a film, and a novel. Her relationship to language constitutes the core of *Lumpérica*. Significantly, her language and thought patterns, as well as the novel itself, correspond to a distinctly scrambled code. This situation of a broken woman at the center of a chaotic code recalls an observation by de Lauretis concerning woman's place in representation: "The position of woman in language and in cinema is one of non-coherence; she finds herself only in a void of meaning, the empty space between the signs" (8). In *Lumpérica*, the plaza—a void of meaning, an empty space between flickering neon signs—corresponds to L. Iluminada's position of noncoherence in language and cinema, as well as in society at large. L. Iluminada therefore inhabits the negative space that narrative imposes on "the feminine." In Derridean terms, Eltit's novel solicits the foundations of narrative. By superimposing narrative montage and her own corporeal mutilation, Eltit creates and employs a special kind of "body language" that underscores the inescapable nature of discourse. She carves her critique within that space of representation.

Interrogating the Plaza: Re-presenting Representation

At several points in the novel, enigmatic scenes of interrogation appear out of context. In chapter 2, for example, an unidentified questioner suddenly grills the narrator (and later another unidentified person) about the utility of a public plaza. Within the context of postcoup Chile, the interrogation evokes an encounter with the (secret) police. As Eltit writes in *Lumpérica*, "Someone will no longer be there, some names will be erased from the kardex and . . . the plaza will no longer be important" (56). The *interrogador* demands obedience, forcing the *interrogado* to describe the plaza again and again. This situation in the plaza alludes to the tenuous condition of contemporary reality under dictatorship. People simply disappear, their names erased. The public plaza becomes a superficial facade, a decoration, remodeled by those who represent the nation.

In chapter 7, another cross-examination (this time regarding la *caída* de L. Iluminada [L. Iluminada's fall]) eventually becomes an argument about the film. A dissatisfied director interrogates someone (an actor?

a technician?), insisting that he restate, over and over, the sequence of events. This scene of interrogation links the notions of political, technological, and ideological representation to the novel's merging of incision and inscription. In film, "cutting" corresponds to a reorganization of reality, framing specific perspectives and re-presenting them, resulting in a produced narrative. *Lumpérica*'s film of a homeless woman in Santiago evokes the discursive manipulation of political representation and hegemony. Similarly, the Pinochet regime strove to re-present Chile, recasting the film, as it were, and projecting an image of political order. In time the interrogation uncovers a planned rebellion within the film. The interrogado confesses his guilt—he attempted to derail the mise-en-scène by impeding L. Iluminada's fall and persuading her to abandon the script. However, the mutiny fails when the planned subversion gets cut from the film. The director refuses the protagonist the right to represent herself: the authority figure controls the image of the public plaza.

Ultimately, the episode of interrogation proves to be a "scene" in the same film it examines (147). In other words, it stages a self-reflexive film within a self-reflexive novel. *Lumpérica* thereby exposes its own representational foundations at the same time as it implicitly interrogates the political situation in Chile. All of this occurs without even mentioning the coup or military repression. The novel does not describe its referent but rather circumscribes the issue—inscribing, then, a political critique.

"Ensayo General": Rehearsing an In-scripting Performance

In *Lumpérica*'s eighth chapter, "Ensayo General" (Dress Rehearsal/General Essay/Test), inscription becomes an explicit spectacle of mutilation. The chapter begins with three one-line verses, each of which occupy an entire page. Since these phrases are virtually untranslatable, I will confine my analysis to the subsequent series of epidermal incisions. Suffice to say that "Ensayo General" opens with a series of linguistic mutilations. This episode significantly expands the text's projection by implying a spectrum of simultaneous subjects and images. In the following sequence of incisions, the narrator's body becomes text, inscribed by the blade of a knife in a series of six self-immolating gashes. A photo of Eltit's lacerated arms introduces the chapter, implying a concatenate continuity between the novel and Eltit's corporeal "art action." "Ensayo General" constitutes the nexus linking Eltit's scarification, her novel, and the video *Maipu*.

Eugenia Brito posits a relationship between the incisions and *Lumpérica*'s syntactical and narrative fragmentation: "The opening of the skin coincides with the opening—the rupturing—of syntax and with the rup-

turing of a unified meaning" (172). Eltit shreds language, pulling words apart into syllables, substituting mathematical and orthographic symbols, varying the type set, altering syntax, and substituting words from slang, underground, and indigenous vocabularies. Nevertheless, while she tears language apart, this mutilation results in a reconstituted poetic language that releases the myriad shards of meaning contained within words.

How does one "read" *Lumpérica*'s textual incisions?[8] The corpus of "Ensayo General" clearly draws parallels between physical incision and writing as textual inscription.[9] Following the narrator's indications, this episode of inscription initially reads like a standard structuralist text in which meaning derives from difference. The text foregrounds the first cut on her left arm and presents it as a sign: "It is only a mark, sign or line of writing" (155). The second gash acquires significance through comparison with its predecessor: "It is notably weaker" (156). The implied author interprets the third incision as a "flaw" in relation to the pattern previously established (157). This "error," or change of direction, recapitulates the experience of reading *Lumpérica*. As soon as one begins to follow a narrative line (L. Iluminada in the plaza, a film of her, an interrogation, an evaluation of the film, etc.) the novel interrupts its progression and changes direction.

Following the third "line," the text severs the narrative series of incisions, shifting to a meta-textual analysis of the preceding pages. This self-reflexive "cut," splitting "Ensayo General" by delaying the progression of epidermal scoring, recalls the interrupted film shoot from the previous chapter. Someone yelled " 'cut,' they stopped the machines" (148). Within this interval of frozen narrative, the text interrogates the first three slices individually and in relation to one another: "The first cut, if isolated, is the general essay. Is it really a cut? Yes because it breaks a given surface . . . The cut is the limit. Then, what is the border? The cut? No, the cut is scarcely the sign" (158). "Ensayo General" probes the wounds of its exposition with crosscut meta-narrative *cortes*.

The following page begins parenthetically, hence separating the series of epidermal and narrative lacerations orthographically. This new narrative corte, "(In relation to a photographic cut)" (159), widens the meta-textual implications of the "Ensayo General." The section specifically examines a photograph of Eltit's lacerations (included in the original edition) in the context of photography (such as framing the image or cropping the print). Whereas the preceding passage reads and analyzes the narrative incisions, the text now examines a photographic reproduction (a re-presentation) of the incisions. This passage analyzes its own

process of reading the photograph of lacerated skin, rendering a two-dimensional, flattened image. Viewing the photograph, the reader's eye cuts open the surface image, much as a reader cuts through the text. Nevertheless, the eye's hermeneutic potential remains limited to linear interpretation: "The eye that reads, is imprisoned in a linear reading" (159).

Accumulating questions and returning to the sequence of epidermal slashing, the text confounds a linear reading by inverting its chronology. It "chops up" and precariously reconfigures the narrative order of incisions that it had previously established. The reader no longer knows where to enter the series since "the third cut could have been the first one made" (160). The complications compound progressively with the remaining incisions. The fourth slice, itself physically interrupted by a "fragment of skin," evokes two (logically divided) hypotheses related to both time and depth (162). With the fifth cut, the text introduces a burn to create a new surface variation (163). A final sixth incision becomes subsumed and expelled by the burnt flesh (now blistered, showing a raised scab and the traces of singed hairs) (163–66).

"Ensayo General" consists of an open series of epidermal, narrative, temporal, logical, and visual cortes. The text obstructs the individual incisions with skin fragments and splits the narrative sequence—reading, analyzing, and dividing itself. Finally, on the last page, the focus shifts back to encompass the entire subject, who poses in the plaza gripping the knife. Significantly, as she approaches the knife to her skin on the last page of "Ensayo," she has yet to inflict any incisions: "The Ensayo General is about to begin" (167). Chronologically, then, by juxtaposing the last cut cyclically to the first, "Ensayo General" rehearses a circular performance of inscription. As in Barthes's *texte scriptible*, "It has no beginning, it is reversible. One enters through several points of which none can be declared principle" (12).[10]

The cycle of mutilation/inscription can be traced throughout the novel's editorial history as well. The photograph of Eltit's slashed arms was "cut" from the second edition. When the second edition did not sell well, the editor (Planeta) shredded, or "chopped up," the unsold copies. This circular continuity linking incision, inscription, and representation also holds true between Eltit's performance of self-mutilation and L. Iluminada's spectacle. From a biographical and historical perspective, Eltit's action precedes the publication of *Lumpérica*. Her self-mutilation therefore corresponds to a pre-textual (corporeal) inscription that initiates and motivates her novelistic representation. As she writes in "Ensayo General," "The truth about the first five cuts plus the burns is to think about

them, for example, as gesture and pretexts [*pose y pretextos*]" (165). Although the novel and video constitute subsequent texts that record, document, and re-present Eltit's action, this chronology can be reversed. In the video *Maipu*, Eltit displays her recently burnt and slashed arms while reading from *Lumpérica*'s manuscript. Accordingly, the fictional episode of incisions prefigures the author's self-immolation. Eltit's performance, in other words, rehearses the scene of inscription narratively delineated in *Lumpérica*'s "Ensayo General."

Lumpérica constitutes one crucial but not all-encompassing phase in Eltit's overall performance. "Reading" the video *Maipu* helps bring the full extension of Eltit's performance into focus. *Maipu* documents Eltit's performance at the same time as it embodies L. Iluminada's fictional spectacle.

From *Lumpérica* to *Maipu* and Beyond:
Tracing the Projection of Eltit's Performance

In *Maipu*, Eltit reads *Lumpérica*'s chapter 4.4. This passage draws parallels between "diamela eltit" (the implied author, represented in the text by lowercase letters) and her fictional character, L. Iluminada (90). Focusing on minute details of her body, the narrator compares herself to her twin. Ultimately, both of these bodies constitute symmetrical texts bearing parallel lines of inscription: "Her arms are symmetrical twins to mine. In the transparency of their skin they show the veiny traces that surround them" (89). The novel's passage, then, conflates three corporeal subjects—narrator, protagonist, and implied author. In the video, the fact that Eltit herself reads the text involves the historical author in this chain of narrative re-presentation. Furthermore, the particular location of Eltit's performance imposes far-reaching political and social consequences.

Eltit's performance of *Lumpérica*'s manuscript takes place in a brothel located on Maipu Street in Santiago. By reading in a space where women's flesh is routinely rented, Eltit implies a parallel between literary production and prostitution. Publishing *Lumpérica*, Eltit both sells a narrative body, L. Iluminada, and her own textual body. As she writes in *Lumpérica*, "the *luminoso* [light, sign] announces that bodies are sold. Yes, bodies are sold in the plaza" (13). Eltit's reading evokes images of L. Iluminada, while at the same time addressing an audience of prostitutes attending her performance. The last line of the chapter, "Su alma es a la mia gemela" (90), for example, might be translated as either "Her soul [L. Iluminada's] is the twin of my soul," or "Your soul [the audience's] is

the twin of my soul," due to the ambiguity of the subject pronoun *su* in Spanish. Consider also the novel's title, *Lumpérica*, which conflates three terms: *lumpen* (underground), *perica* (Chilean slang for a prostitute), and *América*.

Historically, as Luce Irigaray writes, women correspond to passive objects that men circulate among themselves for pleasure and reproduction: "Woman is traditionally a use-value for man, an exchange value among men; in other words, a commodity . . . *Women are marked* phallically by their fathers, husbands, procurers. And *this branding determines their value* in sexual commerce" (31, emphasis mine). *Lumpérica*, accordingly, is sold on the literary market, where its commodity "value" is configured by the consensus of critics. And yet by "marking" herself, by inscribing her own body as text, Eltit critically underscores the traditional dynamic of woman as commodity. Although she cannot completely invert the market principle, she calls attention to the obscene exploitation inherent in the gender economy. Consequently, her performance in *Maipu* situates the brothel as a locus of narrative. She explicitly inserts herself and her text within the narrative/sexual market economy. Further, she addresses prostitutes—who are traditionally the "goods" sold —not the sellers or critics. This gesture recontextualizes both *Lumpérica* and prostitution, highlighting an act of literature within the marginal space of the brothel.

Eltit's conflation of literature and prostitution thus works simultaneously in two directions: if marketing a novel corresponds to selling one's body, then conversely prostitutes, who create fantasy for payment, sell fiction. Feigning sexual desire in exchange for money, prostitutes perform in a world of (male) fiction. As the text specifies, "in those years she divided herself between fiction and the fiction of her jobs" (83). *Lumpérica* not only exposes reality through fiction, but underscores the constant play of fiction in reality. Furthermore, *Maipu* indicates a signifying chain of texts, images, and performances in perpetual flux between reality and fiction.

Maipu reveals the extraordinary sequence of interconnected mises en abyme which form the continuum of Eltit's performances. The video text explicitly foregrounds Eltit's arms, focusing on her skin literally inscribed as "text." As Peter Brooks writes in *Body Work: Objects of Desire in Modern Narrative*, the process of corporeal inscription indicates a transformation of the body into a literary text that can be interpreted: "The bodily mark is in some manner a 'character,' a hieroglyph, a sign that can eventually, at the right moment of the narrative, be read" (22). Eltit, a woman/text, sits in front of a camera reading *Lumpérica*. Significantly, *Maipu* presents Eltit in the process of reading her work-in-progress: the

video documents a stage in *Lumpérica*'s textual evolution. Several times the camera focuses over her shoulder, revealing her typed manuscript replete with handwritten corrections. Eltit, a woman/text, sits reading (on camera) *Lumpérica*-in-progress. The definitive *Lumpérica*, in turn, represents L. Iluminada, a woman/text, who sits reading a sign (the luminoso) while performing on camera.

The meta-textual relationship that defines these representations of representations also reverses direction. *Lumpérica*'s manuscript appears in *Maipu*, comprising both audio and video image. Conversely, the original edition of *Lumpérica* displays a still from *Maipu*—a double projection of Eltit's face—on the cover. Projection works as the linchpin of Eltit's double-edged critique. While the successive images of incision-becoming-script retreat farther and farther into "fictional" representations, Eltit's action of self-mutilation, the novel, and the video spiral "outward" to protest all-too-real social, political, and discursive violations.

Chilean neo-fascism projected its own fictional representation of an ideal woman—the Madonna—and placed her prominently upon a pedestal. Augusto Pinochet told Chilean women shortly after the coup that there is a "role corresponding to women in the plans of the government" and that they have a "mission as women and mothers" (qtd. in Pratt 151–52). According to Pinochet (as paraphrased by Mary Louise Pratt) the mission for Chilean women was "to defend and transmit spiritual values, serve as a moderating element . . . educate and instill consciousness and conscience, and serve as repositories of national traditions" (152). In *Lumpérica*, Diamela Eltit knocks this ideological sculpture off the pedestal and places her inverse image, L. Iluminada, center stage in the public plaza. Eltit displaces the mythical mother figure and replaces her with L. Iluminada. Furthermore, Eltit not only mutilates the fictional "woman," she also effaces the pedestal—the discourse—that supports the Madonna image.[11] Eltit's narrative shredding constitutes a neo-avant-garde performance which is both deconstructive of narrative and narratively poetic. Eltit radically re-presents narrative to articulate a critique that mutilates the fascist image of national, cultural, and political unity.

Reading *Lumpérica* only as a national allegory ignores the performative component of Eltit's rearticulation of the discursive body. *Lumpérica* does not merely represent the violence of neo-fascism symbolically; the novel systematically reads and deconstructs the discursive and representational violence that precedes and legitimates oppression. Rather than countering the government discourse by replacing the fascist national allegory with a counter-allegory, Eltit displaces the official discourse and then proceeds to efface her own narrative allegory.

Lumpérica deconstructs, re-presents, and subsequently self-de(con)-

structs. Carving her skin as text, Eltit's performance embodies her awareness of the post-structuralist paradigm: she can no more get outside of language or discourse than she can escape her body. As Eltit represents a wounded body, she simultaneously mutilates the discursive and representational texts—the official discourse, her novel, and her body. She slashes herself in protest, and thereby affirms the power to rewrite and represent her own body: Eltit seizes control of her body and enacts a performance—a complex series of corporeal, literary, and visual texts.

Presupposing that no discourse can get outside of language and that no countercultural critique can escape its host culture, Eltit marks off an internal space that can be visualized metaphorically as a performance within the frame of a public square. This space is internal precisely because of her awareness that both she and her narrative are represented but not silenced by the images, laws, representations, and realities of an infinitely complex hegemonic matrix. The performance dynamic, constituting a dialogue between spectator and performer, instates an active process of communication that exceeds monological pronouncement. An audience gathering around a performer delineates a circle whose circumference both separates the performer from the surrounding city and at the same time attracts more spectators to view and interpret the performance.

And yet, what kind of conclusion can an audience draw from Eltit's performance of textual and corporeal effacement? If her agenda stages the deconstruction of narrative continuity, can her audience/readers construe her actions of mutilation in terms of an embodied art that performs politically? Obviously there is a risk involved with a strategy such as Eltit's. Some readers, especially those not familiar with the context of the Pinochet dictatorship, will inevitably lose the strand of Eltit's nonlinear series of cortes. On the other hand, a contextualized analysis reveals both the coherence of Eltit's agenda as well as the political effectiveness of her performance. By not attempting to reflect reality, Eltit modifies mimetic codes refracting the "fiction" enveloped within the hegemonic image of "reality." She avoids a linear mode of narrative description, choosing rather to write, read, and perform inscription. The hermeticism of her performance, consequently, avoids and denies authoritarian predication. Instead of "informing" her public, Eltit provokes thought and action.

The ensemble of Eltit's texts functions within the context of her literary, artistic, and political action. The publication of *Lumpérica* inaugurated a resurgence of "resistance literature" in Chile. As Eugenia Brito writes, "It is no coincidence that the publication of this novel bore witness to the appearance of a literature of the Resistance, that appeared in

the space opened by Diamela Eltit" (169). Eltit's performance carves an opening within the repression of postcoup Chile. Much as each episode of *Lumpérica* contributes to L. Iluminada's mise-en-scène, each of Eltit's "texts" plays a protagonizing role in the staging of a performance. Cutting through and across narrative, images, discourse, and flesh, Diamela Eltit realizes a performance that in turn performs critically, clearing space for critical performance and political action.

The performance of L. Iluminada in *Lumpérica*, writes Mary Louise Pratt, "prophesized a related struggle, five years later . . . The 'Campaign of the No'—the political campaign in the fall of 1988 that ended Pinochet's rule" (162). As Pratt explains, this movement attempted to " 'open a new circle,' not in literature but in politics, public life and the social imagination of the Chilean citizenry" (162). CADA also played a performative role in the growth of this pro-democracy movement. In their action "No +" (*No más*, 1983–84), CADA members subversively painted "No +" throughout Santiago. The public subsequently added words to the graffiti, such as "torture," "disappearances," "violence," or at times they followed the phrase with drawings of guns and other images of repression. Over time, "No +" became the rallying cry that was carried on banners at the front of pro-democracy marches throughout Chile. Of course only a few Chileans are aware that the use of the phrase "No +" in Chile grew from an anonymous art action instigated by CADA. Similarly, only a group of people directly witnessed Eltit's performances. The scenes from the novel and performance combine nevertheless—they fuse with political action in the streets and in so doing change the representation into an even larger performance, a performance that exceeds the text.

Notes

Portions of this essay were previously published in my book *(Con)Fusing Signs and Postmodern Positions: Spanish American Performance, Experimental Writing and the Critique of Political Confusion* (New York: Garland, 1999) and in an earlier essay, "Diamela Eltit: Clearing Space for Critical Performance." *Women and Performance: A Journal of Feminist Theory* 7.2–8.1 (1995): 219–39.

1. I should note that Eltit's videos (produced in collaboration with Lotty Rosenfeld) are unavailable commercially and have never been distributed. When I asked Eltit for a copy, promising that I would not redistribute them, she assured me that the videos were merely *ensayos* (essays) of limited interest: "¿a quién pueden interesar esas cosas?, sin contar que son trabajos de una máxima precariedad, ni siquiera son piezas audiovisuales formales, más bien ensayos en los que deposité parte de mi locura" (fax to the author, 27 Oct. 1993). *Maipu* is a historic videographic document that registers a key episode in Eltit's political and literary performance. Eltit's choice of the term *ensayo*, furthermore, underscores the perti-

nence of considering her performance actions together with the "Ensayo General" of *Lumpérica*.

2. On the role of gender in the Pinochet coup, see Sonia Montecino's *Madres y huachos: Alegorías del mestizaje chileno*. Montecino partially inverts the image of women's passivity with respect to the coup. In her chapter on "maternal politics," Montecino describes how right-wing women took to the streets before the coup, clattering cookware and protesting what they perceived as the communist rape of the Chilean *matria* (motherland). While this political intervention implicates these women in the rise of Chilean (neo-)fascism, Montecino points out that these women situated themselves within the patriarchal discourse as mothers, calling on male soldiers to restore a traditional state of order (103–10).

3. In her article "Remapping Culture," Franco recognizes some feminist agency in Eltit's work: "It is too easy to dismiss as 'elitist' middle-class women writers who have chosen to write difficult or self-reflexive prose, since frequently (as in the case of Diamela Eltit and Cristina Peri-Rossi) they address questions of women's sexuality or the definition of aesthetic desire and pleasure, which generally have been represented in masculine terms. On the other hand, to consider their testimonials as major alternatives to the prevailing literary institution is problematic" (183).

4. See Nelly Richard's essay, "The Rhetoric of the Body," in *Margins and Institutions* for analysis of the use of the body in works by Leppe, Eltit, and Raúl Zurita. See also *Cuerpo correccional*, the book conceptualized collaboratively between N. Richard and Carlos Leppe.

5. For description and analysis of CADA's art actions, interviews with each founding member, and a compilation of the majority of CADA manifestos and documents, see my book *CADA día: La creación de un arte social*. For an early essay written by Eltit about the concept of art actions, see "Sobre las acciones de arte: Un nuevo espacio crítico."

6. See Lotty Rosenfeld's book *Una milla de cruces sobre el pavimento*. See also *Desacato: Sobre la obra de Lotty Rosenfeld*.

7. All quotations from *Lumpérica* are cited parenthetically with the pagination from the 1991 edition of Editorial Planeta Chilena; I also use the Spanish spelling of L. Iluminada. All translations cited in this essay are my own. The novel has been translated into English by Ronald Christ with the collaboration of Gene Bell-Villada, Helen Lane, and Catalina Parra; see *E. Luminata*.

8. My reading of incisions will emphasize their discursive more than their symbolic enunciation. Castro-Klarén's article underscores the text's engagement with Roman Catholic symbolism. According to Castro-Klarén, *Lumpérica* (and by extension one might add Eltit's mutilation) stages a "scandal" by positioning a self-sacrificing woman in the role of Christ. Castro-Klarén writes, "*Lumpérica* re-writes the scene as a ritual pertaining to a feminine body that simultaneously achieves her sexuality and her text. . . . *Lumpérica* traces the message of the Gospel in reverse: 'And the word became flesh' " (106–8, my translation).

9. Gilles Deleuze and Félix Guattari in *Anti-Oedipus: Capitalism and Schizophrenia* employ the metaphor of corporeal "inscription" to describe the interrelatedness of culture, violence, language, and writing: "Cruelty is the movement of

culture that is realized in bodies and inscribed on them, belaboring them . . . The sign is a position of desire; but the first signs are the territorial signs that plant their flags in bodies. And if one wants to call this inscription in naked flesh 'writing,' then it must be said that speech in fact presupposes writing, and that it is this cruel system of inscribed signs that renders man capable of language, and gives him a memory of the spoken word" (145).

10. Thematically as well, *Lumpérica* evokes the reproductive cycles of women and the universal need for sleep, food, and light (itself a cycle) among society's nonproductive sector.

11. As Julio Ortega writes in "Diamela Eltit y el imaginario de la virtualidad," "To replace patriarchy with matriarchy only confirms hierarchy. It is a matter, then, of problematizing the entire system of representation" (54).

Works Cited

Barthes, Roland. *S/Z*. Paris: Editions du Seuil, 1970.

Brito, Eugenia. "La narrativa de Diamela Eltit: Un nuevo paradigma socio-literario de lectura." *Campos minados: Literatura post-golpe en Chile*. Santiago: Editorial Cuarto Propio, 1990. 167–218.

Brooks, Peter. *Body Work: Objects of Desire in Modern Narrative*. Cambridge: Harvard University Press, 1993.

Castro-Klarén, Sara. "Escritura y cuerpo en *Lumpérica*." *Una poética de literatura menor: La narrativa de Diamela Eltit*. Ed. Juan Carlos Lértora. Santiago: Editorial Cuarto Propio, 1993. 97–110.

de la Parra, Marco Antonio. *La mala memoria: Historia personal de Chile contemporáneo*. Santiago: Editorial Planeta Chilena, 1997.

de Lauretis, Teresa. "Imaging." *Alice Doesn't: Feminism, Semiotics, Cinema*. Bloomington: Indiana University Press, 1982. 37–69.

Deleuze, Gilles, and Félix Guattari. *Anti-Oedipus: Capitalism and Schizophrenia*. Trans. Robert Hurley, Mark Seem, and Helen R. Lane. Minneapolis: University of Minnesota Press, 1992.

Eltit, Diamela. *E. Luminata*. Trans. Ronald Christ with Gene Bell-Villada, Helen Lane, and Catalina Parra. Santa Fe: Lumen, 1997.

———. *Lumpérica*. Santiago: Editorial Planeta Chilena, 1991.

———. "Sobre las acciones de arte: Un nuevo espacio crítico." *Umbral (Nueva Epoca)* 3 (1980): 23–27.

Eltit, Diamela, and Lotty Rosenfeld. *Maipu*. Videocassette. 1980.

Franco, Jean. "Going Public: Reinhabiting the Private." *On Edge: The Crisis of Contemporary Latin American Culture*. Ed. George Yúdice, Jean Franco, and Juan Flores. Minneapolis: University of Minnesota Press, 1992. 65–83.

———. "Remapping Culture." *Americas: New Interpretive Essays*. Ed. Alfred Stepan. New York: Oxford University Press, 1992. 172–88.

Irigaray, Luce. *This Sex Which Is Not One*. Trans. Catherine Porter with Carolyn Burke. Ithaca: Cornell University Press, 1985.

Jara, René. *Los límites de la representación: La novela chilena del golpe*. Madrid: Fundación Instituto Shakespeare, 1985.

Montecino, Sonia. *Madres y huachos: Alegorías del mestizaje chileno.* Santiago: Editorial Cuarto Propio, 1993.

Neustadt, Robert. CADA *día: La creación de un arte social.* Santiago: Editorial Cuarto Propio, 2001.

Ortega, Julio. "Diamela Eltit y el imaginario de la virtualidad." *Una poética de literatura menor: La narrativa de Diamela Eltit.* Ed. Juan Carlos Lértora. Santiago: Editorial Cuarto Propio, 1993. 53–81.

Pratt, Mary Louise. "Overwriting Pinochet: Undoing the Culture of Fear in Chile." *Modern Language Quarterly* 57.2 (1996): 151–63.

Richard, Nelly. *Margins and Institutions: Art in Chile since 1973.* Melbourne: Art & Text, 1986.

Richard, Nelly, and Carlos Leppe. *Cuerpo correccional.* Santiago: V.I.S.U.A.L., 1980.

Rosenfeld, Lotty. *Desacato: Sobre la obra de Lotty Rosenfeld.* With María Eugenia Brito, Diamela Eltit, Gonzalo Muñoz, Nelly Richard, and Raúl Zurita. Santiago: Francisco Zegers Editor, 1986.

———. *Una milla de cruces sobre el pavimento.* Santiago: Ediciones C.A.D.A., 1980.

DENISE STOKLOS

(Brazil)

Denise Stoklos is the foremost solo performance artist from Latin America. She started working in theatre as a child, and moved into professional theatre in 1968. She left for England in the late 1970s to get away from the tyranny of Brazil's military dictatorship, and trained with various European and U.S. performance practitioners. Stoklos was in voluntary exile in England when she composed her first solo piece. She found English offered her "lightness," one more means for transporting herself from the "vision and vicinity of torture and dictatorship" of the Brazilian military regime. She continues to perform her works in Spanish, English, French, Ukrainian, Russian, German, and Portuguese. Brazilian performer Eleonora Fabião writes that Denise Stoklos's "compositions are based on extreme physicality. Even the verbal word achieves a material quality. The text is not declaimed, far from it; the words grow in her mouth to be cut by her untamed tongue, chewed by her teeth, and modeled by her lips. The words she pronounces are parts of her body. Meaning acquires a physical sense, thinking become matter. Her intimacy with verbal language and her capacity to incorporate words and phrases is so overwhelming that she shifts idiom according to the place where she is performing" (see Holy Terrors website).

Since her early training in mime, solo performance, and other corporeal techniques, Stoklos has developed the capacity to work in multiple languages, linguistic as well as aesthetic. In the last thirty years she has created many major

pieces, including *Mary Stuart* (1987), *Des-Medéia* (1989), *Casa* (1990), *500 Years: A Fax from Denise Stoklos to Christopher Columbus* (1992), *Civil Disobedience* (1997), *I Do, I Undo, I Redo: Louise Bourgeoise* (2000), and *Calendario de piedra* (2001). She has won a number of prestigious national and international awards, including many for best actress in Brazil and a Guggenheim in the United States.

Selections from Writings on Essential Theatre

DENISE STOKLOS

Edited and Translated by Diana Taylor

"Manifesto of Essential Theatre" (1987)

Essential Theatre: A theatre that has the minimum possible gestures, movements, words, wardrobe, scenery, accessories and effects but which contains the maximum dramatic power.

The human figure onstage performs a unique alchemy.

I want the stage naked.

I want no decoration.

I want it dry.

Throw away the brooch. Put the chest onstage.

As an actor, director, and author, I am always questioning power, social injustice, normative behaviors, aesthetics, and the workings of the State in this capitalist, patriarchal system. I am less and less interested in the microcosmic movements of society . . . More and more, I am becoming an anarchist. I laugh more and more at politicians. I save myself by following my own personal, unique path."

If my students asked me what to do, I would answer: Invent something.

I do not have the slightest belief in immediate results.

I hate most of the rules of our social organization. Accepted behaviors and bourgeois aesthetic tastes . . . seem anti-life to me.

To believe in the actor as the source of theatricality itself is a utopian force.

I miss no chance to display myself in my full femininity, which is peculiar, unique.

I do not participate in political demonstrations in my country anymore. Not even against censorship. Because I am against the censorship of those who demonstrate there.

After three months in New York, I found an unopened bottle of grape juice in my refrigerator marked Cr$ 12,00. When I went shopping, the same one cost Cr$ 48,00. I do not forget the poverty in Brazil, the poverty in Latin America, the poverty of the bread-less, the home-less, the school-less, the poverty of selfishness, the poverty of ideals, cultural poverty, television poverty, the poverty of human relationships, the poverty of health, the poverty of dreams, the poverty of the lottery, of remedies, of despair, of loneliness. The Brazilian poverty.

I always come back home to Brazil. I always want to be with my children. We are trying to stay in our homeland.

I remember one day in the sixties when I wrote: "The American astronaut landed on the moon today. The monopoly has expanded throughout the universe." Today, after two decades of absurd wars (Vietnam, the Gulf War, Croatia), I consider myself victorious in my activist pacifist creative resistance—with a very special family, a personal theatre, and wildly happy.

"A Brazilian Proposal"

It's necessary to situate historically the birth of the idea of an essential theatre. From 1964 to 1977, censorship had taken hold in Brazil. This thirteen-year period overshadowed my first professional contact with theatre. I began writing, directing, producing, and acting in 1968 . . . An open expression of style or focus was prohibited, discouraged both by the military and by the terrorized civil society. Being a woman (in Brazil women are still not recognized as authors), and coming from the marginalized South (in my country not even the southern accent makes it on the stage), I had already experienced the isolation that motivated my critique. I amassed a repertoire of revolutionary impulses. No negotiation

or simple reform could satisfy my organic need for change. From early on, my artistic choice was clearly for a theatre that would not reproduce proposals developed by others, but for a theatre that sought its own voice and corporeality.

[*After training in her native Paraná, then Río, then São Paulo, Stoklos went into voluntary exile in England. She gave birth to two children, an experience that she describes as transformative in her artistic development.*] Motherhood put me in contact with what was most intrinsic in my artistic path. I started searching, more rigorously than ever before, not for the superfluous, the disposable, but for the essential.

[*About performance*] I worked on several performances in England. They prompted my research into the graphic projection of the text, which later became an important part of my solo work. By this I mean the alienated verbal representation of a text that occurs, for example, when a text is delivered in a foreign language. The expression of "feeling in Portuguese" and "communicating in English" reveals the denial of the emotional flow that occurs spontaneously when one uses one's native language. I perceived that this divergence dramatized the encounter between signs . . . between the sound and the meaning of the word. That research shed light on the verbal path of my future stage work.

Casa

DENISE STOKLOS

Translated by Denise Stoklos and Diana Taylor

Characters:

INHABITANT and STAGE MANAGER
 or
ONE and ANOTHER
 or
SUBJECT and PREDICATE
 or
PERSONAL and SOCIAL
 or
FÍSICA e JURÍDICA
 or
FIRST and SECOND
 or
AGENT and WITNESS
 or
OPEN and CLOSED
 or
TIED and UNTIED
 or
LOCK and KEY

Set:

HOUSE or CAVE or TEPEE or IGLOO or CABIN or PALACE or ANIMA
 or
COUNTRY or MIND or IDEOLOGY or REPERTOIRE OF EMOTIONS or HABITS or
MEMORIES, etc.

Soft music. Various rooms are slowly illuminated. A simple residence. There are no walls on stage, although it is obvious from the character's movements that the halls are very narrow. The rooms are suggested only by specific objects: the bedroom is only a bed, the kitchen a refrigerator and stove. The dining room consists of a table and chair. In the living room there is a sofa, an imaginary door, and red flowers in a shoulder-high, free standing vase. The bathroom is suggested only by the toilet. The character, in formal wear, gray suit, red high heels, and black hand-bag under the arm. Her long hair is swept straight-up, fixed absolutely on end at the top of her head. (Were a man to play this role, certain adaptations would be necessary regarding clothing.) Enters house. Fumbles with keys at the door. She rolls on the floor. She moves through the rooms, looking at the spaces, thinking out loud.*

One and a half million years ago. Hominidae embarked on the development of language. This process was slow, as slow as mastering the use of sophisticated tools. Simple devices, made of stone, were used by Australopithecus during long periods of time, before the appearance of hammers. There is evidence of improvement in the manufacture of artifacts *(Pause. Flirting with the audience.)* and also evidence of cooperative hunting. This data suggests a more complex communication system, which certainly indicates the period of time in which language achieved a new importance. *(She fumbles with her back garter. Contorts and twists around trying to align the seam in her stocking.)*

The "Homo Erectus" *(She straightens up.)* was taller. His brain was bigger. *(Picks up orange juice container and an empty glass from top of the stove and carries them over to the table.)* His face and teeth were smaller than the Australopithecus. Some of them had bigger skulls than the average modern man. Some of them even bigger than post-modern man. *(In excruciatingly slow motion, she starts pouring the orange juice. She pours so slowly that her body reacts with impatience—she taps the heels of her shoes, she looks around, fed-up. She continues to pour the liquid until it reaches the very top of the glass. She stops and sings an aria by Monteverdi from "Ritorno de Ulisses in Patria," in free translation.)*

Immortal I am
Within a human body
Everything, everything surprises me
A single drop tells me
That the time in which I grow old
Is the same in which I grow up
Is the same in which I grow up

(She tries to drink the juice but cannot find a way to hold the glass. Frustrated, she finally moves back a step and bends over, her hands behind her back, to try to drink. Gives up. Stands, arms crossed, doing nothing. Moves around the table. Stands, arms crossed, doing nothing. Nothing changes. She moves again, trapped in a circular motion that speeds up. Stops suddenly, and tries to recompose herself by sitting in the chair. Again, she tries to get comfortable, resting her head on her arms, then hands, but finds no satisfactory position. Still searching for something that gives meaning to her moment, she opens her handbag. She nearly puts her head inside of it. Extracts some personal belongings, such as dental floss, and a letter. Drops both. Suddenly her attention is drawn to the sofa. Finally focused, she stalks towards the sofa.)

Those artifacts, frequently found during the Stone Age, consisted of many types of scrapers, with saw-like and indented edges. *(Flicks a speck off of it. With a new resolution, she moves towards the bed.)* The period of time in which those tools were made begins during the primitive Low Pleistocene and goes at least until the Riss glaciation period, at the end of the Middle Pleistocene period. The Kenyapithecus, a Ramapithecus-type fossil, is considered by many people to be a very ancient representative of the human family. *(Sitting on the bed, she looks at the audience.)* I don't know why I expose myself so much.

(She tosses on the bed, flipping up into the air, determined to find a comfortable position. Frustrated, she switches on a bed-light, which starts Vivaldi's "Four Seasons: Winter." She continues to toss, increasingly aroused by the music that moves together with her tossing and turning. Switches off bed-light. Music stops. Goes to the living room, exhausted from trying to rest. She tries to transform her physical agitation into some source of harmony, suggestive of a dance. The dance is tense and tight, as if she were miming a dance. She goes to the sofa, as if she were going to flick a speck off of it. Instead, she's reaching for a red accordion behind the sofa. Places it on the floor at the center of the living room, and starts to examine it, as if she were trying to decipher its complexities. She figures out how to put on the accordion, but it overwhelms her body,

making it appear very small and crouched, with only the head and feet showing. She is stuck in the dwarfed position. Resisting the image she's projecting, she pushes herself up. Genesis of a performer. She starts to play randomly. Disorganized sound. She moves left and right across the stage. When she gets near the flowers, at eye-level, she stops, inspired suddenly by their color, perfume, form. Caresses the accordion. Backs up to the sofa, where she proceeds to erotically stroke the keys of the accordion and, in extension, her body—downwards and upwards—as if she were playing. Sensual pleasure. Her miming coincides with the sound of recorded organ music. In ecstasy, she realizes she can play the music.)

(Plays the accordion. Famous piece for beginners.) It's not easy playing the accordion. It's very heavy. I used to have a very light one. But it was stolen. Everything gets stolen, everything. Well, it is not worth playing the accordion. I'm not going to play it anymore—it doesn't change anything. *(With the accordion hanging from her shoulders, she stops, wriggling uncomfortably. She puts down the accordion, right underneath the flowers. She moves sideways, in short jerky steps, towards the toilet, as if she needed to use it. She opens the lid. Looks into the bowl, very upset. Something is in there. Torn between disgust and urgency, she hesitates about what to do. Finally, disgusted but determined, she rolls up her sleeves, puts her hand inside the bowl and pulls out a clock—dry. Places the clock on the kitchen table. Looking at the clock.)*

Well. It's already been one minute and five seconds since I . . . Six. Seven. Eight. Nine. Ten. Eleven. Twelve seconds since I . . . Fourteen. Sixteen. Twenty-two. Thirty . . . *(She tries to keep up with the clock, but it's always ahead of her. In extreme frustration, she tries to catch up by putting the clock on her head. She sits on the sofa, puts the clock beside her, facing the audience. Only occasionally does she steal a glance at it and mumbles the seconds. She covers her mouth, trying to stop herself.)* It's exasperating. *(Opens her handbag. Puts her head inside. Burrows. Finally she pulls out money—five bundles. She arranges the bundles in a geometric line on the sofa and counts them. Not satisfied, she rearranges the bundles in a different geometric line and recounts. Never satisfied, she takes off the rubber band and counts the bills. She counts the money again and again and again, first with her hands, then with her feet. She momentarily takes off her shoes, to use them as weights as she organizes her piles. She picks them up again, disorganized. They become an object in her hand. She sticks the money back into the bag—and pushes it down with her high heels. After packing her money in the handbag, she stands up straight, crosses the stage.)* I eat, I eat, I eat, I eat, I eat, I eat, I eat, I eat,

1. "She rolls up her sleeves, puts her hand inside the bowl." Photo by Isla Jay.

2. "She tries to keep up with the clock, but it's always ahead of her." Photo by Isla Jay.

I eat, I eat, I eat, I eat, I eat, I eat, I eat . . . and I never put on weight. *(Picks up the dental floss. Goes to sit at the table. Tries again to drink the juice and again fails. Picks up the letter. Looking at the glass with revenge.)* My God! Oh my God! My God . . . I am writing you these few lines . . . oh my God! . . . these "non"-thoughts which occur whenever I think about our absurdity, which flows through the sewage of this non-signalized metropolis inside our head, we, the peculiar people, the daring people, the desperate people, the deprived people, the ambitious people . . . my God! How many firemen falsely alarmed . . . my God! . . . how many burning hoses do we have to extinguish? The hammer in flames, the siren mute and astonished. And we have to deal with the memories of so many of those who were important in our history and now burn themselves out in a sentimental samba that spells longing and Brazilian beer that promises happiness. It's so inglorious to lose these people, as inglorious as losing the prayer we pray to Saint Benedict to help us recover our losses. And it's useless to believe that faith moves mounta . . . I am talking about these contemporary people that survive only in memory, those whom I search for among the firemen, among the fire and the emerald-green melancholy, but I search without fury. Let's recognize what is in the ruins—that which is fleeting, that which is foundation, that which hovers, like radar, over the screen, and that which is Kryptonite. Oh my God!!! . . . It is necessary to recognize the Music, the non-numeric scale of our pentagram, the center of the yolk or the myth, what is in the Past, the Known, the Structured, the Ancient, the Old, that which vibrates within the mantle of the orgasm, that which sparkles within the multiple sounds that visit the universe, before and during the existence of that which sounds and intones. Feeding from professional dissonance, I choose the error, the experimental, the transverse, the worn-out dress-coat, the tears of the maestro, the clown. And it hurts, an image of the pacifier poisoned by roach piss, a dirty sack full of old things kicked around like whore's guts. So much shit, so much whipping. The well-done rare, the bare ass undone by what it has been. The rotten barbecue hoopla of our 1964 macho murderers, who defecated on our heads, and they keep on doing this, these rioters of the universe who defecate over our sweetness, over our dreams, over the cotton of our wills, over our beliefs, over play, over laughter, over alleyways, over songs and over texts on love. No, no, no. Whatever we used to treasure will still be ours, personal, authenticated, and firmly recognized as Flight, as Shock, as Urgent, as food that is eaten without substance, without digestion, without reality, this kind of food that all of us, with full stomachs, will pick from our sharp teeth, deliver with a deep belch, because, at last, a freedom banquet will be served on our table, big hugs. My God!

(Repeating "my God, my God" in different registers, alternately scared, angry, making fun of herself, suspicious, and finally, with finality, my God!!)

(She goes to the kitchen, negotiating the narrow hall. Goes to the fridge, opens the door, looks inside, indecisive. From her movements, it looks as if she is looking at her whole body in the mirror, arranging her clothes. Suddenly, she grabs the chair and places it in front of the open fridge. Changes location of identical objects — i.e., the position of two cartons of milk. Stares at the refrigerator for a while. Suddenly picks up the handbag that is on the table. Takes the money from inside and puts it inside the freezer, to freeze her assets. Closes the door, with her body across it to protect it. With a very dramatic and stylized movement, she picks up the chair and takes it to downstage to the living room. Dances with the chair. Places it, and with her hands, starts measuring the space in front of the chair. Goes to the stove, opens the oven, puts her head inside of it. Reaches up her hand as if turning on the gas. Instead, she extracts a container with take-out. Very happily, she returns to the living room, with her container. Suddenly, she pulls a television set from the wing. She sets it exactly where she had measured with her hands. She sits, grabs her food, and turns on the TV. Choreography of her reactions to the sounds (dramatic cello music) that come from the TV. Interaction with the images we suppose she is seeing. Many facial expressions and contortions. Suddenly, she turns the TV towards the audience, putting herself right in front of it, making the same faces. We see now it's a mirror, not a TV. She pushes the TV across the stage very slowly in such a way that the audience sees itself reflected in it. Lights up slightly on the audience. Leaves the TV on the opposite side of the stage and comes back with a popcorn popper. Places it on the floor, right in front. She assumes an upright and composed position and delivers the following.)

My possessions: A car, a diesel-fueled Deluxe Model. Another car, a gasoline-fueled BR800 Model. One commercial telephone number 815-8929. One private telephone number 211-5350. Another telephone number, an even more private one, which I don't want to disclose. A complete stereo set: turntable, radio, amplifier and cassette recorder and player. A top asset: Motherhood. Persistence. A walkman with two small speakers. A videocamera. A tripod. A microphone. Strong, big and beautiful hands and feet. A radio alarm. One watch, not very valuable, but very dear to me and that I've just lost. Very good sex. Artistic mind. One hundred and thirty-two cassette tapes. Very good sex. I've already counted that, but it doesn't matter. *(Flirts with the audience)* It's always good to repeat it. One

3. "She grabs the chair and places it in front of the open fridge. She stares at the refrigerator for a while." Photo by Isla Jay.

4. She moves the chair and starts measuring the space in front of the chair. Photo by Isla Jay.

never knows. Two hundred and eighteen CDs. Four hundred and forty-seven books. Hatred of mediocrity. An electric guitar. One accordion. Obsession with uniqueness and a popcorn machine. *(Picks up the popcorn machine)* I've had this machine for eight years. I take it with me everywhere I go. On all my trips. All of them. I bought it when I went to São Paulo to work. I am from the south of Brazil. Then I went to live in London, and then to Rio de Janeiro. Then an excellent theatre director invited me to create the choreography for a very good show of his in São Paulo. But he had no money to pay me. Since he was also the artistic director of a television channel he invited me to act in a soap opera, where I would be very well paid and would have a very unique role, especially written for me by the author, who was also a great playwright. And then they put me in a very comfortable hotel in São Paulo. The apartment was very good, but it had no kitchen. Well, it didn't matter, because I don't know how to do anything in a kitchen. The only thing I can cook is popcorn. So I bought myself this wonderful popcorn machine, self-sufficient, self-generating. I plug it in, and it cooks brilliant popcorn. And at that hotel, there were no black-outs. In that hotel there lived another actress from the same soap opera. That actress died there. All of us were informed about her death, we were told to go to her apartment. When I got there, it was too crowded, and I did not know what to do. I went to the bathroom and found some panties of hers, dirty ones, she did not have time to wash them, and I thought: "What do I do?" I decided to throw them out, these panties, into the garbage. That was my little after-death intimacy with the actress. I knew. I knew I had time to tell this story while the popcorn was getting ready! I know my popcorn! *(The popcorn is ready. She disconnects the popcorn machine.)* But, in Washington, the popcorn did not pop. I was desperate. I told the whole story and the popcorn didn't react. I know popcorn! But then I found out: In Washington, the voltage is different! I don't understand such things. In a world like ours. So big. Everybody knows what's going on everywhere. From North to South. And in Washington the voltage is different! *(Sitting and eating popcorn from the bowl)* There are other things I don't understand about this world. It's not only a matter of voltage. And everybody knows I am taking about other injustices that are known to us. We know. We do, don't we? WE do. SO! This talk about the general astonishment of the population . . . It's not surprising . . . We've been living in chaos so long. Pressure and helplessness are the laws of the . . .

(Puts down the popcorn bowl. She covers her mouth with her hands. She takes her hands away and tries to speak. Repeats this action.)

Lov . . .

148 Denise Stoklos

(Covers her mouth with both hands. Tries to put both hands in her mouth as if pulling out the words. Feels relieved. Serenely:)

Yes, I said love. Love. *(Points to her mouth)* It fits. Fits, see? *(Encouraged)* Love, love.

(Turns upstage, saying:)

And, who survives the atomic bomb? The cockroach! Yet it succumbs to our prosaic insecticide. C'est la vie . . .

(Looking at the set:)

How did this set get here? I hate disposable objects. Someone please help me get this set out.

(She calls the stage manager by his name. He enters from the wings.)*

Please help me get these things out of here. I have nothing else to do with this stove here. Everything I needed to do with the fridge, I did already. Please, take out everything, everything, everything while I finish my argumentation there up front. *(She returns to stage center. Very quietly, the stage manager and an assistant take out the objects—lights low.)*

So, the first ancestor of man appeared twenty million years ago or more. That creature got separated from our ancestor's parents, the great anthropomorphic apes, and its descendants never stopped their evolution in a different direction. Therefore, more than twenty million years ago, man had already started to evolve. But the monkey, no! The monkey stayed there. It remained loyal to its own roots. It never betrayed its own class. Once a monkey, forever a monkey! And for more than twenty million years, the monkey has continued to watch man's attempts to come into Being. Since the fireball, the cooling of the planet, the appearance of vegetable and animal life, the transformation of rocks into minerals, the formation of the seas, the monkeys were there, watching. The Great Wall of China, the Tower of Babel, Noah's Ark, the monkey was inside! The Montessori Method, Pavlov, the monkey was there! It was there, watching humans trying to calculate the distance between an asteroid to Pluto. Developing a geodesic theory. Devising a science of how to build a distillery. Engineering the recipe of a manioc cake. Heavy industry. Figuring out the treatment of wood. The investigation of the genetic components of an aquiline nose. Calculating the odds of winning the lottery. Registering in the collective memory the name of the best center-forward of the third World Cup, the monkey is there watching. The linguistic discovery

*If a male is playing the character, then the stage manager should be female.

of how to say, in an Ethiopian dialect: that after all, there are fools for everything and there are more fools than everything.

(Turns back to look at the stage that is now completely empty. Only the popcorn bowl stays where it was.)

How beautiful! Now everything is possible. This is what I call a stage. Empty, like our contemporary world. Magnificent job . . . *(Name of the actual stage manager).* It takes so much time to build a set, and you pull it down so fast. Very good. It's perfect like this. Come here, please. *(Calling the stage manager)*

(Stage manager comes back onstage. Actor continues.)

It's nice. It's really nice. *(Pause. Awkward moment.)*

ACTOR: What's your house like?

STAGE MANAGER: White.

ACTOR: My house was white too, when I was little. A wooden house. Because I don't know if you know that I come from Irati, in the southern part of the state of Paraná, and there is a lot of wood there, common pines, Brazilian pines. So the houses are made of wood. And my whole house was painted white. We used to bake pine nuts. Do you know what pine nuts are, *(Name)*?

(Stage manager nods affirmatively.)

ACTOR: Oh. *(Desperate)* You know, many people don't know what pine nuts are. Once I showed them to a friend of mine from England, and she asked, "What are these little seeds?" She did not know them. *(Pause, looking at the stage)* But it looks good like that. We also used to eat jabuticaba. Do you know what jabuticaba is?

(Stage manager shakes his head no.)

ACTOR: Jabuticaba is a wonderful Brazilian fruit. You pick it straight from the tree and eat it. It tastes of earth. It's beautiful. You know, *(Name)*, these things I'm telling you are not private. I mean, they are private, but I . . . Do you understand, *(Name)*? I don't feel violated. I am just trying to go a little further, like that, beyond conventions, do you understand? Because I think that these conventions around language and behavior are electric fences. And I believe that, when you express yourself like this, the core, the inside, remains completely preserved, and I actually believe that the core is fed from this kind of delivery. Expressing oneself is a

kind of organic manure for the inner core. *(Pause)* But what's your house like, *(Name)*?

STAGE MANAGER: White.

ACTOR: But what is your house like?

STAGE MANAGER: White.

ACTOR: *(Trying another intonation)* What is your house *like? (Falls on the floor, in desperation. Stage manager, implacable, looks at her and leaves.)*

ACTOR: *(Banging her arms and legs on the floor)* I need to know what your house is like! *(Pause. Stands up.)* One day I will be able to communicate. *(Standing stage front, looking up, ceremoniously says:)* God is jabuticaba, and the Devil is gravity, which knocks them all down. *(Pause. Doubts, but concludes.)* God is jabuticaba, and the Devil is the gravity that knocks them all down. Love. What nonsense. *(Pause. Confirms.)* God is jabuticaba, and the Devil is the gravity that knocks them all down. What nonsense. *(The Brazilian national anthem, played only on the piano. The actor gestures reaching up towards the fruit, and the falling of the fruit. The gestures suggest that we must reach for the fruit but not accept the fall. She makes a last effort, and happily reaches an imaginary fruit. She manages to put it in her mouth. The gesture, for a moment, looks like a kiss. She leaves the stage, closing the imaginary door she opened at the beginning of the play. The exit coincides with the last note of the national anthem.)*

End

The Gestural Art of Reclaiming Utopia:
Denise Stoklos at Play with the Hysterical-Historical

LESLIE DAMASCENO

History, in the sense in which Benjamin speaks of the double exposure of dialectical images through which the significant past comes back to us and flashes up at a moment of extreme danger, needs to be recognized. This recognition is the precondition for theatre.—Johannes Birringer, *Theatre, Theory, Postmodernism*

This economic and political conditioning has led us to philosophical weakness and impotence that engenders sterility when conscious and hysteria when unconscious. It is for this reason that the hunger of Latin America is not simply an alarming symptom: it is the essence of our society.—Glauber Rocha, "An Aesthetic of Hunger"[1]

CENA NOVE: UM TELEFONEMA
"Alô, é daí?"
"Não, não é daí, Escócia. É daqui, Brasil."
—Denise Stoklos, *Denise Stoklos in Mary Stuart*[2]

Denise Stoklos proclaims herself, unabashedly, an optimist, a full-out utopian, in print and on the stage. Speaking as the director of her solo piece, *500 Years: A Fax from Denise Stoklos to Christopher Columbus* (1992), she ends her comments on the play's production by declaring: "I opted for the joy of insisting on the realization (*estabelecimento*) of happiness. I opted for the ecstasy of optimism, in which I believed, and believe (52)."[3] In *Des-Medéia* (1994), a piece that uses the myth of Medea as a metaphor for the Brazilian soul, the chorus, as Stoklos interprets it, ends its prefatory speech by calling on Medea to "dis-medeafy" herself, to transform the myth, to remedy it (*remendéia*, a play on the word *Medea*), to take the reins of the sun-chariot in a flight glorified by the

"effusive victory of love." The chorus signifies a communal utopian process: "Even if this is called utopia, that for us, souls in the daily process of des-medeafication on route to an eternity of love, for us utopia in truth rhymes well with transformation now, already and every day" (9).

Stoklos's plays are textually punctuated and structured by such declarations, though the tone and sense of them vary: they may be didactic, effusive, and even sentimental, or battle cries of resistance, defiance, and transformation. They are often comic, hilarious, even hysterical in tone. What all these declarations have in common is an insistence on utopia as a transformative process motivated by a visceral (and collective) need for communication, community, and love. In one sense, the shape and geography of Stoklos's utopia is affirmed by histrionic negation: it is a global "non-place" in which the historical atrocities and social injustices that she textually eviscerates in her plays could be cleansed from the collective body.

But she is also a realist. A call for utopia is a reading of history, and her performances are interrogations of historical reality, past and present, global and local.[4] Her point of departure: Irati, the small interior town in the state of Paraná in which she was raised. *Irati*, an Indian word that she breaks down into Portuguese syllables—"ir–a–ti / to go to you." Local, personal reference expands, encompasses global history, and is always referential to home, despite the fact that many of Stoklos's performances have minimal verbal references to Brazil.

For Stoklos, the local and the global (Brazil–world) are not in opposition but figure as historical and geographical coordinates whose tension she explores as a citizen of the world, aiming for a transcultural communication in her work. Although Stoklos's gesturality is rooted in Brazilian corporeal expression, her plays are eminently international in conception and exhibit an international gesturality that allows her to shift languages with ease, playing linguistic inflections off of one another, and counterposing verbal commentary with nonverbal punctuation.

In her "Manifesto of the Essential Theatre," Stoklos has defined her performance work as "essential theatre," as "that which has the minimum possible of gestures, movements, words, wardrobe, scenery and accessories and effects. And which contains the maximum power of drama in itself" (5).[5] Indeed, her theatre presents a kind of "baroque minimalism" that, in its patterns of gestural containment and expansion, serves to synthesize and critique the contradictions of applying parameters of first world late capitalism to transmit what she calls the "Brazilian tragedy" (5). She elaborates on this tragedy, linking Brazil's plight to emblems of international disaster: "The daily Cambodias at the Brazilian hospitals.

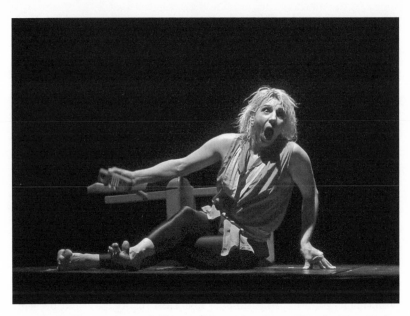

5. Denise Stoklos receives a telephone call from Mary Stuart. Photo by Diana Taylor.

Chernobyls running from the slums, in the trains of the Central Station. Heroism leaving sword and cloak, and jumping to the headlines . . ." (12).

When Stoklos describes her theatrical task, she declares, "I want to retake the tie, the knot, the manufacturing of my Brazilianism out from within the ragged fabric of the first world, so repressed, so disastrously depressive, dead before the atomic bomb" (10). In this way, she strives to present corporeal expression that communicates her joy for optimism even within dramatic situations that she sees as clearly dystopian— past, present, or pending social catastrophes defined by those first world parameters she considers "repressive, depressive, dead." Despite these proclamations, the repertoire of her essential theatre reveals an optimistic humanism that is international in conception. Indeed, many of her plays were first developed within the nurturing space of New York's La Mama Theatre.

As an actor, Stoklos juggles realism with transformative optimism through corporeal expression, an option for the utopian "gestus" which she feels is the base of an actor's credibility, generator and key to theatrical communication. As she comments, "to believe in the actor as the source of theatricality in itself is the Utopian force, the humanism, the existentialism, the semiology of drama" (8). Performing historical specificity and theatricalizing utopian ideals—ambitious goals for theatrical communication. How does Stoklos go about achieving these goals? She

sets up shifting coordinates of history/utopia by plugging into and playing against hysteria, individual and collective. Stoklos has a paradoxical performance style by which she constructs an "as if" space of utopia on stage precisely by historicizing the hysterical subject.

Briefly, it works this way. Stoklos plays up the notion that theatre is a utopian act of communication.[6] From the moment of her stage entrance, she directly engages her audience, usually by some vaudevillian stage business, perhaps reminiscent of Jimmy Durante or Groucho Marx for North American viewers.[7] She then begins to present us with a series of characters and situations. They may be historical (such as Thoreau), collective and anonymous (the crowd that watches Mary Stuart's execution), or Stoklos presenting Stoklos as Stoklos watches/reflects and acts on the situation she has created on stage. Whatever the role she assumes, she always makes the fact of her relationship with her audience visible. She makes it clear to us that she is "trying on" characters much in the manner that she dons and doffs hats (a characteristic gesture). In effect, she is performing mini-rehearsals for utopia in her convocations toward social transformation, and the interweaving of these mini-rehearsals constitutes what would be plot and message in her plays.

Textually, that is, read or seen with emphasis on textual significance, her plays can suggest a nostalgic, if comical, yearning of the solitary performer for community. Stoklos's vocal dexterity is characterized by the machine-gun rapidity with which she spouts utopian statements, lists of historical facts, and sound-biting political observations, confesses humorous tidbits, quotes from historical and literary dissidents, performs histrionic inversions of philosophical polemics, and entertains with hilarious readings from seemingly incongruous texts. Indeed, if emphasis is put on text, the reader/spectator can become a voyeuristic witness to a performer on the verge of hysterical paralysis.

No doubt about it, her verbal utterances, in themselves, are often over the top. However, Denise Stoklos's controlled virtuosity as a performer wrestling with hyperbolic text is indisputable, and much of the originality and impact of her performance technique comes precisely from her tight control and manipulation of the hysteric edge. Stoklos plays the fringes of hysteria as a mode of empowering theatrical communication, "acting out" what we commonly think of as some of the symptoms of hysteria: histrionic behavior, vocal paroxysms, and exaggerated gestures. However, the disjuncture between language and gestus that characterizes her performance style is powerfully disciplined, a theatrical tension used to polyvalent advantage. She can be hysterically funny. She also cautions us about the real and potential hysteria of a world, and individuals, driven

mad by repression, oppression, alienation, and hunger. In this sense, her performances are cautionary tales in which her vocal and gestural skirmishes with hysteria are grounded by historical reference.

This historical grounding, in turn, serves to invest her utopian invocations with authority. Juggling the hysterical with the historical has paradoxical effects. It allows her audience distance from the shrill, improbable, and even absurd nature of some of her utopian pronouncements. This distancing also allows us an emotional space, a will to believe. In this respect, it is important to see Stoklos's work in a context of continuity, or contiguity, with the Brazilian political theatre of the 1960s and 1970s, a movement whose various theatrical forms of social critique were brutally truncated by the military dictatorship.[8]

Thus, for those of us of her generation or older, Stoklos reclaims a space of hope and invites us to share dreams of transformation that we might have cast away. For younger audiences, she instills a sense of possibilities, making the political available as language, and as a way of feeling for a younger generation that grew up in a political culture that did its best to stifle or distort historical memory. Stoklos has a tremendous following among post-dictatorship Brazilian youth, and these younger viewers are distinctly aware that she is addressing them directly, that, in a way, she is reclaiming history for them.

As a friend of mine commented upon leaving the theatre after seeing *Des-Medéia* in Rio in 1996—a performance in which Stoklos unconditionally condemned Fernando Henrique Cardoso's neoliberal policies as a dressed-up version of the same old capitulations to economic dependency: "I dunno . . . Hilarious . . . but . . . I'm sort of uncomfortable with the hysteria of a revolution that never took place." Then she reflected, "But she's putting Brazilian history on stage, telling things that the younger audience hasn't seen and doesn't know. And they're listening."

.

My main intention in this essay regarding hysteria is to show how Stoklos manipulates it in the name of historicity. *Historicity*, as I use the term here, is not primarily a question of historical fact or event, but rather the larger process of perception, interpretation, and representation of historical movement and moment. *Historicity* also implies a sense of locale, the place from which we seek identity, and how we seek it. In theatre, it implies the task of finding the image(s) that impact on the histrionic sensibility of the spectator, thus tapping into a sense of connectedness with events represented on stage.

Stoklos's performative dialogue with hysteria goes much beyond the

illustrative, the symptomatic. Her mode of performing divided subjectivities and the complexity she achieves by playing language off, against, or with gesturality are suggestive of psychoanalytic understandings of hysteria, while they also challenge such readings. In other word, she *performs*, or stages, hysteria in a nuanced way in which "acting out" is part of a structural strategy. It is the performative structural analogy to hysteria, I will argue, that gives the most density to her performance in terms of her play with the hysterical.[9] The brief points I wish to make about the structure of hysteria follow Slavoj Žižek's understanding of it, particularly as he tries to puzzle out the relationship between hysteria and history.[10]

The first thing to note is that for Žižek, following Lacan, hysteria is constitutive of being-of-language, the marker ("leftover") of differential between imaginary and symbolic identifications. As a simple statement, this points to "contradiction as an integral condition of every identity" (6). This has to do with point of view in conjunction with place (locale and power) of enunciation. Taking this from the position of the subject and the other, imaginary identification starts from what we would like to be, "identification with the image in which we appear likeable to ourselves" (106). Symbolic identification is "from the very place *from where* we are being observed, *from where* we look at ourselves so that we appear to ourselves likeable, worthy of love" (105).

This interplay of identifications determines how we integrate ourselves into our social roles. However, even in ordinary social interactions Žižek identifies a gap between how we are seen and how we might wish to be seen, a gap that could be expressed as a kind of comical second-guessing that the subject does about the object of desire. For example, a lover tries to figure out what the loved one *really* wants from her/him in order to fulfill this demand. The lover tries to discover what the loved one "lacks" in order to fulfill this lack, to be essential to the other. But this is the catch-22 of desire, that it leads to the attempt to decipher the inaccessible desire of the other—a gap of language and being that constitutes what we might call "normal" hysteria.[11]

So what is hysteria in its non-normal, or exaggerated, pathological form? This goes back to the location and problem of the gaze in the gap that exists between imaginary and symbolic identification. According to Žižek, finding a point of view from which we appear likeable to ourselves is not a simple operation for the hysteric. As he comments, "imaginary identification is always identification *on behalf of a certain gaze in the Other*." Identifying this "certain" gaze is crucial: "Which *gaze* is considered when the subject identifies himself with a certain image?

This gap between the way I see myself and the point from which I am being observed to appear likeable to myself is crucial for grasping hysteria . . ." (106).

Stoklos plays with such ideas as normal hysteria and the concept of hysteria as structured by a repeated failure of interpellation, strategizing the nature and shape of the gap, and positioning Žižek's "gaze" to suit her theatrical purposes. First of all, she exaggerates linguistic hysteria in conjunction with corporeal expression. But how does her display of vocal hysterical symptoms—stuttering, variation and repetition, growling—work to her performative advantage beyond spoofing the fundamental hysteria, or normal contradictions, of the speaking subject? As intermediary to the stories she relates to her audience, she constantly and rapidly shifts from the position of a neutral (putatively nonhysterical) narrator, that is from the position of a "normal" person commenting on extraordinary events, to a position of wonderment (or horror) at the self she is presenting to her public.

This posture shifting allows Stoklos to position herself as subject-interlocutor to the problems she theatrically investigates. This duality permits her, in turn, to act as referent to the event, where Stoklos the performer can playfully and ironically point to herself as a kind of "everywoman" spectator—that particular individual who wiggles her toes, repeating "O, meu Deus" (Oh, my God) as she bears witness to the spectacle of history.[12] In effect, the structure of Stoklos's performance is a reformulation of the structure of hysteria that replaces history with History. One of the precepts of theories on hysteria is that the hysteric feels her/himself to have no history, or at least no integrated personal history that can be a basis for dealing with the demands made on her/him. This feeling of lack of history is what prompts the hysteric's question—"Why am I what you're telling me that I am?" In Stoklos's work this question becomes historically contextualized as the performer continually reinserts herself into the crossed identifications of the historical dilemmas she presents.

As Stoklos intensifies these divided selves of the performer, she heightens the specular sense of hysteria in a way that links personal (subjective) hysteria, or its potential, to the element of hysteria intrinsic to performance. The process of the making-visible-of-self, the specular sine qua non of performance, in itself indicates a basic dynamic of hysterical structure following Žižek: the play between the gaze and the gap that resists interpellation, even as the performer works to seduce the public. Stoklos is hilarious in her spoofs of compulsive acting out, and in her performed and commented on humiliations and fears precisely because she, as performer, knows how to locate their source, although it's part of her performance to just as often pretend otherwise.

A scene from the prologue to *Mary Stuart* that presents the two queens (Elizabeth I and Mary Stuart) illustrates how Stoklos plays with the hysterical. The performer oscillates between manifesting the temperaments of the two queens and then, as performer, comments on the performance of this oscillation. Almost at the beginning of a text that consists almost exclusively of stage directions to the actress, Stoklos directs that Elizabeth should be described as a strong personality "with a vocation for leadership and politics and an explosive temperament" (8).

Stoklos directs that "the words are sometimes whispered, sometimes stuttered, shouted and even simply and colloquially articulated." She proceeds to mark the disjuncture between body and language: "There are moments in which the posture of the body doesn't seem to correspond to what is trying to get expressed." This is when the performer intervenes to try to bodily rectify the expressive situation, but gives in to the feigned impossibility of representation. As always in her stage directions, Stoklos is explicit in her kinetic descriptions:

> The actress then stops talking, trying to correct her occupation of space: she goes from one corner of the stage to the other, trying on different positions, she stands up erect, aligning her ankle bones in exact parallel, but cedes to the impossibility of finding a corporeal position that completely satisfies the search for expressive exactitude: she brusquely lets her spinal column collapse, and, in a curved position, takes the text up again. But there's no way to rectify the expressive dilemma—the text is now declaimed with the vertebrae trying to resist, one by one, with force, but still ceding, as gravity pulls it [the body and text] towards the ground. (8–9)

From this jerking position, the performer observes the alternations of Elizabeth's temperament, and when she (the performer) demonstrates Elizabeth's constant anger (*ira*), Stoklos directs the performer to "hold on to the scream that is contained in the vowel 'I' ('*iiiiira*'), elongating it and transforming the vowel into the very expression of flagrant anger." The performer is then directed to reestablish complicity with her public. She is to redeem her (the performer's) "interpretative excess," which she confesses is a "truly hysterical gestural and vocal exaggeration of lived anger," by confiding that the lack of control is really the queen's, not hers (the performer's).

This technique of performative oscillation, a constant in Stoklos's performances, is essential to setting up the game of staging potency/impotency in a way that situates her as citizen and performer. It also signals that a conundrum of impossible interpellation translates on Stoklos's stage as a replay of (or play with) a historical power imbalance, where the disenfranchised subject tries to uncover the lack of the Other in order

to please it, while at the same time attempts an impossible imitation of the "big Other." In other words, it's impossible for Brazil to be the United States and mostly ridiculous to try to imitate the first world in the terms in which the first world performs its own identity. As Stoklos succinctly puts it, "We have to do something better in this web of a universe, because the 'First World' is rotten, fallen, there's nothing left there" (interview with Leslie Damasceno, 2000).

.

Stoklos uses the hysterical to propose a perspective of hope toward historical change in two very different performance pieces: *Denise Stoklos in Mary Stuart* and *500 Years: A Fax from Denise Stoklos to Christopher Columbus. Mary Stuart* is an astonishing tour de force, a play of compact imagery. Playing both Mary Stuart and her cousin Elizabeth, Stoklos manages to weave metaphors of power and feminism, propitiously linked at strategic moments to authoritarianism in Brazil. A consummate mime, Stoklos uses a gestural abstraction that is exquisitely referential to Brazilian linguistic and gestural codes but in no way limited by these references.

Theatrical space is minimalist, with only one wooden chair as prop. In one sense, this chair represents a specified historical moment and locale, signifying both the distance and contiguity of the Elizabethan court and Mary in the Tower. But it is also the communal space from which Stoklos constructs her major personages and marks their respective isolations. Mary and Elizabeth engage in a power struggle for that chair. When Stoklos invokes the presence of the crowd assembled for Mary Stuart's execution, the chair signifies the common ground of public spectacle. It is also the site from which Stoklos, as engaged but anxious spectator, puts it all together.

Stoklos strides into the stage space in tights and a tunic and circles the stage twice, all the while looking directly at the audience. In the long prologue, Stoklos compresses an abbreviated narration of Mary Stuart's story and presentation of characters (Elizabeth and Mary) into an intentionally verbally and corporeally disjointed discussion of both the necessity and enormity (read impossibility) of actually staging such a history. The "play" (or second scene) starts with Mary in prison, an enclosure traced out as Stoklos anxiously explores its parameters in conventional enough pantomimic language. However, locales shift with a flick of a finger (a raised digit that signals Elizabeth's authority), or a smoothed "bustle" that signifies her court. At times Stoklos plays against herself, as the words of one queen respond to the body language of the other. Temporal/cultural

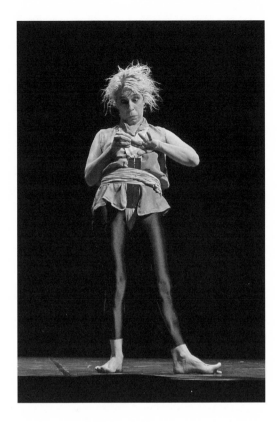

6. Denise Stoklos as Elizabeth I in *Mary Stuart*. Photo by Lorie Novak.

allusion is expanded, as references to modern technology foreground the struggle between the women. For instance, Mary telephones Elizabeth from her cell (an anachronism), complaining about the conditions of her imprisonment, and pleading with Elizabeth to answer her letters. (It is historical fact that Mary wrote Elizabeth numerous such letters, and Stoklos actually quotes from them.)

The drama/comedy is not restricted to the women's struggle. Stoklos also portrays the Elizabethan cultural body and suggests the excitement of an Elizabethan crowd stuffing sausages into their mouths in hungry anticipation of Mary's execution; the toes of one of Stoklos's feet chase each other up and down the calf of her other leg in a display of fervent excitement. Mary's execution is signified by the final spot that falls on Stoklos, now thoroughly Mary Queen of Scots. It's as if an immobile Stoklos, without bodily inflection, lends her corporeal space for a solitary Mary to register her death. And yet, the frozen wide-eyed expression of her face, lips forming a large red square framing teeth set tightly on edge confronts the audience with a polyvalent mask that suggests, at the same time and without movement, terror, amazement, paralysis, fascination,

and questioning. It's a facial ambiguity that provokes a moment of historical freeze-framing (Mary's terror, the crowd's fascination) while suggesting continuity and historical analogy (Stoklos's/the mask's unspoken questions regarding the injustices of present historical reality—how do we respond?). This is the penultimate scene of the play. Although Stoklos stages a kind of epilogue in which the performer loosens the noose from around her neck, declaring herself free, I believe that the penultimate image of Mary's execution provides the more powerful final imagistic impact on the audience.

Throughout the play, historical time is telescoped as references to Elizabethan history bring up mention of contemporary figures such as Mandela, Meinhoff, and Vladimir Herzog.[13] Stoklos's bodily contortions add image and shape to verbal reference. She expands, and then conflates, her concept of historicity—its sense and feeling—in *Mary Stuart*. Speaking of the tragic aspect of the play in a 1991 interview with María Teresa Alvarado, she affirms:

> [*Mary Stuart*] is a tragedy about power between two women in an extremely important moment in history . . . It's about the potentiality of Mary Stuart's power, disabled [*condenada*] by her sentimentalism and passion, confronted by a Queen Elizabeth [who is] objective, and has tremendous physical strength. [Mere] potentiality of power is always destructive. It's a metaphor for the Latin American situation: our future, part free, part imprisoned by political motives. We are violated, fecundated by the First World, seduced . . . (my translation)

Now, these metaphorical oppositions that present a feminized Latin America have long been a central convention of Latin American theatre and literature. And, especially since the surge of feminist literary and cultural criticism of the 1980s, the problematization of such feminized imagery—whether it has served to portray exploitation, violation, or glorification of nationhood—has become a critical source for the reexamination of Latin American political and cultural history.[14]

Stoklos's brief metaphorical interpretation of a feminized Latin America is made more complex by two points integral to my interpretation of how her performance plays with the structuration of hysteria: a) the fact that she has chosen to perform, as metaphor, a tragedy in which both protagonist and antagonist are women; and b) her ambiguous statement that "the [mere] potentiality of power is always destructive . . ."

If we think of hysteria as structured by the repeated failure to interpellate identification, then Stoklos's performance in *Mary Stuart* plays with the failure of interpellation in three interconnected, but often seemingly

contradictory, ways: she de-genders but sexualizes the notion of hysteria; she ontologizes hysteria by inflating the specular sense of it; and, ultimately, she historicizes hysteria, pointedly locating the hysterical subject in history with a perspective toward agency.

First of all, choosing as analogy to the present a historical moment in which the major players are women already suggests a counter-patriarchal reading of history. But even though Stoklos makes the point of staging "a tragedy about power between two women in an extremely important moment in history," *Mary Stuart* might still suggest the stereotypical binomial equation: powerless but passionate (feminine) Mary (Latin America) remains imprisoned, if not murdered, by oppressive rational (masculine) Elizabeth. How does Stoklos problematize that possible equation? In part because, as performed by Stoklos, Mary is condemned by her sentimentalism and passion not because these characteristics signify a conflict of identity in gender and/or sexual terms, but primarily because they coincide with historical fact. Elizabeth's claim to Henry's crown was stronger, and she remained unswerving in her determination to maintain her advantage. Mary's potential claim was doomed because, among other things, her heart led her to choose alliances that proved disastrous. But more importantly, the skewering of categories of hysteria is accomplished by acknowledging a third major player, the performer (as played by Stoklos), who hystericizes both queens at advantageous moments, while historicizing the hysterical subject (the performer). In a sense, this performer works the gap that Žižek describes, as she simultaneously resists interpellation and demands recognition. As performer and clown, this intermediary figure continually recasts the problem of potentiality, a problem that is intricately bound with the structure of hysteria and spectacle.

The power struggle between the two queens as mediated by a performer who intermittently professes her own lack of power to interpret such a struggle both recalls and displaces psychoanalytic notions that the conflict between masculine and feminine identification is the constitutive conflict of hysteria, and that hysterical physical symptoms are conversions of psychic conflict. But the question of who wins identification with the father-as-power (Henry) is not the point of Stoklos's *Mary Stuart*.[15] In fact, Henry's absence/presence is mostly ignored in the performance, which in itself helps to disqualify the patriarchal as the focus of identification. Symbolic identification is not unidirectional; rather it is represented as a shifting triangulated movement among the major players (Mary, Elizabeth, Stoklos/performer). In this triangulated movement, the tragic spiral of potentiality is constantly recast as shift-

ing positions that finally converge in an intentionally de-gendered ambiguity that restores agency—at least on stage and in a manner that implies extension beyond the footlights.

There is a gender ambivalence in Stoklos's performance that points to an intriguingly conceptualized play between the psychoanalytic and the historical. In a more vertical reading of power struggles, it's possible to see Stoklos's performative hysteria as in line with Cixous's and Clément's argument about the "hysteric as a threshold figure for women's liberation and as a form of resistance to patriarchy" (qtd. in Ragland-Sullivan 165).[16] However, in a certain sense and in all of her pieces, Stoklos performs androgyny (an ambiguity that, in turn, hints at hysterical possibilities).[17] She often plays off gender stereotypes and talks about sex, but when hysteria is performed as an engendered, embodied battle between the masculine and the feminine, it is because she—in character or as performer—wants to manifest as a split self in order to comment on that split.

In brief, it seems that Stoklos wishes to keep the vitality of sexuality alive in performance without reproducing gender distinctions. This movement between gender and sex (or sensuality) relates to historical analogy in *Mary Stuart*. Near the beginning of the play where Stoklos directs that Elizabeth should be described as a strong personality "with a vocation for leadership and politics and an explosive temperament" (8), the performer then matter-of-factly comments on Elizabeth's sexual voracity and disdain for her suitors before she segues into a description/embodiment of Mary's charms. She makes crude sexual remarks about what Mary's suitors really want from her. But she immediately excuses this lapse from historical narrative rectitude by explaining that this urge toward bestial silliness (*avacalhação*) "comes from the depths of her Brazilian soul, a national desire to make fun of or mock (*esculhambar*) everything" (16).

Here, the technique of performative oscillation sets up the game of staging potency/impotency in a sensualized but gender-minimized manner. What does this have to do with the power play between Brazil and the first world (remembering Stoklos's intention "to retake the tie, the knot, the manufacturing of my Brazilianism out from within the ragged fabric of the first world")? Or, how does Stoklos "sensualize" history to restore the possibility of potency? Although Stoklos mentions that Elizabeth is also, at times, tender in her affections, her sexuality is mainly characterized as raw power. This is suggestive of the rigidity of power (oppression and repression) of empires before they crash. On the other hand, Mary's sexuality is cast in terms of the flexibility of sensuality. One of Stoklos's frequent messages is that sexual sensuality will eventually prove to be

more powerful than a raw display of power—that, in terms of emotional expressivity collectively galvanized, Brazil's, and Latin America's, ability to express unrepressed sensuality shows the way to a global community constructed on love and communication, rather than on hierarchical repression. But, then again, Stoklos characteristically pokes fun at such proclamations even as she makes them, claiming irony—in its capacity to see oneself in a situation and make fun of self and situation—as a complementary national trait and strength. This is a thematic contrast that we see, in one way or another, in all of Stoklos's plays.

This precarious performative tension between the sexualized subject/object and historical agency works because Stoklos, as performer, displaces the locus of hysteria from the gendered to the ontological in a way that counterbalances what, as briefly described above, might seem an over-highlighted sexuality. Paradoxically, this is done by inflating the specular sense of hysteria in a way that performs a very comic exaggeration of the Lacanian notion of the fundamental hysteria of the speaking subject.

Stoklos inflates, strategically exaggerates, and identifies by verbal or gestural pointing. It's a deictic function that characterizes all of her work. The deictic function of Stoklos's intentionally performed ambiguity with identification and power in *Mary Stuart* (with whatever or whomever has it) is to *point* to the historical and social consequences of abuse of power. The deictic is the expressive mode that dominates in *Mary Stuart*: Stoklos is constantly verbally and gesturally "pointing at" connections between events, places, and positions. Indeed, her historical analogy is encapsulated in the adverbial pointing to connections in the brief telephone call Mary tries to complete to Elizabeth, an epigraph to this essay.

"Hello, are you calling from there?"
"No, not from there, Scotland. From here, Brazil."

As I've commented, the slippage between who is placing the call—the operator? Mary Stuart? Denise Stoklos?—indicates a crossed line in international connections, in which Brazil is equated with a colonized and embattled Scotland in an unequal struggle for power. It's the deictic that repositions the hysteric as a historical subject as well.

However, there is a more precise moment of historical analogy that Stoklos is flagging, or pointing to, in *Mary Stuart*. 1985 marks the moment of "official redemocratization" in Brazil, the "New Republic," the official end of the dictatorship, a paradoxical return to representative government without public access to the vote. Citizens had no direct vote; the president was elected by congressional vote. In a series of short scenes

toward the end of *Mary Stuart* titled "Wash your feet," "Wash your arms," and "Wash your hands," Stoklos sums up her skepticism regarding the new government's intentions to empower the Brazilian people: "And they wash their hands in the soap of the Brazilian lack of memory" (65). It is clear that Stoklos wishes to underline the precarious state of Brazil's still potential civil autonomy.

Again, this brings to mind Stoklos's ambiguous statement that "the [mere] potentiality of power is always destructive." The potentiality of power is always destructive, following Stoklos's metaphor, because as long as power is stifled in its realization, signifying an uncompleted identity, it is vulnerable to repetition of the circumstances of its own unfulfillment. It is also destructive in that, as a potentiality, it leaves the subject in a permanent state of indecision or postponed agency. Stoklos's call to alarm in *Mary Stuart*, in Benjaminian terms, seeks to bring the significant and recent past to us in an analogy that uses the many artifices of performed hysteria to let us know that Brazil's interpellation into the global system still remains uncertain, very much in the terms of the hysteria-impotence stasis that Glauber Rocha allegorized in 1965.

In her 1992 production *500 Years: A Fax from Denise Stoklos to Christopher Columbus*, Stoklos employs the same performative strategies to tease out and explicate the contradictions between imaginary and symbolic identification. However, *Fax* is not posed as historical analogy, but rather as a direct confrontation with history-as-knowledge. Accordingly, the hysterical conflict she interprets is that between truth and knowledge.

.

One of the common strategies of Stoklos's work is an irreverent play with the rhetoric of public knowledge. At some point in all her plays Stoklos directly engages her audience in the act of reading or recitation. This hallmark stage business is intended to be simultaneously serious and funny. These public "lectures" are different in intent and tone from her corresponding signature device of quoting historical people, although both devices are often used to contrapuntal effect. Stoklos quotes from historical figures whom she respects. She often exalts them as she quotes, standing tall, sweeping their words out to the world, to the sky, with her arms. Like Thoreau and Paulo Freire, as she portrays them in *Civil Disobedience*, they are people whose integrity and visions of the future are to be emulated.

Her "lectures," on the other hand, are generally delivered with much vocal pyrotechnics, facial mugging, and gesticulation, to hilarious effect.

7. Denise Stoklos portrays Thoreau, pointing towards the future in *Civil Disobedience*. Photo by Denis Leão.

But they are also serious: exaggeration can augment or diminish the value given to received knowledge and culture. If she gives an outrageously exaggerated reading from Gertrude Stein, we howl with laughter, but we also gain a fine appreciation for her prose.[18] On the other side, Stoklos often deflates official history and epistemological systems, interrupting and commenting on her readings. Whether she is inflating or deflating knowledge, her histrionics raise serious questions about the value we give to our cultures and to the truth of written histories.

These lectures are also triangulated. The comic performer in the middle takes on the arduous task of answering the riddle of how, and where, truth is not knowledge, and vice versa. In Lacanian theory, truth is never conflated with knowledge because "truth" is structured within, and perceived from, the constitutive gap between imaginary and symbolic identification. As such, "truth" always puts knowledge into question. It is a conundrum of being-of-language. In the case of the hysteric, the hysteric's insistent questions amplify the disjuncture. As Gérard Wajeman condenses it, "while knowledge cannot articulate the hysteric, the hysteric ushers the articulation of knowledge" (12).[19]

In *500 Years: A Fax from Denise Stoklos to Christopher Columbus*, Stoklos works to reorganize the categories of knowledge and truth from the personal to the public. The work is one long rant about historical

"truth." Perhaps the most discursive of Stoklos's plays in the sense that its text is a discourse directly delivered to Columbus (and his inheritors in exploitation), *Fax* gives voice to a counter-reading of the celebration of the discovery of the Americas. Textually, it is structured as a "lecture" in a double sense: Stoklos plays with readings (in the ways mentioned above), as she delivers a passionate and aggressive polemic against Columbus. Textual movement is expository: a short preface, followed by a long monologue on historical accountability that segues into a series of declamations regarding the citizen's (and artist's) responsibility toward reshaping deformative hate and passivity into transformative love. However, this textual exposition is not a smooth one, rather one interrupted by a series of chaotic scenes in which Stoklos pits modes of communication and interpretation against one another. In other words, the themes are textually expounded, but the gesturality is meta-textual.

There is also an interpenetration and compression between verbal and written text initially set up by the play's textual framing device: a *diário a bordo* (daily ship's log) becomes a fax sent in 1992. It is a temporal/historical compression perhaps best exemplified by her lexical play with the word *Columbus*. This occurs in the middle of the short preface. After rhetorically positioning Columbus's discovery in the nonrecorded history of the world (starting with the "big bang" of some 15 billion years ago), the actress disdains him as a historical dwarf, almost an accident with disastrous consequences in which the name *Colombo* (Columbus) becomes an abbreviation representative of the "multinational gang" that has taken control of America in these last 500 years. She spells it out: "*Co* de corrupção, *L* de lucro, *O* de obsessivos, *M* de manter *Bo* nós, bobos. Colombo: *C*orrupção e *L*ucro *O*bsessivos *M*antém-nos *B*obos" (6).[20] She then spits out that this is a history so common and vulgar—profit above all—that she doesn't understand how it can be spoken of for even five minutes without exacting an "urgent clamor for revolution." She shouts this several times before she "remembers" that in Latin America "we are all Hamlets"—that is, eternally dispossessed inheritors, incapable of "reordering the primitive state of law/rights." The preface ends with the question "why?" repeated three times, a paroxysm of anguish and anger.[21] The hysteric's question resoundingly prevails over the master's answers (see figure 9 in introduction).[22]

This rather constant textual rhythm and meta-textual contrapositioning is staged throughout the play. In contrast to the sparse or scattered design of props of most of her other plays, *Fax* presents a unified stage design that equates Latin America with a shipwrecked beach. Ripped but continuous netting crosses the entire stage diagonally. Stage space is lit-

tered with the flotsam of shipwreck, chests of strange design that will later disclose evidence of 500 years of civilization/barbarism.

Stoklos's presence has three registers that are interspersed and played off of one another throughout *Fax*: shipwreck victim, performer, and citizen. She first appears, gyrating underneath the netting in characteristic tights covered with a tunic of netting: a victim of shipwreck caught up in the web of history, but a victim condemned to document her situation (her fax/daily ship's log). This is a statement of relative passivity (observer/participant) complemented by her other two registers as creative performer and citizen. Creativity and citizenship are functions and effects of responsibility. A rhetorical apology for the chaotic nature of her performance made at the beginning (textual chaos signifying historical chaos) is answered by a moment near the end of the play when Stoklos conflates her artistic and ethical responsibilities: "I wanted to make this performance exactly this way: reflective. From text. I could be doing a performance about any other thing. But I chose to manifest myself explicitly as a Brazilian citizen, I refused to retreat from the fierce fight of this moment" (42–43).

But what does this moment signify? And why such urgency? Obviously, it is referential to the hoopla of the Columbus quincentennial. But it is also explicitly referential to a crisis between government and citizenship that was rocking Brazil, provoking the contextual immediacy of *Fax*. In 1989, after twenty-one years of official military dictatorship, and after the beginning of the Nova República of 1985 (captained by a president elected by representative vote), Fernando Collor de Mello became the first president since 1961 to be elected by direct popular vote. Soon after assuming the presidency in 1990, Collor was linked to a series of outrageous scams and economic frauds (outrageous even for our times), a scandal marked by questionable deaths of key persons. As Stoklos developed and performed *Fax*, her protest resonated with the multitude of public protests that inexorably led to Collor's impeachment in December of 1992.[23]

Among other things, this crisis underscored fundamental contradictions between the power of mass media and the exercise of citizenship. Collor was a media candidate: a handsome, articulate politician, unequivocally backed by the media conglomerates. In a tirade against Collor and media politics, Stoklos alternately strides and races around the edges of large circles of light made by spots, denouncing the deformative cyclicity of the citizen's seduction by the media and complicity with media politics. At one point in this physical frenzy representing the dumbing down of a regressive civilization, Stoklos begins to reverse the process,

gesturally and textually. She has grabbed a tattered sack of manioc flour—up until that moment just another unidentified scenic element of detritus. Tossing flour up into the air as she circles, she marks the stage with footprints as it floats down, imprinting a declaration of historical reversal: the flour—symbol of a diet of deprivation—is, as she declares and demonstrates, "thrown on high like confetti to celebrate a new era in which unprocessed flour is NOT the only daily bread" (35).[24]

The fierce and overt acting out and manic reappropriation of clichés and stereotypes that marks the play throughout is leavened by a meta-textual inquiry that extends itself to the scenery and illumination. The particular urgency of Stoklos's rage against the abuse of communications systems is interwoven with an insistence on ripping truth from the written word. At one point, she actually rips pages out of books. As in all of her plays after *Mary Stuart*, books are important, but perhaps even more so in *Fax*. Books can tell the truth as well as lie. You have to know how, and in which position, to read them. It's quite literally about epistemological positioning.

In *Fax*, playing the hysteric is playing out positionalities regarding knowledge and truth. According to Wajeman, the hysteric's injunction—"Tell me!"—pushes the limits of knowledge, since her demand is ambiguous: on the one hand her injunction produces some answer (knowledge), but "on the other hand, her solicitation pushes knowledge to its limits, demonstrating that knowledge does not coincide with the truth that it supposedly expresses" (15). Inasmuch as the hysteric remains a hysteric, however, this is a dead-end game. The hysteric may have the power to banalize or question knowledge, but has commandeered no personal identity—integration of the imaginary and symbolic—from which to do more than pose her/his history as a continual riddle. Again, this is an exaggeration of an ontological unanswerability that has to do with acknowledgment of personal history, in which the category of truth is ever experienced as shifting subjectivity.

Stoklos theatrically transposes the personal to the body politic as she literally repositions herself corporeally with history in *Fax*. In its conflict with knowledge, "truth" becomes History as experienced. That is, the hysteric's riddle is still posed, but paradoxically de-hystericized in its demand for empowerment vis-à-vis knowledge.

Towards the beginning of the play, Stoklos the shipwreck victim/actress/citizen opens a chest that resembles a time capsule. Energetically extracting books, she gives an enraged recital of the horrors of colonization, connecting Indian massacres to Tiananmen Square, transposing locales and epochs. Some of the books are official histories, which she

reads against the grain, slamming them down on the stage in disgust. She then slides across the stage, using the books as slippers, chanting "burn, burn, burn." Other books, such as those written by Eduardo Galeano, are reverentially guarded as testaments.

Having alternated between frontal declamation and circular movement in a fixed circle of light, Stoklos suddenly crouches down, refusing to read further. A quick shift of illumination to backlighting projects a gossamer quality to her hair and clothing that evokes a fully formed fetus awaiting birth. Backlighting transforms into numerous and uneven spots that pepper the stage, Stoklos, and her books—fragmentation and contiguity.

Stoklos positions history upside down (or right side up) in a sequence in which she stretches out on her back, head to the audience, and pulls up her legs to support a large book which she opens to pictures of the destruction of a Polish city in World War II. As she shares this image, she chases a fly with one hand, crushes it in the book, which she slams shut, reopens the book, picks out the fly, and eats it. This is a gestural defiance of an old Portuguese proverb: *Em boca fechada não entra mosca* (No flies enter a closed mouth). For her it is transformative resistance: she will keep talking, ingesting, and digesting flies (hate) until hate becomes love.

In our final image of the play, the discursive repetitions and histrionic ending of *Fax* are both restrained and organized by the permanence of the stage set. An appeal to cliché/counter-cliché provides the tone for the play's ending. After a punctuating numerical reversal—500 represents the statistical 500 grams of meat that is consumed by the average poor Brazilian family yearly—she bellows out the abbreviated essence of her counter-communication/fax: "Enough! (LOUD MUSIC). I said 500 times enough!" (35). Stoklos's counterproposal relies, somewhat frenetically, on an ambiguously problematized characterization of the Latin American/Brazilian soul as passionate and musical. Speaking of the importance of lovemaking to the Latin, she proposes a radicalization of love: "Then, if this is our way out, perhaps naïve, but let it be a restored way out. Let it be radicalized as a sign, installing itself as integral energy, indispensable and intense, this passion that we inherited from the primitive presence of Africa in our countries, and that saves us" (42). This scene climaxes with Nina Simone singing "I loves you Porgy," thus linking the Americas through African heritage. This scene culminates as Stoklos "signs" her fax with music: Elis Regina singing Violeta Parra's "Gracias a la vida." Thanking the life that brings with it the possibility of transformation, she argues the need to speak without fear.

Although she concludes her performance by declaring "the doors

of the theatre are open for those who want to abandon this ship in flames" (Taylor 12), it's clear that she indites the historical present as a means of enjoining those who would stay to fight for a better future. The pervasiveness of netting the full stage may be metaphoric of a Latin America trapped in historical determination, and of a Brazil seduced, shipwrecked, and abandoned at the very moment of its first bid for direct democratic process. But this stage design can also be read as referential to continental solidarity and resistance precisely by its disparity from the professed minimalism of Stoklos's "essential theatre."[25]

.

I would like to return now to the idea of utopia, which, in itself, recalls hysteria inasmuch as it (utopia) represents an unattainable state, a potential but inherently deferred identity. One could argue that performing hysteria makes for problems with interpreting history. However, as performer, I don't believe it's necessary that Stoklos actually solve the problem of whether hysteria is psychological or historical, but that she perform the ambiguities that she raises in such a way that the audience becomes engaged in historical thinking. Stoklos's historicized hysterical subject, the performer as intermediary, engages us with her very serious arguments. As we laugh at the performer's compulsive repetitive insistence on historical recognition, we also cheer her dramatized moments of triumph.

However, in the process of writing this essay, I've come to recast Stoklos's definition of herself as a utopian optimist from a slightly different angle. It's not that I quarrel with that definition. But after some thirteen years of accompanying her work, and puzzling it out in the terms of playing with the hysterical-historical as I've done here, I've come to see the self she exhibits in performance in a somewhat different light. To indirectly borrow a phrase of Cornel West's, I've come to view Stoklos in performance not so much as an optimist, but as a "prisoner of hope."[26]

This distinction describes the particular tensions that Stoklos sets up. Is it by design that her plays scenically and thematically deal with incarceration and liberation?[27] Certainly the tense freeze-frame final images of most of her plays also remit to peril held at bay, suspended by will and hope. And whether our final view of her taut immobilized body with its facial contortions is nuanced by soft verbal appeal or countermanded by intense proclamation, the effect is essentially the same. Each of these endings is a frozen moment, an imagistic conflation that projects a utopia of immediacy in which body and voice are intimately connected. It is a stage moment, a fantasy moment, a performed possibility of the voice of a historical collective body. An "as if" moment that asks us to join her play

for utopia. Play, in the double sense of her ludic rehearsal for utopia, and her bid to reclaim it. And reclaiming utopia can be a powerful strategy for a prisoner of hope.

Notes

1. A key manifesto of Brazilian *cinema novo*, and for Latin American cinema of the 1960s and 1970s, "A estética da fome"—perhaps more forcefully translated as "The Aesthetics of Hunger"—was first delivered by Glauber Rocha as a short speech at a retrospective of Latin American cinema in Genoa, Italy in 1965. Condemning both the Brazilian artist for whom misery becomes "the formal exoticism that vulgarizes social problems" as well as the "European observer [for whom] the process of artistic creation in the underdeveloped world is of interest only in so far as it satisfies his nostalgia for primitivism," Rocha argues that the economic and political conditioning of colonialism (and neocolonialism) has led to a multifaceted hunger constitutive of a "culture of hunger." And he states: "The most noble cultural manifestation of hunger is violence." This violence is not engendered by hatred, however, but linked to love: "The love that this violence encompasses is as brutal as violence itself, because it is not the kind of love which derives from complacency or contemplation, but rather a love of action and transformation" (70).

Clearly, the political-philosophical and imagistic complexity of his films, shot through by contrapuntal images of impotence and hysteria, testify to the transformative dreams and disillusionments of the 1960s. However, the social and cultural circumstances Rocha decries still exist, modified by different "conditionings." And the incipient paralysis of sterility/hysteria is still an undercurrent of aesthetic innovation, as argued here in the context of Stoklos's work.

2. Loosely translated:

NINTH SCENE: A TELEPHONE CALL
"Hello, are you calling from there?"
"No, not from there, Scotland. From here, Brazil."

This is the entire text, or dialogue/stage directions, of the Ninth Scene from the published version of *Denise Stoklos in Mary Stuart* (58). In performance, this is the cue for a tragicomic telephone interchange between Mary Stuart and Elizabeth.

3. Unless otherwise noted, all translations of play titles and quotes are mine.

4. As a reading of history, the utopian imaginary is a rewriting of history, or in a sense, history inverted, distorted, or transformed. Put simply, the search for a utopia reveals a necessity, or anxiety, to analyze the world "such as it is," envision a better world (perhaps with a plan to implement the changes necessary to get there), as well as develop an imaginary, or ideology, that can explain and promote the necessity for a new community. Clearly, not everyone has the same idea of utopia—a fact chillingly, but fascinatingly, demonstrated in the work of German filmmaker Leni Riefenstahl.

5. Although Stoklos has had a long career, beginning in 1968, that spans co-

productions and adaptations much along the lines of her "essential theatre," *Mary Stuart* (1987), developed at La Mama, is the first production to articulate Stoklos's theories of essential theatre, as Suzy Capo Sobral mentions in her thesis chapters published in *Denise Stoklos*. Stoklos herself gives a repertory of ten plays to her essential theatre: *Circle on the Moon, Mud on the Street* (1968); *The Week* (1969); *I See the Sun* (1970); *Sea Sweet Prison* (1971); *Canned Cadillac* (adaptation, 1973); *Habeas Corpus* (coauthorship, 1986); *Denise Stoklos in Mary Stuart* (1987); *Pre-Medea* (1990); *Casa Trilogy: Lobby, Attic and Basement* (1990); *500 Years: A Fax from Denise Stoklos to Christopher Columbus* (1992); *Tomorrow Will be too Late and the Day after Doesn't Even Exist* (1994); *Des-Medéia* (1994); and *Civil Disobedience: Morning is When I am Awake and There is an Aurora in Me* (1998). She has since completed and performed internationally, *I Do, I Undo, I Redo: Louise Bourgeoise* (2000) and a homage to Gertrude Stein, *Denise Stoklos in the Calendar of Stone* (2001).

Since Stoklos, who considers herself a writer and not solely a performer, wishes to have her plays accessible to readers and still maintain control of the text, she has published most of her plays through her own editorial company, Denise Stoklos Produções Artísticas Ltda. *Mary Stuart* is unique as a "text" in that Stoklos has described it as a subtext in which she wishes to convey not text, but stage directions that describe what the actress does and feels, only indicating what she might say (interview with Leslie Damasceno, 2000). And she includes a cautionary preface to the edition: "It is recommended that this book only be read after having seen the play a first time without having previous knowledge even about what has been written about it. It is suggested, then, that the spectator return to see the play a second time. In much the same way that one would come back to see a painting, after reading the catalogue with its references about the work, the materials used, its date, title, the aesthetic to which it is attributed, etc." (5).

6. Following this argument, to which Stoklos subscribes, by virtue of its immediacy and live relationship to audience, theatrical communication necessarily alludes to a utopian impulse toward, or sense of, community, regardless of whatever nonutopian theme or image may be represented. As theatre critic Eric Bentley succinctly put it: "There is something about ceasing to be merely an *I* and becoming, in this *place*, before that *actor* part of a *we*" (57). Obviously, the question of community begs for further clarification since the idea of a community implies boundaries, issues of inclusion and exclusion. For a more recent sounding of theatre and utopian ideals, see *Utopias and Theater*, a special issue of *Theater*.

7. Although I will discuss Stoklos's connections with Brazilian "vaudevillian" traditions in another version of this essay, it should be mentioned here that Stoklos is often quite rightly seen as carrying on the pointedly hilarious histrionics of comedienne Dercy Gonçalves. At 93 and having had a long career as a revista, stage, screen, and television artist, Gonçalves mainly appears on television now, but continues to confound, entertain, and amaze audiences with her irreverent repartee.

8. Issues of political representation and representation of the political are central to analysis of Latin American theatre, but beyond the scope of this essay. Stoklos's theatre resounds with the call for social justice and political transforma-

tion that has been, and continues to be, a primary thematic characteristic of Latin American theatre. But while her convoking message may be similar, her theatrical language seems to make the message more accessible (or perhaps acceptable) to audiences unwilling, or lacking the historical knowledge, to engage with other didactic forms of Latin American theatre. And although some spectators may read her histrionic language as stereotyping the Latin American (this critique has been leveled both in Brazil and abroad), I find that the control with which she plays off that stereotype—and she does—effectively adds further metaphoric and metonymic layers to her performed anxieties. For an idea of how Stoklos's theatrical message of urgency and demand for social transformation is perceived outside of Brazil, see Diana Taylor's "ethnographic poll" on public reception of *Civil Disobedience* during its fall 1999 New York run.

9. Although Stoklos often explicitly calls attention to the "hysterical self," at moments acknowledging or spoofing performative hysterics, and cites Lacan and Freud, it's not clear to me to what extent she intentionally stages the structuration of hysteria.

10. See particularly, in his chapter, "*Che Vuoi*," the sections "Image and Gaze" and " '*Che Vuoi?*' " (105–14). Žižek's main point here is to speak of interpellation and hysteria in terms of the psychoanalytic process. Žižek's interpretation of subjectivity, repetition, and interpellation as applied to history can be seen as problematic, as Dominick LaCapra has pointed out (206–7), but the way he poses the "hysteric's questions" is helpful to understanding Stoklos in performance.

11. In Gérard Wajeman's articulation of Lacan's concept of discourse "as a specific formalization of the basic components of speech and its effects, whose effects depend on the place of enunciation," Wajeman contrasts "normal" and pathological hysteria thus: "The contradiction between hysteria as 'social link' and as clinical image vanishes however as soon as we think of it as a structure accounting not just for pathological, but rather for *normal* hysteria. Normal hysteria has no symptoms and is an essential characteristic of the speaking subject. Rather than a particular speech relation, the discourse of the hysteric exhibits the most elementary mode of speech. Drastically put: the speaking subject is hysterical as such" (11).

12. Stoklos's often manic humor plays off concepts of cultural and social pathologies. Subverting verbal instances of fragmentation by corporeal buffoonery, she stubbornly and belligerently reasserts herself in terms of a subject resisting existential alienation while subverting fragmentation: a subject whose refusal to view her corporeal self as a machine is fundamental to the exploration and communication of the sources of her circumstantial alienation. In brief, her insistence on mapping the alienating aspects of her world reveal a will to triumph through communication. In many other instances, exaggerated reactions of mime emphasize that slight exhibitionism by which those living alone amuse themselves. This exhibitionist air of "playing *at*" to an "as if" audience layers Stoklos's dialogue with the real audience. Personal idiosyncrasies become metonymically suggestive of collective yearnings.

13. Mandela, Meinhoff, and Herzog present different prison experiences, with all three indicating a stance of revolutionary marginality: Nelson Mandela in South Africa, Ulrike Meinhoff as a German terrorist, and the Brazilian journalist

Vladimir Herzog as leftist and Jewish. Both Meinhoff and Herzog died in prison, alleged suicides.

14. For example, see Doris Sommer's now classic critique on the rhetorical use of gender in elaborating concepts of nationhood, *Foundational Fictions: The National Romances of Latin America*. Also, the special volume of *Women in Performance: Holy Terrors*, which attests to the varied critical work done on Latin American theatre in terms of gender/sex analysis and in studies of Latin American women playwrights and performers.

15. Although this is my argument, it is possible to take analysis of Stoklos in performance in another direction, where the whole question of the move from gendering to sexuality could be seen as a kind of phallic gesture toward identification with the missing father. However, I think that Stoklos's particular mode of carnivalesque buffoonery allows her to *play* with this possibility rather than "acting it out."

16. Following Ragland-Sullivan's summary of Cixous and Clément on hysteria (*The Newly Born Woman*), Stoklos's corporeal ambivalence could be seen as playing out the tension between the two critical visions. To quote Ragland-Sullivan: "While Cixous argues that the 'hero' of women's writing in the twentieth century is the hysteric, Clément, insisting that the hysteric is a victim rather than a hero, maintains that women must act collectively" (165). A contrasting reading of Stoklos's corporeal images as counter-patriarchy could be made in conjunction with Mady Schutzman's discussion of how Charcot's iconographic experimentation with photography invented typologies of hysteria. Schutzman questions the symptomatology of hysteria from the point of view of its complicity or resistance to the "inter-imaging" of the role of advertising in late capitalism (183).

17. See Taylor for interpretation of Stoklos as androgyny in action.

18. See Taylor for analysis of this histrionic moment in *Civil Disobedience*.

19. See "The Hysteric's Discourse" for his discussion on how the hysteric's "truth" is constituted by challenging knowledge. Also, Ragland-Sullivan on Lacan: "Lacan reserved his greatest praise for the *truth* of hysteria as a structure which speaks dissatisfaction with knowledge as it stands, in any age. He argued, moreover, that knowledge—cultural, academic, clinical—can only advance in so far as the hysteric's question prevails over the master's answer" (165).

20. A transliteration from Portuguese would go this way: "*Co* from corruption, *L* from profit ("lucro"), *O* from obsessives, *M* from maintaining us idiots (*Bo*, for *bobos* = idiots)."

21. Graphically, this question marks the only division in the discursive play text, other than several notations of "Music" that indicate histrionic dances.

22. Wajeman on the hysteric and questioning within the psychoanalytic relationship: "The questioning one is the hysteric. Asking a question is so elementary a relation of language that it can done without words: when the hysteric presents her riddled body to the physician, even though mute, she poses her question" (3).

23. The Collor debacle provided public spectacle in various senses. Brazilian youth, harkening back to the 1960s, organized protests, becoming known as *caras pintadas* in reference to their trademark: faces festively painted in the colors of the Brazilian flag. This resurge of youth activity interestingly coincided with the year's most highly acclaimed miniseries, T.V. Globo's *Anos rebeldes* (*The Rebel-*

lious Years). *Anos rebeldes*, written in the 1990s, was a televised rereading of the 1960s generation. Indeed, the whole process of Collor's impeachment became a spectacle of nationwide participation. I was in São Paulo in October when Collor called for a public demonstration of solidarity, asking all loyal Brazilians to step out on a Sunday decked out in Brazil's colors. Overwhelmingly (at least in São Paulo), citizens opted for black. In Rio, citizens stepped out in white, but with the same testimonial intention.

A note: It is remarkable—and worthy of study—how quickly T.V. Globo's miniseries and soap operas "interestingly coincide with" social and cultural movements in Brazil.

24. Her referents here—Parra and Regina—signify the tragedy of art under siege, and associate political terror with the fragility of creativity under dictatorship. Violeta Parra was killed by the Chilean military. Elis Regina, a supremely talented heroine of popular music, died of a drug overdose. Regina is Stoklos's favorite interpreter of Brazilian popular music, and if memory serves me, all of her plays have a reference to Regina, and most use Regina's songs as musical background. In fact, Stoklos did a one-woman show on Elis Regina in 1982. Perhaps in recognition of an element of melodramatic hype that haunts her revisiting of the past, Stoklos is explicit in justifying what she herself, throughout the play, has called her theatrical excesses, as the ending text shows: "I speak without fear of any kind because I've never been interested in my career but in the search for a simple essential truth. Free. Like you. Thanks? To life" (48).

25. Indeed, a large number of plays produced in 1992 that contested the "discovery" were staged with some nautical variant of the theme of shipwreck.

26. In a memorial pastiche to Martin Luther King Jr. performed at Duke University on 18 January 1999, Anna Deavere Smith incorporates (she terms it "trespassing") West as he is asked whether he is an optimist. He responds, and I paraphrase, that he doesn't consider himself an optimist because that would imply that he thinks that things will turn out well. He is, instead, a prisoner of hope.

27. Regardless of their other themes, Stoklos's plays are confined and exploded by a movement from incarceration toward communication and liberation, although the weight of tropes and rhetorical tactics that convey the relationship of historical significance to utopian desire varies. Of those I have seen and studied, *Mary Stuart* and *Civil Disobedience* perform literal instances of historical imprisonment. Analogy predominates in *Mary Stuart*, while *Civil Disobedience* celebrates rhetoric of persuasion. *Fax* plays on discursive rhetoric, decrying historical entrapment, as scenically demonstrated by the attenuated fishnet. What Stoklos perceives as the moment/event of the neoliberal betrayal of Brazil is allegorized in the case of *Des-Medéia*, as a breaking through the boundaries of myth. *Basement/Casa* presents a kind of "everywoman" and Chaplinesque morality lesson in breaking through the isolation of late capitalist alienation.

Works Cited

Bentley, Eric. *The Theater of Commitment and Other Essays on Drama in Our Society*. New York: Atheneum, 1954.

Birringer, Johannes. *Theater, Theory, Postmodernism*. Bloomington: Indiana University Press, 1991.

Capó Sobral, Suzi. "The Essential Theatre of Denise Stoklos." *Denise Stoklos: The Essential Theatre*. São Paulo: Denise Stoklos Produções Artísticas, 1992.

LaCapra, Dominick. *Representing the Holocaust: History, Theory, Trauma*. Ithaca: Cornell University Press, 1994.

Ragland-Sullivan, Ellie. "Hysteria." *Feminism and Psychoanalysis: A Critical Dictionary*. Ed. Elizabeth Wright. Oxford: Blackwell, 1992.

Rocha, Glauber. "An Esthetic of Hunger." 1965. Trans. Randal Johnson and Burnes Hollyman. *Brazilian Cinema*. Ed. Randal Johnson and Robert Stam. Austin: University of Texas Press, 1982.

Schutzman, Mady. *The Real Thing: Performance, Hysteria, and Advertising*. Hanover, N.H.: Wesleyan University Press/University Press of New England, 1999.

Sommer, Doris. *Foundational Fictions: The National Romances of Latin America*. Berkeley: University of California Press, 1991.

Stoklos, Denise. *Denise Stoklos in Mary Stuart*. São Paulo: Denise Stoklos Produções Artísticas, 1995.

———. *Des-Medéia*. São Paulo: Denise Stoklos Produções Artísticas, 1995.

———. *500 anos: Un fax de Denise Stoklos para Critóvão Colombo*. São Paulo: Denise Stoklos Produções Artísticas, 1992.

———. Interview by e-mail with Leslie Damasceno. 5 May 2000.

———. Interview by telephone with Leslie Damasceno. 7 August 2002.

———. "Interview with María Teresa Alvarado." *Economia hoy*, 5 September 1991.

———. "Manifesto of the Essential Theater." *Denise Stoklos: The Essential Theater*. São Paulo: Denise Stoklos Produções Artísticas, 1992.

Taylor, Diana. "Denise Stoklos: The Politics of Decipherability." *TDR* 44 (2000): 7–29.

Wajeman, Geerard. "The Hysteric's Discourse." 1982. Trans. Thelma Sowley. *Lacan Study Notes*, nos. 6–9 (1988): 1–22.

Žižek, Slavoj. *The Sublime Object of Ideology*. London: Verso, 1989.

ASTRID HADAD

(Mexico)

Astrid Hadad, born in Mexico in 1957, looks to cabaret and performance to represent social, cultural, and political crisis in Mexico and, at the same time, to entertain. Her intensity on the stage as she sings, dances, and throws barbs at Mexico's sacred cows is contagious, and audience members can often be seen dancing in their seats. Borrowing from Mexico's rich cultural heritage, her shows consist of fast-paced, fragmented, parodic unveilings of traditional Mexican song, dress, dance, and political satire in which the focus is the female body. In her shows *Heavy Nopal, Corazón sangrante, La multimamada,* and *Pecadora,* she recuperates and articulates the sexuality, sensuality, and human desires suppressed by official morality. Into her productions *Faxes a Rumberta* and *Cartas a Dragoberta,* Hadad incorporates elements from Mexican visual arts, music, and cinema, along with actions and gestures from popular culture.

Since rejecting institutional support and affiliation early in her career, Hadad has written, produced, managed, and promoted her work, creating audiences throughout Mexico, the United States, Europe, Australia, Canada, and Latin America. An accomplished vocalist, her music CDs circulate internationally.

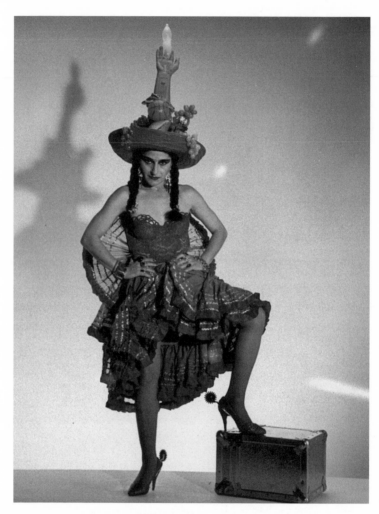

1. Astrid Hadad. Photo by Pancho Gilardi.

Selected Lyrics and Monologue Fragments

ASTRID HADAD

Corazón sangrante (Bleeding Heart)

Where shall I go?
Where shall I put this bleeding heart?
So it won't hurt,
So it won't bleed,
So it won't burn.
I'll wear it pinned to my breast like a saint
So you can see how cruelly
You have wounded me.
My heart is steeped in chili,
With pepper you doused it. In lies you soused it.
How it squirms. How it burns.
Your name is tattooed on my heart.
You might have left it stuck to your sleeve.
Or why didn't you eat it, not leave me like Christ
With a sore and bleeding heart.
Where shall I go . . . Wherever shall I put this
Bleeding, scorching, smarting,
Vanquished, anguished, languished, sandwiched,
Shattered, battered, flattened heart? This lonely, groaning,
 moaning heart,
Dizzy, grizzly, woozy, boozy,
Roasted, toasted, crunchy, munchy heart,

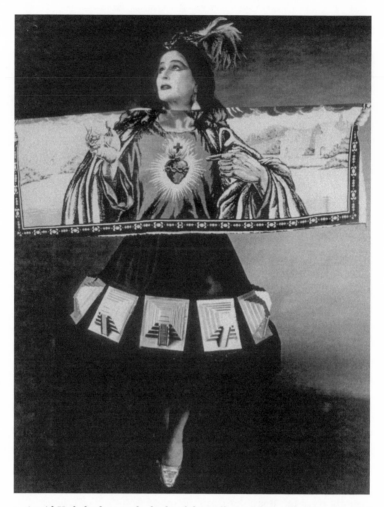

2. Astrid Hadad takes on the body of the suffering Christ. Photo courtesy of
Astrid Hadad.

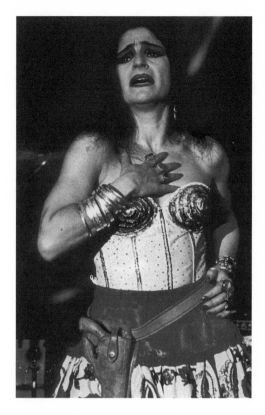

3. Astrid Hadad wears her holster, pistol, and Virgin of Guadelupe skirt. Photo by Roselyn Costantino.

Trampled, mangled, humbled, crumpled,
Decaying, fraying, weeping, not sleeping,
Disprotected, rejected, dejected, infected,
Seriously manhandled heart.

—*Translated by Lorna Scott*

¡Mata! Dios perdona (Kill, God Forgives!)

Fear not the path. Tread steadily on. Have no qualms about what they might say.
If you see a student peace march, mow 'em down! Those delinquents and gays.
Just kill! God forgives. Just kill! God forgives.
Once a great conquistador was told by his confessor, "Slaughtering Indians is fine if God knows in time." Since Justice smiles on those who kill, why are we waiting?
Let's feel the thrill! Kill, kill, kill . . .

Fear not the path. Tread steadily on. Have no qualms about what they
 might say.
Are your neighbor's lands richer than yours? Blow his head off with
 UN approval.
Just kill! God always forgives. Just kill! God always forgives.

— Translated by Roselyn Costantino

La tequilera (The Tequila Lady)

My soul is always pickled in tequila
To drown the sorrows that couldn't be realer.
I drink because love lost has made me.
I can't hate him, although he betrayed me.

A true Mexican lass, I take blows without blinking.
Tomorrow's another day, a new chance for drinking.
They call me Tequilera.

— Translated by Lorna Scott

You Beat Me So Hard Last Night

With or without you I have no peace.
With you, because you are killing me.
Without you, because I am dying.

You beat me so hard last night, and I'm leaving . . .
I didn't deserve such abuse. [. . .]
But if you ask me to stay, I will.
Do whatever you want with me [. . .]
Hit me in the face, hit anywhere on my body,
Just don't go . . .

You beat me so hard last night,
And yet, I stay!

— Translated by Roselyn Costantino

4. La monja coronada. Astrid Hadad dressed as a virgin nun, with a cityscape in her headpiece and a ladder climbing to heaven. Photo by Lourdes Almeida.

Monologue Fragments from Various Shows

(provided by Hadad; repeated in various shows)

I. The song I just sang is surrealist. In Mexico, surrealism is almost a way of governing. For those who don't know what surrealism is and think it's a stomach disorder, I'm going to describe it. According to the dictionary: an effort to move beyond the real by way of the imaginary and the irrational. An artistic movement that seeks the expression of pure thought to the exclusion of all logic and all moral and aesthetic worry. A Mexican political movement, lacking any morality, ethics, or aesthetics, which seeks to convince us that the reality we live is a product of our imagination.

II. Everyone thinks that sinning is easy, but that's not true. Sometimes you can't even find anyone to do it with. Often, even though we want to we can't sin because we share the moon's destiny . . . everyone admires us, everyone sings to us, dreams of us, but nobody touches us and if they do touch us, they do it badly. Aye, a woman with the destiny of the moon, so generous and delicious, and no one enjoys her.

III. I'm always confused, I don't know if I'm coming or going, although I always try to be coming and to come well, of course. I don't know if I'm good or bad because according to the good ones, I'm bad, and to the bad ones, I'm worse.

IV. I am so many women in one and, sometimes, one of so many. The only thing for sure is that I am a woman, beautiful, smart, and immodest.

—*Translated by Roselyn Costantino*

Politics and Culture in a Diva's Diversion:
The Body of Astrid Hadad in Performance

ROSELYN COSTANTINO

Ni contigo ni sintigo tienen mis males remedio.
Contigo porque me matas. Sintigo porque me muero.

Surrealismo: Movimiento político mexicano,
carente de toda moral, ética y estética,
que intenta convencernos de que la realidad que vivimos
es sólo producto de nuestra imaginación.
—Astrid Hadad

Astrid Hadad, of Lebanese heritage, was born in 1957 and raised in Chetumal in the southern Mexican state of Quintana Roo. She is a product of the heterogeneous, hybrid nature of Mexican culture. Laughingly she admits, "I don't know if I'm Maya, Lebanese, Mexican or Gringa?" (PI),[1] not a rare confusion in a country characterized by its "multitemporal heterogeneity"—that is, by the coexistence of a number of communities and symbolic systems.[2] Out of Hadad's meditations on the multiplicity of influences shaping her and other Mexicans' sense of themselves, and on the violence implicit in that process, emerge performances featuring a fast-paced, fragmented, parodic unveiling of traditional Mexican song, dress, and dance. Hadad avails herself of the humorous sociopolitical criticism of cabaret, *carpa*, and *teatro de revista*—important theatrical styles in Mexican cultural history.[3] Within these marginal forms of so-called *género chico* or "light" theatre, she juxtaposes national and religious icons with witty vernacular parlance. Her motivations are several: to celebrate cultural experiences that lie at the base of national identity; to critique contemporary political and economic policy; to recu-

perate and articulate the sexuality, sensuality, and human desires repressed by the morality imposed by the patriarchal institutions that structure Mexican society; to demonstrate the centrality of woman's body to those institutions; and finally, to entertain. As a woman who has internalized and displays Lebanese, Mayan, and Afro-Caribbean cultural markers, Hadad simultaneously represents, deconstructs, and reinscribes the exotic Other.

Hadad explains that in her early years she was profoundly influenced by the sights, sounds, and smells of the tropics, by Caribbean rhythms transmitted over Cuban radio, and by the films of Mexican cinema's Golden Age. The silver screen, she explains, impacted her not only with its divas, many of whom transgressed the roles of the acceptable Mexican mother or wife, but also with its creation of a version of Mexico as a nation, as an "imagined community." As folkloric as that filmic version arguably may have been, even in the remote region of her birth, it made an imprint on Hadad which would manifest itself throughout her career both in body and spirit, as artist, woman, and Mexican.

Passionate about music and with some experience performing in her parents' restaurant, Hadad discovered that singing and dancing were not enough, that she wanted to create a fuller show, one in which she could articulate through various stage languages her interpretation of the passions and pains of life in general, and of Mexican reality in particular. With a B.A. in political science, in 1980 she moved to Mexico City and entered the Center for University Theatre (CUT) of Mexico's National Autonomous University to study acting. Her teachers, quite dismayed by her ideas of mixing cabaret-style singing and carpa and revista sketches with traditional theatre, tried to convince her to come to her senses and study directing. She persisted, however, and at the CUT Hadad was exposed to a new generation of playwrights including Sabina Berman, and formed part of a group of theatre practitioners that experimented in creating cycles of staged dramatic first readings in which the participants switched roles with each week's production of a new work. In these cycles, Hadad would direct one week, act another, design and construct scenery, work lights, and so on, giving her broad experience in theatre production. The overwhelmingly positive audience response to the innovation (dramatic readings were not usually staged with props and scenery) as well as the criticism from the theatre establishment convinced Hadad of two things: that the public was open to different theatrical experiences, and that she would work independently of the theatre establishment.

Hadad left the CUT after two years, and in 1984 had her acting debut

in Jesusa Rodríguez's production, *Donna Giovanni*. The show, an adaptation of Mozart's *Don Giovanni* in which almost all the actors were women and everyone played the Don, was not simply a feminist critique of classic theatre, but rather, as Jean Franco suggests, a celebration of the "libertine" in all of us—that is, of the naturalness of sexuality seen against society's deforming norms (52). After this production, Hadad separated from Rodríguez. She acted in a few *telenovelas* (Mexican soap operas) and debuted in commercial cinema in the successful Mexican film *Sola con tu pareja* (Alone with Your Partner). Most of her energy, however, went into developing her own show, which she began to present in cantinas in Mexico City, as she fondly recalls, literally "singing and dancing on the bar because the joints were so small" (PI).

From the initial stages of her shows' development, Hadad inserted monologues filled with political satire between her belted-out renditions of ranchera and bolero music. The influences of Mexican musical traditions, of Mexican and German cabaret (which she went to Germany to observe), and of the style of the divas manifest themselves in her early works. She performed *Nostalgia arrabalera* (Gutter Nostalgia) and *Del rancho a la ciudad* (From the Country to the City) and *La mujer del golfo apocalípsis* (The Woman of Apocalypse Golf) and *La ociosa . . . O Luz levantate y lucha* (The Lazy One . . . or Oh Luz, Get Up and Fight) in cantinas in Mexico City. In addition to performing in these spaces, she also appeared in Jesusa Rodríguez and Liliana Felipe's cabaret-bar El Cuervo, one of the few theatre bars owned by women in Mexico City. El Cuervo also served as a gathering place for many of Mexico's writers and intellectuals. Hadad soon expanded her show to include the sketches of teatro de revista and teatro de carpa, forms popular from the late 1880s to the 1930s, filling them with humorous sociopolitical criticism. Unconcerned with classifying her work and undaunted by critics who referred to it as frivolous, Hadad incorporated elements of performance styles and spectacle that hadn't made it into official theatre histories: "My show has its roots in cabaret. I know that in the U.S. they call it performance. My style is syncretic, aesthetic, pathetic, and diuretic, which demonstrates, without shame, the attitudes of machismo, masochism, nihilism, and 'I-could-give-a-damn' inherent in all cultures" (qtd. in Beltrán, 16). In her racy, nonlinear exposition of traditional Mexican song, dress, dance, and political satire, the focus is the female body and its position and representation in various critical discourses.

From these humble beginnings emerge *Heavy Nopal: Ode to Lucha Reyes* (1990), *Cartas a Dragoberta* (Letters to Dragoberta, 1993), and *Faxes to Rumberta* (1994), some of her best-known shows (particularly

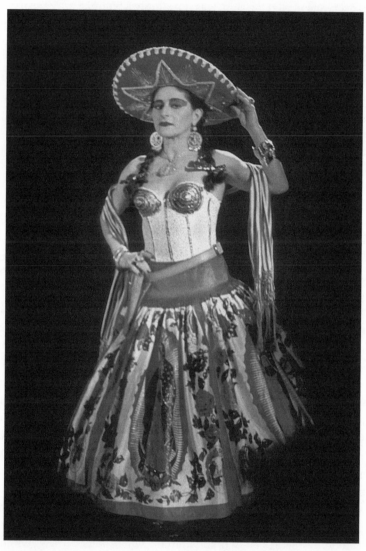

5. Astrid Hadad as La Tequilera in *Cartas a Dragoberta*. Photo by Cheryl Bellows.

the first). These shows are never "completed" but rather are workshops or works in progress to which she adds or subtracts costumes, dances, music, or monologues, at times according to her mood, at times according to the venue's physical layout and its urban, provincial, or international location. Performing the sensual dances and rhythms of rumba, merengue, salsa, and *sones* of Caribbean culture found in Quintana Roo, in these productions Hadad places the female body center stage. Her body serves as both the vehicle of communication and the message. It is a body that continuously re-presents and constructs its gender—a body, according to Hadad, that is the recipient of social signs of femininity even as it contests them. Through her body's corporeality, Hadad makes explicit the individual's material relationship to the larger society. Her work, while entertaining and exploring theatre as an art form, is politically and socially committed. She never attempts to mask its ideological premise; on the contrary, she showcases it, calling her obsession to speak about politics "my professional deformation; even though I promise myself that I won't, a political element always emerges because it's inevitable, it's what we are living, it's the anger we feel" (PI). She structures her performance around issues of gender bias, political authoritarianism, religious dogmatism, and feudalistic systems whose hierarchies are based on ethnic groups and class distinctions in general, and on female submission and male machismo in particular. Layers of clothing and props evoke the layers of meaning of seemingly innocent elements of popular culture that the Mexican audience obviously recognizes and responds to with enthusiastic laughter. The "discourses of power" are situated on a strong female body—a body whose sensuality Hadad emphasizes and takes pleasure in, although, in Mexico, it is a body that all structures of society attempt to regulate. This societal control is fortified and guarded by Mexico's "sacred cows," none of which escape Hadad's criticism: the Catholic Church and the pope, the president and other well-known politicians, and of course, macho men and submissive women, some of whom comprise her audience.

I first saw her show in 1993 in La Bodega, where she had frequently performed since 1990. La Bodega is located in the Colonia Condesa, a historic, fashionable section of Mexico City where it is obvious that the spectators in this small but packed theatre/dining room are from the middle and upper-middle class.[4] Not an inexpensive night out by most Mexicans' standards, the cover was 60 pesos ($20 in 1993), plus expensive food and drink. The show that night was *Cartas a Dragoberta* (based on a text by Alfonso Morales). Hadad walked through the crowd, climbed onto the stage, and joined her two musicians, Los Tarzanes. What followed was a mixture of parodied artistic forms: visual art, dance, music, and theatre

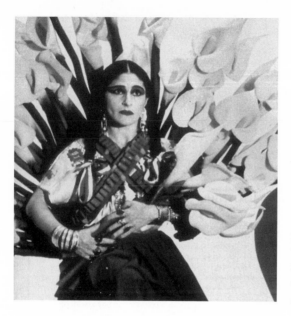

6. With giant white calla lilies attached to her back, Astrid Hadad evokes the Diego Rivera painting of a young indigenous woman holding such flowers. Photo courtesy of Astrid Hadad.

of different genres. As in *Heavy Nopal* and *Faxes to Rumberta*, Hadad donned a full, green "peasant" skirt of the nineteenth century, with a frilly feminine white blouse trimmed in red, thus featuring the colors of the Mexican flag, which were also visible in her glittery eye makeup and large, kitschy earrings. This folkloric reference to the *china poblana* (nineteenth-century women's dress in the state of Puebla, a popular folkloric image) was completed with her long, black hair woven into two braids decorated with red, white, and green striped ribbon. Giant white calla lilies attached to her back formed a crown or large frame around her head that evoked the Diego Rivera painting of a young indigenous woman holding such flowers. Finally, Pancho Villa–style bullet belts crossed over her chest like a dark, ominous substitute for a pearl necklace. Hadad danced and sang well-known lyrics of a traditional song: "I am a virgin watering my flowers/and with the flowers, my identity." In this way, she playfully juxtaposed the image of the humble, passive indigenous girl of Rivera's painting with a feisty virgin or a playfully seductive prostitute. Similarly, Rumberta of *Faxes* begins as a rather innocent provincial woman who breaks with patriarchal traditions and travels alone to Mexico City. In the city, she develops another vision of life and of her place and role in it. She decides to live on her own terms, regardless of the cost. Hadad suggests that Rumberta, like herself, becomes a cabaret performer, a woman who enjoys life and "claims the self-dignity of not selling herself to anyone" (Dávila 41).

For all their folkloric critique, Hadad's costumes are beautiful, many with historical value. By representing objects of popular culture within this parodic frame, she references Mexican kitsch, exemplifying the inscription of the indigenous and provincial as folkloric and exotic. This image of the non-Western becomes synonymous with innocence, beauty, and nature. And the image is not restricted to U.S. mass media or Hollywood. Beginning in the late 1920s, the Mexican government capitalized on the lure of the exotic to attract U.S. tourists: folkloric images with sleepy Mexicans and hot señoritas appeared on everything from newspaper ads, travel agency brochures, and calendars to Corona beer trays. Many of these items are popular at flea markets on both sides of the border.[5] Such stereotypical representations distance "ethnicity" from reality, and elide the many crimes—past and present—committed against indigenous peoples. Only recently have images of activist indigenous women made it into the media, with the ongoing coverage of migration at the Mexico-Guatemala border and the visibility of women's leadership roles in the Zapatista insurgency in Chiapas. Simultaneously, scholars continue to reevaluate the role of women in Mexico's history. For instance, we have witnessed the resignification of the *soldaderas*, the women soldiers of the 1910 Mexican Revolution. Once considered camp followers who cooked for and provided sex to the soldiers, they have acquired the status of a cultural icon for the active role they played as soldiers and even generals in the various revolutionary armies. The soldaderas are now the subject of academic studies, fiction, and documentary writing. As commercialization often accompanies recuperation, vendors on the street and high-end stores offer photos of these women (especially of Adelita, an anonymous soldadera immortalized in revolutionary folk songs) on t-shirts, postcards, bookmarks, and album and book covers.

The use of women in economic exchange always lingers in the background of Hadad's work. She folds onto herself the objectification and consumption of woman within neoliberal capitalism as she simultaneously participates in her own commodification—not as passive object but as a woman with an attitude. She attempts to maintain control of as many details as possible in the production of shows and the music recordings that circulate nationally and internationally. Hadad's CD and cassette covers feature her in dramatic poses, similar to those on front covers of Mexican and U.S. magazines in which she dons provocatively ironic (and ironically provocative) costumes. Through her success as a businesswoman and artist, Hadad promotes the increased visibility of women. As a Mexican woman who designs, produces, performs, and therefore owns her show (her stage, her body), she provides an alterna-

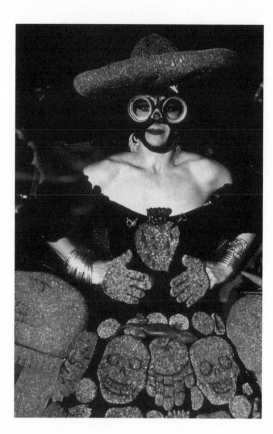

7. Astrid Hadad pays homage to Coatlicue, the Aztec Mother of the Gods, now forced to adapt to the conditions of present-day Mexico City. From *Heavy Nopal*. Photo by Cheryl Bellows.

tive model to women's traditional participation in cultural production, as well as an alternative model of the history of that participation.

By overlaying the images with contradictory humorous gestures, bawdy linguistic play, and the critical commentary implicit in the props and makeup, Hadad creates ironic and satirical tones that permit her to revive, connect, and resignify constructing symbols to reflect the hybridity that marks Mexican culture. She strikes a chord in the illusive concept of *ser mexicano* or Mexicanness by, without falling into nostalgia, underscoring those sights, sounds, smells, traditions, and historical realities that do create a common bond within a shared geographic space. And, it is obvious, she thoroughly enjoys the process.

Hadad becomes the surrogate for Mexican and women's cultures. By juxtaposing contradictory discourses on her body and her stage, in her lyrics and her private life, she performs both the continuity of stereotypical roles and a critical analysis of them. Her show, *Cartas a Dragoberta*, demonstrates that process. Hadad begins by reading letters exchanged between a couple now separated due to the woman's search for

fulfillment. In the exchange, the man, left alone in Mexico City, laments that Dragoberta just won't stay at home like a good woman should. He's not at all sympathetic to her complaints of the mistreatment she experiences as a woman traveling alone in the provinces of late nineteenth-century Mexico. He feels no pity; she exhibits no desire to change her plans. As Hadad delivers the lines, she puts on a large, amusing mustache, like those from nineteenth-century popular performance. The detachable mustache, in a pop-Freudian reading, metonymically represents the phallus. With this prop she both appropriates and parodies the acquisition of "the power of the word" that dominates all official discourse in Mexico, be it religious, social, or political. In the Mexican context, it evokes former President Salinas de Gortari, or the macho figure par excellence, Pancho Villa, or any other authoritarian figure. On a woman, the mustache appears unnatural, a manly characteristic that can even create a freakish aspect, like that of a circus woman (Nigro, "Inventions," 145).[6] By employing the mustache in her monologues, Hadad visually reenacts the arbitrary and theatrical aspects of gender construction in Mexican culture. Masculine control of the word/power is an element shared by all the cultures and societies that comprise Mexico, although some progress has been made, with varying degrees of success, in the empowerment of women across the Mexican cultural scapes. Recent examples include not only the visibility of women as leaders in the Zapatista insurgent movement, but also the increased presence of women in political office, including the naming of a woman as mayor of Mexico City. Dragoberta's voice embodies the resistant traces that Hadad seeks to tease out of cultural registers. Although in official histories it might be rare to find examples of women who, like Dragoberta, do speak out in their own voices, Hadad sings their tunes, so to speak, and judging by the audience's response, she does that well.

An important source of inspiration for Hadad has been the pioneer of vernacular song in Mexico, Lucha Reyes.[7] Reyes (1904–1944) appeared on the Mexican musical scene in the 1930s and introduced the *bravía* (deep, gutsy) style of singing—a feminine interpretation of ranchera music (Márquez). According to Dueñas, the singer's form of expression emerged from the "female soldiers of the Mexican Revolution, prototypes of the tough people in the countryside, especially certain female characters that [Reyes] portrayed in cantinas" (qtd. in Ramírez, "Derrumbe" 23). Considered by some a femme fatale, for others Reyes personified a strong woman who takes responsibility for, and claims as her own, her sexuality, her economic well-being, her career, and her public and private identities. In a country where the citizens are criticized and criticize them-

selves for their often "sheepish acceptance of authority, their capacity for meekness and manageableness" (Cazés 9)—a characteristic traced to Mexico's indigenous, Hispanic, and Roman Catholic roots—Reyes was and still is a model of resistance for *both* men and women.

The similarities between Hadad's and Reyes's public and private lives did not escape Hadad, who researched in depth the truths and consequences of Reyes's transgressive choices. Hadad's "fatal attraction" (in her words) to Reyes's almost mythical figure, and her incorporation of Reyes's life and work into her performances, reflect her desire to resignify female historical figures and elements of traditional Mexican culture. Similar to Chicanas's work with the figure of La Malinche (often referred to as the Mexican Eve), Hadad teases out the ironies and ambiguities in these women's images, histories, and myths, and cites them literally on her body and stage. Drawing on Kristeva's thoughts, in *The Explicit Body in Performance* Rebecca Schneider suggests that "to render the symbolic literal is to disrupt and make apparent the fetishistic prerogatives of the symbol by which a thing, such as a body or a word, stands by convention for something else. To render literal is to collapse symbolic space" (6).

For Hadad, this process of recuperation and representation is both personal and artistic. She seeks modes of articulation of the psychological and corporeal manifestations of sexuality repressed but not eliminated, of femaleness circumscribed but not eradicated. The dedication accompanying her album *!Ay!* reads: "Thank you my Virgin for performing the miracle of permitting me to mold my contradictions of being Mexican, Mayan, and Lebanese into this recording, *Heavy Nopal*; a crucible into which I mix the heap of experiences that we Mexicans are." Hadad's body becomes the crucible on which she performs the experiment of reformulation. She takes the myriad elements used to construct history, myth, and, consequently, identity, society, and nation, and rearranges them by altering the syntax to produce new narratives that complement and contradict, and thereby, come closer to representing lived experiences. As she notes: "I express the myriad contradictions which we are, all the variations on character and personality, moods and moments that define us and in which we exist. If there is a contradiction between the words of the songs I sing and what happens on stage, it is because we are that contradiction" (qtd. in Beltrán 18).

Through her research and on her stage, Hadad interrogates the ways in which we know history and how its official version becomes the cornerstone for constructing a social consciousness. Through her use of the languages of the stage and the body (spaces which converge in her productions), she demonstrates how that stone can be removed and reused in the

process of reconfiguring of self and community. In her work and her life, Hadad demands an open reading of that identity-in-process and urges others, women and men, to do the same. But not all contradictions are good or equal, and neither is society's view or treatment of them. Much depends on whose contradiction it is, where it is located, and with whose truth or law it is in conflict. The song "Mata, Dios perdona" (Kill, God Forgives) on Hadad's CD *Corazón sangrante* (Bleeding Heart, 1995) encapsulates the voluminous history of man's manipulation of Man's and God's truths. "Mata, Dios perdona" traces man's invention of rules and regulations, wrapped up in myth and religion—all of which affect women and other disenfranchised groups in quantitatively and qualitatively different ways. In this three-and-a-half-minute recording, Hadad scans history for the genocides, crimes of passion, and mindless homicides that slide by the most basic Judeo-Christian mandate, Thou Shall Not Kill. In her interpretation of historical fact, she locates the "convenient" rationalizations used to excuse breaking this rule, and implicates the individuals and institutions complicit in the resulting hypocrisy:

> Fear not the path. Tread steadily on. Have no qualms about what they might say.
> If you see a student peace march, mow 'em down! Those delinquents and gays.
> Just kill! God forgives. Just kill! God forgives.
> Once a great conquistador was told by his confessor, "Slaughtering Indians is fine if
> God knows in time." Since Justice smiles on those who kill, why are we waiting?
> Let's feel the thrill! Kill, kill, kill . . .
> Fear not the path. Tread steadily on. Have no qualms about what they might say.
> Are your neighbor's lands richer than yours? Blow his head off with UN approval.
> Just kill! God always forgives. Just kill! God always forgives.

As she performs this song, Hadad's hips undulate and her mass of thick, long black hair swings sensually over exposed shoulders, leading the rest of her body and our gaze through its entrancing movements. Her small five-ringed hand brandishes a pistol as shiny as her bracelets and the large earrings that sparkle like her green-and-red glittering eye shadow. Suddenly one realizes that Hadad has caught the spectator somewhere between the hypnotic rhythms of her movement and her biting yet cynical response not only to the evil and violence, but to the past and present

impunity for those who perpetrate them. This reality repeats itself not only in Mexico but throughout the world. The image of the sensual figure of Hadad performing God's forgiveness conjures up that of Salomé offering up the head of John the Baptist. And the spectator is no longer a mere observer. Few escape the seductive Caribbean salsa rhythms. Somewhat like a priestess leading her own ritual ceremony, Hadad, in the act of empowering herself to access the pleasures of her flesh, authorizes her audience to do the same. She focuses on this desire and experienced pleasure just long enough to hold the audience there viscerally until, suddenly, a line of the lyrics shakes them out of the corporeal into an intellectual moment, sometimes so unexpectedly that the contradiction or contrast causes a jolt of laughter.

While often highlighting such themes as the madness and vanity fabricated and marketed globally by voracious capitalist appetites, Hadad's performances also provide insight into Mexican culture and society under the influence of global capitalism and exchange. Mexico's middle and working classes have suffered severe economic stress under the weight of the 1994 NAFTA agreement. The air never dirtier, the poor seldom more disenfranchised, street violence at its most visible in recent memory, worker and indigenous rights as precarious as ever—Mexico, ironically, appears to be more democratic than ever. *Appears* is the operative word in the ongoing battle for interpretive power.

Hadad represents these struggles onstage where we see bleeding hearts, the Statue of Liberty, giant foam cacti, chili peppers, computers, and multi-breasted goddesses. The mother of the Aztec gods, Coatlicue, and the mother of Mexico's disenfranchised, the Virgin of Guadalupe, circulate with María Magdelena's crying eyes and the flames of hell, empty tequila bottles, and condoms. Hadad dons headdresses containing everything from a miniature Statue of the Angel of Independence with crazed soccer fans partying at her feet, to the dome of the Bolsa de Valores, Mexico's stock market, basketball hoops, and the tree of life from the Aztec codices, here decorated with the faces of international political leaders and a string of blinking Christmas lights. When asked about the creative process of designing these objects and costumes and composing the shows, Hadad explains that "in some instances I have the words to the songs first, in others an idea for a dress, and in still others, everything is planned together, the costumes and the music. Sometimes the songs don't have anything to do with a 'theme' . . . they're what I feel like singing about, songs that I feel like singing" (PI). Her music draws from a broad variety of styles: Mexican rancheras and corridos, romantic boleros, samba, bossa nova, pop music, Caribbean beats, tango, the blues,

tunes from Broadway shows. The adjective *eclectic* only begins to describe the myriad sources and styles of her sets and props. The materials from which many of these are made add another layer of signification: inexpensive and ephemeral foam rubber. In some cases, the foam rubber adds to the exaggeration of the parodic moment, as is the case of the foam rubber female breasts featured in several of her costumes. In others, ironic tones are sharpened, as in her homage to the Aztec goddess Coatlicue. For that, Hadad puts on a feminine black skirt composed of replicas of the skulls and snakes we see on the goddess's large stone statue in Mexico's National Museum of Anthropology. Larger foam skulls protrude like guns from a cowboy's holster, a mariachi sombrero tops her head, her back flanked by huge foam green cactus leaves. In contrast is the hardness of the metal of the small brass heart that adorns her chest. It is reminiscent of the *milagros* (small metal representations of ailing body parts) used by the faithful to give thanks, except this one is lighted with a pulsating red glow like Jesus' sacred bleeding heart—a parody of the kitschy commercialization of religious objects so much a part of popular culture. The inexpensiveness of foam rubber makes the creation of these elaborate costumes possible in the tight Mexican economy, and this lightweight material that permits Hadad to dance around as she "performs" the lyrics of songs about love and passion is ephemeral. But the icons of power, faith, and harsh landscape she creates from the material are those that cement Mexican national identity.

Similar irony and parody structure what is perhaps Hadad's most performed and well-known show, *Heavy Nopal*, various versions of which have traveled around the world. In this performance, Hadad emerges from a backstage mist onto a stage decorated with large foam rubber reproductions of the cactus typical of Mexico's semiarid and desert landscape (cactus is found in official symbols like the national flag as well as in Hollywood caricatures of Mexico). Although she's dressed in her beautiful Virgin skirt, her accessories and makeup evoke an image certainly not of the Virgin/Mother type but of a woman transgressively comfortable with her body and sexuality. Hadad further complicates the already dense accumulation of signs. She makes her entrance hobbling on crutches, arm in a sling and head covered with a large bandage. Beginning in a low, pained voice, she sings: "You beat me so last night and still I can't leave you" and "Beat me, abuse me, but just don't leave me" (from the song "Me golpeaste tanta anoche" [You Beat Me So Hard Last Night]). The image transcends cultural and linguistic frontiers. Each of the four times I have seen this segment (three in Mexico City, one in Miami) the response was the same: the audience goes wild with laughter, at first.

I discovered in conversations, however, that many spectators vacillated between glee and sorrow, a sense of distance and involvement, as they witnessed the disturbing image of a woman unabashedly admitting to her dependency, to her complicity in her own abuse. The history of domestic violence that this scene embodies, and the fear and weakness of the victim that it quotes, cannot be joked away. Hadad makes explicit the manner by which the lack of action or resolve perpetuates the crime. She implicates seemingly innocuous lyrics of popular songs in the perpetuation of social attitudes that bring communal denial and prevent intervention in domestic violence. Through her use of the languages of the stage, Hadad literalizes the lyrics of old popular songs that many Mexicans, men and women alike, sing with gusto at parties, family gatherings, and other social functions. Music and dance in Mexico, in that sense, are truly democratic cultural elements as they are shared across generations, social and economic classes, and genders (but not, one can argue, some indigenous communities). In that way, these songs participate in the creation of Mexico's imagined community even (and perhaps more so) as the influx of foreign, particularly U.S., products assaults local markets and patterns of behavior. By engaging the crowd in a practice in which they (Mexicans) participate frequently, Hadad implicates them in the violence inherent in the underlying belief systems and mechanisms of such cultural practices. Our laughter, our pleasure, become suspect too. Although the tone is very humorous, the message is transparent and indisputable: these traditions—the songs and the realities to which they implicitly or explicitly make reference—write themselves violently across women's real, material bodies.

Another contradiction that Hadad takes on is her own and other Mexicans' relationship with their homeland, characterized by frustration bordering on cynicism (due to the eternal state of crisis and corruption) and by love and admiration (due to the country's rich cultural and social heritage and the beauty of the character of the people). Despite her pointed criticism and disgust at times, there is, she explains, no other place she would rather live. "The smells, colors, sounds of Mexico never cease to seduce and nourish me" (PI). This ambiguous relationship is evoked in her show and costume *La multimamada. Mamada* in Mexico loosely translates as either suckle *(mamar* is to suckle), or an exaggeration or stupidity, or, a more vulgar use, a blow job (although this last street use has never been mentioned by Hadad, it nonetheless exists in the vernacular lexicon). *Multimamada*, then, suggests mass suckling or mass stupidity. The inspiration for the costume is Isis, the goddess of nourishment, portrayed in several cultures as a goddess with multiple breasts.

Hadad translates the concept into a skirt covered with foam rubber, life-sized breasts with pronounced dark nipples. Miniature caricatures of Mexican masculine types dangle from several of the breasts, each marked by his clothing, such as a politician or businessman and a blue-collar worker. Hanging from the breasts, these figures seem to have their macho egos deflated, converting each of them into the macho who, despite his bravado, can't wean himself off his mother's breast. The breasts are fabricated versions, like old-style falsies, made of the same foam rubber material. The female breast is represented here as a masculine fetish that propels advertising and marketing sales throughout the twentieth century, with no sign of vanishing in the twenty-first, as indicated in part by the booming business of breast implants. Also caught in the entanglement of meanings is Mexicans' relationship to their mother/motherland. While the mother is placed on a pedestal, she figures in one of the strongest curses in Mexican Spanish: *Chinga tu madre*, screw or fuck your mother. This dual attitude is reflected in the relationship to the motherland as well. While defending Mexico in some instances, throughout the nation's history its elite looked elsewhere for "high culture" and civilization (Paris was often the site of envy). One often hears Mexicans say somewhat jokingly, somewhat seriously that only imported goods are of quality. This attitude, known as *malinchismo*, refers to la Malinche, Hernán Cortes's Indian mistress, translator, and advisor, who is written into history as a traitor. Hadad offers still another take on the paradox of mother/motherland, a concept at the center of her show *Multimamada*:

> My idea was to speak of the chaos that we were living at that moment . . . To speak of the chaos. I had to speak about the mythical idea that everything in the past was better. Another lie. And so I thought about Isis, who is known as the *many breasted goddess*. I wanted to transport her to *La República Mexicana*, the Republic of Mexico, to the motherland, the *madre patria* that is always there for everyone, that never dries up. It doesn't matter how much we suck, it doesn't matter how much we rape her, we exploit her, how much we take, how many thousands die, she keeps giving, and giving, and giving." (PI)

This giving mother, whose body provides for everyone, contrasts with *la tequilera*, the strong, loud, tequila-swigging woman of Hadad's signature song. La tequilera claims her sexuality and body as her own, available for her pleasure. She cries out that she'd rather die alone than compromise herself. On Hadad's body-stage, the either/or binary oppositions (mother/whore, evil/pure, suffering/libertine) recast themselves as spaces in which various seemingly incompatible characteristics coexist.

She performs this rearrangement in many of her creations, making obvious the processes of identity construction on the individual and national level. She offers herself as a model by demonstrating explicitly another way to be.

Hadad strikes even closer to the heart of Mexican culture (indigenous, Hispanic, and Catholic) as she explodes the virgin/whore binary and ridicules the church's paternalism and hypocrisy. *Pecadora* (Sinful Woman) focuses on the characterization of women as innately evil beings that can and must be redeemed for their and society's well-being. For this, she summons the figure of María Magdelena, the quintessential pecadora, used by the Catholic Church to exemplify the repentant and thus saved fallen woman. Hadad maps her version onto her body: her dress's skirt is covered with some thirty-three large red foam rubber hearts (the foam creating a three-dimensionality), each with an eye (large black pupils against bright whites); yellow flames frame the top, simultaneously evoking Christ's bleeding heart and looking like bright hair or eyelashes. Connected to an elaborate electrical and water system, some eyes both light up and emit tears. She wears a black corset and a bright red feather boa frames her waist. *Pecadora* is a piece in which, the performer confesses:

> the dress, the song, the image of Mary Magdalene, and my personal life all came together . . . She was a generous woman with an impressive futuristic vision, and so the hearts with eyes are this vision toward the future. Also, María Magdalena was a woman and we know that she cried. That's why Laurencio Ruiz and I designed the Tree of Life headpiece from Aztec codices, which functioned as a sombrero with eyes that light up. I had just finished writing the song for a tango, *Amar amarga* (Love Embitters) because I was involved in a passion, rather conflictive, at the time . . . The name *María* means to love bitterly. *Magdalena* means a magnificent tower, or also the prisoner, the guilty one." (PI)

The Catholic Church's version differs. They portray María Magdelena as a weak, sinful, seductive, and dangerous daughter of Eve. By recognizing her sins and repenting, she achieved salvation. She therefore becomes the perfect model for all women considered dangerous by patriarchal institutions: orphans, widows, abandoned wives, prostitutes, actresses, single women. In Mexico, for hundreds of years, portraits of Magdelena hung in women's prisons, sanctuaries, and reformatories to scare the female inmates into believing that the remedy to perdition consisted of total submission to the Father in all his manifestations. Hadad's María Magdelena, however, thinks, sees, feels, loves passionately and generously, and doesn't seem likely to buckle under the church's weight any time soon.

The intimate space of the body becomes simultaneously a site of domination *and* of resistance and transgression, but not of the guilt so much a part of the Catholic perspective of the human condition—there's always guilt. "It's always present, no matter how you free yourself, how liberated you think you are, because it's what they gave you when you were a child and it is very difficult to rid yourself of it. It's not totally useless as long as it's not an obsession. Not feeling it, well, that's the problem of our governmental leaders, they feel no element of guilt at all, that's why their cynicism is unusual, so strange" (PI).[8]

In her exploration of the interior and exterior of the self, Hadad consistently makes her way back to official Mexican culture. Availing herself of postmodern parody that at once reproduces and admires that which it criticizes, Hadad incorporates and mocks the official rhetoric and symbolic systems utilized by the Mexican power structures as part of the colonization process and, since the late nineteenth century, as part of a strategy of nation-building, of constructing national identity. Highlighted in this rhetoric is the appeal to "good" Mexicans inscribed in the symbol of the Mexican flag and in the image of the Virgin of Guadalupe. Hadad invokes both in one of her favorite costumes, her Virgin skirt. It consists of a full-length skirt made of six large scarves sewn together, each adorned with the image of the Virgin Mary that in Mexico features the red, white, and green of the Mexican flag. Unlike other versions of the Virgin, whose cloak commonly is sky blue, Mexico's Virgin wears a green cloak with yellow stars; she seems to be supported by a cherub at her feet whose wings, instead of angel white, are red, white, and green. The nation's political and religious souls are conflated in this image—love of one implies adoration of (and obedience to) the other. The power and legitimacy of the nation (and its leading *fathers*) resides in the divine. The emotional power of the Virgin of Guadalupe's image is not to be underestimated; the cult of the Virgin and the profound dedication to her are by any measure impressive and moving. One need only witness the outpouring of love and dedication demonstrated by the thousands of faithful who visit her Basilica in Mexico City—some completing a pilgrimage on foot from hundreds of miles away. The Virgin is one of the few icons in Mexico of which any perceived "desecration" or mockery is considered sacrilegious and usually not tolerated (while, at the same time, she graces commercial products as nonreligious as beach towels and t-shirts). Hadad's Virgin costume was censored when she was invited to appear on national television, a medium with close ties to the seventy-year ruling party, the PRI.[9] Further underscoring the elites' recognition of the power of image, so much a part of Mexico's systems of social control—and the resistance

to that power—is the fact that the PRI has a legal monopoly on the colors of the flag. No other political party can use the red, white, and green in their logo. During the 1990s, cries for democratic change included the call for the "release" of the colors of the Mexican flag.

Censorship of Hadad's work has been minimal, though it has surfaced in various forms. Although her Virgin of Guadalupe skirt and her *Multimamada* costumes were censored (the latter considered pornographic), she has appeared numerous times on Mexican and other Latin American mainstream TV. She was filmed by MTV's Latin American show, and continually tours in Europe (France, Spain, Austria, Switzerland, Germany, England, Portugal, Belgium), the United States, Australia, and throughout South America, in such diverse places as Argentina, Bolivia, Columbia, and Brazil. Her music, recorded on compact discs and cassettes, sells around the world. She has been featured in prestigious international theatre festivals. Her broad acceptance, however, does not include (or has been slow to develop) approval by many Mexican and other Latin American theatre elites who cringe at the idea of their works appearing in the same venue as Hadad's. To cite an example of another type of censorship, on several occasions invitations for Hadad to represent Mexico at international festivals never arrived. The protocol for official invitations is handled institution to institution. Those in charge decided not to forward invitations to her and, instead, sent other performers in her place. She remains undaunted, however. She understands that certain responses to her work (calling it frivolous) form part of a long tradition in Mexico of rejection of so-called low culture by high cultural elites. The system of patronage that functions within official cultural institutions has its own long history.

Hadad has, in general, demonstrated a strong resistance to censorship of her freedoms as an artist, a woman, and a Mexican. After a performance in San Francisco in July 1994, a group of feminists levied harsh criticism, questioning the politics of a female performer who flaunts her body—a marked body, according to them, with no chance of recuperation in existing systems of representation. Hadad replied sharply, maintaining that her performance must be situated and analyzed within its Mexican context. To attempt to force such choices on a work for it to be considered feminist, Hadad insists, reveals a position as authoritarian as the systems she attempts to dismantle (PI).

Such negative reactions, however, are the exception. Hadad carefully constructs a space of encounter for her audiences, and the spectators in her often packed houses respond in overwhelmingly positive ways, as evidenced by the thunderous applause, the in-motion bodies, and the hoots and hollers of pleasure. The complicity between Hadad and the

spectator enhances solidarity among the various groups represented in the audience. The connection is made, Rosa Beltrán notes, with "the wink of an eye in which she becomes the iconic referent of our national symbols as she interprets, to the letter, the songs to which we Mexicans usually cry with more pleasure" (17). Through this solidarity, Hadad seeks to create a sense of community and motivate social participation that might spill over into the public sphere. Laughter becomes a release of the frustration Mexicans experience when they, as individuals, feel powerless to change systems operated by those whose calls for "democracy" and "plurality" prove to be another exercise in public theatricality.

Reading or evaluating the effects of art is complex, and important questions remain as we consider Hadad's work. Is her performance, in spite of her intentions, received by the audience as commercial entertainment empty of the power to begin the process of social and political transformation? Does her show simply generate voyeurism and the male gaze that resists rupture while recreating and reinscribing the very systems it sets out to criticize? Do the elements of popular culture, decontextualized and then recontextualized on her cabaret stage, especially in the setting of the *La Bodega* in the Colonia Condesa of Mexico City, become Mexican kitsch—a bad imitation that, in the end, turns into folklore or commercializes popular Mexican culture without ever assigning it value as a "valid" art form?

I suggest that the answers may partially be found in one of the motivating forces in Hadad's (and, similarly, other Chicana, Latina, and Mexican women's) work—that of recycling and reinterpreting the very images, forms, and spaces that have constructed the categories of female and, by extension, national identity. The figure of the Mexican diva of the early twentieth century, with her sensuality, sexuality, passion, and demands for social, artistic, and economic autonomy continues to inspire. A new generation of scholars and artists is reviving, studying, and resituating the diva in Mexican history—a point of departure for Mexicans in the process of constructing identities which enable them to respond to their lived experiences.

The questions raised here are neither rhetorical nor frivolous, as Mexico's ongoing economic and social crises make clear. Our work as critics has required the same kind of rethinking and reinterpretation that Hadad proposes. Implicit in that process is the task of locating what traces of the past linger in the present and devising strategies to move more humanely toward the future. We continually develop critical paradigms capable of reading art and artists within their particular context and historical moment. Perhaps the questions we ask will permit us to expand the field of inquiry to be more inclusive of the full range of issues at stake. In the

meantime, we can enjoy the pleasure of the spectacles Astrid Hadad creates, as well as the challenge of their analysis.

Notes

1. In this essay, PI refers to a series of personal interviews that Hadad so generously granted over a period of eight years (1993–2000), which were conducted mainly in Mexico City. All translations of the interviews and other texts in this essay are mine.

2. For further discussion of the concept of multitemporal hybridity, see cultural critic Nestor García Canclini's *Culturas híbridas* and "Cultural Conversion."

3. *Teatro de carpa* is literally theatre under a tent. Itinerant theatre that moved around the urban area and into the regions, teatro de carpa constituted a principal form of popular entertainment during the last half of the nineteenth century and the early decades of the twentieth. *Teatro de revista*, or revue theatre, with its parade of recognizable characters, costumes, customs, and music, was popular at the end of the nineteenth century and during the first three decades of the twentieth. It not only served as entertainment, but in a country as large as Mexico, due to illiteracy and lack of access to newspapers, revue theatre was a source of news, a venue for open criticism of the government or other figures of the times, and participated in the process of creating in the Mexican imagination a sense of nation and national identity (Escarcega Rodríguez 3–8).

4. And, as Kirsten Nigro pointed out in her reading of this essay, these patrons "are from the 'hip' intelligentsia, which loves to be 'liberal.'"

5. For an analysis of the public relations campaign to boost the Mexican economy through tourism, see Alex Saragoza's "The Selling of Mexico."

6. Nigro's comments are from her analysis of Mexican playwright Sabina Berman's play *Suplicio del placer* (the translation of which is included in this volume) in which a removable mustache is passed back and forth between a husband and wife in a hilarious play on gender construction, amorous relationships, and power.

7. In recent years, Reyes has captured the imagination of various Mexican female artists who have attempted to revive her legendary strong personality and spirit as well as singing style. Hadad was one of the first on this project, writing a movie script which was then taken over by film director Arturo Ripstein. The result is the film, *Reina de la noche*, first screened in Mexico in August 1994, the anniversary of Reyes's death/suicide.

8. Performing our inherent dualities is also highlighted in *El extraño caso de Miss Hadad y el Doctor Malillo* (The Strange Case of Miss Hadad and Dr. Mallilo), a play on the themes of *Dr. Jeckle and Mr. Hyde* and on the character of Mexican president Ernesto Zedillo (1994–2000). In this critic's opinion, the images and criticism in this show are weak. Hadad, dressed in a prom-like pink gown, never makes the contrasts or contradictions clear enough, and the romantic music featured in the show fails to parody, but rather reproduces, sappier TV–style entertainment.

9. When Hadad appeared in 1987 on national television, the camera crew, on

orders to censor the image of the Virgin of Guadalupe on her skirt, used special red lighting to block the image all together.

Works Cited

Agustín, José. *Tragicomedia mexicana*. Vol. 1. Mexico City: Planeta, 1990.

Anderson, Benedict. *Imagined Communities: Reflections on the Origin and Spread of Nationalism*. London: Verso, 1983.

Beltrán, Rosa. "Entrevista con Astrid Hadad." *La jornada semanal* 16 May (1993): 16–19.

Cazés, Daniel. "Subestimar para saquearnos y volvernos a saquear." *La jornada* 31 December 1994: 9.

Dávila, María del Mar. "La mujer nocturna." *X / Equis: Cultura y sociedad* 19 (1999): 36–42.

Dueñas, Pablo. *Las Divas en el teatro de revista mexicano*. Mexico City: Asociación Mexicana de Estudios Fonográficos, 1994.

Escarcega Rodríguez, Francisco. *El teatro de revista y la política nacional: 1910–1940*. Tesis de licenciado en literatura dramática y teatro. Mexico City: UNAM, 1988.

Franco, Jean. "A Touch of Evil." *Drama Review* 36.2 (1992): 48–55.

García Canclini, Néstor. "Cultural Reconversion." Trans. Holly Staver. *On Edge: The Crisis of Contemporary Latin American Culture*. Ed. George Yúdice, Jean Franco, and Juan Flores. Minneapolis: University of Minnesota Press, 1992.

———. *Culturas híbridas: Estrategias para entrar y salir de la modernidad*. Mexico City: Grijalbo, Consejo Nacional para la Cultura y las Artes, 1989.

Hadad, Astrid. Personal interviews. Mexico City, 1993–1999. Cited as PI.

Márquez, Ernesto. "Lucha Reyes, a cincuenta años de su voz." *Tiempo libre* 21 July 1994: 23.

Monsiváis, Carlos. *El amor perdido*. Mexico City: Ediciones Era, 1977.

———. *Escenas de pudor y liviandad*. Mexico City: Grijalbo, 1988.

Nigro, Kirsten F. "Inventions and Transgressions: A Fractured Narrative on Feminist Theatre in Mexico." *Negotiating Performance: Gender, Sexuality, and Theatricality in Latin America*. Ed. Diana Taylor and Juan Villegas. Durham: Duke University Press, 1994. 137–58.

Peguero, Raquel. "En cine, la Reyes sólo fue soldadera cantadora." *La jornada* 19 July 1994: 25.

Ramírez, Luis Enrique. "Lucha Reyes: El vértigo de una voz." *La jornada* 16 July 1994: 21.

———. "Derrumbe y partida final de Lucha Reyes." *La jornada* 17 July 1994: 23–24.

Saragoza, Alex. "The Selling of Mexico: Tourism and the State, 1929–1952." *Fragments of a Golden Age: The Politics of Culture in Mexico since 1940*. Ed. Gilbert Joseph, Anne Rubenstein, and Eric Zolov. Durham: Duke University Press, 2001. 91–115.

Schneider, Rebecca. *The Explicit Body in Performance*. London: Routledge, 1997.

JESUSA RODRÍGUEZ

(Mexico)

Soy una mujer inconveniente

(I am an inconvenient woman)

When I was a child they told me I was autistic,

And I understood artistic, that's why I dedicated

myself to this.

—Jesusa Rodríguez

Mexican director, actor, playwright, performance artist, scenographer, entrepreneur, and social activist Jesusa Rodríguez has been called the most important woman of Mexico. Often referred to as a "chameleon," Rodríguez moves seemingly effortlessly and with vigor across the spectrum of cultural forms, styles, and tones. Her *espectáculos* (as both spectacles and shows) challenge traditional classification, crossing with ease generic boundaries: from elite to popular to mass culture, from Greek tragedy to cabaret, from pre-Columbian indigenous to opera, from revue, sketch, and *carpa*, to performative acts within political projects. The work she has written and/or directed and acted in includes adaptations of Shakespeare (*¿Cómo va la noche, Macbeth?* 1981), opera (*Donna Giovanni* 1983–1987), *pastorelas* (*Fue niña; Sor Juana en Almaloya* 1995; *Narco pastorela*), cabaret (*Cielo de abajo: Cabaret prehispánico* 1992; *Sufragio pero me aguanto* 1992), classic Greek tragedy (*Crimen* 1989, 1992), revue and sketch (*Critina* 1994; *El conde del or-*

gasmo 1996), melodrama (*El pecado neoliberal* 1994), and conventional Western-style theater (*El concilio de amor*, adaptation of Oskar Panizza's *The Council of Love* 1988, 1995).

Jesusa Rodríguez has collaborated internationally, most recently on the award-winning *Las horas de Belén* (A Book of Hours 1999), for which she and her Argentine companion Liliana Felipe were awarded an Obie for Best Actor. In 1977 she received a Rockefeller Foundation grant to complete the film adaptation of the opera *Così fan tutte*. She has staged her shows around the world including in the United States, Peru, Argentina, France, and Germany. A social activist, Rodríguez has worked with street children; presently she, along with Liliana Felipe and Regina Orozco, has been traveling to indigenous areas of Mexico, doing cabaret workshops with indigenous women community leaders. Rodríguez contributes regularly to Mexico's most important feminist journal, *debate feminista*.

Humor, satire, linguistic play, and the body are constants in her productions. She seeks to render corporeal and, thus, visible, the tensions between the discourses in operation on and through the individual and collective body. Rodríguez's energy is intense and her commitment nonnegotiable; she is always interrogating the nature, site, and consequences of power and its representation. Insistent on independence from government-sponsored cultural agencies and established institutions, Rodríguez and Felipe own and manage the cabaret/bar, El Hábito, and the adjacent theatre, La Capilla Theatre in Coyoacan, Mexico City. In these off-off spaces, and with the collaboration of her theatre cooperative, Las divas, Rodríguez has produced hundreds of shows since the 1980s. Numbers, however, do not give an indication of the depth and breadth of Jesusa Rodríguez's artistic production and the central role she has played—from the margins—for over three decades in the cultural, political, and social stages of Mexico.

Sor Juana in Prison: A Virtual Pageant Play

JESUSA RODRÍGUEZ with the Collaboration of Tito Vasconcelos,
Manuel Poncelis, and Liliana Felipe

Translated by Diana Taylor with Marlène Ramírez-Cancio
This play was written for Channel 40 in Mexico City.

Characters:

SOR JUANA INÉS DE LA CRUZ

LISY/LYSY

ATTORNEY

PROSECUTOR

The spectacle that you are about to see is the result of years of experimentation with high tech. It is the Blessed Year of Our Lord 2000, and thanks to Him the National re-Action Party has come to power in Mexico and finally restored decency and good manners to the social and political life of our country.

Any resemblance to real life is purely virtual.

The scene takes place in Sor Juana's jail cell in the Almoloya penitentiary. Stage left is the nun's desk, filled with books, ancient geometrical instruments, a pen, an inkwell, and a small Macintosh computer, the first kind to be introduced into the market. Downstage center is a single cot, and above it, a video screen. To the right, a black grand piano.

Sor Juana laughs as she reads a letter to the press from former president of Mexico Salinas de Gotari in November 1995. The text of that letter, and a photograph of the ex-President dressed as Sister (Sor) Philothea, is projected on the screen.

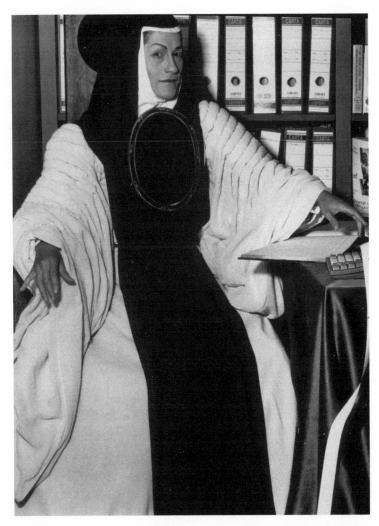

1. Jesusa Rodríguez as Sor Juana Inés de la Cruz. Photo by Gabriela Saavedra.

JUANA: Ha, ha, ha, this guy was really something! What a man! With one little letter written from his virtual exile he activated a whole group of politicians and intellectuals. "It was all a huge conspiracy," he said. Ha, ha, ha. What a guy, smart-ass, and with that he got off the hook. He never got accused of anything, he was never forced to testify about the murders and the collapse of the country, he never returned a penny of what he stole, come on, he didn't even get kicked out of the Party. No doubt about it: either this guy was a genius, or his peers were total assholes.

Oh well. The important thing is that the epistolary genre is alive and well again in Mexico. This can be my chance to get out of here. I have to send a message to the media, though it's probably like throwing a letter in a bottle out to sea—or better, launching a bit into cyberspace. Naturally, only letters sent from abroad matter around here. I've got it! I'll answer the ex-President's letter! It never occurred to anyone to respond back then, and a five-year-old news item might interest the press.

I will title it: "Sister Sor Juana Gets Sore"

To my most illustrious Ex-president, Ex-man, Ex-Cell-Intense, Carlos Salinas Kissinher, Bare-on of Bumsfeld, Chain-me, and lineage of the Fucksy, folksy Bush:

It is no will of mine, but my indignation, that has held up my reply these many years. It can hardly be a surprise that at the outset my bungling digital pen encountered two obstacles. The first, and for me the most obdurate, I find myself imprisoned in the Almoloya jail, where I was brought, deceived by men who said they believed in the NAP (later I found out it meant the right-wing "National Action Party" that you supported to gain power). Perversely, they scrambled the seventeenth and the twenty-first centuries through virtual technology—imposing a reign of terror and persecution in Mexico, refrying ancient laws to the detriment of people like me, who refuse to have their brains fried and prefer to think freely.

When I recall how that Angel of the Media, David Brock, on being questioned about his silence towards Newt Gingrich, his mentor, replied that he was keeping silent because there was nothing he could say worthy of Newt, how much more reason must there be for me to keep silent—not, like the saint, out of humility—but because I am cut off from the outside world, under surveillance night and day. As if that weren't enough, they've assigned me a criminal lawyer, who, far from defending me, has been paid off and will try to condemn me.

The second impossibility is that they have placed in my cell, as if it were the convent of St. Jerome, a false, two-dimensional library, courtesy of

The Official Press, hologram furniture, and an obviously obsolete Internet system. I would have preferred the Quadra 605 and not this Apple BCE. To top it all off, they want me to write their speeches for them, write splendid praises to their fundamentalism, and build triumphant arches to Presidents Fucks and Bush, which, needless to say, is not in my nature.

Actually I know a lot of those guys get off jack-free. Take Cheney: although he did good things, that all seemed bad, he didn't do any bad things that seemed worse. But me, they have in chains, to beat and humiliate me just for being a woman and inclined to COGITATION. I write desperately because today the attorney—believe it or not, NAP has put a nun in charge of the tribunal—today she will pass sentence on my case and I have reasons to fear she won't even give me a chance to defend myself.

In short, I know that you (to resort to the language of NAP) don't give a fuck, but whereas thou hast more influence than any among the NAP-PERS, I appeal to thy merciful Internet beseeching thy intercession on my behalf from the bottom of your hard drive. From this Convent of Our Father Saint Ignatius of Almoloya, your least fortunate, Juana Inés de la Cruz.

JUANA: Perfect, now I just have to format it, and it's done. *(Presses the wrong button)* Oh my God! I made a mistake! I just sent twelve carrier pigeons to Baghdad! Oh, bionics can be cruel! *(Presses another key, again a mistaken one)* Shit! I messed up again! Well, what can you expect? I wasn't born with a mouse in my hand. My God! I just materialized my horrendous attorney! Well, tough. You'll have to sit through a scene from "Impounding the House," a little play I wrote for those anti-gentrification doves as well as the hawks in Congress and the Office of Homeland Security. I'll remain alienated by a Brechtian effect they now call "TV presence," and wait patiently for this guy to finish.

Meanwhile, I'll compose Sonnet 165.

(From the other side of the stage, the attorney materializes, cross-dressed as the viceroy's wife.)

Text of Mr. Starr, the attorney:

ATTORNEY: What do you think, ladies?

The Viceroy's wife has paid me
Eighty thousand new pesos
to trade jewels, clothes,
shoes and accessories with her,

and to fool the guards
at the Almoloya penitentiary.

Lucky for me, I didn't wear
brown sweatpants today.
I can just imagine the Vicereine
dressed in Benetton gear.
The truth is, I'm a fucking genius
And not a fucking turn-coat.
I'm taking off these rags
starting with the jacket.

I'm an honest attorney,
but faced with such pressure
That twisted my arm, (and greased my palm),
I have to wear this, and sweeten my gestures
because my job is at stake.

So first let me tie up this mass of hair
For death to all if it flows freely
And with this mane, I'll cover my crown
If it looks good, they'll be calling me 'Blondie'!

Now on with the crinolines!
Jesus! What fabric! No doubt I'll look radiant
And because I'm dark, they say I'm succulent.

And what do you think of this whale dress, ladies?
Even if the priests dressed me,
I couldn't look better.

What about a push-up bra?
Do I need it? I doubt it.
Being an attorney, I always make a clean breast of tit.

Isn't it true I'm a beauty?
God love me, I'm stunning.
Everything looks good on me
Because my figure is so alluring.

Now let me finish decorating myself
I'm still not the perfect lady
Shoes, thus so
So my feet don't show
And even though my bunions burn
I can still dance a damn good turn

Make-up's really not my vice
but if I want to be the mirror
of the Viceroy's insipid wife
I'll have to add an extra layer
Just like Fuck's spouse, Ms. Martha

Lord! This vice-dress covers up a lot!
I can walk into the White House without being stopped
and stash sausages and fine wines in my crotch
To distribute to poor children in the anti-hunger plot
And win their souls for the Legions of Christ.

There's no thief that hides as much,
no page that lies as much
no gypsy can out-scam me,
I am an attorney for NAP,
And before I was pro-PRI.

So, dear ladies,
I step lightly,
with upright posture
and graceful spirit,
my head inclined
my hand in my dress.
I gotta go, because beauty
wilts in confinement.
Plus I fear some other party
might seduce me.

(Exit)

JUANA: There! I'm finally able to initialize this! It didn't come out too bad, my friends tell me.

But I beseech you intervene.
For a passive audience
Fails to fulfill the demands
Of an interactive sonnet.

Sonnet 165
(To the ex-President)

Semblance of my elusive Viceroy, hold still—
Image of a dope most fondly cherished

216 Jesusa Rodríguez

The creep that robs my heart of joy
Fucking fool that makes it joy to perish.

Since already my resources, like willing iron,
Yield to the powerful magnet of your transnationals
Why must you so flatteringly allure me,
Then slip away and cheat my eager arms?
Even so, you shan't boast, self-satisfied,
That your tyranny has triumphed over me,
Evade as you might the closing net
That the drug agencies have laid for you
In vain shall you elude the deadly bullet
The deadly clasp
If the World Tribunal, or I, catch you in our grasp.

(The Countess of Paredes—aka the Marquise de la Laguna, Vicereine of Mexico—dressed as an attorney, stealthily enters the cell, her back turned to Sor Juana.)

JUANA: Attorney! Get out of here immediately! How many times have I told you not to enter without knocking! I am caught up in a whirl of inspiration and I can't stand being interrupted. Out!

LISY: *(Smiles and turns around)* Juana . . .

JUANA: Oh voice of the awesome sun, whose light we needs extinguish. Either we block it with our wings, or exhaust it with our vision! Lawy . . . Lili, Lisy! It's you! *(They walk around each other in silence.)*

LISY: How do I look?

JUANA: Divine! You look like you've been airbrushed in Page Maker. But why are you wearing this disguise?

LISY: It was a ruse to enter your cell. I thought it up with your attorney, who by the way is an idiot. Where did you get him?

JUANA: I know he's an asshole, but they won't let me choose another. But tell me little Lisy, now that I'm close to you, now that you're close to me . . . Did you bring me those diskettes, those Double High Density?

LISY: Enough of hypertexts, my lovely, enough!

Don't let the techno tyrants torment you,
Nor trouble the contrast on your tranquility screen,
for in liquid humor you've typed and seen
my heart unraveling in your hands.

But what you really need, my love,
is to unglue yourself from that odious computer
and have something to eat.
Look, I brought you some sushi.

JUANA: Eeh! And what is that?

LISY: They're just like Haikus, except they come in different flavors. *(Lisy hands her a lunch box, Juana takes out the chopsticks from the plastic bag.)*

JUANA: These are strange haikus if one eats them with a compass.

LISY: Juana, listen, we have no time to lose. Do you know the Holy Orifice is on the verge of condemning you? *(She kneels down.)* I implore you, renounce! For our love, for whatever you want, I beg you: renounce.

JUANA: No, no, I can't.

LISY: Please, my adored love, renounce your books, let them burn. What the hell, when you get out of here you can write them again.

JUANA: It's too late. They've been accepted for publication by *Flee Expression*. And anyway I gave them to *Inside/Out* and I think even *ViceVerse* is going to publish some sonnets. My work's even been pirated by MTV! I'm lost!

LISY: Come here, calm down. The situation is serious. Let's think calmly. *(They sit on the cot while a voice from OFF expounds the opinions of Octavio Paz about the relationship between the two women.)*

VOICE OFF: The majority of Sor Juana's biographers would give their fellowships and grant money to have the opportunity to catch a glimpse of the scene that you are about to see. Octavio Paz, in his book on Sor Juana, *The Traps of Faith*, dispels all doubts that might have arisen concerning the decent and chaste relationship between the Most Excellent Doña María Luisa Manrique de Lara, Countess of Paredes, Marquise de la Laguna, and Sor Juana Inés de la Cruz, a professed nun in the Convent of St. Jerome in this loyal and faithful Mexico City. We will have the opportunity to fully understand the true significance of the terms used by this erudite and pristine thinker to explain this friendship. *(The two women move dangerously close to each other.)* "Note the sublimated sapphism." *(The women start kissing passionately.)* "Regard how they surrender to the silent orgies of meditation. One a nun, the other married. What could they possibly have done together?" *(Sor Juana jumps on top of the Vicereine and they frolic wildly.)*

LYSY: Renounce! Renounce!

JUANA: Relax! Relax!

VOICE OFF: "Sor Juana's powerful libido finds no outlet; her medallion is a symbol of sublimated virility. The Vicereine is ultimately a muse for Sor Juana, pregnant not with children but with tropes and metaphors." *(The two women compose themselves.)*

LYSY: Explain the lingual pattern to me.

JUANA: I don't know anything about that stuff. All I know is I just came here, and if by happenstance I'm a woman, no one will ever attest to it. Oh Lysy!! You were absolutely syllabic! You just inspired a free verse poem in my insides. Let's see what you think.

May Heaven serve as a copper plate, Lísida,
On which to engrave your clitic form;
May the sun make quills of its beams
May all the stars in syllables scintillate.

LYSY: I understood the quills part, but I don't get the clitic thing.

JUANA: Hum, I wanted to be elusive and obscure but maybe I should change it because it sounds too much like "clitoris" and Octavio Paz will write that we were sexing.

LYSY: While we were thinking I also came upon a song. *(Plays the piano and sings "The Sexes" by Henry Miller)*

JUANA: You know, your song got me thinking about that idea of Octavio Paz being a hermaphrodite that Paco Ignacio Taibo III proposes. In his biography of the poet he says: "The only thing we know is that, in his relationship with Mary Jo, the only thing that interested him was the collage: the mixing of elements from daily life with formal receptions. From that, we can infer traces of spiritual androgyny. For the profession of being a public intellectual on TV has neutralized the poet's libido, and there are even people who see him on the screen and confuse him with what's her name, the brunette on *All My Children*—spiritually, of course."

What I don't get is why biographies have to meddle with people's intimate lives. Intimate life is sacred. As a response to Paz's *Traps of Faith*, I will write a philosophic satire:

You silly men, who wrongly fault women for lacking reason
Fail to note the many of us who know full well the reason

You half-baked intellectuals, aching for a Nobel, prove half-assed
When you go along with those who gave the prize to Paz.

You attend his lecture, and then with *gravitas*
Accuse the press of maligning him with *levitas*
Paz wants another prize, he's been heard to report
We heard him say the Nobel is ignoble to come up so short.

Silly men, when a woman doesn't want you as her lover
You immediately think there's some dirt you must uncover
If she tells you politely to go and take a hike
Then you must conclude that the wretch is a dyke.

(As Sor Juana writes, the Attorney enters, dressed as the Vicereine.)

ATTORNEY: Vicereine! Ladies, what should we do? The Prosecutor confused me with your excellency and is on her way here, following me.

JUANA: It's no surprise she would confuse you! You're as alike as Trent and Frist!

ATTORNEY: Listen, ladies, one tries to have things come out as honestly as possible, but the truth is that I'm doing things that aren't becoming for an attorney. I have a family, too, you know, and imagine what my kids would say if they saw me dressed up like this! *(He cries.)* Oh God, I don't know what to do. I'm a damsel in distress!

(The Prosecutor enters, and sings the NAP hymn to the music of Shostakovich's 7th symphony.)

PROSECUTOR:

Death to faggots,
Kill the blind,
Then the prostitutes and degenerates!
Clean the earth of unclean vertebrates!

God told a few of us, fervent NAPPERS,
That all sexes are filthy,
They're hairy holes, and they're stinky,
And, to top it all off, they're kinky.
God gave us genitals so we could multiply,
Multiply, like rats and rabbits.

HE said, "Oh, great prosecutor,
Your purity makes my soul stand erect,
I have no interest for the wormy ways of sex."

God gave us genitals to make us human,
To multiply,
Multiply like rats and rabbits.
God gave us genitals to make us fecund,
To make us fervent NAPPERS.
To multiply,
Multiply like rats and rabbits.

(The Prosecutor's cell phone rings.)

PROSECUTOR: Hello? Mister Inquisitor! How are you? Really? You're burning down our National Archive? How moving! Oh, and our Monsignor Lawless is starting his livecast on the Internet? I'll log on right now. Bye!

(She approaches Sor Juana's desk.)

Get out of the way! What is this piece of shit? How do you turn it on? What's the password?

JUANA: I don't know, Mother, I just use it for word processing.

ATTORNEY: Hit *enter*.

PROSECUTOR: By the holy foreskin! How many MBS does this mother have?

JUANA: I don't know what mother you're talking about, Mother. Or anything about those BMS, either.

ATTORNEY: Back it up and initialize it.

PROSECUTOR: I'm referring to the memory, Sister, *rams*. Is your scanner manual or a flatbed?

JUANA: I don't know, Mother. I think it's a cot.

ATTORNEY: Don't press undo! You've fucked it up now.

PROSECUTOR: Madame Marquise!

LYSY: By the way, allow me to introduce you, Sor Juana Inés de la Cruz, and the Prosecutor, Mother Condom Rice.

JUANA: My pleasure, Mother.

PROSECUTOR: You won't be so happy when you hear what I've come to tell you, Sister. I want you to know that your virtual performance art piece on the Birth of Christ does not qualify, and it is prohibited on the grounds that it offends intimacy, genitality, and human reproduction according to the regulations for spectacles mandated by the municipality.

JUANA: But Mother! This performance is being presented in the Capital!

PROSECUTOR: But you have Susan Sarandon in the cast, and she's a hippie radical, plus Trudy Guiliani says it's a piece of shit.

LYSY: Address my client more respectfully!

PROSECUTOR: Attorney, you be quiet and stay over there. You've already forfeited your Christmas basket.

ATTORNEY: As the Vicereine, I demand that you reinstate the Christmas basket for the Attorney, and that you add a couple of cheeses and some eggnog.

PROSECUTOR: I'm sorry, Vicereine, but that attorney is an asshole. By the way, the performance can't be presented anywhere else either.

JUANA: Excuse me, Mother, but I removed that scene of Mary Magdalene table-dancing.

PROSECUTOR: According to chapter 9 of the law of public spectacles, Article 140, it is absolutely forbidden to display a naked human body in any establishment, as well as any sexual acts that go against morality and good manners, as well as any other act that goes *contra natura*.

JUANA: But Mother, what is really contra natura in my view is the current attack on Iraq and our civil liberties.

PROSECUTOR: We have resolved that issue. Don't you read the newspapers? But don't change the topic. We have concluded that your show is destabilizing. Why do the subalterns have to speak? Don't you understand that it provokes subversion? People are the ones who provoke violence. Why would they go out in their cars if they know they're going to get stolen? Provocation. Anyway, you're an emissary from the past. Can you tell me why you mention events from 1995 in your performance?

JUANA: I'm only trying to give some historical fundamentals.

PROSECUTOR: I see. Fundamentals, is it? And they say that we're the fundamentalists.

(The President comes on the screen with whatever news made the headlines that day. "Economic recovery is not only wishful thinking. It's bushwhacked idiocy.")

JUANA: By the way, Mother, who is that guy? No one remembers him anymore.

PROSECUTOR: He was a functionary of the past regime, but he died at the hands of his wife. And because we're behind in cataloging, his name hasn't been entered into the database yet.

JUANA: And what happened to Subcommandante Marcos?

PROSECUTOR: His cause became meaningless. Now that we've exterminated all the Indians in the country, the Zapatista movement has become obsolete—good riddance! But I'm the interrogator here, Sister.

LYSY: I demand that you respect my client's human rights.

PROSECUTOR: The Commission on Human Rights no longer exists, Attorney. That was merely one of the excesses of the last regime. And to make sure you learn your lesson, you've just lost your bonus and your Christmas blanket.

(The Attorney, dressed as the Vicereine, becomes desperate and starts to cry.)

Now you've done it, Attorney. You've made the Vicereine cry! You're fired!

(Lysy laughs at the confusion.)

JUANA: All right, Mother. I want to know exactly what I stand accused of.

PROSECUTOR: You stage the birth of the Messiah live, and that goes against the intimacy of human persons according to Article 30 of the regulations. Moreover, in that scene, you include a total frontal nudity with the objective of attracting morbid attention and increasing your revenues.

JUANA: But Mother, that is not correct. I never staged frontal nudity.

PROSECUTOR: What are you talking about? Let's look at that Nativity scene.

(Image of the Manger with the classic Virgin and Child pose.)

There! You see! The baby is stark naked!

VICEREINE: But it's a baby!

PROSECUTOR: Baby or not, his disgusting little things hang down.

JUANA: Medical science has still not succeeded in dressing baby Jesuses in utero, Mother.

PROSECUTOR: Well it can't be that difficult. It's like building one of those little ships in a bottle.

JUANA: It seems someone has been trying it, and three patients have sued him already, so no more virgins are willing to undergo the procedure.

PROSECUTOR: Well I'm sorry, but this is an obscenity. *(She grabs the Baby Jesus from the Virgin's arms and stabs him against Sor Juana's desk.)* Oh look, a baby's cadaver on your desk, Sister, speared with your paperknife. Sister, you are a confessed murderer.

JUANA: I didn't murder anyone. *(To the attorney.)* You're my witness, Attorney. You too, Lysy, you saw that I didn't do it.

PROSECUTOR: What do you mean, "Attorney"? What's going on here?

ATTORNEY: Let me explain. These fucking lesbians forced me to dress up like this.

JUANA: Retract that "fucking" immediately!

ATTORNEY: You know how homosexuals are. They told me that if I didn't dress up as the Vicereine they'd make me go on the Rosie O'Donnell show. Damn lesbians!

JUANA: That's a lie! He accepted for money.

ATTORNEY: Shut up you fucking nun!

LYSY: Listen here, she's the tenth Muse, the Phoenix of the Americas!

PROSECUTOR: She wouldn't qualify for Turkey of Appalachia. So we can add complicity and intent to deceive in addition to pushing public functionaries into prostitution and travestism. No ladies, the Inquisition's got you now. As the Little Tree from the North said: "We will hunt down the evildoers. Make no mistake."

JUANA: Lysy, I'm lost, but you still have a chance to save yourself.

VICEREINE: No way. The Tribunal of the Holy Orifice is going to hear what I have to say.

(Sings. Music, Liliana Felipe. Words, Jesusa Rodríguez and Liliana Felipe. Performers can add any song that is outrageously bawdy, political, and anti-church.)

PROSECUTOR: *(Attacks the Vicereine and hits her over the head with an enormous volume by Athanasius Kircher)* Attorney, lock this woman up at Bellevue, the Ronald Reagan psychiatric pavilion.

(The Vicereine is dragged out.)

JUANA: *(Crying)* Goodbye, Lysy, my love, and remember. Being a woman and being absent are no impediment to my love for you, for you know that souls ignore both distance and sex.

PROSECUTOR: And you, enemy of Mexico, give it up. You're going to rot in Almoloya. Here is the sentence passed by the Holy Tribunal:

Edict:

In exercise of the power vested in us, we, the NAPPING Inquisitors against depraved heresy and apostasy declare:

Hitherto, the virtual performance art piece proposed by the nun, Sor Juana Inés de la Cruz, is banned *In Totum.* Or better still, the work of the aforementioned nun is banned *In Totototum Piarum Aurium.* And it will be banned by the Holy Orifice in any language, even for those who do not know how to read, even in books-on-tape. It cannot be translated, nor printed, nor pirated on pain of *Excomunio Ipsofacto Incurrenda.* And aforementioned nun will remain in custody for the rest of her days to write the hagiographies of the saints: Saint Jesse Helms, Saint Strom Thurmond, and Saint Clarence Thomas.

Furthermore and in addition, all instruments of torture that were on display in the Med School and expropriated by our party for the benefit of morality and good manners in our nation, will be tested on Sor Juana to see if they still work.

Ours by the grace of God.
Mexico, ever true.
National reAction Party.

(Exits)

JUANA: *(Desperate)* Gods! This was the democratic change we were waiting for? We've moved from the dinosaurs to the fundamentalist troglodytes. Poor Mexico, so close to God, so far from the United Way. The beginning of the NAP for the elite, and the end of the nap for the workers. The worst torture is to lose hope. I will write my epitaph.

"I, Juana Inés de la Cruz, ratify my version of events and sign it with my blood. I wish I could let all of it out in benefit of the truth. I beg my beloved sisters to take pity on this country and not vote either for the dinosaurs or the troglodytes. I, the worst of all: Juana Inés de la Cruz."

(Condemned unto perpetuity, Sor Juana finished her days in the Almoloya prison. Others, however, were set free after proving their innocence:

Pinochet of Chile, Kissinger of the U.S., Menem and Cavallo of Argentina. The list goes on and on. To conclude, we will listen to the opinions on Sor Juana offered by the moral authorities of the Americas.)

John Asscroft: We also know the nun by the name, Sin Laden, aka, the avocado.

Trudy Guiliani: These stockings look better on me than they did on her!

University President Slumbers: Now they've caught a fat fish!

Reverend Farewell: It's all their fault, fucking commie lesbo bitches.

Phyllis Shatly: Kill that anti-life freak.

President Bushed: Can't talk now. There's an orange alert. Or is it yellow? Or red? Dick . . . !!!!

The End

Nahuatlismo: The Aztec Acting Method

JESUSA RODRÍGUEZ, Conversation with Diana Taylor

Translated by Marlène Ramírez-Cancio

What I'm going to tell you sounds kind of exotic, but it's really the result of my past fifteen years working onstage. I've been tying together the loose ends of a rarely studied and very obscure world: the theatre and acting techniques of Mesoamerica. Since I don't know of any studies that deal specifically with Mesoamerican theatre, how can I deduce that there's a Mesoamerican acting technique? So this is what I've been working on over the past fifteen years. Alfredo López Austin, in his book *The Human Body and Ideology: The Conceptions of the Ancient Nahuas* (which is the first great systematization of the Mesoamerican worldview), refers to the soul as three entities: Tonalli, Teyolía, and Ihíyotl, three souls in the body. One, which is here in the back of the head, is called Tonalli. There is another one in the heart, called Teyolía, and another one in the liver, called Ihíyotl. Each of these souls has its own functions and protective deities. But there are important differences. The Tonalli is the soul that enters and leaves the body; this is the soul that travels while you sleep at night, and then comes back. This is the soul that leaves and comes back every time you sneeze, or whenever you yawn, or when you're startled, it leaves. That's why it's not good to sneeze and keep talking, because when you sneeze, your Tonalli leaves, and you have to wait a little bit, and then it comes back. At that moment, anything can enter your body. However, the soul of the heart and the soul of the liver only leave your body when you die; those two souls will exit only at the exact moment of your death. You will release them like humors.

It's a different worldview and understanding of the human body. When you divide your body in a different way, which isn't the way you're used to dividing it, you feel other things. When you name your body in a different way, you feel it in a different way. Every part of the body is appointed its own function. So for instance, the hand, which is the number five, in Nahuatl is called *macuilli*, meaning "open hand." But at the same time, the other function of the hand, which is to grab, is also named by the hand—"that which grabs." "That which hits" is the fist. The function is in the name. *The Human Body* by Alfredo López Austin is a book you can read your whole life. It was the springboard for my work on all these ideas.

Over time, I began to notice that something was happening to the characters I was developing. Suddenly people started asking me, "How can you look so much like President Salinas, or Carlos Monsiváis, or Marilyn Monroe?" And I'd say no, it's not that I'm identical, because it's not enough for you to just wear the mask or the costume of a certain character to look like him. The question is rather: What goes on beyond the costume?

I started to see where I could take it, and then in López Austin's book I found an interesting function of the liver soul. For example, the Mesoamericans attributed the function of memory to the heart. You remember with your heart. In fact, the Latin root for "remembering" (*recordar*) is "to pass once more through the heart," isn't it? Not necessarily through the brain, which is the ultimate organ for the West. This soul of the heart is the soul that remembers, while the liver soul is the malignant soul, the soul that disguises itself. It is the "nahual." That's where I started to put two and two together.

It sounds totally absurd to say: "Act from your liver." Nobody would understand what you're talking about. How can you act from your liver? But many years ago I realized that whenever I was really angry, when something had happened to me, even something stupid—like the gas for the hot water heater hadn't been delivered, but I had to take a shower to go to the performance, and I'd get angry—when I'd get to the theatre with that rage, my emotions flowed incredibly well during the show. Weird, huh? And I would always say, "Rage is a great emotion for actors, because it opens all the channels of expression." And then of course, I associated rage with the liver, with bile.

Now I'm reading a lot more because the topic of Nahualism is very broad. I asked López Austin what Nahual meant to him. Nahual is something so broad, because Nahual is something we all have, each one of us has his or her own Nahual, that is, your own animal, which is the ani-

mal that corresponds to you by birth, by your day, time, year, and place of birth. The Aztecs would read a child's Tonalamatl right after birth. Who will this baby be? This was the tradition, and when children were born they would have their Tonalamatl read, to find out about their destiny, their occupation, and their purpose in life.

When people would ask me how I developed my characters, I'd say, "Well, I never imitate, I don't watch videos to see what gestures Salinas makes, I simply work with what I remember of the character." Little by little, through the ideas of the ancient Nahuas, I started making connections, because they say that the Nahual is a soul that leaves your body and can steal another person's essence—or it takes a bite of their essence and then takes hold of them, of their substance. Each person has his or her own substance. If you manage to suck it in, to possess it, then you can reconstruct that person inside you and let it express itself. I see you, and I leave, and every time I think of Diana, I think of that substance. I don't think of the details of your eyes or of your body, but I have a substance that is Diana. And if I appeal to that substance and I use it through my liver, my Ihíyotl, my soul that's right here, in my liver, then I can reproduce Diana, and not only can I reproduce her, but I can think like her. If I let the substance that I stole from Diana take its own course, it begins to have a life of its own, its own way of thinking.

During these past eight or ten years, when I've been performing many characters, things have happened to me. For example, I'd tell myself, "This woman will be against the legalization of abortion." Then I'd get up on stage, and the character would say she was in *favor* of legalization! And I'd say to myself, how can this be? I had planned for her to be against it, and now the character is in favor of it—and I couldn't go against the character. Dostoyevsky used to say that he constantly created characters that he couldn't stand, who would say things he didn't want to say, but he couldn't betray the characters. I can't betray the characters. Actually, what I'd experience wasn't exactly whether or not to betray them. The characters would betray me. I wanted to say other things, and the characters would articulate a different idea. Suddenly I'd be playing Salinas de Gotari, and he'd answer like a man I didn't know, he'd say things I didn't know, but not like a medium that goes into a trance, but I myself, perfectly conscious, even conscious of how to make it funny, things like: "Sir, it's not the right time, it's not the right time or the right circumstances to answer this question. But let's go to the men's room, and there, with my heart in my hand, I'll give you an answer." Can you imagine! I've never in my life peed like a man, much less in a urinal—oh, because that's what I said to him, I said "from one urinal to another, with my heart

in my hand." Of course, it was a joke about having his penis in his hand, but I was horrified, because I was in an everyday situation for two men, but it was completely foreign to me. And there I was, replying with such ease, as if I'd been peeing in men's bathrooms my whole life. When the show ended, there were people who thought I was a man. One time I was playing the role of Carlos Monsiváis, one of Mexico's most important cultural theorists, and suddenly my responses were fast and agile, at times I felt I knew secret aspects of Monsiváis. I started to think something was happening, that I was handling other people's substance—which wasn't something external, formal, but something that was really shared, much more internal. When you open up that source, you can improvise much better, because the person speaking is *that person*, right there next to you, another mind is responding inside you. The miracle of the actor is entirely fulfilled: two people in one. Well, this is what I was going to tell you about.

The Conquest According to La Malinche

JESUSA RODRÍGUEZ

Translated by Marlène Ramírez-Cancio

In this conversation with Diana Taylor, Jesusa Rodríguez illustrates how Mexicans tell entire histories using the verb *to tell* in all its manifestations. Here, she assumes the role of Malinche, telling about the conquest of Mexico in terms that point heavily to the political corruption of Carlos Salinas de Gortari, president of Mexico from 1988 to 1994. The video of this conversation, as well as the *Nahuatlismo* one, is available on the Holy Terrors website.

This is La Malinche, the woman I was telling you about, from the Conquest . . . "Good evening, dear urinal-goers. Today I have come to inform you, or to tell you, or to narrate to you, what really happened when what happened came to pass. I mean, that time when it happened, whose annals are so faithfully recorded by Bernal Díaz del Castillo and Fray Bartolomé de las Casas. It so happens that we were all looking into the black mirror of Tezcatlvisa, when suddenly the Tlatoani, our leader, says, "Look," he says, he tells me, "look Malinche," he says, he says, "look," he says, "go check it out, go, go to Veracruz," he tells me, "because I think what I'm seeing here is turning ugly," he tells me. And I tell him, I tell him, "Oh really? Why?" I tell him. "Well cause I say so," he tells me. "Well," I say, "if you say so," I tell him, "what can I say?" And then he tells me, he says, "Well, then go," he says, "and see what you can tell me." And so then I went to Veracruz. It was amazing, because by that point, this Tlatoani had got it in his head that he wanted wireless Papantla bungee jumpers, to modernize the state or whatever. So I got there, to Laguna

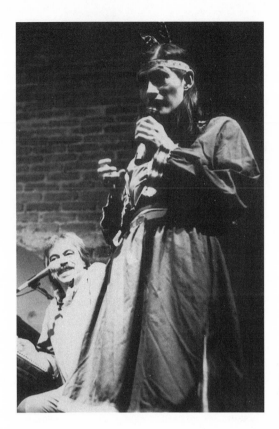

2. Jesusa Rodríguez as La Malinche. Photo courtesy of Jesusa Rodríguez.

Verde, and just imagine my surprise when I see these conquistadors walking my way, and they were half-man, half-hotpant! And then I tell one of them, I tell him, "What?" I tell him. And he tells me, he says, "Nothing," he says, "you tell me." "Oh yeah?" I tell him, "*you* tell me." He tells me, he says, "Look," he says, "we," he says, "we want you to tell us." "Oh . . ." I tell him, "and what should I say?" I tell him, "Tell me what you want me to tell you, and I'll tell you," I tell him. "Cause if you don't tell me, then how am I gonna tell you?" And he tells me, he says, "Look, just tell us where the water is," he says. "We're looking for Evian water." And I tell him, I tell him, "Evian *quoi*?" As if I couldn't speak French, right? And I tell him, "I'm the first cunnilingual translator of Mesoamerica." Then he tells me, he tells me, "No," he says, "Evian water, of the pure kind," he says, "they already told us you can tell us how to find the city that has this water." I tell him, I tell him, "Well yeah," I tell him, I say, "but what do you say?" [*Extending her hand for money*] "You don't say," he told me, and I tell him, "Okay," I tell him, "you said it, let's go," I tell him. "Just don't tell anyone," I tell him, "cause if you go around telling, then

they'll come to me and start telling me 'Why'd you go around telling?!'"
"No," he tells me, "I won't tell," he tells me. "Okay," I tell him, "perfect,
if you tell me you won't tell, then let's go." So off we went, and we were
walking to Tenochtitlan, and we passed through Ixtapalapa, and every-
thing was falling apart over there. There wasn't even any water left, but
I didn't even tell them, cause if I told them then they'd tell me, "Why'd
you go and tell them?!" That's why I said, "Look," I tell him, I tell him,
"go ahead," I tell him. Then he says, "Well, if you say so, I'll go ahead."
Then we really got into a horrible jam over there, and well, they told us
we could all go to hell. "What did they tell you?" I tell him. "Nothing," he
says, "what did *you* tell them?" "Nothing, what could I have told them?
I'll just go around telling and then they'll tell me." "Oh!," I say, "you're the
one who's been telling." "No," he says, "I didn't say anything!" "Listen,
don't even tell me," I tell him. "Let's go to the palace." And so we get to
the palace, and there's the great Tlatoani, and he was, well, in a manner
of speaking, he was saying something to everyone, and I tell him, I tell
him, "Oh Great Tlatoani, these gentlemen have come to tell you some-
thing. They want to say something." He says, "why don't you tell me?"
he tells me. "No," I tell him, "they should tell you. I shouldn't have to
tell you anything." "No," he says, "you tell me." "Well, okay," I tell him.
"After all, I'm the only one here who knows how to say anything. But
anyway. They say they want to buy the city's spring waters from you."
Then he says, he says, "Well," he says, "you don't say. Let me see, hold
on, I'll tell you in a second." And he goes back there and meets with Lilia
Patricia, his wife, and you can tell they have a very good relationship,
because he tells her, he tells her, "Listen, they say they want to buy the
spring waters from us, what should I tell them?" he tells her. "Just sell
them, you fucking idiot!" "Oh yeah, I guess," he says, "right?" It's great to
have such a clear and honest relationship with people. So he comes back
and says, he says, "Alright, I'll sell them to you." I mean, they sold them-
selves so easily over there, so I tell him, "Tell me how much they gave
you," I tell him. "I'm not telling you," he tells me. "Well," I tell him, "why
not?" And he says, "Cause you'll go around telling." And I say, "What
have I ever told anyone?" I tell him, "Who's told you I've been telling?"
"Well, they just told me," he says. And I say, "They shouldn't go around
telling you! I never said anything." Anyway. The point is that he starts
saying the spring waters had been emptied out, so the sewage channel
of Mexico City, which used to be like this, sloped downwards—so that
all the shit and the filth and the nastiness that comes out of the human
body could go down—it turns out that by now the great channel is like
this, going up. We're the only city that pumps shit uphill, and it's incred-

ibly expensive. But one of these days, all the shit will come back to us, and that's why I'm narrating the true story of the collapse of the great Tenochtitlan. That's the way it happened, and it was the great Tlatoani's doing. I have spoken. It's a way of narrating the conquest with very few elements.

Excerpts from "Genesis," "Barbie: The Revenge of the Devil," and "Censorship: The Bald Rat in the Garbage"

JESUSA RODRÍGUEZ

Translated by Roselyn Costantino

"Genesis"

Inspired by the expulsion of the triumphant beast, Giordano Bruno.

Interlocutors:

GOD

MOTHER NATURE

In the beginning the earth was without form; nothing could be seen in the darkness; there was only chaos. The Spirit of God played squash in the void . . .

First Dialogue

GOD: Since, if in body, substance, and being nothing existed but men and women, varieties and vicissitudes, nothing would be good, nothing convenient, nothing delightful, nothing delicious.

MOTHER NATURE: Very well, Eternal Father, but why, if you are my Creator, did you make those "rare ones," the ones they call "queers?" Why, Origin of Origins, did you make beings that go against nature? I can accept that there are bastards, eunuchs, madmen, mindless people, but why queers, my Father?

GOD: We simply see that all pleasure derives from certain difference, course, and movement. Given that it is tedious and sad if the only people

to exist are ones with two testicles, and it is unpleasant and tiresome if the only ones to exist have two ovaries, then, that which gives us pleasure is the passing from one state to another with all its intersexual ambiguities. The state of venereal ardor torments us, the state of steaming lust afflicts us, therefore that which calms us is the passing from one to the other; in no absolute condition can pleasure be found. Fatigue is not pleasant, but it becomes so after rest.

MOTHER NATURE: If it is such, if in movement there is participation in that which is pleasurable as well as that which is bothersome, then there is no pleasure without a mixture of sadness.

GOD: And so it is. He who does not know the efficiency of pants and who then puts on a skirt, does not enjoy the breeze between his legs. In the same way, I, GOD, on certain occasions, becoming bored with my condition of being GOD, take a vacation and buy myself some Chanel and put it on. In the same way the cowboys find themselves a whore and distract themselves. To he who has lain down or sat, it is pleasurable to walk; to he who has walked, it is a relief to sit down. He who has spent much time locked in a closet finds pleasure on the balcony; and he who is fed up with stripping naked becomes a nun. Frequently eating a delicacy, as delicious as it may be, ends up causing nausea. And so it is satisfying to experience the mutation of one opposite into the other through activity, and the movement of one opposite to the other through its middle; and finally we see so much familiarity of the opposites amongst themselves that they become more comfortable among themselves than with their own kind. And so, "a straight who goes with another straight" is also homosexual.

MOTHER NATURE: And so it appears to me, since justice is not applied in the act but wherever the error lies, harmony exists only where there is contrariness; that which is spheric does not rest in the spheric but only touches on one point; but the concave, yes, rests on the convex.

Morally, then, why are there gays and lesbians if the arrogant cannot harmonize with the arrogant, the poor with the poor, the miserly with the miserly; but one finds pleasure with the humble, the other with the rich, another with the splendid. However, men find pleasure with men, women with women, and straights with straights. Therefore, all that you have professed is very true, but I would like to know, my GOD, why, for what end have you pronounced it to be so?

GOD: What I want to infer is that the beginning, the middle, and the end, birth, development, and the perfection we see, all exist beginning with the diverse (queer), through, in, and for the diverse (queer). And where

there is difference there is action and reaction, movement, multiplicity, order, levels, succession, and vicissitude. Because no one who reasons soundly would ever knock down or exalt his spirit for being and owning the here and now, even though in comparison with other habits and fortunes it seems to him good or bad, better or worse. In that way, I, with my divine object which is RIGHT ON, so long fugitive, occult, depressed, and submerged, by edict of destiny, I have judged that term as the principle of my return, apparition, exaltation, and magnificence; which will be even greater as the ways of sexing become evermore different.

MOTHER NATURE: And so it happens with he who desires to elevate himself on Earth, leaping nobly, that he must first bend over. He who plans to jump efficiently over a pit, at times measures the impulse, stepping back eight or nine paces.

GOD: We do not see that all pleasure consists of transit, course, and movement. Given that the state of man is bothersome and sad, the state of woman unpleasant and heavy, then that which gives us pleasure is the passage from one state to another. The state of venereal burning torments us, the state of unbridled lust afflicts us, then that which gives us peace is the movement from one to the other.

In no present condition is there pleasure, if the previous one did not come to annoy us. Sexual identity is not pleasurable except when doubt appears; in rest there is no pleasure.

MOTHER NATURE: If it is so, if in the participation of both pleasures movement exists, the participation of both that which brings pleasure and that which disturbs, then no pleasure exists without a mixture of sadness.

GOD: And so it is. Homophobia is closeting.

MOTHER NATURE: And so my Lord, must I admit that those "anti-natures," the queers, the different ones are my complement?

GOD: You yourself have said it: the Merms (persons with testicles who display other sexual female characteristics), the Herms (in whom appear at the same time a testicle and an ovary), and the Ferms (persons with ovaries but with masculine sexual characteristics) are the mirror, MOTHER NATURE, where you are reflected into infinity.

MOTHER NATURE: If to be nature I must be unnatural, then not believing in You should, once in a while, be my dogma of faith?

GOD: How do I know, MOTHER NATURE! I made you so you would doubt my existence. If God were man, I would be a woman, if God were queer,

he would be a topic of feminist debate. I am what I am, I am God and God is queer in order to keep on enjoying being God.

"Barbie: The Revenge of the Devil"

The Devil, played by Jesusa Rodríguez, nude, with large wings, a white painted face, and two small white horns, sits on a small square box/ pedestal reading The New York Times. *The black stage floor is littered with white water cooler cones; we see a small chemical lab table and, behind the seated Devil, a tree-like structure covered with large, sweeping cobwebs. The Devil is sobbing, in agony, as she reads.*

Aye!!!!! How can human beings be so evil!!!
Homicide, robbery, rape, torture, missing people!!
I can't believe this!
A touch of evil . . . a human perversion!

(The Devil first moves into a Rodin's Thinker pose, and then stands up to proclaim:)

This is too much, I will punish you!
All my anger will fall between your eyes,
on your children. *(Pointing to the white cones)*
Look at them! They are the world!
There will be a terrible poison!
Ya! Ha! Ha! Ha! Ha, ha, ha, ha, ha, ha!!!!!

(The Devil laughs. Throughout the piece, Jesusa's laugh recalls those evil laughs of early Hollywood horror films. She jumps off the box/pedestal and goes over to the lab table. Dry ice is boiling over.)

Double, double, toil and trouble, fire and burn, etc., etc.!

(On the table she has a pile of white cones, resembling KKK *hoods with black painted eyes.)*

These are the souls of those who already belong to me:
Reagan, Thatcher, Khomeini, Oliver North, Pinochet, Viola, Videla . . .
There are thousands! *(Pointing to the caps on the floor)*
Those are the few pure souls that live on the face of the earth . . . they will be the victims of my curse!!

(In a glass beaker she concocts a mixture that includes large plastic insects, some of which she throws at the audience. The concoction bubbles over. She takes a drink.)

238 Jesusa Rodríguez

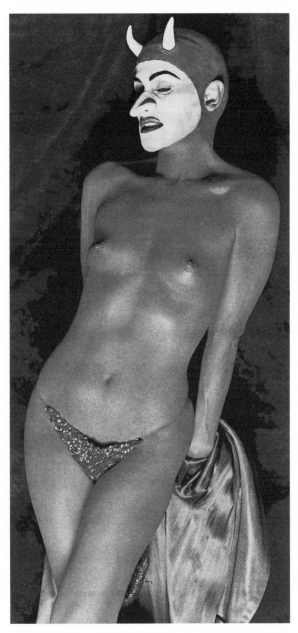

3. Miss Devil, played by Jesusa Rodríguez. Photo by Adolfo
Pérez-Burrón.

Glug! Glug! Glug! Glug! Glug!
It should be acid, like rain.
What kind of poison should it be?
Oh God! Enlighten me!!!

(A spotlight encases the Devil. Naked except for wings and horns, Jesusa moves toward the audience, picks up a microphone, and begins to move sensuously to a cumbia rhythm as she sings in Spanish.)

It must be a fine poison.
It must be something very special
that will madden all the little girls of the world
and their mom and dads.
It has to be a subtle poison.
With hair and vinyl.
Something gossipy, meddling, flirtatious
that everyone adores–a fetish!
Like this *(Imitating penetration with her hands)* it will penetrate
the world!
Like that, it will penetrate the whole world!!
The poison and its double.
Its rage and ecstasy will reign supreme over Man.
The vortex of buying happiness for the innocent.
Imperious amongst men.
A fetish!!
Like this it will penetrate the whole world!
(The Devil moves back to the table.)
Eureka!! I've got it now!
(Mixes up another potion and smells it, then takes a drink)
Aye! Ohhh!! Ughhh!
It smells like Catsup!
Glug! Glug! Glug! Glug! Glug!
Ughhhhhhh!

.

(She rubs her stomach as she grimaces. She's about to vomit. She walks over to the pedestal, and lifts up the top, converting it into a toilet. She sits and strains as she attempts to relieve herself. No luck, so she gets up, pops a cigarette into her mouth and walks to the edge of the stage, asking for a light from an audience member. With her lighted cigarette, she returns to the pedestal-toilet, takes off her wings. Sitting, again she strains and groans, and, eventually, is successful. She stands up, looks into the

toilet and screams. She runs to the lab table, picks up some tongs, and tries to fish something out of the obviously smelly toilet. Finally, from the toilet she removes the basin bubbling over with dry ice, takes it to the lab table, and fishes something out. It is a naked Barbie doll. She takes a cone, fills it with the poisonous liquid, and ceremoniously baptizes Barbie.)

I pronounce you Barbie as a tribute to Klaus Barbie! Isn't he memorable!
(Moving toward the caps on the floor)
My sweet little Darlings! The hour has come! This is your end!
All the perfume in the world will not sweeten this little doll!

(The Devil, still naked, puts on red Converse sneakers and begins to step on and squash all the little white cones on the floor. She works to the rhythm of a harpsichord, destroying all but two. She approaches what she thinks is the last.)

The only soul that I will save! My own!

(Black out. When the lights come up the floor is still littered with smashed cups.)

Look at this! What are you doing? You bastard!
The poor little girls! It seems like a street in New York, all that trash!

(She pulls on the edges of the tarp covering the floor, and drags it so that all the cones form a small pile in the center. To complete the task, she walks along the front row of the seated audience, still naked.)

Tonight will be the conquest of the universe!
Macy's, Bloomingdale's, Sak's, McDonald's, General Motors.
Everyone will sell you, starting with me!
(She takes out a small washboard and begins to scrub Barbie's clothes while singing "Somewhere Over the Rainbow." She addresses Barbie.)
Oh my sweetie, be quiet my lady.
You will become the center of the family!
(She cuddles the doll, caresses her.)
Hello! How are you?
(She rests Barbie on her neck and suddenly screams.)
Ohhhh! It's alive! It's alive! Get her off me! Get her off me!

(With karate grunts and moves, she pulls Barbie off. The Devil makes a string of indecipherable guttural sounds. In anger at Barbie's behavior,

she places her in a black cage covered with a black cloth and suspended from above.)

Don't make that face! You will be better off!!!
(She goes back to the cage to check on Barbie, pulls off the cloth, and screams.)
Oh my God!!! What have I done!!! She's horrible!!! Mass production!!!
(The cage is filled with identical Barbie dolls.)
This is the end! This is the Plague! This could turn into the Barbie Project!
Anyway, they are my daughters and I have to feed them!
(Singing "One little, two little, three little Barbies, four little . . . ," she feeds dollar bills into the cage. She screams again.)
Aye! I lost my right finger! Come here, come here you Barbie! Cannibal!
(She pulls one of the dolls from the cage and examines her.)
A-sexual! Slot-machine! Plastic bitch! I will make you feel good! Remember Siberia?!
Let's take a plunge! *(She plunges Barbie's head into a container with water.)* Are you feeling alright?

(She takes a butcher knife and mutilates Barbie—cuts off a leg that she picks up from the floor and places in her mouth like a cigar. Metal scraping sounds create an agonizing sense of death.)

This is not too bad! I'm starting to enjoy the job! Let's take another one . . .
(She removes another Barbie from the cage.)
Wow, you are beautiful! And God made you white . . . how wonderful!

(The Devil removes a black cloth covering a miniature guillotine, places a black hood over her head. She then walks over to a small block of wood and with some small sticks, does a drum roll. She then proceeds to place the Barbie under the guillotine, release the blade, and, while laughing hysterically, decapitates her. Satisfied, the Devil returns to the original task and, still laughing, once again she begins to mix chemicals in the beaker.)

Blackout

"Censorship: The Bald Rat in the Garbage"

We invite the free spirits to escape from state and ecclesiastical censorship as well as from self-censorship.

In the end one becomes embarrassed to express simple and evident things because one's expression has become something vulgar and improper.

Against this syphilis of the brain there exists only one remedy: from a position of eccentricity and outside the law, with the freedom of a bird, free of vertigo, to hurl ideas in a totally brutal way.—Oskar Panizza

1. To think and not be able to express our thoughts is the worst of all tortures.

2. Don't laugh at the president, he takes care of that himself.

3. Don't censor yourself, that's the job of the self-censorship of the media.

4. The more you say, the more you will be able to say; the more you think, the more you will be able to think.

5. All topics can be treated with humor, especially those that are the most solemn, for example, yourself.

6. Don't ever rejoice over receiving threats of censorship or of death, even when they serve as publicity.

7. Freedom of expression is also freedom of the idiot. Who is the professional idiot? He who assumes the ridiculous.

8. If you truly want to laugh at the enemy, defend him.

9. When you give in to fear, terror increases; when terror increases, silence kills.

10. In those ultimate situations, like torture, none of us knows what we will say or do.

Note

"Genesis" was originally published as "El génesis" in *Raras rarezas*, a special issue of *debate feminista* 8.16 (1997): 401–3.

The script for "Barbie: The Revenge of the Devil" was transcribed by Roselyn Costantino from a video copy of a 1987 New York performance generously provided by Jesusa Rodríguez. The monologue was in English, the song in Spanish.

"Censorship: The Bald Rat in the Garbage" was originally published as "Censura: La rata pelón en la basura," *debate feminista* 5.9 (1994): 479.

KATIA TIRADO AND
EMA VILLANUEVA

(Mexico)

Katia Tirado was born in Mexico City in 1965. Performance artist, body piercing artist, and actress, Tirado studied acting with Julio Castillo, Rafael Degar, and Juan José Gurrola from 1981 to 1984. Her performances include: *Miss Koatl* (Katastase 90 Festival, Berlin 1991); *Día 28* (Third International Performance Festival, Ex-Teresa, Mexico City 1994); *Jálatela hasta que truene* (Festival Libre Enganche, San Antonio, Texas 1995); *Exhivilización: Las perras en celo* (Fourth International Performance Festival, Ex- Teresa, Mexico City 1995; Carrillo Gil Museum and Merced Market 1997); *Lady Muck and Her Burlesque Revue* (cabaret for the Art Performance Festival Now, Nottingham, England 1996); *Lady Luck* (Bar La Perla and Epicentro Gallery, Mexico City 1999); and *La revolución intervenida, o inciertamente insertada en la incertidumbre* (Festejos del Milenio, Mexico City Zocalo 1999). Her most recent theatre foray is acting in *Lorca sin título* (2001), directed by David Hevia. Tirado's work has been reviewed in the major Mexico City newspapers (*La jornada, Uno más uno, Reforma, Milenio*, etc.). She has been interviewed for *Desnudarse* and *ViceVersa* magazines, and she wrote a short text for *Desnudarse* in April 2000.

.

Visual and performance artist Ema Villanueva, born in 1975 in Mexico City, studied literature at the Universidad Nacional Autónoma de México from 1995 to 1999. She performs in the streets as well as in established cultural spaces of Mexico. Her

at times controversial performance projects, mostly done in collaboration with her partner Eduardo Flores (collective name, EDEMA) include: *Todo se vale (strip-tease político)* (Escuela Nacional de Pintura, Escultura y Grabado "La Esmeralda" 1999); *Pasionaria, caminata por la dignidad* (street intervention 2000); *Clase de dibujo libre* (ongoing project since 2000); *Sex Art* (ongoing project of table dance interventions since 2000); *Ausencia* (Ninth Performance Festival, Ex-Teresa, Mexico City 2000; the Red de Derechos Humanos a Todos Para Todos and the Hemispheric Institute of Performance and Politics of the Americas 2001); *Have You Raped?* (Caja Dos Gallery 2000); *Orgullosamente UNAM* (Department of Political and Social Sciences of the UNAM 2001); and *Rebellion Pose,* an ongoing project of street interventions with Indonesian artist Iwan Wijono. Villanueva has participated in several round tables and conferences in art schools around Mexico City. Her work has been reviewed in major newspapers such as *Reforma, La jornada,* and *Milenio,* and discussed in academic papers and conference presentations.

Wrestling the Phallus, Resisting Amnesia:
The Body Politics of *Chilanga* Performance Artists

ANTONIO PRIETO STAMBAUGH

ella se desnuda en el paraíso
de su memoria
ella desconoce el feroz destino
de sus visiones
ella tiene miedo de no saber nombrar
lo que no existe

she undresses herself in the paradise
of her memory
she does not know the fierce destiny
of her visions
she is afraid of not knowing how to name what does not exist
—Alejandra Pizarnik

Alejandra Pizarnik's poem speaks to issues addressed in the following pages: the relationship between memory and the body, and the scary task of naming the unseen. The poem evokes the image of a visionary woman who renders herself nude "in the paradise of her memory," but who is "afraid of not knowing how to name what does not exist." The image of an artist perhaps, tentatively setting out to name—and thus create—something new. From the safe halls of memory to the uncertain destiny of imagination exposed to public debate, this is a journey that involves the body, not only of she who performs the act, but also of those of us who witness it. The journey may be perilous as well if the artist intends to name that which has been rendered invisible and unspeakable by power. This essay examines the work of performance artists who move us to reflect

on how power splits the body by exercising phallic violence in everyday life, and the way power produces institutional amnesia as a mechanism of silencing and control.

If, as Janet Wolff maintains, the body is a site of repression and possession, a visual marker of social hierarchy (122), it must then tread carefully towards the path of subversion because patriarchal culture has already situated the symbolic regime under which it is read. Performance art has been used by many women artists as a way to engage with how the body is displayed and viewed. As a self-reflexive genre, performance art never takes for granted the premises under which the subject is represented. As opposed to theatre, it doesn't attempt to tell a story by means of actors who represent characters imagined by a playwright. On the contrary, a performance artist may choose to represent herself autobiographically or to raise issues by displaying conceptual personas that can help, in Wolff's terms, question and expose "the construction of the body in culture" (137).

While the use of performance by feminist artists in Europe and the United States has been the subject of numerous studies (e.g., Forte, Phelan, Schneider), less known is the work of their Latin American counterparts. Mexico City–based artists Katia Tirado and Ema Villanueva both critique how female bodies are positioned within patriarchal culture and politics. They not only expose the construction of the body in culture, but also the metaphorical and physical *destruction* of bodies in society. Working in a cultural environment that reproduces the ideal image of women as silent and passive, they aggressively create "noise" within silence, a disturbance not necessarily dependent on speech, for they may resort to the performance of silence as a way of unsettling their audiences into another way of seeing the body politic.

Feminism Debated

Katia Tirado, born in 1965, and Ema Villanueva, born in 1975, represent a new generation of performance artists in Mexico who continue a tradition begun by their senior colleagues. They all work in critical conversation with Euro-American artists and feminist theories, but address issues specific to their context of urban chaos.

In Mexico, the topic of feminist art is controversial, as evidenced in a recent debate between different generations of artists published in *debate feminista*.[1] There, for example, veteran artist and critic Mónica Mayer recalls how women of her generation—born in the late 1940s and early 1950s—took pride in erasing any trace of "the feminine" in their art in order to access the larger (male-dominated) art world (Arias

279). While artists may have had sympathy with the political struggles of women, they didn't believe in bringing them to their work. In fact, during the 1970s and early 1980s, there seems to have been a clear distance between feminist political groups and women artists. This was a time when politicized conceptual art was taken up by the post–1968 generation of mostly male artists who organized in several groups of collective art (Bustamante). Women who participated in these groups, such as Magali Lara, Maris Bustamante, Lourdes Grobet, and Carla Rippey, occasionally took up women's issues in their work but avoided labeling it as *feminist*, a term often seen as ideologically loaded and even colonialist.

Attitudes began to change, however, and the first explicitly feminist group was created in 1983 by Maris Bustamante and Mayer (who studied at Los Angeles's Women's Building). The group's name, Polvo de Gallina Negra, was based on a powder sold in popular herb markets as a protection against the "evil eye." Bustamante explains that the name derived from their finding "a connection between 'evil eye' and our professional role as visual artists in a male-dominated medium" (236). The team sought to intervene in the specular regime of the mass media by strategically getting themselves invited to widely viewed TV talk shows, or making appearances in newspapers, popular magazines, and radio to talk about issues such as motherhood and domestic labor. Bustamante states that the group's goal was to "modify the image of women" in the media, and to "assert our condition of women and our claims in a patriarchal society" (236).

Inspired by Bustamante and Mayer's pioneering efforts, other feminist art groups appeared during the mid-1980s, such as Tlacuilas y retrateras (Indigenous Painters and Portrait-makers) and Bio-Arte. Mayer describes this as a boom of feminist conceptual performance in Mexico, albeit a short-lived one, as the groups disbanded towards the late 1980s and early 1990s ("Del boom al bang," 1). However, women in other areas of the performing arts were also making their mark, notably Jesusa Rodríguez, Liliana Felipe, and Astrid Hadad. While not considered "*performanceras*,"[2] Rodríguez's and Hadad's genre-blurring acts used the talents of conceptual artists such as Bustamante and Laurencio Ruiz, who designed many of their memorable stage props and costumes.

By the early 1990s, a new generation of young women began to be noticed, thanks to their appearances in performance festivals, as well as their many street and independent gallery interventions.[3] Elvira Santamaría, Eugenia Vargas, Lorena Wolffer, Hortensia Ramírez, Lorena Orozco, Doris Steinbichler, Mirna Manrique, and Katia Tirado took up issues such as the body's vulnerability, the body's relation to technology, the intersections of gender and national identity, popular urban culture,

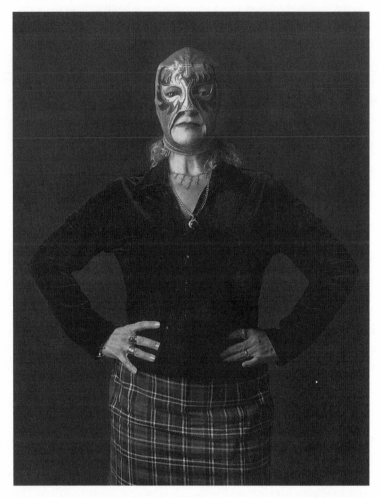

1. Bustamante as "Luchadora"—a female wrestler. Photo courtesy of Maris Bustamante.

and violence. But, perhaps with the exception of Wolffer, none of these artists explicitly identifies her work as "feminist" (Mayer, "Del boom al bang," 1), a decision often associated with the desire not to be pigeon-holed. Recently, Mayer suggested that the basic difference between her generation and that of the younger artists is that, while performanceras in the seventies agreed that the personal is political, those of the 1990s see *the political as personal* (Mayer, "Cuando lo político es personal"). Mayer argues that some artists of the new generation might raise political issues, but "perhaps out of mistrust towards politicians or politics in general, they work isolated," with no connection to larger political movements. However, the individualism Mayer critiques does not apply to all performanceras, as I shall argue in the case of Ema Villanueva, who works collaboratively with grassroots activists. The performances discussed below are testimony to new ways of dealing with politics and sexuality in Mexico.

Tirado and Villanueva belong to a generation that saw encouraging developments such as the neo-Zapatista uprising, an increasingly vocal, if conflictive, civil society, and the crumbling of the PRI's hegemony.[4] On the downside, those years also saw the institutionalization of neoliberal policies best represented by NAFTA, accompanied by the weakening of national sovereignty understood as the ability to control resources. The general crisis saw symptomatic representation in urban violence at nearly uncontrollable levels, the crippling of public education during the UNAM strike, and the strengthening of drug cartels.

These critical issues went nearly unaddressed by the majority of young conceptual artists who are loath to be labeled as political. And while conceptual performance during the 1970s and early 1980s was often highly politicized, the next generation rebelled against this trend, preferring to adopt an art for art's sake position, or to indulge in actions of esoteric intimacy. Tirado and Villanueva are to a certain extent exceptions to the rule, although their concern for the political is shared by a few colleagues such as César Martínez.[5]

As with most Mexican performanceros/as who appeared in the 1990s, Tirado and Villanueva focus more on image and movement than on speech. While Tirado stages a parody of the "phallic war" in which people willingly fight, Villanueva directly addresses institutional amnesia and the role women's bodies play in the public sphere. Their work affects memory without promising to cure amnesia, but moving consciousness in unpredictable ways. The following pages register sometimes dream-like traces of how these works, as well as the artists' own recollections, unsettled my particular memory.

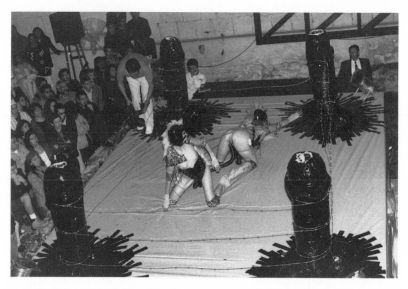

2. Katia Tirado's *Exhivilización: Las perras en celo* (Exhibition/Ex-civilization: Bitches in Heat) recontextualized the popular sport of wrestling, so dear to the urban working class, when presented in Mexico City's museums. When performed in the city's popular market, spectators were taken off-balance by the sight of two semi-naked women engaged in the bizarre conceptual action. Photos courtesy of the artist.

Katia Tirado Wrestles the Phallus

Tirado is a rebel of the theatre arts who studied under the mentorship of director Julio Castillo and later Juan José Gurrola, the first Mexican theatre director to espouse radical conceptual art in the 1960s. Her forays into performance art were galvanized by meeting the likes of Annie Sprinkle and Nao Bustamante during her stay in California in the early 1990s. Tirado's work reflects a fascination with, on the one hand, burlesque cabaret, and, on the other, with punk aesthetics in their original spirit of pure anarchy.

Tirado's work explores certain aspects of what she calls "the contemporary feminine condition" (Interview), and she does this by resorting to archetypal images from different religions, particularly those that display the ability of women to simultaneously seduce and terrorize. Tirado explicitly rejects any pretense of "diva-hood," preferring the role of the freak or the clown who deliberately upsets the viewer's expectations by performing "unsexy nudity" (Interview).

Her hybrid personas are a mélange of female deities of diverse traditions attired with (post)modern imagery, one of her best known being

"Lady Luck," a contemporary, multi-limbed Kali.[6] Through Lady Luck, Tirado wishes to address the relationship between fortune, chance, and the body, as well as "our ability to be gods with and from our bodies" (*dioses a partir del cuerpo*) (Interview). When performing this nonspeaking persona in galleries and bars, Tirado displays extreme concentration while slowly moving her four arms in a hypnotic choreography. She seems transformed—an inhuman creature somewhere between the postindustrial replicant and the archaic goddess. Lady Luck appears as the embodiment of a hybrid, androgynous subject whose religion, nationality, and gender are indefinable. This ambiguity extends to Tirado's back and forth movement from a focused character, owner of her actions, to one that is reminiscent of a marionette controlled by some outside force. This performance is an example of Tirado's cryptic and minimalist line of work exploring a profane, tribal, yet postmodern sacredness. But another aspect of her oeuvre indulges in crass humor, abject imagery, popular sensibilities, and the unabashedly grotesque.

One of Tirado's most important and ambitious performances is *Exhivilización: Las perras en celo* (*Exhibition/Ex-civilization: Bitches in Heat*) (1995–1997). The piece was staged in a wrestling ring in which she and a collaborator appeared down on knees and arms, their bodies linked by a vacuum cleaner tube stretching from one vagina to the other.[7] Their arms and legs were further connected by a series of elastic ropes that made any independent movement impossible. The performers were extravagantly attired as *luchadoras* (wrestlers) wearing the traditional Mexican wrestlers' masks out of which colorful synthetic manes flowed to accentuate their "animality." They wore corset-like vests that did not conceal their pierced breasts or genitals, as well as jaguar-patterned shoulder and kneepads. Tied to their thighs were two kitchen "pistol" lighters. These were their only weapons used towards this game's main goal: to ignite any of the four penis-shaped posts standing at the ring's corners. When a wrestler reached the hole on top of the post and activated the lighter, it would "ejaculate" a firecracker.

The image was of a startling two-headed creature facing opposite directions, but with its two asses aggressively exposed and linked by a tube maybe feeding, or maybe draining each other. Their frantic attempts to reach the huge (1.6 meter) penises within the barbed-wire ring were accompanied by the excited crowd's whistles, cheers, and insults, and Tirado recalls being amazed at how even the artsy gallery-going audience really got into the show, dropping their solemn facades, and yelling exclamations as in any popular wrestling match. During the course of the performance, the wrestlers displayed ambivalent attitudes that wavered

between aggressive competition and tender seduction. Never turning to face each other, they would at times interrupt the painful scramble towards the phalluses to reach back and caress the opponent's skin as they writhed with pleasure, a sadomasochistic spectacle of phallocentric pain and homoerotic pleasure.

Around the elevated ring's base, a series of 64 photographs were projected, showing a shaved vagina with pierced labia from which hung different objects: toy hammers, scissors, screwdrivers, Mexican curios.[8] After four rounds that culminated once one of the women succeeded in igniting a penis, a midget woman (Guadalupe Rosales), dressed as a cross between Miss Mexico and a *quinceañera*,[9] appeared in the ring carried by a man wearing a gorilla mask. Behind them followed a trio of guitar-playing men. The tiny woman climbed onto the wrestlers, standing with one foot on each back; a referee of sorts, although her intervention did not name a winner or loser. She then proceeded to sing popular ballads about love and treason, introducing references to melodrama familiar to all the audience members. The lavishly dressed midget pacified the wrestling creatures with her song, in the process tempering the audience's excitement.[10] But while she was no deus ex machina leading to salvation, she introduced a strangely joyful atmosphere into the wrestling ring. The performance ended with a touch of romance that seemed to comment on how the "war for the phallus" underlies even the sweetest of popular songs.

Exhivilización thrived on popular culture idioms that the previous generation of conceptual artists resorted to as an antiestablishment strategy, while it introduced a punk aesthetic already present in Chilango urban youth culture. The bizarre, violent, circus-like environment is also indebted to Tod Browning's *Freaks*, to the films of Luis Buñuel and more recently Alejandro Jodorowsky (especially his *Santa Sangre*).

The *lucha libre* genre so dear to the urban working class was recontextualized in the Ex-Teresa and Carrillo Gil museum spaces attended by the cultured middle and upper-middle class. However, Tirado also staged *Exhivilización* in the popular market of la Merced. It was performed without previous warning in one of the neighborhood's small plazas, immediately attracting a crowd that Tirado recalls was taken off-balance by the sight of two semi-naked women engaged in the bizarre conceptual action (Interview). While the audience appeared to enjoy the unexpected spectacle, Tirado said she could also feel the morbid attitude of several men, an attitude that the audience of the gallery performances might have shared, but that in la Merced was apparently more explicit.

In spite of the fact that performance art pieces often go unnoticed by

the Mexican press due to the virtual nonexistence of critics interested in this genre, theatre critic and playwright Jorge Kuri devoted one of his columns to an extremely positive review of *Exhivilización*. Kuri reads the performance as a conceptual wrestling match between archetypal opposing forces, a ritual act that takes "the condition of femininity to its last consequences," although his gloss on this "condition" is problematic: "If the condition of the feminine is not apt for battle, that's where the outstandingly unusual nature of this wrestling match resides, for here the feminine harbors within itself an ambiguous condition that wavers between the erotic and the deadly."

Kuri sees in Tirado's "paratheatrical" show a postindustrial return to Dionysian rituals, reminiscent also of gladiator combats and bull fighting. But among all these references, the reviewer significantly omits any mention of the phallic sculptures or the vagina images. Other brief descriptions of the performance in the press mention the "biomechanical sculptures," without saying they are penis-shaped. Are we before an issue of censorship, or rather the anxiety of male critics unwilling to engage symbolic genitalia? Kuri does, however, acknowledge *Exhivilización's* ironic tone, present for example at the performance's conclusion during the small lady's singing number. As in the work of Astrid Hadad, here popular Mexican sentimentality as it's conveyed in ranchero songs was cleverly ironized.

This stereotypical aspect of the "Mexican character"—prone to melodramatic emotion, anarchical *relajo*,[11] and violent machismo—is deconstructed by anthropologist Roger Bartra. Bartra argues these sentiments are cast into potent imagery by the intellectual elite, fed to the public via cinema or other media, and celebrated by the state. The image of a sentimental, proud, violent, yet ultimately passive Mexican—always coded male—is all too convenient to a political class fearful of a populace prone to rebellion (Bartra 121–25). *Exhivilización's* absurd wrestling match obliquely speaks to these stereotypes, introducing a gender argument. The ring is also a prison-cage in which Mexican women emotively fight but with no winner in sight, just as Bartra's "Mexican of revolutionary modernity, inscribed in a circle that defines his patriotism but that also imprisons him; from violence to emotivity, from emotions to resentment, and by means of indignation, back to violence. It is a permanent circular movement that one cannot know where it will stop, just as in the roulette" (137–38).

Bartra metaphorizes this caged subject by means of the amphibian *axolote* indigenous to the lakes of Xochimilco. The axolote—not accidentally penis-shaped—is a potent symbol due to "its mysterious dual

nature (larvae/salamander) and its repressed potential for metamorphosis" (20). Bartra proposes the image as a way of examining binary constructs underlying Mexican nationalist discourse such as rural/urban and traditional/modern. The axolote's peculiar condition "cages" it in a schizophrenic split between melancholia (tradition) and metamorphosis (modernity), a situation Bartra suggests is symbolic of Mexicans' alleged resistance to change. *Exhivilización*'s dual creature is an axolote of sorts, but the performance does not show the path out of the wrestling ring, nor does it deliver redeeming metamorphoses to cure the axolote's melancholia. It works fundamentally as a parody of modern civilization, as its title suggests, an *ex-civilization* rendered a mere exhibition of vile, base instincts.

The performance's uncivilized wrestling match dramatizes a predicament faced by Mexican women as theorized by Estela Serret. In her essay on the intersections between national identity and gender identity in Mexico, Serret traces the origins of gendered self-perception, which, she argues, is structured "on the one hand, around the feminine-masculine opposition and, on the other, the opposition of antagonistic images of femininity" (262). She examines the theory that argues Mexican womanhood is based on two opposing images: the mestiza Virgin of Guadalupe, symbol of submission and sacrifice, and the indigenous Malinche, who was symbolically raped by the Spanish conquistadores and whose evil resides in treason. Serret points out that these two symbols are ultimately submissive, and thus different from the classic Eve/Mary polarity that underlies Christian attitudes towards women. While Guadalupe is equivalent to Mary, Malinche is different from Eve in that her wrongdoing is passive. Her evil is not diabolical or scheming, but rather linked to subordination, shame, and slavery (Serret 266). This image of double submission, suggests Serret, accounts for Mexican women's traditional acceptance of male domination, and why "the feminine imaginary in Mexico has expressed self-degradation and mutual mistrust between women" (270).

These polarized females are transformed into a bicephalous monster that performs the drama of split subjectivity, a condition examined by Lacan, and of schizophrenia, posited by Deleuze and Guattari as a force potentially destabilizing capitalist rationalism, and by critics like Jameson (63–4) and Harvey (55) as paradigmatic of the postmodern subject. In her production notes, Tirado states she wanted to explore "the schizophrenic nature of the human species, in constant struggle between its animal, irrational aspect, and its civilized, rational one." For Lacan, the subject is always already split, that is, separated from herself inso-

far as she can never exercise self-knowledge completely. The subject's split is essentially a separation between signifiers, and in the process of illustrating this, Lacan recalls the monster or homunculus as a classic Cartesian image separating the thinking "I" from the thought itself (141). Tirado's bicephalous monster is a radically split subject, ignorant of itself and obsessively driven towards the phallus as its only raison d'être. Tirado explained how she set out to convey this: "I always start with a main issue, in this case rivalry between women, and then look for what I call a 'mother image' that will guide the total concept . . . The wrestlers from *Exhivilización* were inspired by a pre-Hispanic codex that showed a serpent-like creature with heads facing opposite directions, like Siamese twins. This perfectly conveyed the image of schizophrenia, of the divided being (*el ser escindido de sí mismo*)" (Interview).

From a pre-Hispanic serpent to a postmodern monster, *Exhivilización* stages a symbolic order that cages the split subject within its perverse game. Interestingly, the source image for this performance was a double-headed serpent, a creature both bicephalous and *bice-phallus*.[12] Could this creature, chosen by Tirado as the performance's "mother" image, suggest a decentering of the symbolic realm theorized by Lacan (Evans 61–62), challenging the symbolic father as a herald of language and law? The multiplied phalluses staged throughout *Exhivilización* serve to underscore omnipresent phallocentricity, but they may also be seen destabilizing the "centricity" of the phallus as a privileged signifier, and with it modern notions of rationality and identity.[13]

The phallic signifier represented by the penis-shaped sculptures is explored in a more subtle yet provocative way in the above-mentioned series of photographs projected at the base of the wrestling ring. Tirado calls them "Nichos púbicos" (Pubic Niches), a play of words between the private, profane pubic area and the public sacredness of churches' candlelit niches. The images are so stark—exposed, pierced labia from which hang miniature toys—they are challenging to watch. The performer's thighs are open, creating an arch, and shown side by side the pictures appear as a row of arches. The artist's intention was to "parody the Roman Coliseum as symbol of Western culture where cruelty was first performed as a circus" (Interview). The niches' toys are defiantly displayed, some as ritual fetishes, others household appliances of sharp, metallic surfaces hanging close to the pierced flesh. They represent phallic decoys and also threatening symbols of castration. "I used objects that represented masculine power," explained Tirado, "and I used them as toys, Mexican miniatures making fun of that great violence of power [and also] of the vagina associated with evil" (Interview). Amy S.

Carroll reads these images in the context of Octavio Paz's argument regarding the "Mexican Woman" as symbolic of *la rajada* or *la Chingada*, the subject raped and wounded by colonialism (Paz 67–80). Carroll suggests Tirado's images expose "the unmistakably female body, but monumentalizing it; concentrating upon the Pazian 'wound' itself, but demonstrating the 'wound's' ability to bear/bare the weight of the symbolic." She further argues that Tirado "creates a tension between the construction of the subject and objects (in the plural), putting into contrast the female body as that which frames objectification, posing the feminine figure as the rafters versus the foundation of national fictions" ("In 'Los nichos públicos,' " 13).

Carroll maintains the "pubic niches" play with symbolic references of Woman and Nation, suggesting the phallic underpinnings of these foundational fictions displayed under the wrestling match. The miniaturized toys, paradoxically enlarged in the projected slides, serve to stress the phallic simulacra of nationalist imagery.

One toy stubbornly hangs in my memory: a tiny devil of the kind representing Judas during Holy Week celebrations in Mexico. These Judases are handcrafted of papier-mâché and full of firecrackers that are noisily ignited to commemorate the stray apostle's self-punishment. The Judas-devil hangs under the performer's genitals, maybe a guardian of the profane threshold, maybe a potential rapist, challenging the viewer to set him off and burn the nearby flesh. The hanging toy/fetish speaks to the ambivalence underlying *Exhivilización*, where love and rivalry, playfulness and violence, humanity and animality, act in suspension against each other.

Tirado's performances address the paradoxes of contemporary women: at war against each other, but also in metamorphosis towards something else. Her biomechanical personas seek to "restore the body's language of memory" within an exploration of "the body as machine" (Tirado, "Concepto"). She works with utopian possibilities of cyborgs as explored by Donna Haraway in her well-known manifesto. And yet, her critical stance in *Exhivilización* seems to caution against cyborgs "without memory" that could potentially lead to the "appropriation of women's bodies in a masculinist orgy of war" (Haraway 154). Tirado's Lady Luck, on the other hand, is a cyber-goddess who masters the language of memory.[14] She is not a split subject, but rather a hybrid, androgynous persona acting with self-possessed serenity that suggests a transformative potential. And it is by means of remembering this latent metamorphosis that the axolote may finally be unsettled into a self-empowering mutation beyond the cage.

However, as the cage is still very much in place, other artists seek ways of resisting the repressive political forces operating within. Ema Villanueva is one such artist who works with a potent mixture of sexuality and politics as a disturbance to amnesia.

Ema Villanueva's Unsettling Memories

Villanueva's work may be read as exercises in what I elsewhere call "unsettled memories." Unsettled memories are narratives that resist official history and challenge the "social institutions of forgetting" whose mission is to deliberately erase memories that are inconvenient to the dominant system (Douglas). Unsettled memories operate within what Chela Sandoval describes as "oppositional consciousness" (54–55) because they are articulated by subjects whose position in society is marginal, who are not only unsettled from power, but are held thrall to it. Subaltern artists and activists may choose to upset and unsettle the anesthetized memories of their audience, in the hope of signaling paths towards politicized remembering.

Unsettled memories call attention to the mechanisms of institutional amnesia, the way power deploys silence and absence to control a population and keep it from demanding justice. "Strong is the silence," writes Elena Poniatowska, imposed on those whose existence is systematically erased by power: political dissidents, the poor, *campesinos* and *indígenas*, or migrants without a fixed home (11). While Poniatowska evokes an oppressed multitude silenced by power, she is mainly interested in the silence of the state, which goes deaf and mute before the injustice it generates. It is in the spirit of Poniatowska's work that I want to examine how Villanueva's performances address the silencing violence of power and also, obliquely, the power silence may have in unsettling memories of violence so as to mobilize an oppositional consciousness.[15]

The performance of silence and absence would seem an impossible endeavor if by *performance* we understand merely audible or visible actions. But as Peggy Phelan and Diana Taylor have argued, performance may also be a powerful means of evoking what cannot be seen. Phelan maintains that "performance is the art form which most fully understands the generative possibilities of disappearance" (*Unmarked* 27), and she specifically refers to an "active vanishing" (19) skeptical of visibility and thus deconstructive of representational regimes. While Phelan stakes the political power of performance in its ability to unsettle the Lacanian symbolic, Taylor addresses the way Argentina's Madres de la Plaza de Mayo stage demonstrations that restore to public memory the young

political prisoners "disappeared" during that country's brutal military regime.

The paradox of performance—a visible act "predicated on [its] own disappearance" (Phelan, *Mourning* 2) and an action that may resurface recollections of the missing—creates a subversive energy very effectively deployed by Villanueva, who considers herself both artist *and* activist (Interviews), and resorts to performance as a way "to fight against forgetting" (Villanueva, "Todo se vale"). One of her first performances—*Pasionaria, caminata por la dignidad* (Passionary, march for dignity)—succeeded in drawing public and media attention to the unresolved political conflict at the National University (UNAM).[16] The date of the performance, 20 April 2000, marked the first anniversary of the beginning of the ten-month-long student strike that culminated in February with the campus's forceful occupation by some 2,300 agents of the newly created Federal Preventive Police (PFP, in effect a paramilitary unit) and the arrest of more than 700 students. Two months later, classes resumed under very tense circumstances, as the students' demands were still unresolved and 264 students remained held in prison. By then, however, the media and public attention had grown tired of the issue, buying the official version that the strike had been "solved" and things were back to normal. On 20 April, spring vacations were under way and PFP agents were posted in the campus to prevent strikers from reclaiming territory.

Villanueva decided she wanted to commemorate the anniversary by means of a performance designed by herself and partner/collaborator Eduardo Flores to coax the public to resume debate over the strike. The artist began by undressing outside a Metro station until she was down to a bikini and high-heeled shoes. Flores proceeded to paint her body one half red, one half black (the colors used during strikes in Mexico), and to write two signs with white paint on her chest and back ("No PFP" and "Libertad"). Villanueva then began her eight-kilometer trek to the UNAM campus distributing flyers with statements on the strike's unresolved issues. More significantly, she invited curious bystanders to overcome their passive voyeuristic attitudes and to paint other words and phrases on her body expressing their diverse opinions regarding the strike. One female bystander painted the phrase "Mirones sin pantalones" (roughly, Gutless Onlookers) on her thigh, challenging the men who jeered and whistled at Villanueva. Most of the slogans painted were supportive of the strike, except for two that read "Huelga manipulada" (Manipulated Strike) and an ambiguous "No sirve" (It Doesn't Work). As she approached the campus, photographers from the press and TV cameras began to appear paparazzi-like to capture images of this "naked activist" who was attempting to dis-

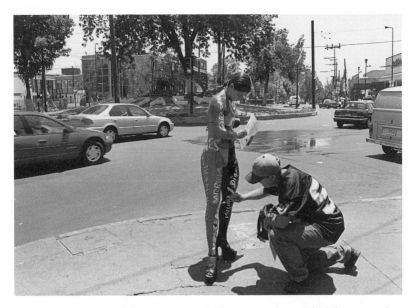

3. In *Pasionaria—March for Dignity*, Ema Villanueva made an eight-kilometer trek to the National Autonomous University Mexico City campus. She succeeded in drawing public and media attention to the unresolved political conflict at the university. Photos by Eduardo Flores; courtesy of the artist.

tribute flyers to the Federal Police. In spite of the fact that student activists were simultaneously holding a meeting at the campus, it's not surprising that the evening's TV newscasts and next day's newspapers focused exclusively on Villanueva's attention-grabbing act.

Villanueva's performance belongs to the tradition of performative and media-savvy demonstrations, not only of Greenpeace and Act-Up, but also of Mexican activists like Super Barrio.[17] Indeed, even the anarchical UNAM strikers became notorious by repeatedly demonstrating half-naked, their torsos painted with slogans. What made Villanueva's intervention different? First, she's a woman, while the image disseminated by the media of protesting students was of a ragged, mostly male bunch of kids out for trouble. In contrast, Villanueva appeared to be dignified while at the same time sensually alluring, walking like a top model down the traffic-jammed avenue, at times pausing to have people paint on her body and to strike a "V for victory" pose for reporters. No screaming, jumping, collective *relajo* here, but a focused, silent, and solo march made eloquent by her effective use of symbolic colors and texts, not to mention exposed body. And while some media reports misrepresented her by saying she was a member of the strikers' council (her flyers pointed

out she was not), and the TV cameras ogled at her buttocks, overall her message went through. One male reporter from Channel 40 said: "The presence of the police body coincided with activities to remember the strike's first anniversary in the presence of *other bodies*, not precisely of repression" (EDEMA video). Villanueva's body was topic for a sly remark that nevertheless made clear who was exerting the repression. While TV reports tended to be more sensationalistic, some newspapers highlighted Villanueva's political message. Perhaps unsurprisingly, it is in the reporting of women journalists where one can find more politically sensitive readings, as in the case of Dora Luz Haw's eloquently titled article "Dignidad en bikini" (Dignity in Bikini). Mónica Mayer wrote that Villanueva succeeded in weaving the social and political context, not only concerning the students' demands, but also of "her own position as a woman who, being both subject and object of the piece, is able to attract the other's gaze by means of her body, and then direct it towards her ideas" (Mayer, "Performance de primera plana"). Mayer also notes that this performance broke out of the cultural pages and into the front-page headlines, as no other performance art piece in Mexico had done before.

In *Pasionaria*, the performer's explicit body appears to go hand-in-hand with her explicit politics, and succeeds in leaving an indelible trace on an urban environment that is already highly saturated with competing signs of all sorts. She played with the viewers' desire at a time when the strike had become an ugly confrontation of radically split fractions within the UNAM and had lost much public support. Villanueva used her exposed body as bait that forced viewers to take notice again and remember the original reasons why the students had protested a year earlier. She seduced, and then forced passersby to *assume a position*, both ideologically and physically, when they had to reach up, bend over, or kneel to paint their views on her skin. Villanueva rendered herself a sign, a walking political billboard so to speak, but one upon which the viewer could contribute her own reading of the issue raised. Rebecca Schneider discusses how several women artists "[manipulate] the body itself as *mise en scène*, [making] *their own bodies* explicit as the stage, canvas, or screen across which social agendas of privilege and disprivilege have been manipulated" (20). Villanueva, too, makes her body a literal canvas as a way of emphasizing how society not only marks the student body, but renders it a sexually charged object of surveillance.

This aspect of Villanueva's work, along with other controversial performances such as *Todo se vale* and *Orgullosamente UNAM*, bring to the public sphere debates on how women's bodies are viewed and concealed at a time when conservative policies jostle with a much more open-

minded urban population. As Jean Franco argues in her essay on public installations in Chile, "the body, long unacknowledged in political thought, is now a major site of contention" (44). Franco examines how claims to democratic modernity in Latin America are put into question by conceptual art that, by resorting to controversial public displays of the body, exposes the contradictions inherent in post-dictatorship governments. In Mexico, the quasi-dictatorial PRI hegemony was recently toppled by a presidential candidate from a conservative political party whose economic agenda is identical to that of his technocratic/neoliberal predecessors. Artists such as Villanueva and others challenge the new administration's democratic claims by means of performances that advocate principles such as freedom of expression. Their work further suggests the body is not only a site of contention, but also *a site from which the subject may think politically*.

In *Ausencia* (Absence), Villanueva aimed to directly challenge Vicente Fox's administration as well as to unsettle her audience into awareness of issues erased by institutional amnesia. First performed during Ex-Teresa's performance festival of October 2000, two months before Fox assumed office, the piece addressed Mexican political prisoners "disappeared" by government forces from the 1970s to the present.[18] She did this at a time when most Mexicans believed they were witnessing the dawn of a genuine liberal democracy, where "dirty war" practices common under the PRI were a thing of the past. Thus, at the outset of the twenty-first century, the *desaparecidos* are doubly absent: in body and in discourse, in spite of efforts by groups such as Rosario Ibarra de Piedra's Eureka committee, which for the past twenty-five years has demanded justice for the missing political prisoners and their families.

On the performative strategies used to address the issue of the desaparecidos under Argentina's military regime, Diana Taylor discusses how the demonstrations staged by the Madres de la Plaza de Mayo very soon adopted theatricality as a way of not only attracting attention, but also releasing repressed narratives into the public sphere ("Performing Gender" 286). This move was extremely effective, as Michael Taussig argues, because South American military regimes actually did not aim to erase memory of the dirty war, but to maintain it alive, although hidden away from public debate. "The memory of protest, and the violence enacted against it by the State, best serves the official forces of repression when the collective nature of that memory is broken, when it is fragmented and located not in the public sphere but in the private fantasies of the individual self or of the family" (48).

The demonstrations staged by the madres prevent the state from lock-

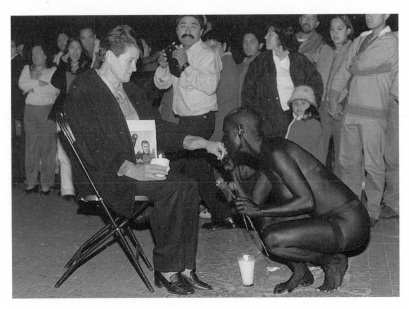

4. In *Ausencia (Absence)*, Ema Villanueva addresses the topic of the *desaparecidos* that had remained virtually undiscussed until recently, especially in the contemporary art milieu. During the performance, she hands the photo of a disappeared son to his mother. Photo by Eduardo Flores; courtesy of the artist.

ing up recollections of terror; they liberate and mobilize that memory in plazas, avenues, and parks in such a way that terror loses its ability to paralyze. The madres resorted to speech, chants, processions, organized silence, symbolic use of white scarves that contrasted with their black clothes, the display of pictures of their disappeared, and other actions. As Taylor puts it, "Through their bodies they wanted to show the absence/presence of all those who disappeared without trace, without leaving a body" ("Performing Gender" 296).

In order to create a performance that resorted to this dialectic of absence/presence, Villanueva approached Rosario Ibarra with her idea to stage a piece possibly involving several of the madres. Ibarra agreed and presented Villanueva to members of the Eureka committee with whom she began to brainstorm.[19]

The first performance was held on 20 October in the newly inaugurated Laboratorio de Arte Alameda which, like Ex-Teresa, is housed in a colonial church in downtown Mexico City. The space used was a huge nave devoid of chairs. The audience, with no instructions about where to stand, entered to find the floor full of altar-like collections of objects placed around candles that served as the only source of light. An elderly

woman sat silently to one side, dressed in black with the portrait of a young man hanging over her chest, and holding a candle. Villanueva entered the space naked and completely painted in black. Uttering no words, she approached each individual altar and examined the objects: toys, photographs, and personal souvenirs belonging to the political prisoners. The performer picked some pictures and tied them to her body, then slowly moved among the audience to the other altars and finally up to the seated woman to whom she gave the framed portrait of her son that had been lying at her feet. She then climbed a scaffold and sat at the top where pictures of young women and men were projected. The soundtrack mixed the voices of people giving testimony of the kidnappings with nondescript trance music. As the images followed one another, Villanueva took dried roses and began dropping their petals to the floor. The projections were followed by a text describing what a desaparecido is ("Not a dead person, but someone illegally held in a clandestine prison"), listing the names of the presidents under whose administrations these kidnappings took place, and reporting the fact that in Mexico two hundred of the missing have already been found and returned alive to their families. The text concluded with the phrase "*El silencio es cómplice de la ausencia*" (Silence is complicit with absence).

While several of the people I spoke with after the performance said they enjoyed it and found the issue to be relevant, months later the festival's curator criticized *Ausencia* for being overtly "pamphletary" (Alvarado). These opinions speak to the conflicting responses that Villanueva's work receives in the performance art world. For some, Villanueva's explicit politics compromised *Ausencia*'s status as a work of art, a view that appears to have left the artist unfazed, for her ultimate goal was didactic, in her own words, "to help raise awareness" (Interviews). Villanueva told me that she was interested in addressing the topic of the desaparecidos because she found it was virtually undiscussed, especially in the contemporary art milieu. Staged in the context of a performance art festival, *Ausencia* betrayed a conflicting tension between the conceptual artist and the activist, especially when Villanueva's phantasmic intervention is replaced by a text that lists facts about the political prisoners, as if her silent act were not enough. Indeed, one could ask: why end a performance of silence with the slogan "silence is complicit with absence" (in obvious resonance with Act-Up's "Silence = Death")? Silence has historically been used as an act of resistance, for example, during 1968's memorable "Manifestación del Silencio" (Demonstration of Silence), when families of the students being repressed and arrested by the government staged a multitudinous march down Mexico City's Re-

forma Avenue wearing tape over their mouths. It would seem more conceptually challenging to go beyond the classic assumption that visibility and speech *always* equal power, to explore the many ways silence and invisibility may also be rendered empowering (Phelan, *Unmarked* 6–10). This is a possibility Villanueva's piece suggested at the outset, but then abandoned in favor of hard facts. She appears to have been overcome, as in Pizarnik's poem, by "the fear of not knowing how to name what does not exist." For the hope is, against all odds, that the missing *will* reappear.

The next staging of *Ausencia* took place the night of 9 December 2000, in the central plaza of Coyoacán, a southern section of the city known for its bohemian atmosphere. This time it was Villanueva who got invited by the Eureka committee to participate in the context of a meeting called "Contra la impunidad, la memoria" (Against Impunity, Memory) organized by the Red de Derechos Humanos Todos Para Todos (Human Rights Network "All for Everybody"). The performance had essentially the same structure, although this time three madres participated, among them Rosario Ibarra herself. In light of the fact that Vicente Fox assumed office as president a week earlier, Ibarra suggested adding to the background video the phrase "Todo gobierno que no libere a todos los desaparecidos el primer día, se convierte en cómplice del crimen" [Any government that doesn't liberate the disappeared on the first day is accomplice to crime]. After the piece concluded, Ibarra took a microphone and gave a short but impassioned speech on the continuing urgency of fighting for justice and for the return of the political prisoners. The moved audience—casual onlookers who happened to be in the plaza that night—enthusiastically applauded and later approached both Ibarra and Villanueva to express their amazement and concern on an issue of which some were completely ignorant.

Somewhere between conceptual performance and agitprop, *Ausencia* resists rigid classifications. Moreover, any attempt to assign a fixed authorship is problematic. Villanueva conceived the piece in collaboration with her partner Eduardo Flores (both of them by that time began using the collective name "EDEMA"), and with input from the Eureka committee. *Ausencia* incorporated the madres' discourse, along with their demonstration paraphernalia: black dresses, their disappeared family members' portraits, and candles. This way, Villanueva wove a preexisting performative tradition into her piece. In turn, the Eureka committee members wove performance art into their demonstration.

The artist's naked body was again painted jet black, simultaneously attracting and deflecting the gaze. Villanueva explains her decision to appear that way: "During my research for this piece, reading and talking to

families of the disappeared, I constantly came across references to how the prisoners were stripped of their clothes and tortured naked. The color black to me represents the body stripped of identity, also the absence of these bodies. I wanted to address the humiliation these people suffered" (Interviews).

Black is conceived in the West as the color of absence and mourning, but can also be seen as the color of possibility and shelter. During the Coyoacán performance, Villanueva acted as an embodiment of the night's darkness, moving from one madre to the next and gently kissing their hands or giving them flowers. Her shadow-presence contrasted with the candlelit faces of the seated women, and the bright pictures projected on a screen above the kiosk. She became disappearance materialized, the negative in search of the positive, a symbolic absence reminding the audience that what's missing may become present again. The performance enacted loss as Phelan discusses it in another context: "Loss acquires meaning and generates recovery—not only of and for the object, but for the one who remembers. The disappearance of the object is fundamental to performance; it rehearses and repeats the disappearance of the subject who longs always to be remembered" (*Unmarked* 147).

Ausencia was ostensibly an attempt to render loss into remembrance and hope. The solemnly expectant women dressed in black, the candles, and objects belonging to the disappeared also strongly evoked mourning. However, this wake is closer to the tradition of indigenous Día de Muertos commemorations (albeit sans sugar skulls) than that of a Western-style funeral. If Phelan argues that "theatre and performance respond to a psychic need to rehearse for loss, and especially for death" (*Mourning* 3), I posit that *Ausencia* was not a rehearsal for death, but a mobilization of memory as it is put into circulation during Día de Muertos, when people return to the cemeteries to commemorate their dead as living presences that return to feast with them. The madres are in no funeral, but rather in a vigil where they silently protest, demand justice, and challenge the state's own indifferent silence.

Ausencia works with the mechanics of abjection as played out by a state capable of disappearing bodies and trampling on legality. The state has disposed of its inconvenient citizens, deploying an abjection that would have the families of the disappeared forget their kin, to the point of banishing "even the shadow of a memory" (Kristeva 5). The Eureka committee and artist/activists like Villanueva refuse to accept the state-imposed abjection, and through their work the shadow of memory resurfaces so that the hope of restored kinship is never lost.[20]

More than thirty years ago, Julio Cortázar described the conceptual

Happening as it was being practiced in the '60s as "a hole in the present" (119). To a certain extent, performance art continues to be an evasive gap in the midst of commodified cultural production, difficult to document, classify, and critique. But it is precisely this "undocumentable" quality that makes performance art an ideal way of staging disappearance. *Ausencia* addresses the continuing presence of loss, the hole left by people kidnapped by government forces and never to be seen again except in the reiteration of their existences through performance. The performance may work on one level to address trauma by means of re-surfacing the repressed narratives of disappearance, but it is not aimed at cathartic cure, nor is it a rehearsal for death. *Ausencia* is a politicized ritual that reiterates unresolved crimes all too easily sucked into the void of amnesia. It cannot fill the "hole in the present," but may unsettle public memory into never forgetting it's there.

Propositional Performances

Ema Villanueva's performances discussed above subscribe to the historical avant-garde's use of art as a political, awareness-raising vehicle, while on the other hand Katia Tirado thrives on staples of postmodern art: parody, irony, the collapsing of high and low cultures, hybrid imagery. However, both may be posited within a specific trend in postmodern performance that, as Philip Auslander argues, engages with the political (58–72). Auslander takes after Hal Foster in suggesting that postmodern politics can no longer be transgressive in the sense of breaking out of discursive and ideological codes in order to critique them. Given how multinational capitalism collapses the limits between cultural, economic, and political practices, Foster calls for "an understanding of political art as 'resistant' rather than transgressive" (qtd. in Auslander, 60). Still, I find that the work of the performance artists addressed here is both resistant *and* transgressive, insofar as it subverts conventional notions of gender behavior (women are not "supposed" to be wrestlers, to publicly expose their genitals, to mix sexuality and politics . . .). Their performances not only share feminist strategies of exposing the construction of the body in culture (Wolff 137), but also expose bodies deconstructed and split by phallocentric rivalry (*Exhivilización*), and bodies disappeared by state repression (*Ausencia*).

Tirado and Villanueva respond to a historical juncture in which nationalism crumbles and the narratives of citizenship—in Mexico and elsewhere—undergo a severe crisis. Swimming among the flotsam of modern identity discourses, they struggle to articulate new ways of per-

forming not only gender, but also citizenship (Carroll, "Postmoderniz-ing"). In the midst of chaos, they advocate a consciousness that is oppo-sitional and also *propositional*, where acts of resistance go hand in hand with acts of subversive parody (Tirado) and politicized remembrance (Villanueva). A propositional consciousness not only helps critique a dominant regime, but is a frame of mind that encourages the creation of alternative ways of performing the self and of performing citizenship. This is a stance that proposes—not dictates—paths of action, while in-viting the viewer to assume a position regarding a given issue. While Mexicans today negotiate their increasingly complicated identities be-fore the onslaught of globalized capitalism, Tirado and Villanueva affirm that agency—both political and sexual—is possible.

These artists belong to a conflictive and diverse Chilango civil society that, as Poniatowska and others have documented, is increasingly mobi-lized against silence and oppression. In this context, the performances of Tirado and Villanueva seek to unsettle tranquil consciousness into re-membering the "phallic war" we willingly wrestle in, and the unresolved political injustices that keep on grating the social and individual body.

Villanueva performs displaying a silent, marked body that coaxes viewers to actively re-inscribe those signs, especially in *Pasionaria*. Hers is an oppositional consciousness that disturbs her audience into assum-ing critical positions and mobilizing their memories in the midst of silence. Her work attempts to articulate a *rhetoric of silence as speech* (Sandoval 185), a nonnarrative rhetoric that privileges imagery over spo-ken words. Although perhaps unsubtle in their articulation of a politi-cal message, Villanueva's performances suggest ways of resisting am-nesia and putting memory into circulation by means of the generative "silence" of images, sounds, and gestures that involve her audiences' rec-ollections, and thus also their diverse ideologies and identities. On the other hand, Tirado's critique in *Exhivilización* is not aimed at an op-pressor "out there," but at the oppressor within us. The wrestling match makes us whistle, jeer, and be accomplices to its grotesque game. The abject is us, we are axolotes trapped in the cage of phallocentric violence.

Contemporary Chilanga performance artists wrestle, march, and dis/appear in order to rattle the cage of representation that imprisons con-temporary Mexicans.[21] While there may be no "escape route" out of this cage, these artists suggest there are ways of exercising a propositional consciousness and reclaiming agency as subjects even as we live behind bars. The freakish, melancholic axolote may indeed be tickled into meta-morphosis, and into finding the power performance may have in resisting a silencing power.

Notes

Chilango/a is a slang term referring to people from Mexico City. I wish to thank Katia Tirado, Ema Villanueva, and Lorena Gómez of Ex-Teresa for their generous help in providing materials for this essay, and Gustavo Geirola, Roselyn Costantino, Diana Taylor, and Amy S. Carroll for their critical input. All translations are mine.

1. *Debate feminista* is Mexico's foremost scholarly journal on feminist issues, published since 1990 under the direction of activist and anthropologist Martha Lamas.

2. In Mexico, conceptual performance artists are known as "performanceros/as." Although Rodríguez considers herself a theatre director/actress, and Hadad a ranchera singer, they in fact navigate different genres and styles.

3. The first international performance festival took place in the National University's (UNAM) Museo del Chopo in 1992 under the coordination of Gustavo Prado, Hortensia Ramírez, and Montserrat Gali. The following year, Ex-Teresa Arte Alternativo was founded, a government-funded gallery housed in a colonial church in downtown Mexico City. With directors Eloy Tarcicio, Lorena Wolffer, and presently Guillermo Santamarina, this space (renamed Ex-Teresa Arte Actual) has been a high-profile promoter of conceptual art in all of its forms, including installation and sound festivals. Important independent galleries that appeared during the 1990s are La Panadería, Caja Dos, and Epicentro. For an overview of Mexican performance art since the 1960s to the present, see Prieto, "Cuatro décadas."

4. PRI—Institutional Revolutionary Party, in power from 1929 to 2000 (called National Revolutionary Party until 1946).

5. Martínez, born in 1962, has gained international recognition for his provocative conceptual work. In his celebrated performance *PerforMANcena* (Performance-dinner, 1995–97), he addresses the links between the signing of the North American Free Trade Agreement and cultural cannibalism (see Martínez). In *La realidad acteal en México* (1998), he takes up the issue of violence and colonialism in Chiapas by means of a huge Plexiglas labyrinth in the shape of Mexico. As he lay down in the middle of the labyrinth wrapped up as a mummy, white mice were set loose at the Tijuana section of the map from where they slowly progressed towards the food placed at the Chiapas end (Prieto, "Cuatro décadas" 57).

6. Tirado named her character "Lady Luck" in English perhaps because it was conceived when she was working in England (her first incarnation was "Lady Muck"). The Hindu goddess Kali is a terrifying manifestation of Shakti, the universal female energy.

7. *Exhivilización* was performed three times between 1995 and 1997. The collaborator during the performances in Ex-Teresa and the Merced market was Patricia Castellanos, and at the Carrillo Gil museum was Rocío Esteva.

8. These images could not be shown during the Merced performance, not because of censorship, but because of the inadequate lighting conditions.

9. Traditionally, when young women in Mexico turn fifteen, they are regaled with an elaborate quinceañera party.

10. Tirado said she met this woman as she sang in the city's subway for a living. "I invited her and she was thrilled. After the performance she got paid and we went to a bar to get drunk" (Interview). The woman suffered from premature aging, so that at age twenty-seven she appeared to be sixty. Tirado's intention was to "deify this beautiful freak" in her performance in order to "break with stereotypes" of midgets as outcast people.

11. *Relajo* is a colloquial expression in Mexico that refers to a playfully disruptive and irreverent attitude mocking the established order of things (Portilla).

12. In Aztec iconography, the serpent represents the water of rivers, the forces of the underworld, and is also associated with the earth goddess Coatlicue ("She of the serpent skirts"). The famous Coatlicue statue housed in Mexico City's Anthropology Museum shows her after being decapitated by her newborn son Huitzilopochtli (the Sun god). In place of her head, two serpents emerge and face each other, creating a monstrous new head. Between her legs another serpent rears its phallic shape.

13. I want to thank Amy S. Carroll for suggesting this insight in e-mail communication in February 2002.

14. Haraway ends her manifesto stating "I would rather be a cyborg than a goddess" (181), apparently identifying the "goddess" as a purist or essentialist image in opposition to the creative, impure hybridity of the cyborg. Tirado's Lady Luck collapses these images, creating an even more polymorphous creature.

15. Chela Sandoval's *Methodology of the Oppressed* is an impassioned argument for the articulation of an oppositional consciousness based on radical poststructuralist, postcolonial, and feminist theories. She maps several kinds of resistance positions that may be interfaced by means of a non-hegemonic "differential," or "coalitional," consciousness (41–64). Below I advance a complementary "propositional" consciousness.

16. In April 1999, UNAM students began a strike to protest a proposed tuition increase. The students' General Strike Council (CGH) maintained that Mexicans must be guaranteed the right to free higher education, as laid out in the Mexican Constitution. They also claimed university officials were involved in a larger, government-sponsored scheme to privatize public education.

17. In 1987, Marco Rascón created the character of Super Barrio, a masked wrestler, to fight for federal funds to rebuild houses for 500,000 people left homeless after the 1985 earthquakes in Mexico City. His charismatic persona led demonstrations of tens of thousands demanding that the government do more to help the poor.

18. The political kidnappings of the 1970s were part of government-sponsored counter-insurgency actions to eradicate urban and rural guerrilla groups. While these actions diminished during the following years, Amnesty International says that after the 1994 Chiapas uprising numerous cases of political "disappearances" have again been reported, this time directed towards alleged accomplices of the EZLN. During the last four decades, unresolved political disappearances in Mexico are estimated at more than five hundred.

19. Latin American conceptual artists have previously addressed the issue of the desaparecidos. An early example is Brazilian artist Cildo Meireles's 1970

monument to the political prisoner (Muñoz 14). Other atrists from Chile, Argentina, and Mexico followed with various installations and performances, mostly done in public spaces. For example, Argentine artists Rodolfo Aguerrebarry, Julio Flores, and Guillermo Kexel engaged in a project between 1981 and 1984 called "Siluetas de los desaparecidos" (Silhouettes of the Disappeared). The work was carried out during the last years of the military dictatorship responsible for the disappearance of up to thirty thousand dissidents (1976–1983), and consisted of painting a series of white silhouettes, like those used by forensic investigators, on the streets of Buenos Aires. Passersby would spontaneously write the names of their missing inside the figures (Muñoz 16). In Mexico, the conceptual *grupos* and particularly artists like Victor Muñoz have addressed these issues as well. More recently, the children of the disappeared (H.I.J.O.S., with chapters in Argentina and elsewhere in the region) create effective public interventions through guerrilla performances (Taylor, "El espectáculo").

20. Eureka's quarter century of struggles yielded fruit on 1 June 2001 when the government published a reform to the penal code stating that forced disappearance of people is a crime. On 6 July, Villanueva together with artists and activists from Argentina, Brazil, Puerto Rico, and the United States staged a political action in Mexico City's *zócalo* demanding that Fox release the missing people, and that the National Commission of Human Rights release the archives. Simultaneous actions were held in Monterrey and in Buenos Aires, Argentina, in coordination with H.I.J.O.S.

21. See Neustadt (15) for a discussion of the way postmodern Latino and Latin American artists deconstruct the "prisonhouse" of representation.

Works Cited

Alvarado, Karina. "¿Qué comunica el arte?" Paper read at the performance festival of UNAM's Faculty of Political and Social Sciences, Mexico City, February 2001.

Amnesty International. "Bajo la sombra de la impunidad." 25 May 2001 <http: www.derechos.org/nizcor/mexico/doc/ai.html#3>.

Arias, Carlos, et al. "¿Arte feminista?" *debate feminista* 12.23 (April 2001): 277–308.

Auslander, Philip. *From Acting to Performance: Essays in Modernism and Postmodernism.* London: Routledge, 1997.

Bartra, Roger. *La jaula de la melancolía: identidad y metamorfosis del mexicano.* Mexico City: Grijalbo, 1987.

Bustamante, Maris. "Non-objective Arts in Mexico 1963–83." Trans. Eduardo Aparicio. *Corpus Delecti: Performance Art of the Americas.* Ed. Coco Fusco. London: Routledge, 2000. 225–39.

Carroll, Amy S. "In 'Los nichos públicos,' 'Soy totalmente de hierro': Performative Reconstructions of Monumental 'Woman' in Contemporary Mexico City." Paper read at the LASA Conference, Washington D.C., September 2001.

———. "Postmodernising Mexican/Sexual Citizenship: EDEMA's Collaborative/ Performative Politics." Paper read at the Hemispheric Institute of Performance and Politics Conference. Monterrey, Mexico. June 2001.

Cortázar, Julio. "What Happens, Minerva?" *La vuelta al día en ochenta mundos.* 7th ed. Mexico City: Siglo XXI, 1986. 117–19.

Deleuze, Gilles, and Félix Guattari. *Anti-Oedipus: Capitalism and Schizophrenia.* Minneapolis: University of Minnesota Press, 1983.

Douglas, Mary. *How Institutions Think.* London: Routledge, 1986.

EDEMA, prod. *Postmodernizing Mexican Sexual Citizenship: EDEMA's Collaborative Performative Politics.* Videocassette. EDEMA, 2001.

Evans, Dylan. *An Introductory Dictionary of Lacanian Psychoanalysis.* London: Routledge, 1996.

Forte, Jeanie. "Women's Performance Art: Feminism and Postmodernism." *Performing Feminisms: Feminist Critical Theory and Theatre.* Ed. Sue-Ellen Case. Baltimore: Johns Hopkins University Press, 1990. 251–69.

Franco, Jean. "Bodies in Contention." *NACLA Report on the Americas* 34.5 (2001): 41–44.

Haraway, Donna J. *Simians, Cyborgs, and Women: The Reinvention of Nature.* New York: Routledge, 1991.

Harvey, David. *The Condition of Postmodernity.* Cambridge: Blackwell, 1989.

Haw, Dora Luz. "Dignidad en bikini." *Reforma.* 21 April 2000: C1.

Jameson, Fredric. *El postmodernismo o la lógica cultural del capitalismo avanzado.* 2nd ed. Madrid: Paidós Studio, 1991.

Kristeva, Julia. *Powers of Horror: An Essay on Abjection.* New York: Columbia University Press, 1982.

Kuri, Jorge. "El abolengo escénico de las luchas." *Uno más uno* 26 Oct. 1997: 20.

Lacan, Jacques. *The Four Fundamental Concepts of Psycho-Analysis.* 1973. Trans. Alan Sheridan. New York: Norton, 1981.

Martínez, César. "PerforMANcena." *Corpus Delecti: Performance Art of the Americas.* Ed. Coco Fusco. London: Routledge, 2000. 192–94.

Mayer, Mónica. "Cuando lo político es personal." *El universal* 23 June 2001: F3.

———. "Del boom al bang: Las performanceras mexicanas." *Creatividad feminista* (2000): 4 pp. 6 June 2001 <http://www.creatividadfeminista.org/galeria 2000/textos/performanceras.htm>.

———. "Performance de primera plana." *La pala* May 2000 <http://www.lapala. com.mx>.

Muñoz, Víctor. "Notas desde el Puerto de Veracruz." *Arteacción: Ciclo de mesas redondas y exposición de fotografía de acciones.* Ed. Andrea Ferreyra. Mexico City: Impreso, 2000. 11–17.

Neustadt, Robert. *(Con)Fusing Signs and Postmodern Positions.* New York: Garland, 1999.

Paz, Octavio. *El laberinto de la soledad.* 11th ed. Mexico City: FCE, 1983.

Phelan, Peggy. *Mourning Sex: Performing Public Memories.* London: Routledge, 1997.

———. *Unmarked: The politics of performance.* London: Routledge, 1993.

Poniatowska, Elena. *Fuerte es el silencio.* 4th ed. Mexico City: Ediciones Era, 1982.

Portilla, Jorge. *Fenomenología del relajo.* 1966. Mexico City: Fondo de Cultura Económica, 1997.

Prieto Stambaugh, Antonio. "Cuatro décadas de acción no-objetual en México." *Conjunto. Revista de teatro latinoamericano* 121 (April-June) 2001: 50–59.

————. "Unsettled Memories in Border-Crossing Performance." Master's thesis, Tisch School of the Arts, New York University, 1994.

Sandoval, Chela. *Methodology of the Oppressed*. Minneapolis: University of Minnesota Press, 2000.

Serret, Estela. "Identidad de género e identidad nacional en México." *La identidad nacional mexicana como problema político y cultural*. Ed. Raúl Béjar and Héctor Rosales. Mexico City: UNAM, Siglo XXI, 1999.

Schneider, Rebecca. *The Explicit Body in Performance*. London: Routledge, 1997.

Taussig, Michael. *The Nervous System*. London: Routledge, 1992.

Taylor, Diana. "El espectáculo de la memoria: trauma, performance y política." *Hemispheric Institute of Performance and Politics*: 6 pp. 26 March 2001 <http://hemi.ps.tsoa.nyu.edu/archive/text/hijos2.html>.

————. "Performing Gender: Las Madres de la Plaza de Mayo," *Negotiating Performance: Gender, Sexuality, and Theatricality in Latin/o America*. Ed. Diana Taylor and Juan Villegas. Durham: Duke University Press. 275–305.

Tirado, Katia. "Concepto." Unpublished artist's statement. N.d.

————. Personal interviews. February and July 2001.

————. "Producciones Lucha Libre Presenta: Las perras en celo en . . . Exhivilización." Unpublished production notes. 1995.

Villanueva, Ema. Personal interviews. December 2000, April 2001.

————. "Todo se vale: performance y política." *Arte y Política* in Ex-Teresa Arte Actual. 23 June 2000.

Wolff, Janet. *Feminine Sentences: Essays on Women and Culture*. Berkeley: University of California Press, 1990.

SABINA BERMAN

(Mexico)

Sabina Berman is one of the most widely recognized and active playwrights of her generation both in her native Mexico and in all of Latin America. She began receiving national recognition at an early age. Several of her plays have been translated and performed abroad, and she has received twenty-five national and international awards.

Among her plays, *Bill/Yankee* (1979) proposes identity as a creative process, focusing on the relationship between individual and national identities, and the influences which impinge on their formation—a recurrent theme in Berman's productions. *Rompecabezas* (The Puzzle 1981) uses the techniques of documentary theatre to examine the official history and representations of the 1940 assassination in Mexico of Leon Trotsky, while exploring the questions of ethnic and national identity of the two principal characters. *Aguila o sol* (Eagle or Sun 1984), which stages the encounter between Hernán Cortés and Moctezuma, injects the historical account with street theatre and other popular forms such as mariachis, indigenous dances, and *corridos*. *Herejía* (Heresy 1983) depicts the Mexican Inquisition's persecution of Jews and challenges the notion of Mexico as a culturally homogeneous society. *La grieta* (The Crack 1988) establishes the metaphor of a growing crack in the support wall of a new office building to call attention to Mexico's social and political disintegration. Berman has twice received the Na-

tional Award for Director of the Year, for a 1997 production of *La Grieta* and a 1999 production of *Moliere*.

Other critically acclaimed plays include *El suplicio del placer* (The Pain of Pleasure 1986), and *Muerte súbita* (Sudden Death 1988). *Entre Villa y una mujer desnuda* (Between Villa and a Naked Lady 1993) was translated into English and French and then adapted for film and directed by Berman and Isabelle Pardan in 1996. The recipient of major theatre and film awards, *Entre Villa* is a comical view of contemporary relations between the sexes, affected by the sediments of history and tradition. Drawing from another tradition in Mexico's cultural repertoire— indigenous theatre based on oral tradition—*Arux* (1995) recreates the myth of Arux, a Mayan midget god. Staged in a jungle clearing in Xocen, Yucatán, and spoken in Maya and Spanish by 250 young indigenous actors, *Arux* captures and reproduces the vital presence of myth and ritual in the daily existence of Mayan culture while simultaneously injecting humorous political commentary. Perhaps Berman's most controversial work to date is *Krisis*, a dark play based on the events in the life of former president Carlos Salinas de Gortari, in which Salinas and his brother kill their nanny. The play exposes the corruption inherent in Mexican social and political systems.

Like that of other Mexican theatre practitioners of her generation, Berman's work is characterized by its diversity. At times, universal themes or classic forms dig deep into the Mexican psyche, history, and culture. She also traces the intersections of sexuality and politics within the patriarchal power structure that repeats itself at all levels of Mexican society. The interior problematic to which Berman refers is the personal struggle that women experience as they become more active and visible in Mexican society, participating in realms previously prohibited to them. Among her theatrical productions it is in the play included in this volume, *El suplicio del placer*, that Berman most openly explores the concept of the gendered self as she destabilizes various popular, scientific, and literary myths. Explicit in this piece is the concept of "gender" as a social construction and a semiotic process in which men and women are encoded as social subjects. Berman foregrounds various processes through which the formulation of gender becomes embedded in social and power relations. A complex system of cultural, social, psychical, and historical differences constitutes both men's

and women's consciousness and subjective limits. Importantly, she highlights the individual's participation in the systems that both construct and censor. Berman offers neither clear-cut definitions, nor concrete political strategies, but rather engages in an exposition, making her audience aware that the theatrical performance they are witnessing is not unrelated to "real-life theatre," their own performance, as men, as women, as social beings.

The Agony of Ecstasy:
Four One-Act Plays on a Single Theme

SABINA BERMAN

Translated by Adam Versenyi

Each play deals with a couple and an absent third person. A minimum of two actors and a maximum of ten are required for performance. In this edition, we are including only one of the four plays.

One: The Mustache

Characters:

HE: Effeminate male.

SHE: Masculine woman.

HE and SHE both wear their hair cut short and dyed a red mahogany color. They are svelte, beautiful, and elegant—and they know it. They speak and move with leisurely assurance. They look astonishingly alike.

The action takes place in the main room of a hotel suite. A little table on which can be found a tea service and two cups. Two chairs. A door that leads to the bedroom from the main room. It is morning.

When the lights come up SHE reads the newspaper, seated at the table. From time to time she takes a sip of tea. She wears white silk pants and shirt. After a while HE appears, dressed exactly the same as SHE. HE enters through the door to the bedroom. HE is still drowsy. HE approaches her and kisses her on the cheek.

HE: Good morning, dear.

(SHE nods. Continues reading. HE sits down.)

HE: Excuse me. I mean for getting up so late. I think I had one too many last night.

(SHE turns the page. HE watches her every movement.)

HE: In a bad mood?

(SHE shakes her head no. Continues reading. HE keeps watching her.)

HE: There's something different about you today. As if something was missing or . . . Is your shirt new?

SHE: Drink your tea. There it is.

HE: It's cold.

(HE gets up with the cup. Goes to a flower pot and pours out the tea. Sits down again. Tilts the teapot. There isn't any tea left. HE looks at her for a long time with rancor. HE observes the still steaming tea in her teacup. SHE takes a sip. HE looks at her with controlled anger.)

HE: I know what it is. You're not wearing your mustache. *(SHE lowers the newspaper.)*

SHE: My mustache? Of course I'm not wearing my mustache. You have my mustache.

HE: Me?

SHE: You've got my mustache on your face. *(HE touches his lips.)*

HE: Ah, yes. Excuse me, I'm sorry. *(SHE continues reading. HE is deep in thought.)*

HE: Could you tell me why I'm wearing your mustache?

(SHE suddenly lowers the newspaper. Folds it energetically. Looks at him firmly.)

SHE: You've forgotten about last night?

(HE refuses to look at her.)

HE: Do you want it?

SHE: No. What for?

HE: I thought you liked wearing it.

SHE: Liar. You know perfectly well that I only use it so that I won't be propositioned. Only for that. So men don't try to pick me up when I don't feel like it.

HE: I forgot. I'm sorry.

SHE: You didn't forget. You wanted to annoy me.

HE: That's not true. I swear. You know I forget things. *(SHE unfolds the newspaper.)*

SHE: Wretch. *(Pause)*

SHE: I lent it to you last night, remember?

HE: The mustache?

SHE: You wanted to impress that brunette at the next table and asked me to lend it to you. You saw her while we were eating dinner, and since the brunette was alone, you decided to approach her and pick her up.

HE: I did this? I approached her and picked her up? I don't even remember seeing a brunette.

SHE: Incredible. *(Pause)* . . . She was wearing a white chiffon, low neck-line, sleeveless. Her eyes were green, her lips full . . . almond colored skin. And her hair, long, jet black, fell over her shoulders like . . . like a black silk lightning bolt.

HE: *(Maliciously)* And I was the one attracted to her?

SHE: You're insinuating again.

HE: No. Nothing. Really. I'm sorry. Are there any cookies?

SHE: You are so infantile. Just because I'm a woman that doesn't mean that I can't enjoy another woman's beauty. I admire good things when I see them. A beautifully set jewel; a pure bred colt; a sky splashed with white stars . . . And I don't have to take them home to enjoy them. I contemplate beauty from afar . . . I let it be . . . You, on the other hand, who, due to your preconceptions can only appreciate certain kinds of beauty, see something admirable and want to possess it, consume it, use it up.

(HE laughs joyfully.)

HE: I'm sorry I've made you jealous.

SHE: Jealous? Me? *(SHE laughs.)* Me, jealous? Jealousy and I are like oil and water: we don't mix. I was the one who loaned you the mustache.

HE: That's true. You're right. It's just that sometimes I can't believe that you're so liberal. Sometimes I irritate you only to prove it, you know what I mean?

SHE: We're two independent people. Our agreement . . .

HE: Yes, but you never take advantage of our agreement. I do it all the time, all the time, and you never, never . . . *(Moans)*

SHE: *(Vehemently)* Can't you behave like an adult? Why do I have to do the same things you do? We are two people, each of has his or her own tastes and desires. Each of us is free to do as we please.

HE: You're right, you're right. I didn't mean to offend you.

SHE: I didn't mean to offend you. You never want to offend me and you're always doing so.

HE: Excuse me.

SHE: And then you feel guilty.

HE: I'm sorry.

SHE: What good is it if you're sorry?

HE: Pardon me.

SHE: An independent person never asks to be pardoned for what he does.

HE: Excuse me.

SHE: An independent person does what he wants and doesn't ask to be excused because he has no regrets.

HE: I'm sorry.

SHE: What do I care if you're sorry?

HE: You're right. Excuse me.

SHE: Don't ask me to excuse you!

HE: All right, I won't! Pardon me.

SHE: You're driving me crazy!

HE: I'm sorry!

SHE: I'm going to explode!

HE: It's my neurosis!

SHE: So I have to suffer?

HE: I'll throw myself off the balcony! I'll never bother you again!

SHE: Coward, I . . .

(HE gets down on his knees and implores her.)

HE: Excuse me already! Please . . . I can't stand it when you're irritated with me . . . What would I do without you? I'm so weak . . . I'll never become an independent person without your help. *(SHE strokes his hair.)*

SHE: *(Sweetly)* Well, dear, you managed to be independent yesterday.

HE: The only thing I managed to do yesterday was to get so drunk that I can't remember a thing.

SHE: You don't remember but I saw it and I'm telling you. You approached her table and seduced her. You were so sure of yourself that you didn't even wait for her to ask you to sit down.

HE: She must have thought I was rude.

SHE: No way. She was enchanted by your confidence. It was a pleasure to watch you. Such elegance in every gesture. What "charm, mon cherie." With delicious arrogance you called the "maitre d" and ordered: "Champagne, Brut '52. And, have the musicians play Strauss."

HE: Strauss! *(HE hides his face in his hands.)* Good god, how tacky!

SHE: How right. All you had to see was the enthralled look she gave you to know that Strauss was exactly the tone for her. Sweet little girl. She looked at you as if in a dream.

HE: At me?

SHE: Of course at you, who else? With the mustache on you were irresistible. That's why you asked me to loan it to you.

HE: Yes, the mustache does look good on me. I'm more sure of myself with the mustache. I know that when I'm wearing our mustache I'm irresistible. And then, what did I do next?

(SHE acts out what she has to say as if she were him and he were the brunette.)

SHE: You served the champagne. You toasted. You stroked her hands. You smiled at her. You leant against her naked shoulder and began to whisper in her ear . . .

HE: *(Whispering)* What?

SHE: *(Whispering)* What do you mean "what?"

HE: *(Whispering)* What did I whisper to her?

SHE: *(Whispering)* What?

HE: *(Whispering)* Yes, what? What? What?

SHE: How am I supposed to know what you whispered to her! I couldn't hear what you were whispering from across the room.

HE: No, of course not, excuse me. But you watched. *(Playing his part once more, she stands.)*

SHE: Shall we dance? *(HE accepts the invitation.)*

SHE: *(Taking him in her arms)* The Blue Danube.

HE: *(With nervous laughter)* Oh my god, how tacky! *(They dance.)*

SHE: Sweet little girl. She stared at you as if she were in a dream. When had she ever been approached by such a handsome man? She was like a feather in your hands. Your fine hands, your expert hands . . . *(SHE caresses his back, his shoulders, his waist, his buttocks, and, finally, between his legs.)* .

HE: You saw it all . . . *(SHE breaks the embrace. Sits down. Lights a cigarette.)*

SHE: Well, almost. The rest took place behind closed doors.

HE: You mean . . . ? But . . . we'd barely met.

SHE: Well . . . What do you want me to say?

HE: But so easily?

SHE: A naive little girl. Don't judge her too harshly.

HE: I can imagine what she must have thought when she entered our suite. She must have been amazed.

SHE: *(Irritated)* You were polite enough not to bring her to our suite. You took another room for the two of you.

HE: Yes, of course, excuse me . . . And of course I didn't tell her that I was staying in the hotel but took another room to let my wife sleep.

SHE: Your memory is coming back?

HE: Simple logic. She would have found it monstrous. There aren't many people as liberated as you and me. Everyone else demands an absolute, crippling fidelity. They are so insecure about their own worth that they think that if their partner meets someone else that they will be abandoned. That's why they get jealous. Appreciating someone else is taken as treason. They say: it's either you and me, bound together by a thousand vows, or you by yourself and me with someone else. Ah, how beautiful it is to be us. *(They both sigh.)* Liberated, refined, beautiful, and with everyone else within arm's reach. Although sometimes . . . I don't know . . . sometimes.

SHE: *(Irritated)* Sometimes what?

HE: Sometimes I feel guilty for being so beautiful and so refined and so socialist . . . But even deeper down I'm convinced that we shouldn't fight poverty; that poverty is sublime and ugly people are tender. I believe that the smell of rancid urine and rotten apples in decaying cities is the odor of the soul . . . A soul that I can't find inside myself . . .

SHE: Shall I get you an aspirin for your hangover?

HE: *(Pointing to the newspaper)* I'd rather have the cultural section.

SHE: Society or Sights. This paper doesn't have a cultural section.

HE: An aspirin then.

SHE: Go get it.

HE: Where are they? The bathroom or the kitchenette?

SHE: The pharmacy.

HE: I could call room service. *(But he doesn't do anything. Pause.)*

SHE: Do you know why you don't remember things, dear? It's because you feel so guilty about your absurd little adventures that you prefer to forget them.

HE: My adventures don't give me a bad conscience. It's yours . . .

SHE: But I don't have any.

HE: That's precisely what bothers me, you don't have any. You preach to me about free love, even about its social value: that it's a way to free the masses . . . a way to distribute a bit of beauty, but you never . . . I hope it doesn't bother you if I remind you, you never share yourself with anyone. I beg you, for me, for my mental health, share yourself soon.

SHE: Not for you nor for anyone else will I ever do anything that isn't my own personal desire.

HE: If I saw you act like a liberated woman I wouldn't feel bad in the mornings.

SHE: How dare you? You want to limit my freedom by asking me to act like a free woman when I'm so free that I don't need to act free!

HE: You've never felt the urge? Really?

SHE: Not yet.

HE: Not even once? Not for a single minute?

SHE: No.

HE: Do you promise me that the next time you see a good looking man, a very good looking one, that you'll take off the mustache and let him seduce you?

SHE: I forbid you . . . that is, I suggest . . . moreover: I assure you that when the day comes that I want a man to approach me and seduce me, that I will approach him and seduce him first and that I will do it so quickly he won't even realize that I've had him and thrown him away.

HE: You promise? *(Pause)*

SHE: Besides, it's your fault I use the mustache. If you introduced me as your wife . . . if you didn't leave me alone to go to other tables . . . don't want anybody else, I'm liberated enough not to want anyone else and you leave me alone and they proposition me . . . I put the mustache on because I don't have a husband to scare off unwanted suitors.

HE: But you're contradicting yourself. You push me into these adventures and suddenly now . . .

SHE: So I'm contradicting myself. What do you want me to do? I'm a complex person.

HE: *(Maliciously)* Have you seen how women look at you when you're wearing the mustache? How they smile . . . ? You're irresistible with the mustache on and you know it. You enjoy it.

SHE: And just what are you insinuating, my dear?

HE: Well, sometimes it makes me think. You only notice beautiful women. You point them out to me, you advise me to approach them . . . *(SHE stares at him firmly. HE takes it back.)* It's not true. I was joking. Don't look at

me like that. I can't stand it when you look at me like that. It's obvious that you don't like women. If you didn't like men you wouldn't like me, right? And it's plain that you like me because I'm a man. Answer me. Tell me that you like me because I'm a man.

SHE: I like you.

HE: Say the whole thing. Say: I like you because you're a man.

SHE: I already said I like you.

HE: Say it word for word. Say it: I like you because you're a man.

SHE: I think that's obvious as well.

HE: Obvious. Only to you. I can't see myself. I can't see myself through my eyes. I can only see myself through your eyes, and when you look at me like that, from head to toe . . . *(SHE looks away.)*

HE: No. Look at me. Tell me what you see.

SHE: You can't make me . . . *(HE makes her look at him.)*

HE: Tell me, what do you see?

SHE: I see that you're weak. Insecure. That you can't behave like a person independent from me. And even so I love you.

HE: Because I'm a man.

SHE: Because you can't behave like an independent person. Because you're weak. Insecure. Because you need me to know whether or not you're a man. *(Pause)*

HE: You made me like that. I wasn't like that before. You've changed me day by day. Next to you I'm nobody. But as soon as I move away from you *(HE moves away.)* . . . I'm someone else. Yesterday for example. You were sleepy, you didn't want to have anything to do with me that night, so I went and got another woman. Another woman more woman than you, gentler, fresher, younger. Her lingering nudity, you should have seen that little girl naked in front of me, looking at me as if in a dream. Mmn. My hands over her smooth skin. What wonderful skin, so soft. Her breasts. Her belly. Her pubis. Her thighs. Her long, long back. Her quivering, open mouth waiting for me. Sweet little girl . . .

SHE: Sweet little girl.

HE: You can't imagine the pleasure it was to linger in caresses. How won-

derful it was to feel her in the net and to be able to take her or leave her. Her hair falling between my fingers, falling like . . .

SHE: Like a black silk lightning bolt.

HE: What freedom: to be able to take her or leave her. What freedom . . . I felt her unbutton my shirt . . . I let her kiss my chest . . . I lowered my face to hers . . . I said, open my pants with your teeth. With your teeth, I said! My cock. Take it. Grab my cock, little girl! No, no whimpering, for pity's sake, no. Go away, but no tears! I felt her wet cheek against my abdomen, her trembling hand, warm, entering my clothes, searching . . . searching . . . finding . . . kissing it. She kissed it! She kissed it, she kissed it, she kissed it . . . Prince Charming awoke! *(Pause)* The shame . . .

(Lighting shifts to something that suggests the dream. SHE kneels down. SHE crawls around on her knees with her hands before her in the air as if she were blind.)

SHE: *(Like a little girl)* Where's my birdie? I'm tired of looking for it in the dark.

HE: The shame . . . *(SHE approaches him.)*

SHE: Oh, do you have it? Do you have my nightingale, weeping willow? Ay, it's dead.

(Lighting changes to something else that suggests the dream.)

HE: *(Very gently)* I hate you like I've never hated anyone, like only I can hate you. The way that I hate you when I know that you've pushed me into confronting another person's disgust, with all its infinite pain.

(The following lines are spoken indiscriminately by HE or SHE. Each verse is a complete whole.)

HE or SHE: *(Alternating, without emotion)*

It's an ugly world. Other people are ugly.
They demand that you be someone else. They don't want you as
 you are.
No one accepts you like I do.
I love you.
You love me.
I alone understand how painful it is to be you.
I am you.
I love you in me.
I know your shame.

288 Sabina Berman

You are my shame.

Hide me.

Don't go with the others. Go prove to yourself that they don't love you. Only I love you. Understand: only I, only I, only I love you . . .

(They both get up, fix their clothes and hair. Lighting changes back to normal.)

HE: You cried in your sleep last night. I came into the room and I heard you crying in darkness. Were you crying for me?

SHE: I dreamed I was a little girl again. I was blind and I was searching, feeling my way, for a nightingale in the forest. I don't remember if I found it. I don't remember. *(They caress each other.)*

HE: You're beautiful. Like a marble goddess, cold and beautiful. When you wear the mustache you're made of flesh, but still dangerous: do you want it?

SHE: No. What for? There's no other woman tonight to tempt me. But if you want to take it off . . . There might be a man who appeals to you and if you want him to approach you, you have to take off the mustache.

HE: No. I like you more than any other man today. You're irresistible with the mustache on. Put it on. *(HE puts it on her himself. HE caresses the mustache.)*

HE: Like a black silk lightning bolt . . . *(They kiss each other on the lips.)*

Blackout

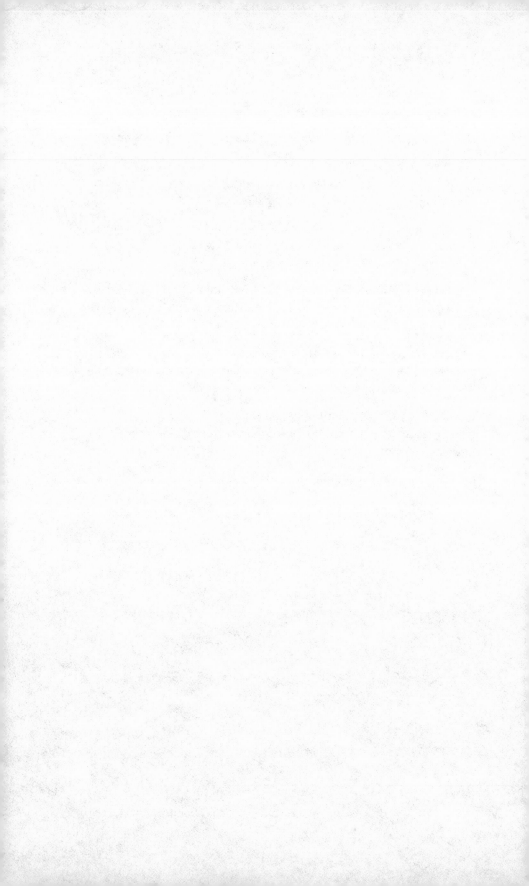

Petrona de la Cruz Cruz

Petrona de la Cruz Cruz sits in the courtyard of Fortaleza de la Mujer Maya (FOMMA), the women's collective that she opened nearly a decade ago. She speaks with calm resolve of her struggle to encourage the creative expression of the women and children who have found in FOMMA a shelter from the violence and poverty that has wreaked havoc in indigenous communities throughout Chiapas in recent years. In 1994, she and fellow actress Isabel Juárez Espinoza founded FOMMA to support Mayan women and children. Using the tools of theatre and puppetry, they opened a space where women empower themselves and their culture as they represent the often traumatic experiences they have lived, and imagine alternative realities. As she gestures to the several small rooms that house the FOMMA projects, de la Cruz Cruz explains that the collective has attempted to meet the needs of women who have left their highland villages in search of work by combining literacy workshops in Spanish and in the Mayan languages of Tzotzil and Tzeltal with skills training in such things as breadmaking and sewing, while offering childcare so that the women are free to attend these classes.

Petrona de la Cruz Cruz herself learned to read and write as a young immigrant to San Cristóbol de las Casas. Her background is unusual for an indigenous woman because she was able to secure a junior high school–level education. Rejected by her community because she was a rape victim, de la Cruz Cruz raised the child born of that violation and supported herself as a domestic servant. She

1. Actors in a scene from *Una mujer desesperada* (A Desperate Woman), 1991. Photo by Diana Taylor.

first practiced theatre with the Sna Jtz'ibajom Mayan cultural cooperative in a so-cial climate that discouraged women from speaking publicly of their experiences. There she began to explore community theatre as a medium for addressing prob-lems such as domestic violence, rape, alcohol abuse, migration, and poverty as they affect the lives of women. Her first play, *Una mujer desesperada*, focuses on the seemingly endless violence visited on Mayan women and the matter-of-fact impossibility of recourse. As Teresa Marrero notes in "Eso sí pasa aquí," her essay on Mayan women, *"Una mujer desesperada* (A Desperate Woman 1991) stands out for being the first play written by an indigenous Highland Mayan woman about the real-life social drama of family violence" (318).

Petrona de la Cruz Cruz was the first indigenous person to win the coveted Rosario Castellanos Prize for literature in 1992. Since then, her plays have been performed in several countries, and she continues to write as she searches for new ways to encourage economic and cultural development. In 1999, for its work in radio, theatre, and education in Mexico, FOMMA received a national award given by IMIFAP (Mexican Institute of Research on the Family and Population) and spon-sored by the Summit Foundation.

A Desperate Woman:
A Play in Two Acts

PETRONA DE LA CRUZ CRUZ

Translated by Shanna Lorenz

Characters:

JUAN (Father)

MARÍA (Mother)

CARMEN (Oldest daughter)

JUANITA (Neighbor)

ANTONIO (Stepfather)

JOSÉ (Neighbor)

LUPITA (Youngest daughter)

MARIO (Employer)

TERESA (Middle daughter)

JUDGE

COMANDANTE

Act 1

Scene 1

A Zinacanteca-style house with a straw roof and a small door. María appears, hugging her sick daughter looking imploringly up at the sky.

MARÍA: *(In anguish)* Lord, help me. I'm dying of hunger and exhaustion. I don't know if I can find a good path for my daughters. Their father has never cared about them. He doesn't even remember to bring them food. He lives in the cantina with his friends. He won't even give us permission to go work so that we can earn our own food. Forgive me Lord, and give me the patience to put up with him.

(Carmen runs through the door, alarmed.)

CARMEN: Mama, mama. Here comes dad, drunk and yelling, and there is no fire in the hearth. He is going to scold us. He is going to hit you again for not having food ready. He is so drunk that he doesn't understand anything. Ay, mama, I am afraid.

MARÍA: No, daughter, don't be afraid; he will only hit me. Hide yourself and I will talk to him. Go on, go out back. *(The daughter leaves and María sits on the bed, resigned, covering up her sick daughter. Juan enters, yelling in a drunken voice.)*

JUAN: What! Weren't you at home? I want to eat! Why isn't there a fire? Who were you with, you disgrace of a wife? Tell me or I'll kill you! *(He grabs a log from the fireplace and throws it at her while she dodges it, huddling on the bed. He lunges towards her and yanks her by the hair until she falls to the floor.)* Hurry up and get me something to eat or I'll beat you to death.

MARÍA: *(Crying)* Don't you understand, man? How can I make a fire if we don't have kindling or food. You are so drunk that you don't see anything. You haven't worked for a long time, even to feed your daughters. Look how sick they are, and you just keep getting drunk and throwing away money that we don't have.

JUAN: *(Furious)* All I need is for you to chide me. *(He goes back to hitting her.)* Take this for your big mouth and learn to respect your husband. *(María cries and hugs her sick daughter, trying to protect herself from the blows.)*

ROSA: *(Having heard the yelling, she appears at the door.)* Don Juan, what are you doing; my God! Don't you realize that your wife and daughter are very sick? Instead of bringing them to be treated you are tormenting them. What a heartless man! Don't you care about your family?

JUAN: What do you care you old gossip. I am her husband and I can do whatever I want to her. *(He lunges towards María again, trying to hit her; Rosa gets between them and gives him a hard push, making him fall.*

He is so intoxicated that he can't control his fall and knocks his head against a stone in the cold fireplace. The women watch, frightened.)

ROSA: Oh, holy God! How could I push him! He has hurt his head! Oh my Lord, I only wanted to defend you and the girl because I know you are sick! Now he's hurt. We have to take him to be treated.

MARÍA: But he's so drunk! We better let him sleep for a while or he will be so furious that he won't let them treat him.

ROSA: *(Worried)* I'm going to call someone to help me take him to the doctor. He looks badly hurt, and his head is bleeding hard.

MARÍA: But . . . how are we going to pay a doctor if we don't even have money for food? *(She hugs her daughter more tightly.)* And what about my sick daughter? She gets worse every day and I don't know if she will die! And since we have no money to bring her to the doctor we can only wait for the grace of God.

ROSA: *(She goes out the door and runs into her husband.)* Ay, José! Thank goodness you are here. Juan is hurt badly. He hit his head and is bleeding a lot.

JOSÉ: What happened? Did he really fall or did they beat him up on the street for being so drunk. What are you doing here? You should be at home!

ROSA: Ay, José: he was hitting these poor women! I was trying to defend them and gave him a shove, and he was so drunk that he hit his head against the stones.

JOSÉ: *(Very angry)* Why do you meddle in things that are none of your business? What! Don't you have enough work to do at home? Now you got me mixed up in this problem. Let's see if I can find someone to treat him. Go on, go home: I'm going to get a doctor. As if we have lots of money.

MARÍA: Don't get mad at her José; no one else tried to defend me.

JOSÉ: *(Bending down to look at Juan's head)* Now we are stuck in a real mess. This man is hurt bad. You go home, Rosa. Let's see if we can get someone to treat him. *(They both leave in a hurry, but then return when they hear Juan's groans and María's cries.)*

JUAN: Aaaaay, God, I feel like I am dying! *(María runs over to attend to him.)*

MARÍA: No, Juan, please don't die! The neighbors will think that I killed you, they won't believe that you fell!

JUAN: *(Suffering)* Aaay, woman. This must be my punishment for having treated you so badly. I am dying; please forgive me for everything that I have done to you. Take care of my daughters. Now they will be happy. I was only a nuisance . . . Just give me a little water. I'm thirsty.

MARÍA: *(She quickly gives him water.)* Here's your water. Come on, drink! *(With great difficulty, Juan drinks from the water jug, and begins to suffer death spasms while his wife, his youngest daughter, and his neighbors look on in anguish.)*

JUAN: Aaay, goodbye woman! God forgive me for what I made you suffer. *(He dies, and upon seeing that he is dead, María lets out a scream and begins to cry.)*

ROSA: Ay, María! Your husband is dead! Now what are we going to do? It is my fault that he is dead. *(She cries.)*

JOSÉ: Ay, Lord, what are we going to do now; I don't know why you had to come meddle in things that are none of your business. All because you wouldn't sit at home. They are going to call you a criminal.

MARÍA: *(Between sobs)* No, Don José. It was not Rosa's fault. Juan was very drunk, we don't have to blame anyone. She just wanted to defend us.

(Carmen, the eldest daughter enters, alarmed; when she sees the scene she screams.)

CARMEN: What happened, mama? What happened to my father? Oh my God, he is dead!

MARÍA: Ay, my daughter: your poor father fell down drunk and hit his head! May God forgive his sins!

CARMEN: He made us suffer so much! Let him rest in peace and may God forgive him! We don't even have enough to buy a mat to bury him. My poor father left us in misery!

JOSÉ: *(Looking at Rosa, resigned)* Although there is little we can offer you, you can count on us to help with cost of the burial. How did this unlucky thing happen! But poor Juan was already in bad shape. May God forgive him and may he rest in peace. We'll have to wash the blood, Doña María, and tell the officials that he died from the fall. Come on, Rosa. We are going to take the corpse and wash it. *(They leave, in tears, carrying the corpse.)*

Scene 2

The same house, after the burial. A worried Rosa enters with María who carries her weak child as she sobs.

ROSA: Don't cry any more, everything will be okay. Now you have to think of your daughter so that she can get better. Don't worry, we will bring her to the clinic in a little while; you'll see that things will be okay.

MARÍA: May God hear you. I don't even want to think that I will have to bury her too, like her father. What are we going to do? We don't know how to work at anything, and we don't know anything about the city; I don't know what we are going to do. Ay, God help us to survive in this world! Rosita, would you please lend us the money to eat today?

ROSA: Fine, María, but I won't be able to keep lending you money. The best thing would be to send Carmen to work, so that she can help you a bit while your youngest daughter gets better. Otherwise you'll die of hunger.

MARÍA: You're right, Rosi; but how can I send them off to work when they don't even know how to work as servants. They won't be able to go anywhere.

ROSA: Even if they don't earn much while they are learning, at least it will be something, Mari. The truth is that I can't keep lending you money. You already owe me a lot and as it is you won't be able to pay me back everything I've given you. You couldn't even pay me when your husband was alive, let alone now.

MARÍA: Ay Rosi, I promise that sooner or later I will pay back all the favors that you have done for us, but you know how it was with my dead husband: he was so jealous that he wouldn't even let us breathe. At least lend me five thousand pesos so that I can feed my little girl.

ROSA: Look, I can give you two thousand, but this is the last time, because I don't have anything left for myself. Forgive me but you'll have to see if you can find help somewhere else because my husband doesn't give me enough to keep lending to you. I have to go, before he gets angry. May God protect you.

MARÍA: *(Crying)* Thank you so much, Rosi. May God reward you; you are so good. We will get through this.

ROSA: Like I said: you have to send your daughter to learn to work. I already talked to some friends who need someone to help take care of their boy. They will probably come to see you. Okay, I am leaving now. Here comes your daughter. *(She leaves quickly.)*

MARÍA: Be well, Rosa. *(Carmen enters.)*

CARMEN: What's wrong, mama? Why are you crying again? Couldn't they lend you money for food?

MARÍA: *(Between sobs)* No, daughter! Rosi says that she can't give us any more. I only got enough for a little corn for the girl. I don't know what we're going to do.

CARMEN: I have something to tell you. The neighbors know a man who says that he will give me a good salary to go the city and clean for him and take care of his children. Since we have nothing to eat now, it would be best for me to go to work. It's for the best.

MARÍA: Ay, daughter! I don't want you to go! I don't know what to say, because we don't know anything about the city! But what other choice do we have? We can't die of hunger. Tell the man that I want to speak with him.

CARMEN: *(Leaning out the door)* He is coming, mama. Doña Rosa must have spoken to him. Come in, Señor. I already told my mother and she wants to speak with you. *(She lets Mario enter and he greets them.)*

MARÍA: Good afternoon, Señor: Is it true that you want my daughter to work for you?

MARIO: Yes, Señora: I need someone to work in my house; your neighbors are my friends and they told me that your daughter might want to work for me. That's why I have come looking for her.

MARÍA: *(Resigned)* That is fine, Señor. But the truth is that she has never worked before, and we don't know how much you mean to pay her.

MARIO: Well, would twenty thousand pesos per month be acceptable while she learns how to do the work? We will pay her more later on if she works well.

MARÍA: I see no problem with that. That's a good salary while she's learning to work, but forgive me, Señor; would you give me half of her salary in advance? It pains me to tell you but my husband just died and we have nothing to eat. *(She begins to cry.)*

MARIO: Don't worry, Señora. Here you are. Once I see how your daughter works I will increase her pay; that way we can help both of you.

MARÍA: May God reward you, Señor. Thank you so much, because we really need it. I suggest that you show her city ways little by little, so that

she learns to take care of herself and to work. And when do you want her to begin?

MARIO: Right now, if she can, Señora. My wife has to go to work and doesn't have anyone to take care of the children. Here is my address, and you already know my relatives, in case you want to come see her. Don't worry, we will take care of her.

MARÍA: Please, Señor, take good care of her there. Let me just get her clothes together.

CARMEN: *(Holding up a small bag)* I have them all ready, mama. The Señor says that his wife will give me a few clothes.

MARÍA: *(Holding back her tears)* God will reward you, Señor. It's just that we are so poor. See you soon, dear. Take care of yourself.

MARIO: Well, Señora. We will be on our way. Don't worry about your daughter, we will take care of her. You can come see her when you want. *(Carmen takes leave of her mother, and follows Mario out the door.)*

MARÍA: *(While watching Carmen from the door she hugs her youngest daughter.)* Ay, my little daughter, if we were not poor your sister would not have to go to their house. I don't know why it makes me so afraid. But . . . what else can we do? *(They exit to one side.)*

Scene 3

María and her youngest daughter appear, next to the fireplace. There is a knock at the door and the voice of Rosa is heard.

ROSA: *(Alarmed)* Are you there, María? *(She quickly knocks again.)*

MARÍA: *(Startled, she hurries to open the door.)* Yes Rosa, come in.

ROSA: *(Entering)* Ay, Doña María; I don't know how to tell you. Something terrible has just happened. Don Mario came with some bad news.

MARÍA: Aaay, what now, Doña Rosa? What did they do to my daughter? What has happened to her? Please don't tell me that they have kidnapped her!

ROSA: Ay, Doña María! It would be better if Don Mario told you. *(Mario enters.)*

MARIO: It is even worse than that, Señora. We are truly sorry. Your daughter went out to buy some things, and since she has never been to the city . . . she didn't look before she crossed the street, and unfortunately . . . a car hit her.

MARÍA: But what happened to her? Is she hurt badly? Oh my God, tell me what happened to my daughter! *(She begins to cry.)*

MARIO: Ay, Señora; I don't know how to tell you . . . They couldn't save her . . . she was hurt badly and sadly . . . she died.

MARÍA: *(Crying inconsolably)* Noooo! Aaay, my God; my Carmen, dead! How could you send her out on her own without knowing the city? I trusted you to take care of her! And what are we going to do now without my beloved daughter? Ay, my God; why are you punishing me like this? *(The younger daughter also cries, hugging her mother.)*

MARIO: *(Remorseful and ashamed)* I understand, Señora. I know that you are suffering a lot for your daughter. What could we do? We had already showed her how to cross streets, but she wasn't careful. She ran out in front of a car. The poor driver wasn't to blame.

MARÍA: And what did they do to the driver? Did they nab him or let him get away?

MARIO: No, Señora. He even stopped to help her, but it was her fault that she was hit. There were witnesses. It was a terrible accident. It wasn't the driver's fault, but he plans to pay for the burial in any case. You just need to go see your daughter for the last time.

MARÍA: So . . . they are not going to bury her here?

MARIO: No, Señora. They can't bury her here because the driver is poor and doesn't have the money to pay for the transportation. Since everyone saw that he wasn't to blame, we can't make him pay. It's very expensive. That's why I ask you to resign yourself to the situation.

MARÍA: *(Hysterical)* How can you ask me to be resigned when she was my only hope! Now I have no one. *(She cries bitterly.)* Ay, my God! And my younger daughter is finally better and loved Carmen so much! If it wasn't for her I would not be able to bear such pain.

MARIO: Yes, Señora; I understand that you are suffering for the loss of your daughter. But . . . what can we do? Really, it was not our fault. Her misfortune came because she didn't know about the city. She should have waited for the light to change.

MARÍA: Oh, my God. My husband wouldn't even let them raise their eyes from the floor. That's why I worried about them so much. But what can we do . . . now she is dead. *(She goes back to crying bitterly.)*

MARIO: *(Dismayed)* I understand, Señora . . . but it's already late. We have to go, because the funeral begins in half an hour; that is if you want to see your daughter's face for the last time . . . We should go.

MARÍA: Okay, Señor. Let's go. Dear God! Why are you punishing me so much?

Act 2

Scene 1

María rushes in, followed by Teresa. They carry piles of clothes, which they throw on the bed.

MARÍA: Daughter, tomorrow you will have to get up early because Señora Juanita asked if we wanted to pick frijoles and I said yes. What do you say? Should we go or not?

TERESA: That's fine with me, mama; I would rather work nearby than die in the city like my sister, even if the pay is less. We could even bring my little sister.

MARÍA: Ay, daughter, thank God we are together, even if we barely earn our meals. Truly I can't stand any more of this poverty.

TERESA: But Don Antonio keeps asking you to marry him. And it seems like you want to get married.

MARÍA: Ay, daughter, I don't know what to think. He seems like a good man. At least he works. And I don't want you to go hungry so often. What would we do if I got sick and couldn't work? People here don't respect widows. At least we would have somebody respectable in the house.

TERESA: Ay, mama. The truth is that I am afraid of him. It is true that he works, but I don't know if he will treat us like daughters or what. What happens if he later regrets having to support us because we are not his daughters.

MARÍA: No, daughter. Don't think like that. He has told me that he wants to be like a father to you. You see how he takes care of the little one. He brings her lots of presents, and has brought you several dresses.

TERESA: It is true, but for some reason I don't like him. I don't like the way he looks at us.

MARÍA: Ay, daughter; don't start me thinking. It's for your good that I want to get married. You've seen how hard it is for a single woman. Someday

you will marry too, and I won't have anyone to look after me. I don't want to be a burden.

TERESA: Don't say that, mother. If I ever get married, the first thing I am going to do is ask my husband to let you live with us.

MARÍA: No, my daughter; that's no good. Married people should live on their own. You know how many problems there are when mothers-in-law live with their sons-in-law.

TERESA: I just don't want this Don Antonio to treat you badly like my father did. Won't he say that he is doing you a favor by marrying a widow with two kids?

MARÍA: No, my daughter. I think that Don Antonio has good intentions. The people from his town say that he's a hard worker. And he has a nice house. I don't think that he will mistreat me. This way I will feel more secure and you'll be able to study. It'll be the best thing for you.

TERESA: Okay, mama. Think it over. Let's hope that you don't have regrets later.

(They both leave, worried.)

Scene 2

Another, bigger Zinacanteca-style house. There are full grain bags and a table that is larger than the one at the other house. María enters, followed by Teresa, who carries a basket full of provisions, which they put on the table.

TERESA: *(Pleading)* I want to go to church now that my stepfather is gone. When he's here he doesn't let us go anywhere.

MARÍA: Ay, no daughter. You better wait for Antonio to come then I'll ask him to take us. He might scold me if he doesn't find you here. As you know, this is a very tender point with him. When he gets mad he doesn't understand anything. Wait for Antonio, daughter! Later, when he comes back we will go together.

TERESA: *(Annoyed, she paces back and forth, speaking angrily:)* But why do I have to suffer because of your marriage? It's not my fault that you married this man. What does it have to do with me? It's one thing if you want to put up with his jealousy, but why should he order me around? Here we are suffering just like we did with my father and I can' t even go to mass.

MARÍA: Please understand, daughter; as you know we now have food to eat and clothes to wear. I know that he is too jealous, but I think he'll get better with time.

TERESA: It seems to me that he gets worse every day. Before he was just protective of you, but now he gets mad every time I talk with anyone. My friends don't invite me to go anywhere because they know he won't give me permission to go out, and they even have to put up with his scolding if they invite me.

MARÍA: It's probably because he wants you to be careful. You know how girls are these days. You shouldn't trust them.

TERESA: Ay, mama; you know how it is. All he wants us to do is sit in the house, answering to his beck and call. He is always coming up with ways to keep us busy running back and forth fetching things for him. We are like his slaves. Sometimes I think it would be better if you left him and we went back to our house to live alone, instead of martyring ourselves.

MARÍA: No, daughter! You are forgetting that I am married to him and can't leave him. Anyway, you have already forgotten how hungry we were. Now we don't suffer so much. It's just a question of time. You'll see that things will come together. *(Animated)* Anyway daughter, calm down, come on. I'll let you go to mass, but come home as soon as it's over so that your stepfather doesn't discover that you have gone. Please understand, daughter!

TERESA: *(Reanimated and almost happy)* Good, mama; I'll be back soon. But in any case it's time for the two of you to understand something: he's not my father and he doesn't have the right to meddle in my life. *(She begins to change for church.)*

MARÍA: Yes, daughter, yes. I will convince him. Go on, hurry up.

(Having changed, Teresa prepares to depart when her stepfather appears. When he sees that Teresa is going out in her church clothes he becomes angry.)

ANTONIO: Where do you think you are going? Haven't I told you that you can't go out without my permission, and definitely not alone. In this house you follow my rules. Do you understand? You need to learn! *(He raises his hand to hit her and Teresa dodges to one side, sobbing, and leaves the scene.)*

MARÍA: *(Imploring Antonio)* No, Antonio! Let her go to mass! She's young and she needs distractions.

ANTONIO: *(Furious)* You better shut up or I will hit you! Didn't I tell your daughter that she can't go out unless I go with her?

MARÍA: Okay, don't get mad. I will tell her that she can't go out. I will tell her to water the plants. *(She goes to find Teresa in the kitchen. Antonio, furious, exits to one side. Teresa immediately enters from the other side, crying from rage, followed by María. They remain in the kitchen.)*

MARÍA: *(Tenderly)* Ay, daughter, Antonio is very angry because he doesn't want you to go out by yourself. But I understand that you want to go out . . . I told him that you were going to water the plants; pretend that you are going out to water and then as soon as he is calm you can go out for a while. I just ask that you don't go out for too long. You know how he is when he gets mad.

TERESA: You are so good, mother! It's too bad that you had to marry this wretch of a man who is making your life impossible just like my father did. Listen mother, there's a really nice young man waiting for me at church who wants to speak with me . . . I am just going to ask him to wait a little while so that we can have a serious talk with the old man and ask his permission to marry. I won't be long mama, I'll be back soon.

MARÍA: Oh Lord, my daughter. Although you are so young to marry . . . I understand. I can't ask you to keep putting up with the mistreatment of your stepfather. I just pray to heaven that you can be happy, and that you are not destined to as much unhappiness as me . . . *(She cries.)*

TERESA: Don't cry, mother. You'll see that everything will be better when I am married. Maybe this man is so angry because he doesn't like supporting us since we are not his real daughters. And if he keeps mistreating you, then leave him and come to live with us. But I am already late. I won't be long *(She exits to one side.)*

MARÍA: May God protect you daughter. Don't be late. *(She goes off the other side. The scene remains empty and silent. Suddenly we hear Antonio's yells.)*

ANTONIO: *(Yelling behind the scene)* Teresa! Teresa! Come here! *(Antonio appears to one side, still yelling.)* Damn! She has escaped! When will this girl learn? She's going to get such a beating. Tereeesa! *(When she doesn't respond he gets furious and kicks a pail. He leaves to one side. María appears on the other side followed, in turn, by Antonio.)* María! Where is your ungrateful daughter; she doesn't answer when I call.

MARÍA: She is outside watering the plants like you asked.

ANTONIO: Don't lie or I will beat you to a pulp. I was just looking for her and she's not there; that's why I am asking you.

MARÍA: *(Annoyed)* Okay! I will tell you the truth. She went to mass. What's wrong with going to mass? Anyway she's young and is neither your wife nor your daughter so you have no right to be so protective of her. I am her mother and she asked for my permission. I have the right to give it to her, because it's my fault that I married a man who is so jealous of her. Let her live her life, man!

ANTONIO: This is my house and I make the rules here! This is all I need. I kill myself working to support you and your daughters and you dare to disobey me? And don't raise your voice to me! *(He hits María, who protects herself from the blow.)* Your hussy of a daughter will get the whipping she deserves for her disobedience. *(At this moment Teresa enters; when she sees they are fighting, she intervenes.)*

TERESA: Enough, stop hitting my mother already! I went out without permission because you are shameless and have no right to order me around. I am not your daughter and I can go out any time I want. And you better think twice about hitting me because I have a boyfriend who is ready to defend me. And I am finally telling you: I am leaving this house today because I am getting married very soon.

ANTONIO: *(Trying to hit her while she dodges him)* Shut up, you demon girl. You hussy. Tell me who this punk is so I can wring his neck. You are not going anywhere. Do you hear me? I am going to lock you up and leave you there until you learn to respect me.

TERESA: Who do you think you are to be locking me up? No, Señor. The days of slavery are over.

ANTONIO: I am your father, you demon child. *(Making a move to hit her)* If you keep raising your voice to me I will break your face. Get down on your knees and beg my forgiveness.

TERESA: You're nothing to me. I don't have to obey you. I wouldn't obey you even if you were my father! You're the one who should be asking forgiveness for the bad life you've given my mother.

ANTONIO: *(Chasing her)* I told you to shut up and I'm warning you. You'll never leave this house, much less to marry some bum. It's time that you understood that you belong to me just as much as your mother does, because I'm in love with you and I'm not going to allow some bum to take my place. You're mine for better or for worse!

MARÍA: My God! What are you saying, Antonio? Are my ears deceiving me?

ANTONIO: *(He goes to the door and locks it with a bolt.)* Yes, that's right. I'm in love with your daughter! Now you know; you both belong to me. That's why I did not want her to marry anyone. From now on you will stay here under lock and key. *(María, furious, grabs a log from the fire and throws it at Antonio, who ducks.)*

MARÍA: I will kill you first you disgraceful man, even if I have to go to jail for the rest of my life.

ANTONIO: *(Crazed)* How are you going to kill me, you whore? You want to go off with someone else? Is that it? Well I won't let you. *(He pulls out his machete from its case and begins to slash at María. Teresa looks on in horror, paralyzed by terror.)* Take this you unlucky woman, now I will finally have your daughter to myself. Finally, finally, finally, finally. *(María, dead, falls to the floor by Antonio's feet, who gazes at her with a crazed look. He then looks lecherously at Teresa, who is mute with terror.)*

TERESA: *(Crying, terrified, yelling)* But . . . but . . . why did you kill my mother? Murderer! Help! Antonio is a murderer! He just killed my mother! Help, please! *(She tries to open the door.)*

ANTONIO: *(Grabbing her by the arms, crazed)* You're not going anywhere! You're staying right here because you're mine! You belong to me whether you like it or not! We're going inside!

TERESA: *(Struggling to get free)* Let me go, you murderer! Help! *(She manages to pull free and lunges for a shotgun that is hanging from the wall. When he sees that she is pointing it at him with resolve, Antonio freezes, surprised.)*

ANTONIO: *(Yelling, afraid)* Put it down, Teresa. Can't you see that it's loaded?

TERESA: You asked for it! You crazy old murderer! I don't care if they send me to jail. At least I can avenge the death of my mother!

ANTONIO: *(He lunges towards her, afraid.)* Give me that shotgun!

(Teresa, still taking aim, shoots. Antonio manages to gaze at her in disbelief before falling down, dead. Teresa remains standing, paralyzed. At this moment an insistent rap is heard at the door. Teresa reacts and slowly opens the door. Lupita, the younger daughter enters, leaving the door open behind her. When she sees the scene she screams.)

306 Petrona de la Cruz Cruz

LUPITA: What's going on? We heard shots! Aaaaay! My mother is dead! What did you do, Teresa! You killed my mother and father? Now who will we live with?

TERESA: (Crying and hugging Lupita) No, little sister! I didn't kill mama! This disgraceful man killed her with his machete, and I killed him for it. I didn't kill my mother! (They cry inconsolably. José enters.)

JOSÉ: (Running, alarmed) What happened here, Teresita? What were those shots? (He looks at the cadaver in shock.) What happened? Who killed your mother?

TERESA: (Sobbing) My stepfather did it, Don José. He was the one who killed my mother. (José discovers the cadaver of Antonio.)

JOSÉ: (Shocked) He's dead too! What happened? Did they kill each other?

TERESA: (Cries uncontrollably) No, Don José! After he killed my mother he wanted to rape me. He was very jealous because I told him that I was going to marry. I never imagined that he was in love with me. He tried to drag me into the bedroom but I managed to grab the shotgun and shoot him.

JOSÉ: Oh, my Lord. What a tragedy! Antonio must have gone crazy. Poor Doña María, to die like this after having suffered so much. May God receive her in all his glory! But now . . . we must notify the officials.

TERESA: (Sobbing) Yes; okay. I just need to ask you one favor: please take care of my little sister because I am sure that they will put me in jail to pay for my crime. (She walks into the bedroom with the shotgun. They hear metallic sounds.)

JOSÉ: (Consoling Lupita, who is crying) It's okay; don't worry about your sister. She will stay with us while you give your statement. You can say that it was in self-defense. Don't move anything. I have to go quickly to the station so that they can come see what happened. (Teresa comes out of the bedroom, and she and Lupita cry together over the body of their dead mother, while José goes offstage and later returns with the judge and the comandante.)

JUDGE: (Annoyed) Good afternoon, young woman. Don José informs us that a double crime has been committed in this house. Would you mind explaining what happened here?

TERESA: (Trying to hold back her tears) Yes, sir. Ay, Lord, if I could have only known what was going to happen . . . ! My mother defied my stepfather by giving me permission to secretly go to mass, which infuriated

him so much that he began to scold and beat her, like he had done many other times . . .

JUDGE: Did they argue and fight a lot?

TERESA: Almost every day, Señor; he made life hard for her. He tried to keep us shut in the house, particularly me. He got very angry when my mother gave me permission to go out.

JUDGE: And he killed her just for that?

TERESA: The thing is that when I came home I found them fighting because of me; I got angry and told him that he didn't have any right to meddle in my life, and that I was going to get married. That made him furious. He became crazed, and began to shout that I belonged to him just as much as my mother did, and that he had been in love with me ever since he married my mother.

JUDGE: And . . . had your stepfather ever said anything that would lead you to believe that he was in love with you?

TERESA: No, Señor . . . The only thing is that he always watched over me and wanted to know where I was all the time. He looked at me in a strange way but I thought that it was because he was always angry at me.

JUDGE: Okay, go back to the moment when he told your mother that he was in love with you. What happened?

TERESA: So . . . he wanted to keep us locked up, and to bring me to the bedroom . . . and my mother got angry and tried to hit him with a log to make him let us out, but she couldn't hit him and he grabbed his machete and hacked at her until she was dead. He seemed crazy; he laughed like he was insane! I began to cry for help but no one heard me.

JUDGE: And . . . how were you able to kill him?

TERESA: When I tried to get away he grabbed me by the arms; here are the bruises! He wanted to force me into the bedroom. I don't know where I got the strength but I pushed him. I jumped over to where the loaded shotgun was hanging . . . and I killed him when he came at me. My little sister arrived, followed by Don José . . . This is all I have to confess, Señor.

JUDGE: *(Very serious)* Okay; from what I have heard I believe that you acted in self-defense. But in any case you will have to come with me to the station. Comandante, come over here to examine the corpses and to record the evidence.

COMANDANTE: *(Serious)* As you say, Señor Judge. *(He looks them over while Teresa and Lupita continue to cry.)*

JUDGE: *(Serious)* Do you have other sisters, young woman?

TERESA: *(Very sad)* No, Señor . . . It was just my mother, my sister, and I.

JUDGE: Your stepfather had no children?

TERESA: Not as far as I know. He claimed that he never had children.

JUDGE: Okay, we'll be on our way. You will have to accompany us to the station.

TERESA: *(Crying)* Am I going to jail, Señor? Oh my God! How many years will I be given?

JUDGE: I don't know. It depends on what comes to light. You will be detained while we do an inquiry. Then we will see.

TERESA: Please don't be mean, Señor. At least let me ask our neighbors to take care of my little sister; she has no one to stay with. We don't have any more close family.

JOSÉ: *(Sincerely)* Don't worry about Lupita, Teresa. We will take care of her as if she was part of our family. You poor people, my God! But what can we do? It must be God's will that things have turned out this way. Maybe it's your destiny to suffer so.

LUPITA: *(Crying)* No, please. Don't take Teresa away! It wasn't her fault! It was Antonio's fault for hitting her and my mother so much!

TERESA: *(Crying uncontrollably)* I'm going now, Lupita. Don José and Doña Rosa are going to take good care of you. Right, Don José? Please behave yourself. *(Rosa enters, very worried.)*

ROSA: Is what I have heard true, Teresita? Is it true that Antonio killed your mother? *(She begins to cry when she sees the corpse.)* Oh my God, how that poor woman suffered! She couldn't even have a peaceful old age!

TERESA: *(Almost unable to speak for her suffering)* . . . Maybe . . . maybe it is our fate to suffer, Doña Rosa. I was going to be married soon! Now you see . . . now I have to go to jail because of that cursed Antonio!

ROSA: *(Hugging her while she looks at the sky)* Oh my God! Give us strength! These women have suffered so much! *(She cries.)*

JUDGE: *(Sympathetic but energetic)* Well, young woman. We have to take your statement and begin the inquiry. Are you willing to follow your husband's lead and take this girl into your care, Señora?

ROSA: *(Wiping away her tears)* Yes, Señor. The only problem is that we have no money for the funerals.

JUDGE: The precinct will have to take care of that since there is no family. We will send a truck to get the corpses.

TERESA: *(Crying and resigned)* Okay, Señor; I will just get my things. Ah, Doña Rosa; I need to ask you for a favor. My boyfriend is going to come this afternoon . . . to ask for my hand in marriage. Tell him that I did all this to protect my honor, and because I love him very much! *(She goes into the bedroom, and for a moment there is silence. Suddenly we hear a pair of shots from the shotgun. The Judge runs into the room, and returns mortified, with the shotgun in his hand.)*

JUDGE: What is this! She has killed herself! Damn! Why didn't I think to ask her for the shotgun? *(Everyone runs to the room and then returns lamenting, particularly Lupita. We hear an automobile pull up and soon the comandante enters.)*

COMANDANTE: The truck is here to pick up the bodies, Judge. Now we just need to bring them to the station to record the evidence and give them a good Christian burial. Such an atrocity. What a sad afternoon it has been.

JUDGE: *(Pensive and sad)* You said it, comandante. What sad luck these women have had. *(Speaking to Rosa and José)* Let's hope that Lupita grows up well now that you've taken her in. We will make sure that she is given this house as her patrimony.

JOSÉ: *(Wiping away her tears)* Why would we want this cursed house! Better to sell it and keep the money for when Lupita needs it.

JUDGE: As you prefer. Take Lupita now. Believe me that like you, all of this has hurt my soul. But now we have to go. *(Two police take away the corpses. The pained judge shakes the hands of Rosa and Juan.)* Until later, Señores. Tomorrow morning we will need you to testify to what you have witnessed. May God protect us all! *(They mournfully take their leave, following the corpse of Teresa.)*

END

Eso sí pasa aquí: Indigenous Women
Performing Revolutions in Mayan Chiapas

TERESA MARRERO

In Highland Chiapas women have many problems, tradition requires that they re-
main in their homes . . . for any behavior that does not go along with the customs and
traditions [of the community], women are ill-regarded and criticized. —Petrona de la
Cruz Cruz, Tzotzil Mayan, 1993

Our path was always that the will of the many be in the hearts of the men and women
who command. — Clandestine Indigenous Revolutionary Committee High Command
of the Zapatista National Liberation Army, *La jornada*, 26 February 1994

The contrasting quotes above signal the tensions that mitigate indige-
nous women's lives in Chiapas today. On the one hand, Petrona de la
Cruz Cruz's testimony exposes the restrictive position of indigenous
women within their own ethnic communities and their growing con-
sciousness of the damage they suffer by adhering to traditional practices.
De la Cruz Cruz and Isabel Juárez Espinosa are founding members of the
only Chiapas indigenous women's theatre and community organization,
FOMMA (Fortaleza de la Mujer Maya, or Strength of Mayan Women). On
the other, the statement by the High Command of the Zapatista National
Liberation Army (Ejército Zapatista de Liberación Nacional, EZLN) fore-
grounds the nature of their military leadership, "men *and* women who
command" (emphasis mine), a position that stands in conflict with tra-
ditional community and national patriarchal practices.

Highland Mayan women are constructing new identities shaped by a
revolutionary performative praxis. Both the self-proclaimed politically
neutral theatrical/cultural group FOMMA and the radical action of the
women within the Zapatista military structure are creating new pos-

sibilities for their own representation in the public arena. "Indigenous women have assumed the position of public and political subjects only since 1994," notes Castro Orepeza (20), the year that marks the advent of the EZLN into the national scene. The Zapatista insurgency is the first Latin American armed group that includes a set of bylaws articulating the demands and needs of its female combatants. The feminization of the armed Zapatista conflict presents a unique historical moment in Mexican and Latin American cultural history.

Through acts of personal defiance and acts of civil disobedience, indigenous women are carving these new possibilities in spite of tremendous odds and physical danger. Recasting the *india* as a positive historical agent avenges the stale, colonial legacy of the indigenous woman as the *chingada* (fucked) victim of the conquistador.[1] As key witnesses to their own lives, indigenous women stand in the face of entrenched systems of denial, a denial that can be seen functioning from the local to the national levels.

Performativity and Contestation

From observations of the Zapatista movement since 1994, my acquaintance with FOMMA's work since the early 1990s, and my work on Latinas in the United States since the mid-1980s, I find the notion of gender identity as a socially constituted, performative activity particularly useful to the analysis of contemporary culture. Theorist Judith Butler suggests that "gender identity is a performative accomplishment compelled by social sanction and taboo. In its very character as performative resides the possibility of contesting its reified status" (271). This contestatory aspect helps us theorize a strategy employed by Highland women against the social implications of biological and social determinism in the context of their contemporary experience. I would like to underscore that whatever achievements I highlight here, parity (or in Zapatista terms, *caminar parejo*, to walk shoulder to shoulder) in most instances remains an imperfect, often fleeting work-in-progress.[2] And, while I am looking at both theatrical performance (FOMMA's work) and political action as performance (the Zapatista women insurgents), they are not to be conflated. Each responds to a different set of positionalities (FOMMA is politically neutral; the Zapatista women are armed combatants). I have joined them here as a means to explore the range and limitations of possibilities for indigenous women in Chiapas.

On Tradition and Nation

In a constant yet quiet way, some Mayan indigenous women are undermining the traditional patriarchal power structures at the local and national leadership levels, challenging notions of ethnic tradition and nation building as *patria*. *Patria*, Diana Taylor notes, is a feminine term for nationhood which remains "entangled with *patriarchy*" (*Disappearing Acts* 77). In the Mexican cultural imaginary, women have been miscast and recast for more than five hundred years as Malintzin, the raped mother penetrated by the conquistador, engendering *los hijos de la chingada* (a commonly used Mexican term meaning "children of the fucked one or the great fuck"). In this paradigm, the indigenous women "have been there all along," double blamed, as women and as *indígenas*.

Nation and tradition join as unholy forces, particularly for indigenous women. The use of the term *traditional* is highly problematic, given the complex historical processes that have modified indigenous life since the conquest. In its most negative sense, *traditional* implies the calcification and misuse of power by local indigenous authorities (such as the case in which indigenous women's human rights are violated by the tradition of institutionalized acceptance of family violence). It also implies the reproduction of colonialist Spanish values by indigenous patriarchal structures of thought. These traditions in Highland Chiapas have pre-Columbian, colonial, postcolonial, and postmodern traces (Gossen). The more literate indigenous women, such as Petrona de la Cruz Cruz and Isabel Juárez Espinosa, rightfully discern that the *machista* models of behavior—including high levels of alcoholism in males—are part and parcel of the Spanish conquest legacy.

Stemming from the San Andrés Peace Talks (signed in February 1996) between the Zapatistas and the Mexican federal government, the term *usos y costumbres* (ways and customs) circulates within the Zapatista camp to indicate the right to indigenous autonomy rooted in a revisionist sense of tradition (Díaz-Polanco; Xib Ruiz and Burguete). This contemporary perspective includes a critical look at the misogynist practices that are perpetuated as tradition. Given the dimensions of the real and theoretical problems related to tradition, I restrict my use of the term to signify the present status quo, represented by the patriarchal, township community structures in place in Mayan Chiapas communities.

Eso no pasa aquí

The Spanish in the title, "eso sí pasa aquí" (that does happen here), stands in defiance to "eso no pasa aquí," a theme that emerged from a tape-

recorded conversation with Petrona de la Cruz Cruz in Texas, 1992. In the interview, she emphasized the resistance to staging her play, *Una mujer desesperada* (A Desperate Woman 1992), by the Highland Mayan men in the acting group to which she then belonged. The play deals with the prevalent problem of alcoholism and spousal abuse among the Highland Mayas in Chiapas. The men argued that such things do not happen in the community (eso no pasa), and there was no need to stage them for the gringos in Texas. De la Cruz Cruz persisted, and her insistence overrode the men's impetus to silence her.

A trail of similar denial can be traced through many levels of political, economic, and social life in Mexico, particularly where the sanctioned privilege of the status quo is threatened. The "theatricalization" of power in what Auslander has called mediatized (particularly televised) culture exclusively serves the economic/political interests of institutionalized power. Within Mexican circles, it is common knowledge that the Partido Revolucionario Institucional (or PRI, the ruling party from the 1920s until the presidential elections in 2000) influenced the broadcast content of major television networks, newspapers, and radio.[3] An example of media disinformation occurred during President Ernesto Zedillo's first few months in office in 1994. He launched an urgently televised campaign to discredit the emerging Zapatistas as foreign and therefore a problem of political infiltration. The ruling party's publicity machinery went out of its way to disinform the public that the rebels were not, *in fact could not be*, Mexican, but rather guerrilla infiltrators from Central America. Subsequently, the Mexican executive intentionally misinterpreted the call for indigenous autonomy by attempting to conflate "autonomy" arguments with "separatist" ones in popular journalistic and televised discourse.[4] In early 1995, President Zedillo put on the best show possible to convince the world and its investors that the eruption of an armed, indigenous insurgent army was not possible in today's Mexico. In other words, "eso no pasa aquí."[5]

From the onset, the Zapatistas have also exploited the public media. They exploded onto the national and international scene as a carefully orchestrated disruptive protest of exiting president Salinas de Gortari's pet project, the North American Free Trade Agreement (NAFTA) on the dawn of its inauguration date, 1 January 1994. In recent years the repercussions of NAFTA have been publicly brought to the foreground by the Zapatista movement's socioeconomic analyses of neoliberal politics (Cleaver, "Nature, Neoliberalism and Sustainable Development" 2). The overt appeal to public opinion has created publicity for the Zapatista cause (and its detractors), but more importantly, it also has made visible the plight of a specific sector of the indigenous population: its women.

Performing Acts of Erasures and Rape

Accompanied by the burden of a neocolonial social fabric and corrupt political structures, the contemporary indigenous woman's condition is exacerbated by an overt misogyny and the insidious denial of violent acts against her. Petrona de la Cruz Cruz's articulation of Highland Mayan women's condition is significant because it stands as an act of physical and symbolic defiance against implicit power structures that enforce the silencing of indigenous women at the most basic of levels: that of the self. Being an Indian woman within her own ethnic community "implies all of the subordinate, colonial relations; the negation of all autonomy; the negation of the Self in favor of biological reproduction and its model of subordination; it implies the negation of their own lives, their sexuality, the expression of their affect" (Olivera 174).

Indigenous patriarchal cultures derive their definition of *woman* through both biologically deterministic and behavioral models. Women are deemed subordinate to men sexually, socially, and politically by virtue of their biological "femaleness." In Highland culture this expresses itself through the vulnerability of women to penetration and rape, actions deeply feared by indigenous women due to repercussions that are specific to Highland culture. These include being sold in marriage to the rapist (Rosenbaum). According to Concepción Villafuerte, cofounder in 1967 of the alternative local Chiapas newspaper *El tiempo:* "The indigenous parents request a 'dowry' of the rapist and hand over the girl, but he is not punished . . . And it is very common, almost the norm, one could say, this ill treatment of men towards women among the indigenous people . . . is almost like their destiny, they have to put up with it" (qtd. in Rovira, 32). In addition to all else, women fear being violated because rape neutralizes their most significant leverage, the one-time privilege of being acquired by a legitimate husband in marriage trade relations.

Similarly, the symbolic interpretation of her physiological/biological vulnerability assigns women the culturally coded task of reproducing the machista model of the first india in the Spanish colonial imagination, Malintzin, Malinche, Doña Marina, as the chingada, the "violated, fucked one." By analogy, indigenous men assume the (neo)colonialist role of the "conqueror" historically attributed to Hernán Cortés, the first European *chingón*, the "big fucker" in the colonized Mesoamerican imagination. The act of rape by *ladino*[6] and indigenous men replicates the initial act of violence by the conquistador, thus replicating the injury towards indias. Worse yet, unwittingly ladino and indigenous men refract themselves in the image of the odious subjugator.

The definition of a "good" india depends upon her willing, submissive obedience to established norms of behavior within her ethnic community. Within traditional ethnic norms in the region (Tzeltal, Tzotzil, Tojolabal, Chol, Zoque), there is no room for a woman to perform in socially creative ways *within* her community. However, this does not mean that all women renounce attempts to influence their communities at various levels, regardless of restrictions.

The Quiet Revolution: FOMMA's Theatre and Literacy Project

Being an actress is considered a very daring activity, one is thought of as crazy, lacking modesty . . . but through theatre we can expose family and social problems that could not be said in any other way. —Petrona de la Cruz Cruz, 1993

In a context that considers an indigenous woman subject to the unprotective law of the father, being visible and visibly pointing out her culture's violation of women's human rights indeed constitute a "quiet revolution," to borrow *New York Times* writer Robert Myers's term. In 1994, Isabel Juárez Espinosa (Tzeltal Mayan) and Petrona de la Cruz Cruz (Tzotzil Mayan) founded FOMMA, a theatre collective dedicated to literacy, training, and awareness related to issues that concern indigenous women in the Highlands. According to Juárez Espinosa, no questions regarding religious beliefs or political affiliation are asked of the women and homeless children who to come to FOMMA's San Cristobal headquarters (Interview). FOMMA conducts literacy, theatre, breadmaking, dressmaking, and weaving workshops, and maintains a neutral stance regarding the political conflict between the government and the Zapatistas, with whom they are not affiliated in any way. While men are also welcome, very few come. According to Juárez Espinosa, the organization lacks stable institutional funding, relying mostly on donations made in the United States through the Fundación Maya in Vermont. Miriam (Mimi) Laughlin, partner and wife of Smithsonian anthropologist Robert M. Laughlin, has been and continues to be instrumental in raising U.S. support for the group.

Juárez Espinosa and de la Cruz Cruz met in the late 1980s while working and participating as members of Lo'il Maxil (Monkey Business), the performing branch of Sna Jtz'ibajom (The Writer's House), a literacy and theatre group in San Cristobal de las Casas.[7] It was founded and directed by Tzotzil men from nearby Zinacantán. Juárez Espinosa was the first (and for a while the only) female indigenous actress in the Highlands. Both women eventually left the Writer's House due to internal conflicts that have been elaborated by Cynthia Steele in her essay "A Woman Fell

into the River: Negotiating Female Subjects in Contemporary Mayan Theater."

The founders of FOMMA share several characteristics that both set them apart from and unite them with other women of their ethnic background. They both graduated from *secundaria*, or the equivalent of junior high school, which is considered higher education since most indias are not allowed by their families to finish primary school. De la Cruz Cruz has taken two semesters of high school. Unfortunately, rape is an experience that de la Cruz Cruz shares with other indigenous women. She raised her child conceived by rape, and has since had a second child outside of marriage. As a single mother, she left her community to find work as a maid in the city of San Cristobal at a time when she could have been in school. Juárez Espinosa was married but widowed at an early age and was left with a child to support. She too left her community to work in San Cristobal as a domestic worker; she has since had a second child on her own and has never remarried.

In spite of adversity, their achievements are noteworthy. In 1992 de la Cruz Cruz became the first indigenous person to win the coveted Rosario Castellanos Prize for literature. Isabel Juárez Espinosa's book, *Cuentos y teatro tzeltales*, was published in 1994. In 1999, for its work in radio, theatre, and education in Mexico, FOMMA received a national award given by IMIFAP and sponsored by the Summit Foundation. In November of 1999, Juárez Espinosa participated in the conference "Men and Women of the Millennium" in Lima, Peru, an event sponsored by the World Bank.[8] They have presented their work in the United States, Mexico, and Australia. Their personal efforts to excel in the craft of acting, their educational achievements, and courage to publicly perform cultural taboos set them outside the conformity required of traditional women who remain in their communities.

Everyday Life and Social Drama

Because the lives and work of Juárez Espinosa and de la Cruz Cruz surpass traditional social norms, it is particularly fitting to explore their work through Victor Turner's notion of social drama. After having read all of de la Cruz Cruz's plays and Juárez Espinosa's plays and prose narratives up to 1996,[9] and after having seen several performances in the United States and Mexico, it is my hypothesis that their work revolves around issues of breach, crisis, and redress. Furthermore, their plays can be seen as morality plays that offer an idealized version of reality.

Similar to the denial and silencing of dissent with the "eso no pasa

aquí" attitude at the national level, traditional (and non-Zapatista) indigenous communities duplicate that practice. They seem unable to negotiate fair and acceptable reintegrative solutions, therefore leaving women who speak out against family violence no alternative but to leave their ethnic communities. Thus the fourth or final phase of Turner's concept of social drama, reintegration, has yet to materialize. In other words, indigenous women who break with patriarchal social norms must remain in "exile" from their own communities.

De la Cruz Cruz's play *Una mujer desesperada* stands out for being the first written by an indigenous Highland Mayan woman about the real-life social drama of family violence.[10] In this work, the conflict is three-pronged: the actual physical violence against women, the lack of confidence in local authorities to fairly address the situation, and the denial that such things happen. The play demonstrates how violence against women is tolerated as inevitable from generation to generation. In the first act we see a mother repeatedly beaten in front of her daughters by a drunken husband, until he accidentally falls and dies when a neighbor woman intervenes to help the mother. In the second act the mother remarries because she sees no way of surviving hunger without a man's economic and social support. The second husband, too, beats her, yet he also wants to "take" (rape) the eldest daughter, because he believes she too "belongs" to him.

Although this play is based on real-life events, the resistance to performing it included the assertion that its depiction of the community was inaccurate. As de la Cruz Cruz relates:

> They tell me: No, why are you going to come out writing these things that men kill and fight over a woman, that doesn't happen in the community. Yes, it does happen in the community, because I lived it. I went through it, I tell them. In my family so many things used to happen, maybe for that reason my mother died, I tell them. So then, I lived part of my work . . . my mother was beaten eight days before dying. Therefore I lived part of my work . . . And another person (a woman) from Zinacantán was machetied . . . the grandmother and the granddaughter were machetied to death in their homes. So I became very, very focused, I tell them . . . I begin including the small parts into what I wrote. Yes, they say, but this does not happen. All right, it doesn't happen, it doesn't happen [*Sí, pero eso no pasa. Bueno, está bien no pasa, no pasa*]. But I, I like it, it's my way of writing, it's my way of being able to do things, I tell them. Well, all right, they tell me. (Interview)

El qué dirán (what will they say?), a Spanish phrase that indicates concern over public opinions regarding one's private actions, reveals an

attitude stereotypically assigned to class-conscious women of Spanish descent. In this case, however, the indigenous males assume the self-assigned position of protectors of the ethnic community's image. In this instance, the men's attitudes and actions represent an unwitting performance of the Spanish cultural value that hinges on notions of honor. The intended protection of the family's (and by extension, the community's) "honor" then amounts to performing—reenacting—a (neo)colonialist social code. The men's refusal to admit what is common experience and knowledge—eso no pasa en el pueblo—also resonates with the policies of the supreme "father" of the country. Recall President Zedillo's initial stance towards the unruly and rebellious Zapatistas. The motion of containment through denial and subsequent erasure and eradication of a known social problem, are parallel—not dissimilar—moves.

The denouement of *Una mujer desesperada* questions the capacity of the redressive phase of ethnic community life. When the authorities arrive, the daughter experiences a sense of distrust and, fearful of her fate after killing her attacker in self-defense, suddenly commits suicide rather than submitting to them. The lack of trust in the system to which she would appeal functions as an indictment against the lack of justice (redress) in cases of rape and family violence in the communities.

In many pre–1996 works, de la Cruz Cruz writes the redressive and reintegrative stages into the plays as an idealized and exemplary version of reality.[11] FOMMA performs these plays in the various communities where they become the subject of discussion. For instance, in *Desprecio paternal, drama tzotzil* (Paternal Disdain) the father rejects and beats the daughters for being female, a biological determinism that guarantees the paternal disdain. In *Mujer olvidada* (Forgotten Woman) de la Cruz Cruz creates a son who acts violently against his aging mother, who prefers him to the daughters because he is male. In *La tragedia de Juanita* (Juanita's Tragedy) de la Cruz Cruz reveals the fate of a nine-year-old girl, who catches the eye of an old, powerful man. She is sold to him as his "wife," but when the drunken man rapes the child and then asks her to cook for him, crying she says she doesn't know how.

FOMMA performs other issues for public scrutiny. Isabel Juárez Espinosa's early play *Migración* deals with the fate of a family once the husband leaves his *terreno* (plot of land). The migration of poor, indigenous peoples to large urban areas afflicts many regions of Latin America. Evident traces of postcolonial urban racism demands the erasure of all identity markers of "Indianness" from costume to language to self-sufficiency.

Collaborative works since 1997 include *Ideas para el cambio* (Ideas for Change), *El sueño del mundo al revés* (The World Upside Down), *Víctimas del engaño* (Victims of Deceit), *La vida de las Juanitas* (The Life

of the Juanitas), and *Amor en la barranca* (Love in the Ravine), which deals with the issue of birth control and was part of the 1999 Summit Foundation prize. These works develop from the participants' experiences, and the act of speaking and sharing their lives, according to Juárez Espinosa, is often difficult but liberating for indigenous women. It is difficult for many to break a lifelong practice of silence. To what degree FOMMA's quiet, personal revolution may alter present cultural practices and understanding remains to be seen.

The Internal Revolution: Men Learn to Cook, Women Give Orders

If the cultural/theatre group FOMMA has been busy helping displaced, indigenous women through intra-family social theatre, the Zapatistas have thrown themselves into the national political theatre by declaring war on the status quo. Such radical action has had deep effects, from the way in which the state has been forced to negotiate with indigenous people, to the way in which rebel indigenous men and women relate to one another within their communities and homes.

Within the Zapatista army, the inclusion and parity that indigenous women enjoy in the military ranks run directly opposite to standard notions of womanhood. Thus, their participation challenges traditional male hierarchies. I am not suggesting, however, an overzealous, idealistic notion of Zapatista indigenous women's attainments to date. Both women and men see the possibility of social changes in generational terms. Machismo will not be eradicated without a radical change in the men. Journalist Rosa Rojas offers this interview with Antonio Hernández, a member of the hard-core Zapastista autonomous municipality of Las Margaritas: "the women's struggle to get us men to collaborate with the exercise of women's rights is going to take a long time, because if the man doesn't let her, she simply is not going to have rights. Men, too, must become educated in women's rights, so that the habit of sharing life, sharing decisions, sharing work, in every sense becomes publicly known" ("Indigenous Autonomy"). Thus militant Zapatista women outside EZLN military ranks still live within the debated terrain of transitional personal politics. Remnants of traditionalist thinking can easily be perceived in a discourse that frames the rights of women within the patriarchal logic of "giving permission." The construction of identities of women belonging to the same cultural groups (the Tzotzil, Tzeltal, Tojolabal, Chol, Zoque) within the rebel Zapatista military structure as described above is based on a different set of guiding principles, antithetical to the traditional cultural model. Both men and women make

choices concerning the level of participation within the communities that support Zapatismo. For instance, one may be an *insurgente* or insurgent, which means leaving one's family, going into the mountains, and gaining military training. Or one may be a *miliciana/o* or militant, which allows the person to stay in their village and work as civilian support.[12] For women, involvement requires they be ideologically in agreement within their hearts (to use the indigenous unity of heart/mind) with the evolving Zapatista social project. This project highlights the democratic, participatory, and community-based indigenous concept of *mandar obedeciendo*, that is, being leaders who govern by obeying the will of the majority.[13] Both positions require that women perform outside the biological definitions of their being, actions based rather on the performative junction of behavior and volition.

And women are crossing those boundaries. One of the notable aspects of the Zapatista struggle has been the visual presence of indigenous women outside the home. A full one-third of the EZLN army is composed of indigenous women (Rojas, "Introducción" vi). Diane Goetze, in "Revolutionary Women: From *Soldaderas* to *Comandantas*," distinguishes the Zapatista women as a distinct movement because: (1) they have a collective identity, which is a different identity than that of the Zapatistas as a whole; (2) they have mobilized and acted as a distinct group from within the Zapatistas; (3) they have some demands and goals distinct from the Zapatistas; and (4) they have brought social change within the Zapatista organization as well as in the indigenous populations of Chiapas (1).

The inclusion of women combatants as equal revolutionary partners also requires an adjustment in the role that men play. In Guiomar Rovira's telling *Mujeres de maíz*, an interview with Captain Irma reveals a significant aspect of that difference: "In the *pueblos* [indigenous traditional communities] it is the woman who works at home; only women make the tortillas and wash clothes. But not here, the men, the *compañeros* [comrades] also work; they also do the service detail" (68). The social markers that define gender through the performative function of household duties are erased. In this new context, men do so-called women's work as part of a shared rebel community. Men acknowledge that they must also obey the command of women of higher military rank; "as part of a military organization, they have no choice but to do as they are ordered" (Rovira 68). In the video *Zapatista Women*, Subcomandante Marcos discusses the courage of Captain Isidora, who saved the lives of an entire column of men, while wounded in Ocosingo in 1994. Thus insurgent women of military rank are respected on an equal footing with men due to their proven military performance.

On the subject of performing a traditional female role, Rolando, an insurgente being interviewed, says that "at the beginning . . . the thing that was hardest for me to get used to was preparing the food. One day I burned the beans, imagine giving the *compañeros* burnt beans" (qtd. in Rovira 69). The transgressive act of men cooking daily meals while women give military orders occurs outside of normal village community life, and as such it transpires in the liminality of a state of war. One thing remains evident—insurgent women have found a new freedom and going back to traditional subservient roles will be difficult if not impossible. Within the new, multiethnic Zapatista military communities, gender parity (caminar parejo) is enforced.

From "Universal" Male-Directed Revolutionary Concerns to the Specificity of Women in Conflict

It may be a little-known fact that the person who commandeered the takeover of the key city of San Cristobal de las Casas that fateful dawn on 1 January 1994 is a Tojolabal woman: Mayor Ana María, then twenty-five years of age. (She joined at the age of fourteen). On 28 February 1994, Mayor Ana María responds to the question of who they are and why they have taken up arms: "There are some *ladinos* who are here. They are those who are helping the ones who understand. For example, Subcomandante Marcos is a *ladino*. But they are not foreigners. We know where he is from. We are not being fooled by anyone. It is we, the *campesinos* and the indigenous people who think that this needs to be done, what we did in January" (Ana María).

According to the declarations of Subcomandante Marcos, Zapatismo as an indigenous, grassroots movement was born on 17 November 1983 (Le Bot 65). The ten-year gestation period afforded them an organic evolution that is and is not Marxist, that has some aspects of fundamentalist and millenarian thought of previous indigenous resistance movements. Speaking of the decisive years of 1993–94, Marcos notes that Zapatismo "was a mixture of all of this, a cocktail that is mixed in the mountain and crystallizes itself in the combative force of the EZLN, that is, in the regular troops" (Le Bot 99). In 1990–92, the Zapatista demands were, according to Marcos, "universal" (Le Bot 322). In 1992, at the end of the gestation period, the issue of women's specific demands emerged. In this year the communities in arms voted in favor of war, and a juridical corpus was created that would establish the "revolutionary laws of war." The highest organizational level of the EZLN asked the women to draft their proposal. "This was the result of the struggle of the women Zapatista offi-

cers" (Marcos, qtd. in LeBot 322). And while women had already gained the right and responsibility to combat on equal footing, at the social level the Zapatista women saw the need to address their biological and reproductive rights, among other social issues. The insurgent ideology of Zapatismo had taught them to question and analyze their own exploited position within dominant power structures, and they did, leaving nothing unexamined, including Zapatismo. Marcos has often commented that the EZLN is not feminist, that the men would have rather retained their privilege, but that the militant Zapatista women would not allow it (Le Bot 322). Within the Zapatista General Demands to the federal government, the twenty-ninth point articulates the Petition of Indigenous Women. Thus indigenous Zapatista women insurgents engendered the right to self-representation within a revolutionary organization.

Insurgency: From *Huipiles* to Masks to Military Camouflage

One of the most visibly surprising aspects that the Zapatistas brought to Mexico and the world on that chilly Highland January morning were the images of "so many women, most very young" (Millán 9). What Millán does not mention in her excellent analysis, yet evidently emerges in the photographic and video images, is the implicit revolution that took place *previous to* the public appearance of heterosexual indigenous Mayan women publicly wearing men's military clothing. Perhaps a more accurate reading might be to equalize the cognitive field by seeing both men and women publicly wearing the same costume, regardless of gender, ethnic, or community identity markers. As in a theatrical context, dress functions as a visual sign that may uphold or subvert consensus of the roles being assumed by the performing body.

In this manner, strategic dressing serves as another way to address the issue of roles and performance. Feminist theorists have discussed performance in transgendered costume, moving from Shakespearean dramas to contemporary discourses of transvestism. Considering the transgressive implications offered by the Highland Chiapas context, it is not a stretch to consider the donning of male military attire a transgendered motion, not sexually but representationally. One must consider that for traditional Mayan women to shed their huipiles (brightly colored woven wool blouses) is to shed their ethnic markings of origin. According to Walter Morris, in his landmark book, *Living Maya*: "When a Maya woman puts on her *huipil* she emerges through the neckhole symbolically in the axis of the world. The designs of the universe radiate from her head . . . Here the supernatural and the ordinary meet. Here, between the very

center of a world woven from dreams and myths, she stands between heaven and the underworld" (108).

If women's traditional clothing marks a cosmological, sacred world order, one which speaks a certain language understood only within the context of ethnic tradition, then the shedding of such a costume implies the overriding choice to assume a different role and convey another meaning. If the traditional huipil also marks normative behavior and roles that differentiate indigenous Highland women not only from men, but from other women belonging to different ethnic groups and from ladinas, then the shedding of these markers functions as a move away from the fragmenting ethnic towards the unifyingly political, from ethnic/gender identity to macro politics.[14] In this way, the politics of dress assumes wider implications.

The use of ski masks by a subversive group has acquired symbolic capital in a nation that has traditionally used masks as markers of institutionalized power. In ancient times, Mayan, Zapotec, and Aztec religious/political leaders used ritual masks to represent animistic forces. The donning of a self-effacing head cover erases individual markers, allowing the individual to transcend to a collective level of experience for and by the group's well being.[15] In contemporary Mexico, the entrenchment of the ruling PRI over the past eighty years has bestowed a more cynical connotation to ritual anonymity. In modern political discourse *el tapado* (hooded or covered man) refers not to a corporeal, actual mask, but to a ritual of the state, "the apotheosis of the mask, the veneration of the mask for its own sake" (Hiriart 94). *El tapado* refers to the secretly anointed successor of the incumbent Mexican president. In light of this practice, Subcomandante Marcos refutes critics of Zapatismo's public use of ski masks, "Why the big deal over the ski masks? Isn't Mexican political culture one of 'hooded men?' " (*Documentos y comunicados* 98). The duplicitous face of a simulated democracy lacks the moral weight to tear away the Zapatista's self-protective mask (Marrero, "La construcción visual" 99).

The donning by Mayan Zapatista insurgent women soldiers of not only the mask but the outer clothing of men functions both as a subversive and as a normalizing element by reassigning the gendered qualities associated with the theatre of war. For men to be willing to accept women wearing "their" signifiers of power implies a revolution within. While there is nothing innovative about the idea of women and men assuming unisex military garb, there is a qualitative difference in the donning of this clothing by women from taboo-regimented, closed, and generally isolated ethnic communities, be it in Latin America, India, Africa, or the

United States (consider the Amish, for instance). This difference carries serious implications at the deepest level of a social organization and its willingness to represent and perform an empowered female.

Pacifist and radical feminists may rightfully object to my suggestion that indigenous women are being empowered through the co-optation of masculine military signs. Ximena Bedregal, for instance, makes such an objection in "Memoria y utopía en la práctica feminista: Diálogo con Mercedes Olivera." As a radical Mexican feminist, she believes that *any* involvement in military action constitutes participation in patriarchal structures/logic of domination, and therefore defeats the efforts to create/imagine new social options for women (185–86). Mercedes Olivera, on the other hand, makes a case for a less utopian perspective, one in which the gains can be accounted for in light of the real conditions of life. In my opinion, the empowering of women as soldiers in the case of Chiapas is an evident fact. Entrance into the world of fighting for the rights so long denied to former colonial objects of racist rule requires seizing opportunities wherever they may appear. At this junction in the process, performing contestatory and combative behavior requires entrance into the world of military logic.

Concluding Thoughts: Performing Public Resistance

If the women's group FOMMA has taken up their communities' social ills through dramatic, symbolic performance, offering ideal redressive and reintegrative conclusions, Zapatista women continue their public struggle for physical survival, redress, and reintegrative practices in the nonfictional space of live political struggle. By doing so, each in their own way, they have not only called into question and reconfigured conventional notions of revolution, they have feminized the public field of war, and social revolutions. In Latin America (and possibly the world), a contemporary declaration of war by an insurgent group that includes the specific demands of its women is a first.

Public demonstrations by indigenous women against the incursions of the Mexican federal army have been documented. In a show of civil defiance against encroaching Mexican military tanks, women in traditional clothing stand in a person-to-person *cordón de resistencia* (resistance line). In an incident recorded by Mexican videographer Carlos Martínez Suárez, unarmed Tzotzil women and girls form a protective single file on the outskirts of the community of Oventic in order to prevent the encroaching tanks from entering.[16] These striking images show indigenous women standing defiantly before the federal soldiers. For women who

have been socialized never to raise their gaze to men, this staring at the face of institutionalized, governmental power bespeaks a new public social role. For ladino men, socialized to ignore indias as the unworthy bottom rung of society, having to contend nonviolently with defiant shoulder-to-shoulder women in red bandanas must indeed constitute a supreme act of self-restraint. The soldiers do not look at the faces of the women, perhaps in yet another act of collective unwillingness, of collective denial. In any case, the feminization of the conflict has fundamentally altered the ways in which civil disobedience is conceived. In the Mexican national consciousness, these acts of civil disobedience by indigenous women single-handedly revolutionize the collective casting of postcolonial indigenous women as subjects and historical agents. Perhaps, finally, Malintzin is avenged. Indeed Zapatista insurgentas are accomplishing what the much-maligned soldaderas of the 1910 Revolution could not: they are respected (Goetze, "Revolutionary Women"). It is crucial to acknowledge that by performing acts of personal, cultural, and civil disobedience indigenous women behave in ways antithetical to the conditioning of the past five-hundred-plus years. Thus they are frontline players in one of the most important social rethinkings in Mexican history since the Mexican Revolution of 1910. FOMMA's theatre of resistance and their rearticulation of women's issues in Highland culture are no less important. Their painstaking role is to raise consciousness one member of the community at a time.

While television cameras in Mexico and the United States do not acknowledge the effort of a few thousand barely literate Chiapas Mayan women, to themselves, and to the world, they no longer remain invisible and silent.

Notes

All translations from Spanish are mine, unless otherwise stated.

1. I use the terms *india* and *indigenous woman* alternatively. *India* can be seen as a pejorative term alluding to the subjugated status of postcolonial indigenous women. In Spanish, it is also a term that they use to refer to themselves with and without the negative connotation. *Indigenous* is the more acceptable term in English. Most often the members of each Chiapas community refers to themselves by the community's ethnic name.

2. For instance, even in self-proclaimed autonomous Zapatista communities, indigenous women presently do not have the legal right to own land.

3. Notable exceptions are the newspaper *La jornada* and the magazine *Proceso*, both published in Mexico City, which are instrumental in the dissemination and political analysis of Zapatista political thought.

4. See María Teresa Marrero's essay "El Ejército Zapatista de Liberación Nacional."

5. See Marrero's essays, "El Ejército Zapatista de Liberación Nacional" and "La constucción visual."

6. *Ladino* and *ladina* are terms used by indigenous people in Chiapas and Guatemala to denote a non-Mayan. For instance, Mayor Ana María refers to Subcomandante Marcos as a ladino. According to Underiner, the word refers to neither white nor mestizo, but to "those who aspire to the privilege of a Western lifestyle" (354 n. 17). Originally, ladino was a term used to refer to the language spoken by Sephardic Jews who were expelled from Spain in the fifteenth century.

7. For further research on general Highland and Yucatec Mayan theatre, see Frischmann's work. On *De todos y para todos* by Lo'il Maxil and *Migración* by Isabel Juárez Espinosa, see Tamara Underiner's "Incidents of Theater in Chiapas."

8. Isabel informed me that her participation had been procured by Cynthia Steele (Interview).

9. Their work between 1997 and 1999 was created in group improvisations and summarized but not written as scripts.

10. Created while de la Cruz Cruz was still a member of the male-dominated Sna Jtz'ibajom, the two-act play met with a great deal of resistance from the male members of the group due to its strongly stated subject matter. In Texas, the male members of the group preferred to stage the more folkloric, lighthearted *El haragán y el zopilote* (The Loafer and the Buzzard 1989), thereby attempting to extend their control over gender and cultural representation of the women beyond local and national boundaries. De la Cruz Cruz did not let up, however, and the second act of *Una mujer* was performed on 12 October 1992 in Fort Worth, Texas. The 1992 Texas visit was hosted by Texas Christian University; the group was invited by Donald Frischmann.

11. Frischmann notes this idealized redressive characteristic in the piece *Herencia fatal* by Diego Méndez Guzman of Sna Jtz'ibajom. See Frischmann's "New Mayan Theater in Chiapas."

12. See the video *Zapatista Women (Las compañeras tienen grado)* for a more detailed discussion.

13. Ibid.

14. See "Los pueblos indios y la refundación del estado," by the indigenous lawyer Margarito Xib Ruiz and Araceli Burguete, and Héctor Díaz-Polanco's excellent *La rebelión zapatista y la autonomía*.

15. See, for instance, "Máscaras y sombras: Del concepto ritual a la práctica cotidiana del anonimato" by Juan Anzaldo Menesses.

16. See Martínez Suárez's video, *Sueños y palabras sabias de las comunidades tzotziles y tzeltales*.

Works Cited

Ana Maria (major of San Cristobal de las Casas). Comments. 28 February 1994 <http://www.flag.blackened.net/revolt/mexico/womindx.html.>

Anzaldo Menesses, Juan. "Máscaras y sombras: del concepto ritual a la práctica

cotidiana del anonimato." *Ce-Acatl, revista de cultura de Anáhuac* 81 (1996): 3–7.

Auslander, Philip. *Presence and Resistance, Postmodernism and Cultural Politics in Contemporary American Performance.* Ann Arbor: University of Michigan Press, 1992.

Bedregal, Ximena. "Memoria y utopía en la práctica feminista: Diálogo con Mercedes Olivera." *Chiapas, ¿y las mujeres qué?* Ed. Rosa Rojas. Mexico City: Ediciones la Correa Feminista, Centro de Investigación y Capacitación del a Mujer A.C., 1995. 185–89.

Butler, Judith. "Performative Acts and Gender Constitution: an Essay in Phenomenology and Feminist Theory." *Performing Feminisms: Feminist Critical Theory and Theatre.* Ed. Sue Ellen Case. Baltimore: Johns Hopkins University Press, 1990. 270–82.

Castro Orepeza, Inés. "Mujeres indígenas en Chiapas: el derecho a participar." *Memoria, revista mensual de política y cultura* 139 (2000): 20–22.

Cleaver, Harry. "Nature, Neoliberalism and Sustainable Development: Between Charybdis and Scylla?" 1997. <http://www.eco.utexas.edu/faculty/Cleaver/port.html>. 1–13.

De la Cruz Cruz, Petrona. "La educación, el teatro y los problemas de las mujeres en los Altos de Chiapas." Texas Christian University. April 1993.

———. Personal interview. Fort Worth, Texas. 13 April 1993.

Díaz-Polanco, Héctor. *La rebelión zapatista y la autonomía.* Mexico City: Siglo XXI Editores, 1997.

Frischmann, Donald H. "New Mayan Theater in Chiapas: Anthropology, Literacy, and Social Drama." *Negotiating Performance: Gender, Sexuality, and Theatricality in Latin/o America.* Ed. Diana Taylor and Juan Villegas. Durham: Duke University Press, 1994.

Goetze, Diane. "Revolutionary Women: From *Soldaderas* to *Comandantas.* The Role of Women in the Mexican Revolution and the Current Zapatista Movement." 1997 <http://www.actlab.utexas.edu/'geneve/zapwomen/goetze/thesis.html>.

———. "The Zapatista Women: The Movement from Within." N.d. <http://www.actlab.utexas.edu/'geneve/zapwomen/goetze/thesis.html>.

Gossen, Gary H. *Telling Maya Tales, Tzotzil Indentities in Modern Mexico.* New York: Routledge, 1999.

Hiriat, Hugo. "Máscaras mexicanas." *Mitos mexicanos.* Ed. Enrique Florescano. Mexico City: Aguilar/Nuevo Siglo, 1995. 93–98.

Islas Cardona, Octavio, and Fernando Gutiérrez Cortés. "La política informativa del gobierno mexicano en la red de redes." *Revista mexicana de comunicación* 62 (2000): 23–26.

Juárez Espinosa, Isabel. *Cuentos y teatro tzeltales.* Mexico City: Editorial Diana, 1994.

———. Telephone interview. 22 November 1999.

Le Bot, Yvan. *El sueño zapatista.* Madrid: Plaza y Janés, 1997.

Marcos, Subcomandante. EZLN, *documentos y comunicados.* Mexico City: Ediciones Era, 1994.

————. "Unas palabras sobre nuesro pensamiento." *Crónicas intergalácticas EZLN, primer encuentro intercontinental por la humanidad y contra el neoliberalismo, Chiapas, México, 1996.* Mexico City, 1996. 65–76.

Marrero, María Teresa. "El Ejército Zapatista de Liberación Nacional: Publicidad, presencia y automía indígena." *Revista de ciencias sociales* 5 (1998): 190–207.

————. "La construcción visual de la Nueva Revolución Mexicana: El Ejército Zapatista de Liberación Nacional." *Gestos* 13.25 (1998): 75–104.

Millán, Márgara. "Las zapatistas de fin de milenio. Hacia políticas de autorrepresentación de las mujeres indígenas." *Chiapas 3.* Mexico City: Instituto de Investigaciones Económicas de México, Ediciones Era, S.A. de C.V., 1996. 19–32.

Morris, Walter F. *Living Maya.* Photographs by Jeffrey J. Foxx. New York: Harry N. Abrams, 1987.

Myers, Robert. "Mayan Indian Women Find Their Place Is on the Stage." *New York Times* 28 September 1997.

Olivera, Mercedes. "Práctica feminista: El Movimiento Zapatista de Liberación Nacional." *Chiapas, ¿y las mujeres qué?* Ed. Rosa Rojas. Mexico City: Ediciones la Correa Feminista, Centro de Investigación y Capacitación de la Mujer A.C., 1995. 168–84.

Rojas, Rosa. "Indigenous Autonomy in Chiapas: The Women Are Missing." 1994 <www.eco.utexas.edu/homepages/faculty/Cleaver/begin.html>. Also see *Chiapas, ¿y las mujeres qué?* Ed. Rosa Rojas. Mexico City: Ediciones la Correa Feminista, Centro de Investigación y Capacitación de la Mujer A.C., 1995.

————. "Introducción." *Chiapas,¿y las mujeres qué?* Mexico City: Ediciones la Correa Feminista, Centro de Investigación y Capacitación de la Mujer A.C., 1995.

————. "Las mujeres en el gobierno de transcicion en rebeldía de Chiapas." *Chiapas, ¿y las mujeres qué?* Mexico City: Ediciones la Correa Feminista, Centro de Investigación y Capacitación de la Mujer A.C., 1995.

Rosenbaum, Brenda. *With Our Heads Bowed: The Dynamics of Gender in a Mayan Community.* Albany: Institute for Mesoamerican Studies, University at Albany, 1993.

Rovira, Guiomar. *Mujeres de maíz.* Mexico City: Ediciones Era, 1997.

Steele, Cynthia. " 'A Woman Fell into the River': Negotiating Female Subjects in Contemporary Mayan Theater." *Negotiating Performance: Gender, Sexuality, and Theatricality in Latin/o America.* Ed. Diana Taylor and Juan Villegas. Durham: Duke University Press, 1994.

Taylor, Diana. *Disappearing Acts: Spectacles of Gender and Nationalism in Argentina's "Dirty War."* Durham: Duke University Press, 1997.

————. "Performing Gender: Las Madres de la Plaza de Mayo." *Negotiating Performance: Gender, Sexuality, and Theatricality in Latin/o America.* Ed. Diana Taylor and Juan Villegas. Durham: Duke University Press, 1994. 275–305.

Turner, Victor. *Dramas, Fields, and Metaphors, Symbolic Action in Human Society.* Ithaca: Cornell University Press, 1974.

Underiner, Tamara. "Incidents of Theater in Chiapas, Tabasco, and Yucatán: Cultural Enactments in Mayan México." *Theater Journal* 50 (1998): 349–69.

Xib Ruiz, Margarito, and Araceli Burguete. "Los pueblos indios y la refundación

del estado." *La autonomía de los pueblos indios*. Mexico City: Grupo Parlamentario PRD, Poder Legislativo, Cámara de Diputados, LVI Legislatura, 1996. 13–22.

Videography

Sueños y palabras sabias de las comunidades tzotziles y tzeltales. Dir. and prod. Carlos Martínez Suárez. Consejo Nacional para la Cultura y las Artes, Fondo Estatal para la Cultura y las Artes de Chiapas y la Universidad de Ciencias y Artes de Chiapas. Video Trópico Sur. Chiapas, Mexico, 1995.

Zapatista Women (Las compañeras tienen grado). Dir. and prod. Gustavo Montiel Pages, Hugo Rodríguez, and Marina Stavehagen. Selva Lacandona. Chiapas, Mexico, 10 April 1994.

TEATRO LA MÁSCARA

(Colombia)

"We gathered in the backyard," Marlène Ramírez-Cancio writes in her essay, "Teatro la máscara: Twenty-Eight Years of Invisibilized Theatre." "Lucy leaned into the small black recorder and said: 'My name is Lucy Bolaños. I am the founder of Teatro la máscara.' We sat back and listened."

This group was started in 1972, so we are now celebrating twenty-five years of artistic work. It was a group that began as a mixed collective, made up of about thirteen men and women. We put on plays during that time, with texts from people like Shakespeare, Enrique Buenaventura, Bertolt Brecht, and also the Chicano director Luis Valdés. After 1985 La máscara becomes an all-women's group, because the difficulties of doing theatre, of making a living out of theatre, are enormous in our country. That is what made our group become unstable, and all the men left. It was a crucial moment. A few women remained who had already begun working together for an International Women's Day. We were Pilar Restrepo, Valentina Vivas, Marina Gil, Claudia Morales, María González, and myself. We took advantage of the circumstances, and from that moment on we focused on taking the feminine problematic to the stage. This became the principal endeavor of Teatro la máscara.

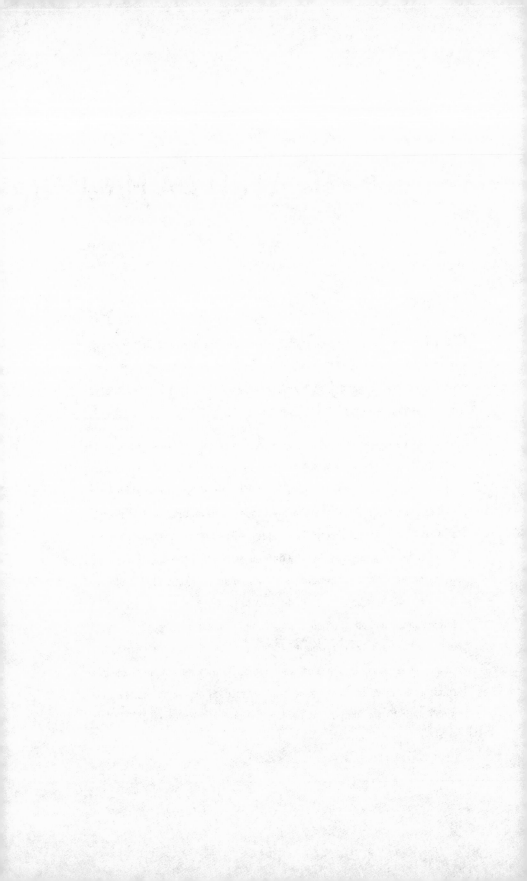

Teatro la máscara:
Twenty-Eight Years of Invisibilized Theatre

MARLÈNE RAMÍREZ-CANCIO

La verdad es que estamos cercados por el miedo. Estamos a tres fuegos: la guerrilla, los paramilitares y los militares, pero también tantas otras "fuerzas oscuras" . . . Yo quiero hablar de eso, aunque todo el mundo lo esté viendo en los periódicos.
[The truth is we are fenced in by fear. We are in a triple crossfire: the guerrilla forces, the paramilitary, and the military, but also so many other "dark forces" . . . I want to talk about all this, even if everyone is seeing it in the newspapers.]
—Lucy Bolaños, Director, Teatro la máscara

Estaban dando la telenovela,
por eso nadie miró pafuera . . .
[The soap opera was on, that's why nobody looked outside . . .]
—Rubén Blades, "Desapariciones"

How can political theatres address violence in a society of violence? Scarred by fifty years of civil war, Colombia is known as one of the most sanguinary regions in the world. Paramilitary forces routinely massacre unarmed villagers, accusing them of collaborating with guerrilla forces. Guerrilla kidnappings abound, and recent events include a woman decapitated by a "necklace" made of explosives, also killing a policeman and ripping off the arm of another. What is the role of political performance in a country like this, where violent atrocities are constantly acknowledged and exposed? Where the words *violencia, masacre*, and *crisis* appear in almost every article, every news hour, every radio show, and even many advertisements? I want to explore the work of Teatro la máscara, a women's theatre collective from Cali that has existed for

twenty-eight years but has remained largely unrecognized, even "invisibilized," as they challenge multiple forms of violence.

Much of the discussion surrounding oppositional theatre in Latin America places it in the context of repressive regimes, where the "official story" in the news far from reflects people's lived experience of violence, but rather seeks to "disappear" it. In places like Argentina during the military dictatorship, for instance, people were "forced to focus on the given-to-be-seen," Diana Taylor writes, "and ignore the atrocities given-to-be-invisible, taking place around them" (*Disappearing Acts* 120). Seeing, or admitting to seeing violence, was "*dangerous seeing*," and "put people at risk in a society that policed the look . . . They knew people were 'disappearing' [but] . . . had to deny what they saw and, by turning away, collude with the violence around them" (123). This act of turning away in terror, of choosing not to see, this "self-blinding of the general population" is what Taylor calls "percepticide" (122). Under such circumstances, political theatres used performance as a means to expose the destruction people endured, insisting on "creating a community of witnesses by and through performance" (Taylor, "Staging Social Memory" 27). Reversing Peggy Phelan's postulation that "performance becomes itself through disappearance," Taylor suggests that "disappearance, as Latin American activists and artists know full well, becomes itself through performance" (21).

While this certainly applies to many Latin American contexts, the situation in present-day Colombia is different. People do not need performances to "make them witnesses" to the violent events around them. Far from covering them up, the major Colombian newspaper *El tiempo* features headlines that are explicit to the point of sounding melodramatic: "Desplazados, en el límite del delirio" (Homeless Refugees, on the Edge of Delirium), "El Salado: Otro pueblo fantasma" (El Salado: Another Ghost Town), "Se desborda la crisis" (Crisis Overflows). Some of the scenarios described are indeed cinematic: "Hacia las ocho de la noche de ayer, cinco minutos antes de iniciarse un partido de fútbol en pleno parque central de Doncello, jugadores y espectadores tuvieron que correr por la lluvia de balas que anunció una incursión de las FARC. Tres muertos y diez secuestrados" [Around 8 P.M. yesterday, five minutes before a soccer match began in Doncello's central park, players and spectators had to run from the shower of bullets that signaled an attack by the FARC. Three dead and ten kidnapped]. The online version of *El tiempo* often includes surveys concerning violence—one in February 2000 read: "¿Quiénes son los mayores violadores de los derechos humanos en Colombia? Haga clic y escoja: la guerrilla, los paramilitares, los narcotraficantes, o el ejér-

cito" [Who are the biggest violators of human rights in Colombia? Click and choose: the guerrilla forces, the paramilitary, the drug dealers, or the army] (*El tiempo*, 22–27 February).

Violence, and the threat of violence, has become a part of people's everyday lives. In the words of medical doctor Juan Marcelo Vásquez, quoted in *El tiempo* after he assisted victims of a massacre, "Dante no conoció el infierno; nos tocó todo a nosotros" [Dante did not know hell; it was all given to us]. Bogotá's RCN Evening News—having reported that the number of child kidnappings increased by 66 percent between 1995 and 2000—aired a brief section reminding parents of the "Nine Rules to Prevent Your Child from Being Kidnapped." This list includes advice such as: "Si su hijo es el consentido, evite que se note" [If your child is the family favorite, avoid showing it]; "No permanezca solo con su hijo en la finca" [Do not be alone with your child in your country home]; or simply, "No permanezca solo con su hijo" [Do not be alone with your child].[1] Privacy is a site of danger and love is a liability: showering a child with affection might put him/her at risk of being taken away, hurt, or— as many indeed are—murdered.

Such daily bombardment of tragedy by the media would perhaps be met in the United States with a severe case of *compassion fatigue*, a term which Olin Robinson says is "meant to describe Western public reaction to a succession of Third World disasters." News and statistics such as "a child dies of hunger every 2 seconds," or "women gang-raped by soldiers," he writes, are "instantly reported and brought into virtually every home in the developed world" (Robinson). In a website entirely dedicated to compassion fatigue, Leslie Smith describes it as "a loss of confidence in our individual abilities to address the problems of our society, especially those that result from poverty."

Could this explain why, as director of La máscara Lucy Bolaños perceives it, Colombian audiences do not want to see their "crisis" represented onstage? Most people know these atrocities happen, Bolaños says, but "we rarely talk about being afraid . . . Everyone's doing their own thing, going forward, without talking" (Video interview). After so many decades of unceasing violence, Colombians are certainly tired, but theirs is not "compassion fatigue." Compassion fatigue implies a position of *privilege* in relation to the suffering "Others," be it people in the so-called Third World or poverty-stricken groups in one's own country. People experiencing compassion fatigue are *not themselves threatened*, they are standing by, watching, and often "just" watching.[2] As Kai Erikson writes in "Notes on Trauma and Community," those who are "not touched [by trauma] try to distance themselves from those touched, almost as if

they are escaping something spoiled, something contaminated, something polluted" (189).

Colombians do not have this privilege of distancing themselves from the violence in their country. You can be walking to work or getting home and a *carrobomba* (car-bomb) can explode on the street and you can die. You can sit among a hundred people in an airplane from Bogotá to Cali, or even in a church on any given Sunday, and be kidnapped by the ELN for months on end. Everyone is aware of this. As Lucy Bolaños said, it appears in the newspapers every day: violence, crisis, violence, crisis, violence, crisis overflowing . . .

If Colombians are suffering from fatigue, I would argue it is a kind of "crisis fatigue." Their nation has remained in crisis—by definition, a turning point—for far too long. "More and more, the long years of war and violence seem to be the essence of our recent history," writes Jorge Orlando Melo in an online February 2000 issue of *Revista semana*. The taste of violence is stale in people's mouths. They want—and perhaps feel they need—to talk about *peace*.

The media know this, too. For every article on war, we see a slogan for peace. The slogan for one of the major national banks is: "Bancolombia: Porque todo *puede* ser mejor" [Bancolombia: Because everything *can* be better]. There are t-shirts sold and banners posted everywhere that read, "La paz somos todos" (We Are All Peace), "La paz comienza contigo" (Peace Starts with You), or "Dale una oportunidad a la paz" (Give Peace a Chance). *La Luciérnaga* (The Firefly), a political satire radio show, is announced every day as "La Luciérnaga: Una forma de sonreírle a la dureza de la vida" [The firefly: A way of smiling at the harshness of life]. Every morning and afternoon, at 6 A.M. and 6 P.M. sharp, the national anthem is broadcast on every single radio and television station in the country. Radio Caracol streams in live through the web, too, so even in New York I can hear the anthem be announced—punctual as ever—as an "homage to one of our national symbols." One night in February 2000, immediately after the anthem, I heard a children's chorus sing: "Que haya paz / Que haya amor / Que seamos todos felices / Y que todo sea mejor / Que haya paz / Que haya amor / Con café Aguila Roja / ¡Alegría de sabor!" [May there be peace / May there be love / May we all be happy / And may everything improve / May there be peace / May there be love / With Aguila Roja Coffee / There's flavor happiness!]. A cheerful male voice followed, exclaiming: "Para los que pensaban que el país estaba estancado, una nota positiva: ¡Llegó la nueva batería Willard, con su súper potencia duradera!" [For those who thought the country was stuck, a positive note: The new Willard battery is here, with its super-lasting power!]

When the country's batteries are running low, so to speak, is a jolt of cheerful peace the only thing people have to hold onto?

The sound bite "peace" has thus become a spectacle itself. It has become—like women posing in bikinis—a marketable commodity that can be sold as well as used to sell products. It can be consumed (with your cup of coffee?) and has indeed become a kind of TV dinner that is served as a palliative, a sign that the country is "working on it." Examining what it would actually mean, politically and economically, to reach that peace is a more difficult question, one that the media (owned for the most part by a few powerful families) do not encourage their audiences to ask.

In the face of all this, political theatres are fading and commercial TV comedies and *telenovelas* are booming. The last thing people want to talk about when they go to the theatre is violence—again. This poses a significant challenge for political theatres that *do* continue their work on violence. Besides their struggle to survive on scant economic means, they are faced with an even harder question: how can they re-present the horrors that the media are already (and almost pornographically) presenting on a daily basis? How can they do this in such a way that touches people *differently* than the media's excesses do? What strategies need they use to expose what is ostensibly already exposed, to pull the invisible out of the visible? And what happens when the political theatre in question is all women run and feminist?

Here is the story of one such theatre. Through the interviews I conducted with the members of Teatro la máscara I will present, largely in their own words, the history and goals of this feminist ensemble. Through my experience with one of their plays, I will also discuss their strategies for thematizing violence on stage, laying bare the "normalized" but insidious fear that Colombians (both privately and collectively) wish to push under the surface.

Teatro la máscara, *Universo femenino* (Feminine Universe)

I first met them by accident.

I was sitting in the dining room of Teatro la candelaria in Bogotá with my friend Cristina Frías, having lunch after a long morning of theatre workshops at Festival al aire puro (Open Air Festival). It was the summer of 1997, the first time I had ever been in Colombia, and going on tour with the San Francisco Mime Troupe was a brilliant accident in itself. I was just beginning to approach Latin American theatre, a task I found much facilitated by the Mime Troupe's recognition: it allowed me to meet dozens of *teatristas*, playwrights, and directors, including "El Maestro"

Santiago García, director of La candelaria, who had invited our group to lunch that afternoon. He was sitting across from me at the end of the table, talking to two women I had not seen at the workshops. One was in her forties and I remember being struck by her poised, grounded presence. The other was younger, tall, and gestured with her hands as she spoke. At a certain point Cristina and I began talking about our upcoming trip to Cali, where we planned to go after the rest of the Mime Troupe returned to San Francisco. The youngest of the two women overheard us and looked up. "When are you going to Cali?" she asked. "We're from there." That was Ximena Escobar. She said they were from an all-women's theatre collective called La máscara, and introduced us to the woman next to her, their director Lucy Bolaños. By the end of lunch, we had their address and phone number, and they had offered us a place to stay during our visit.

Two weeks later, we were in Cali. We arrived at the address they had given us, on Carrera 10, in the heart of Barrio San Antonio. Number 3–40 was a two-story building with a blue mural on the front wall, a plant-filled balcony, a black wrought iron door, and a red sign that read "Teatro la máscara: 25 años" (La máscara Theatre: 25 Years). We rang the doorbell. A few moments later Lucy came out in a white bathrobe, led us through the hallway, and welcomed us to her theatre. The front room—an open area with large black-and-white tiles on the floor and an incredibly high ceiling—was decorated with their old stage sets and props, including a wooden archway with the words "Canción de Naná" (Naná's Song) painted in silver letters. Next to the door to the theatre area, almost like a guardian, stood a tall sculpture of a woman made of white wire. She smiled.

Through that door we walked into the 250-seat house and then onto the black stage, which was set up for their show *A flor de piel* (Skin Deep) with what seemed to be a giant bamboo mobile. Lucy took us through the backstage area, by the lights and mirrors of the narrow dressing room, and out the other end to a small outdoor patio. There were two doors off to the side. One was ajar and I could see it was the bathroom. Pointing to the other door, she said, "This is where I live." She opened the door to a small room with a bed, the walls covered with bookshelves, postcards, and clippings.

This theatre was her home. I was immediately drawn in.

I learned that La máscara was one of the few (and one of the oldest) all-women's ensembles in Latin America. They had worked closely with Enrique Buenaventura, the Teatro experimental de Cali, and the Corporación colombiana de teatro—yet we had never heard of them. Nobody had mentioned them at the festival in Bogotá.

So the next day—after staying at Ximena's nearby apartment, a few blocks away from the TEC—we went back to La máscara with a tape recorder. Four out of the five women in the group were there, Ximena, Lucy, her daughter Susana Uribe, and her niece Janeth Mesías. Once we gathered in the backyard, Lucy leaned into the small black recorder and said: "My name is Lucy Bolaños. I am the founder of Teatro la máscara."[3] We sat back and listened.

> This group was started in 1972, so we are now celebrating twenty-five years of artistic work. It was a group that started as a mixed collective, made up of about thirteen men and women. We put up plays during that time, with texts from people like Shakespeare, Enrique Buenaventura, Bertolt Brecht, and also the Chicano director Luis Valdés. After 1985 La máscara becomes an all-women's group, because the difficulties of doing theatre, of making a living out of theatre, are enormous in our country. That is what made our group become unstable, and all the men left. It was a crucial moment. A few women remained who had already begun working together for an International Women's Day. We were Pilar Restrepo, Valentina Vivas, Marina Gil, Claudia Morales, María González, and myself. We took advantage of the circumstances, and from that moment on we focused on taking the feminine problematic to the stage. This became the principal endeavor of Teatro la máscara. (Audio interview)

Pilar Restrepo—the fifth ensemble member, who was not living in Cali at the time of this interview—has written elsewhere about the group's shift in creative focus. She explains that the change "responded to a consciousness and a need to negotiate transformations in every form of social discrimination, and to a feminine urge to find our own language, one that 'reveals' and 'rebels' us [que 'nos revele' y 'nos rebele'], in the face of habits that "invisibilize" and "imbecilize" the image of woman [de 'invisibilizarnos' e 'imbecilizarnos' la imagen de la mujer]" (*La máscara, la mariposa y la metáfora* 16). The focus on feminine issues, she writes, reflected their desire to "find a historical identity that dignifies not one, but all women" (17). The challenge of doing this onstage, she proposes, is not to "simply point out the habits and relations of dominance that have become 'naturalized' between men and women, but to make them comprehensible to the spectator's eyes" ("La máscara 'dice verdad sobre sí misma'" 2). Lucy continues:

> Our first show was *Noticias de María*. It is a play we put together based on *Nuevas cartas portuguesas*, a book written by Las Tres Marías, three Portuguese writers whose work was banned in their country, and who were

put in jail for attacking public morality. We got to know this book through Jacqueline Vidal, who is Enrique Buenaventura's wife. On the one hand, the show speaks about education, and on the other hand about the relationship of a couple—how the woman at a certain point prefers madness or death rather than returning to her husband . . . We do not stage texts only by women. We have also used works written by men, like Bertolt Brecht. For example, in "Canción de Naná" he deals with prostitution. "María Farrar" talks about a young domestic worker who becomes pregnant and, out of fear, tries to have an abortion. But it doesn't work, so she has her child. When the baby is born, she wants to stop him from crying, so she kills him herself. In these poems Brecht takes up some issues that women must face and presents them as a social problem. A few years ago, we did a collective creation based on a non-theatrical text by Ntozake Shange. The way we build a performance out of twenty poems, the way we make characters speak them, transforms them into dramatic text, makes them a theatrical spectacle. The same thing happened with the texts taken from Galeano and Rigoberta Menchú, which we used in *Mujeres en trance de viaje*.[4]

"Our experimental work on poetry, narrative texts, and epistles," writes Restrepo, "forces the audience to an attentive reading because the lyrical becomes gesture without losing its verbal strength. The play does not end without the audience feeling that we've 'stuck our finger in the wound' [el dedo en la llaga]" ("Las comediantas de la legua" 5).

La máscara works mostly with guest directors, among them Enrique Buenaventura, Jacqueline Vidal, Patricia Ariza, Elena Armengod, and Wilson Pico. They view artistic creation as a mixture of group experimentation and a director's individual work. The director never has full command or the final say about any performance—some, like Wilson Pico, come from other countries to work with them for a week or two, lay the groundwork for a piece, and then leave it to the actresses to elaborate the finished product. But even when the guest director stays with them during the full rehearsal process, s/he must always work closely with Lucy. She has remained at the head of the collective throughout its entire trajectory (not only as actress and director, but also as house manager and business administrator—positions so undervalued in the discussions of small theatres, and which often include sweeping floors, mopping, and cooking). She has also been responsible for maintaining the group's commitment to women's issues (Restrepo, *La máscara, la mariposa y la metáfora* 15).

One of the most difficult times for La máscara was the late 1980s. Lucy again tells the story:

In 1987 and 1988 a wave of violence erupted in Colombia, a wave of perse-cution against artists, intellectuals, teachers, poets. I say it was the work of "dark forces" because one never knew who they were. The extreme right, the paramilitary, the guerrilla forces, the military, one never knew. It was horrible. Many people were tortured and disappeared, so many people were killed . . . We began getting phone calls saying "We're going to kill you, we hope you keep your mouths shut." We got threats by mail that said, "Out, you rats, leave the country, you anti-Colombian cunts, *Black Flag* with you all!" *Black Flag*, like the spray, as if they were going to kill insects. These constant threats kept us up at night, we felt persecuted on the street, as if we already had the gunshot on the back of our heads, you know? It was at that time that one of the women from a feminist organiza-tion helped us leave the country and we went to Costa Rica. It was there that we had our first year-and-a-half long tour. With our daughters, we went from Costa Rica to Mexico, to Cuba, to Nicaragua, a year and a half of traveling, waiting for things here to calm down. We established contacts on our own, sold tickets for our shows, and the solidarity and collabora-tion we received from people in those countries allowed us to live through it . . . Our return home was safe, things had settled down somewhat. Based on that experience, we created a new piece called *Mujeres en trance de viaje* (Women in Travel Trance), directed by Patricia Ariza.

La máscara has had a very close relationship with Patricia Ariza, actress and writer from Teatro la candelaria, head of the Corporación colombiana de teatro, and director of Trama luna teatro. Ariza, one of the most impor-tant influences on the ensemble's development, was herself the victim of death threats during this period in the late eighties. As the story goes, she would walk around Bogotá wearing a bulletproof vest she had deco-rated with embroidery and sequins—a gesture which called attention to the alarming degree of normalization that violence had reached.

In 1994 Ariza wrote and directed a play for La máscara entitled *Luna menguante* (Waning Moon), described in the program as "a voyage into the feminine universe, where four women try to go beyond the barriers of their own self-imposed limits" (La máscara). "After that," Lucy continues, "we did *A flor de piel*. We took some poems from Oliverio Girondo, an Argentinian poet, but the show consists mainly of dialogue generated by us during improvisations on the topic of sexuality. From those improvisa-tions and from some interviews we conducted offstage, we elaborated a 'survey on sexuality' which we later incorporated into the text. We as an ensemble (whoever is in the group at the time), together with the director, always select the final dialogues."

La máscara's only constant members have been Lucy Bolaños and

Pilar Restrepo. The rest of the members have kept rotating, and the group has been comprised of about ten actresses at different moments, which is why Lucy qualifies the ensemble as "whoever is in the group at the time." Some have found it hard to stay, she said, "because we don't have a salary (for being actresses). It's a *'rebusque,'* as we say here, you teach workshops, you make costumes, you do makeup, even jewelry. Each one has to develop a skill to find a means of survival. We constantly strive towards being able to stabilize the group's economy, so we can provide the actresses with a fixed salary."

At the sound of these words the other three actresses let out a huge laugh. The thought of a fixed income for theatre seemed absurd to them at the moment. Lucy's twenty-four-year-old daughter Susana spoke up: "But even so, I can't see myself doing anything different from theatre. It's a passion." Sitting next to her, Ximena raised her hand and said, "It would be great—and I'm not going to say a creative word or give any of those spiels—but I just feel it would be so great and so important if women in theatre began to get together, to organize *encuentros* . . . Because there's a different language here, one particular to women, one that belongs to us and expresses our interiority. There has to be a dramaturgy dealing with that search." And after a short pause she said, "Okay, I have spoken." Janeth, the newest member of the ensemble, said in a soft voice, "For me, theatre is a woman, really. Because at every moment, something new is being created, is being born. And it really does come from inside everyone here, every one of us at La máscara. It is something very beautiful that grows and grows until it becomes ours. We are mothers to our theatre, and with every play something leaves and then something else is born again and grows . . ."

With a few words, Susana finished her cousin's thought: "It should be called *teatra*."

It was late afternoon and we had been talking for hours, clicking the tape recorder on and off. At the end of our interview together, I asked them if they wanted to say anything else to wrap things up. The four women gathered closely around the tape recorder and sang a popular song they had used in their play *¡Emocionales!* (Emotional!), entitled "Mujeres feas" (Ugly Women): "Hay mujeres regulares, / hay mujeres desgraciadas / hay mujeres con mal genio / y las hay con mucha gracia / Pero feas feas feas / pero feas y con ganas / no hay ninguna mujer fea / yo lo juro por mi alma" [There are women who are so-so / There are women who are wretched / There are women who are cranky / And then some are very graceful / But ugly ugly ugly / Ugly really downright ugly / There is no ugly woman / I swear it by my soul].

It was a fun ending to the conversation, yes, but the thought of Black Flag threats never left my mind.

Feminismo es mala palabra (Feminism Is a Curse Word)

One year later, in the summer of 1998, I returned to Cali. This time I had the express intention—and the fellowship funding, which also meant a video camera—to document all I could about La máscara. I was there for the opening night performance of their new piece, *Los perfiles de la espera* (The Profiles of Waiting), directed by Ecuadorian master choreographer Wilson Pico.[5] Out of the four actresses I had met the year before, two were gone: Ximena had moved to Spain, and Susana was doing theatre elsewhere. A few days before the performance, I finally had the pleasure of interviewing original ensemble member Pilar Restrepo. She was no longer an actress—and had not been for several years—but she was and still is an integral part of the group, as a writer, theorist, and organizer (at the time, she was finishing her book on the group, so far the only published theoretical study on La máscara). She is a thin woman about Lucy's age with short brown hair, wide-open eyes, and a deep raspy voice. She sat on a folding chair in front of the video camera and asked, "Should we start?"

I pressed the red button and asked her how she first got involved in La máscara. She began at the beginning:

I got to know theatre through my oldest sisters. When I was a girl, we would participate in the school plays. The first one we ever did was called *The Chinese Princess*. We had to buy our own costumes. We had no money at home at the time, and for my character I needed a kimono with very wide sleeves . . . I remember I cried so much because I wasn't going to have a costume, and I was the Princess! My mother cut up one of my sister's Sunday dresses, and she made the sleeves from a different fabric. It had nothing to do with China, but it didn't matter, I felt I had the best costume ever . . . So that was the age when I began to feel the passion for memorizing texts and poems. Then I had the opportunity to see Enrique Buenaventura's *La maestra*. More than any other play I've ever seen, that one has impacted me the most. I lived in the suburbs in northern Cali, where we were never allowed to go out alone or take the bus . . . But I would run from school, still in my uniform, to go see the TEC's rehearsals. And every weekend, that theatre was an adventure—I felt like the bravest girl going downtown at eight P.M. to see a play by myself. It was forbidden in our family to associate ourselves with the TEC. My parents would say,

"Those people are working class! They are communist revolutionaries!" It was absolutely forbidden. So my sister started dating one of the actors . . . Imagine the scandal? . . . I met Lucy during one of those escapades, when I was in high school. I got involved with La máscara from the beginning, from its first plays in 1972, when there were still men in the group . . . The men left the group in '85, and Lucy and I were left staring at the ceiling . . . We committed ourselves to political causes, and performed at political events. The women from the [communist] party, the feminists, and even the M-19 [guerrilla forces] would call us to do shows. We would stage a poem and go. (Interview)

It did not take long for Pilar to start talking about the obstacles they faced because of their commitment to feminism. As feminist theorist Florence Thomas has written in *Conversaciones con un hombre ausente* (Conversations with an Absent Man), the general attitude in Colombia seems to be, "Why talk about women? Don't you think that subject is a little out of place? Don't you think that in these times, in our so terribly battered Colombia, there are other urgencies, other priorities?" (23).[6] Within the country's intellectual community (and this is certainly not limited to Colombia), there is a legacy of intolerance regarding the discussion of gender inequalities. In the name of revolution and political struggle, some refused to address such "secondary" issues, because "the only valid cause was the proletariat . . . 'And prostitutes, comrade, are not proletariat!'" (Restrepo, *La máscara, la mariposa y la metáfora* 116–17). This type of posture, according to Pilar, has proved to be one of the toughest obstacles for the ensemble. "The mere fact that we are women who do theatre is reason enough for rejection," she affirms. "I am so tired of those attitudes. Even women themselves tell us, 'Ay no, I don't like feminist theatre!'" I asked her what she thought people in general understood by *feminism*, and she responded:

[*Feminism*] is such a terrible word here, it's pejorative, it's evil. It's "You're insane, how could you be a *feminist?*" Instead of being the opposite, a vindication for women, it becomes a stigma . . . Feminists are always accused of being radicals, of hating men, of wanting to take over men's power, of not believing in family and moral values. Here, feminism is understood as the opposite of machismo, as if they were both the same thing, two sides of the same coin . . . To give you a recent example, yesterday a man was interviewing Lucy on the radio about our latest play, *Los perfiles*, and he asked her: "So, now you've switched from feminism to politics?" And these are the hosts of a cultural show in this city! We haven't stopped doing feminist work. Feminism *is* politics. People here don't get that.

María Mercedes Jaramillo has written that La máscara's plays "dramatize taboo themes in a conservative and Catholic milieu" (214). Indeed, Cali is a very Catholic city—I remember my first Sunday there, being awakened at six in the morning by the trumpets, drums, and chanting from the massive weekly procession outside. But when I asked Pilar who, in her opinion, were the people that least "get it," her immediate reply was, "Actually, it's the artists who are the most reticent. Our male colleagues themselves enforce our group's 'invisibilization.' They complain, 'There you go again with those sad plays, talking about those problems! Theatre is entertainment, it's laughter!'"

Discussions of gender inequality and feminism are shoved aside in the name of Colombia's "other priorities," but ironically, when these women tackle the issues of violence and armed conflict, they are chided for producing "sad plays."

La máscara has small, self-selected audiences of people who are generally more open to their work, comprised mostly of women, students, and people from the communities to whom they offer workshops. However, the ensemble has felt most supported during their travels abroad, not only during their period of exile, but also through their participation in international women's festivals such as the Magdalena Project in Cardiff. Having had the chance to interact with other women's ensembles, and seeing how strong women's movements work, Pilar commented, "we were shocked, because we've had to do most of our work alone here."[7]

Bisexuality and homosexuality (especially in women) are realities Pilar feels are still unspeakable in Colombia. La máscara has felt the brunt of this silencing, and has at times even imposed self-censorship on the kind of work they have produced. "We still haven't created *the* play that would . . ." and she made a punching gesture with her fist. "It's not like we set out to talk about scandalous or taboo things in order to cause sensation," she explained, "those are very interior issues . . . In *A flor de piel*, we touched upon the topic of feminine homosexuality, but only tangentially, because it was in the context of laughter, a kind of joke that showed that it's no big deal. Now I really feel the urge to do a piece about that theme. It starts to become a need inside you, to talk about it . . . If we're already so stigmatized as 'lesbians,' then let's make a play that will give them something to talk about!"

I asked her what she thought would happen if a playwright openly declared herself gay and began to produce shows about relationships between women. With a smile, she answered, "I don't know what would happen, but I'd love for it to happen . . . Here in Colombia we are so far behind, though, that congress is still debating whether gay professors

should be allowed to teach... Because of things like these, I went through a period when I did not want to return to Cali or to this country."

Would you want to leave now? I asked. "No, not now," she said. "I feel a vital responsibility with La máscara. There is so much to be done, and I'm dying to do it."

Los perfiles de la espera (The Profiles of Waiting)

¿Cómo convertir el dolor en creación? El teatro es lo que nos devuelve la vida, nos permite vencer los miedos.
[How do we transform pain into creation? Theatre is what brings us back to life, it allows us to vanquish our fears.]
—conversation with Patricia Ariza, 13 April 1998

At the beginning of this essay I posed some questions about the status of political theatres in Colombia: How can political theatres re-present crisis onstage when a country is already fatigued by its own crisis? How can they address violence in a way that differs from the media, with their bombardment of violent images on the one hand, and their palliative catchword *peace* on the other? This binary can be a trap, severing the possibility for any real discussion. What does La máscara do, then, to approach the violence that, as Lucy said, "everyone is seeing in the newspapers?"

La máscara's most recent piece, *Los perfiles de la espera*, is a two-woman piece centered on the labor of waiting. We see the women in their private spaces, as they perform mundane tasks such as washing and sewing. They are mostly silent—they express themselves with their bodies, their physical movements, the sounds they make with their feet and hands, and their versatile handling of two plastic tarps. These tarps figure prominently in the piece, as each woman continually transforms them into a myriad of objects, such as sewing fabric, laundry, tablecloths, skirts, shawls, hiding places, and even the water under which one of them is drowned. As the two women in the play attempt to stay engrossed in their housework, the traumatic memories of violent events—recorded in their bodies—are repeated time and time again: they get startled, get up, hide, go back to work, get startled again, get up, and the cycle repeats itself almost identically. When the characters do speak, it is a fragmented collage of commonplace phrases mixed with texts from Mercé Rodoreda, Eduardo Galeano, Jorge Luis Borges, Miyo Vestrini, and actual testimonies from the families of the disappeared. Its initial sequences are as follows:

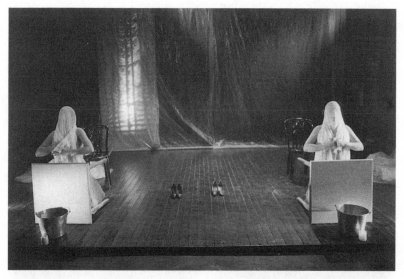

1, 2, 3. From *Perfiles de la espera*. Photo by Carlos Arias; courtesy of Teatro la máscara.

The stage is dark. Andean flute music is heard. The backlit figures of two women become gradually visible against a doorway upstage. We see two small tables covered with large, translucent plastic tarps; in front of them, two tin buckets. Very slowly, still in silhouette, the women embrace. They embrace again. They stand looking at each other and, as the stage becomes dark once more, they cover their faces with their hands. When the lights come back up, the two women quickly walk downstage and begin to recite a list of names: "I am Rosa Paredes. My name is Clara Cortés. They call me Carmen Llanos. I am Rita Pelayos . . ." They then go to separate tables and sit down. Each woman grabs a plastic tarp and begins scrubbing it, beating it with her hands, desperately washing it against the table. After this has gone on for a while, Woman 1 (played by Lucy) stands up and, as if she's heard something, quickly runs upstage to peek out of a large window. She sees nothing. She turns around, slaps her temples, and goes back to work. The silent washing continues. It becomes slower and slower until it stops.

There is absolute silence. Both women rearrange their positions on the tables: the tarps now become large pieces of cloth, and the tables stand in as sewing machines. While tapping their bare feet on the floor (recreating the sound of machine engines), the women slowly slide the tarps across the tables, sewing straight lines onto them. Woman 2 (played by Janeth) stands up and wraps the tarp around her waist, trying on the garment she is working on. She, too, gets suddenly scared, runs to the window, slaps her forehead, and comes back to the table. Woman 1 yells out, "The neighbor got a telephone! She's so happy!" Woman 2 takes the tarp and puts it around her shoulders. "You don't say!" she replies. And again, they both resume their sewing.

The music changes to a slow waltz, and Woman 2 stands up, then kneels, and covers her face with her hands. She crawls under the table and hides, then stands up, retreats, and sits on the table. Covering herself from the waist down with the plastic tarp, she says, "Time and space disappear. The speed and force of the blows extinguish all signs of life. What remains in the aggressor's hands is an inanimate doll. A ball of yarn. A sheet filled by the wind." Woman 1 stands up and faces the audience. "This is my foot," she says, pointing to it. "This is the table. This is the chair. This is the room. That is the window." She sits down, whispers and gestures at someone we can't see, as Woman 2 says, "Before. After. Yesterday. Meanwhile. Now. Right. Left. I. You. He. Time and space disappear. The speed and force of the blows extinguish all signs of life. What remains in the aggressor's hands is an inanimate doll. A ball of yarn. A sheet filled by the wind."

Language has been shattered for these women, replaced by circular, disjointed shards of speech. What La máscara has done is pry open the domestic space of two women, making visible the ingrained *effects* of violence in everyday life. No actual violence is depicted onstage, however, only the memories of its damage. (Even when Woman 1, as I mentioned earlier, is being drowned under the tarp/water, we see only her and her struggle, without an attacker present.) A particularly provocative image is created near the end of the piece. The two women walk downstage, turn the tables on their sides, and kneel down. They reach into the water buckets and pull out soaking white rags. After a moment of contemplation, they raise the wet rags and place them over their faces. In this move, the familiar chore of washing clothes is twisted to evoke the image of a burial shroud. Lodged in their bodies, the scars of violence, death, and terror inevitably puncture every gesture, every task.

As the program for the play declares, "This is a theatrical act made against persecution, torture, desperation, and fear. The two actresses fundamentally represent the many women, at home or in their workplaces, who are living the anguish of waiting for their disappeared family members. The words and movements of the characters subvert silence, making us witnesses to a world encircled by fear" (La máscara). But I believe *Perfiles* does more than this. The strength of this piece for me lies beyond making us witnesses to the world of these specific "Others." It targets the denial that results from crisis fatigue, the self-blinding which, unlike percepticide, is not rooted in the fear of being caught looking (by outside forces), but rather, in the fear of *catching oneself feeling one's own fear*. What *Perfiles* suggests is the following: even if you haven't been *directly* hit by violence, even if you haven't had a family member killed, or had to wear a bulletproof vest, or been forced to flee the country, you're not exempt from the reality of violence. *Living with constant fear is being a victim of violence.* And drinking Café Aguila Roja or buying Willard batteries will not solve that.

Furthermore, La máscara insists on "sticking its finger in the wound" of "our so terribly battered Colombia" while *simultaneously* examining the specificity of women's positionality within it. For them, one critique does not exclude the other.

And yet, their achievements have been repeatedly ignored, their work has been marginalized, and they remain unrecognized as one of the oldest theatre ensembles in Colombia still working today. Even some of their staunchest supporters, albeit unwittingly, help to "enforce their invisibilization": Jacqueline Vidal's introduction to Pilar's book, for instance, describes La máscara as "autoras de esta realidad teatral para

seguir siendo niñas, jugar" [authors of this theatrical reality to continue being girls, playing], a comment whose hint of condescension could very well serve to downplay the depth of their work, to keep them inside a parenthesis of naive femininity.

All this said, I find it truly remarkable that La máscara has survived for twenty-eight years. I especially admire them for their last fifteen years of work, unwavering in their commitment to political work on gender, without succumbing to the multiple pressures they continually endure. Their consciousness and passion for the work they do are absolute. It was through my encounter with them, through our conversations, and through their own reflections about their obstacles, that I began to formulate the questions I pose here and will further investigate in my work. La máscara may not have all the answers, but they will continue to search for strategies to resist the resistance, to "transform pain into creation," to examine their country's wounds and the wounded women within it.

"I have battled this out for myself," Lucy said at the end of our last interview at the theatre, which, let us not forget, is also her home. "The men in La máscara were the ones who couldn't handle it and left the group first, and it was just us, the women, who continued the struggle, despite the many people who told us, 'Why do you keep insisting?'" But they insisted. "We got here because we were stubborn, and it's because we're stubborn that we're still here. That is the challenge of life."

Appendix

The following list appeared in RCN Evening News, Bogotá, Colombia, 10 March 2000.

Nueve reglas para evitar que secuestren a su hijo

1. No permitir que los niños sean ostentosos ni establezcan rutinas.

2. No permitir que los niños caminen solos por la calle o centros comerciales.

3. Si su hijo es el consetido, evite que se note.

4. No permanezca solo con su hijo.

5. No permanezca solo con su hijo en la finca.

6. Las madres no deben salir solas a la calle con hijos de brazos.

7. Adviértale a sus hijos mayores sobre los peligros de permanecer en la calle.

8. Si acaba de dar a luz, no deje que saquen a su hijo de la alcoba.

9. Dialogue con sus hijos sobre la subversión.

[*Nine Rules to Prevent Your Child from Being Kidnapped*

1. Do not allow children to be ostentatious or establish routines.

2. Do not allow children to be alone on the streets or in shopping malls.

3. If your child is the family favorite, avoid showing it.

4. Do not be alone with your child.

5. Do not be alone with your child in your country home.

6. Mothers should not go out alone with their babies.

7. Warn your older children about the dangers they face on the street.

8. If you've just given birth, do not allow your newborn to be taken out of the room.

9. Talk to your children about subversives.]

Notes

All translations of interviews and of original Spanish texts are mine.

1. See the appendix for the complete list.

2. I understand "compassion fatigue" to be different from the notion of "bearing witness" discussed in trauma studies, whose subjects actually bear the burden of responsibility that their witnessing entails.

3. All interviews with the members of La máscara were conducted in Spanish. In this essay, the interviews appear only in their English translation.

4. For a complete list of plays performed by La máscara, please see the Select Bibliography at the end of this volume.

5. Wilson Pico founded Ecuador's first modern dance company, the Ballet experimental moderno (BEM) in 1972. For thirty years he has been a dancer, choreographer, director, and teacher, and is considered to be the pioneer of contemporary dance in Ecuador.

6. Thomas is originally from France, but has been living and working in Colombia since 1969. She founded the first graduate program in Feminist Studies in Colombia, at the Universidad Nacional in Bogotá.

7. The wider, transnational feminist collaboration that is engendered through this kind of encounter ("teatra?"), as well as through the sharing, translation, and reusing of printed texts, certainly merits further attention. Equally important is the investigation of the differences and clashes, for instance, in what Latinas (those in the United States included) consider to be "feminist" or "political" per-

formance. While I plan to elaborate a more detailed study on the subject, for the purposes of this essay I have chosen to stay focused on La máscara, their history, and the challenges they face in their local context.

Works Cited

Ariza, Patricia. Audio interview with Pilar Restrepo. Bogotá, Colombia. 13 April 1998.

Bolaños, Lucy. Audio interview. Cali, Colombia. 10 September 1997.

———. Video interview. Cali, Colombia. 6 September 1998.

Buenaventura, Enrique. "Prospecto promocional de La máscara." Archivo Teatro la máscara, Santiago de Cali, 1986.

Erikson, Kai. "Notes on Trauma and Community." *Trauma: Explorations in Memory*. Ed. Cathy Caruth. Baltimore: Johns Hopkins University Press, 1995.

Jaramillo, María Mercedes. "La máscara: Teatro de práctica artística." *Gestos* 19 (1995): 213–219.

Melo, Jorge Orlando. "La paz, ¿Una realidad utópica?" *Revista semana* 27 February 2000.

La máscara. Archived materials (programs, promotional writings).

Phelan, Peggy. *Unmarked: The Politics of Performance*. London: Routledge, 1993.

Restrepo, Pilar. "'Historia de mujeres' en el teatro." *El país, magazín dominical.* Cali (August 1987): 3–5.

———. "La máscara 'dice verdad sobre sí misma.'" Unpublished essay, 24 February 2000.

———. *La máscara, la mariposa y la metáfora: Creación teatral de mujeres*. Cali: Impresora Cruzz, 1998.

———. "Las comediantas de la legua: Testimonio del trabajo de cuatro mujeres que un día decidieron salir a recorrer el mundo." *El Espectador, Magazín Dominical* 327 (1989): 4–7.

———. Video interview. Cali, Colombia. 6 September 1998.

Robinson, Olin. "Compassion Fatigue." Commentary on Vermont Public Radio, 17 May 1991 <www.salsem.ac.at/orcomments/1991/vpr-051791.html>.

Smith, Leslie. "Dealing with Compassion Fatigue." Accessed 26 February 2000 at <http://www.geocities.com/~sleepwake/Members/fatigue.html>.

Taylor, Diana. *Disappearing Acts: Spectacles of Gender and Nationalism in Argentina's "Dirty War."* Durham: Duke University Press, 1997.

———. "Staging Social Memory: Yuyachkani." Unpublished essay, 1999.

———. *Theatre of Crisis: Drama and Politics in Latin America*. Lexington: University Press of Kentucky, 1991.

Thomas, Florence. *Conversación con un hombre ausente*. Bogotá: Arango Editores, 1997.

TERESA RALLI

(Peru)

Teresa Ralli is one of Peru's major theatre practitioners. She acts, creates, directs, sings, and participates in a vast repertoire of both European and Andean performance traditions. She's as comfortable singing Brecht's poems set to cabaret music, as creating and acting in the one-woman *Antígona*, as participating in Andean performances and *pasacalles*. An extraordinary actor, she has directed theatre workshops for disenfranchised women throughout Peru. She collected material for her *Antígona* by interviewing the mothers and widows of Peru's "disappeared." She has acted *Antígona* for the survivors of Peru's *guerra interna* (their version of a "dirty war"), and has worked with the country's Commission of Truth and Reconciliation. A founding member of Peru's most important theatre collective, Grupo Cultural Yuyachkani, Teresa Ralli has participated in dozens of productions, and worked with communities around the country. Her goals are to challenge her audiences to remember the many historical and political struggles that most tend to forget, to put the past in dialogue with the present, to see events as part of larger, cultural imaginaries. "Perú es un país desmemorizado" [Peru is a dememorized country], she says, and the *de* captures the violent refusal at the heart of a country that does not recognize or understand the realities of its many parts. *Antígona*, fragments of which are included here, illustrates the ways in which she puts the many pieces together. The play is "about" Sophocles' *Antigone*, about civil violence, about gender and atrocity, about Peru's decade of brutal internal

war, about Alberto Fujimori's ruthless methods of suppressing unrest, about Peruvian's efforts to come to terms with their response to criminal politics. Each of the pieces contributes to the rest, revealing layer after layer of tensions generated by social trauma, witnessing, and resistance. Ralli's "Fragments of Memory" shows how she approaches the problem of addressing *desmemorización*.

Fragments of Memory

TERESA RALLI

Translated by Margaret Carson

I've seen Antigone (running cautiously from one column to another, as if hiding from no one). It was in the mid-eighties, during the early years of the internal war. An art gallery with a photography exhibit. Black and white photos showing brutal images from Ayacucho: soldiers in training, caught while leaping in a delicate balletic move, their chests splattered with the blood of dogs they had killed to prove their valor. I step forward: a photo of the arcade in the Plaza de Armas in Ayacucho, the image of a woman dressed in black, walking silently, quickly, almost floating, her shadows in contrast "under the midday sun." She was Antigone.

It was as if she had traveled, in all her antiquity, across the centuries to take flesh once more in all the women I've seen fighting in my country. I had always known about her, about her bravery, yet my readings were very superficial. But what stayed with me was the impression of her act. It slowly turned into an obsession, a recurring image, always waiting for the right moment to emerge and turn into something real.

.

Antigone's Shadow

Throughout those years we were developing other performance pieces within our group. In the first notebook I kept during this process, I wrote down these disconnected words:

Antigone, starving, with short hair (I had never cut my hair before in my life; I always wore it long. Until now.)

 Antigone, her head shaved, builds her own prison on stage with adobe, with mud bricks, until she walls herself inside and glimpses freedom through a tiny window. That image of using mud bricks to build something on stage filtered into another piece that all the group was working on (*Contraelviento* [Against the Wind], about violence in Peru).

I also have a drawing that I've copied into several notebooks, a drawing that I saw while we were in the midst of creating other theatre pieces: it was a woman with short hair, dressed only in what we in Peru call a *fustán*, or a woman's white petticoat. She was sitting on a chair, receiving a verdict, her back so strong that it was as if the weight of the world were upon her. And I said, that's Antigone. This image filtered into another piece the group did in which all the women appeared wearing white *fustánes* (*Hasta cuando corazón* [How Long My Darling]). I recall that I was collecting different fustanes, anticipating the moment when I could use them in Antigone.

I think that ever since this obsession started, this question was always on my mind: Why do I want to do this play? Why do I want to perform this piece? It was only in February 1998 that I understood, after more than fifteen years of internal war, years in which we saw women in every corner of Peru crying, demanding, searching for their *desaparecidos*. When the brutality of all we had lived through dropped down on us like a black shroud, when we could no longer endure the oppression of silence, the pressure of a dictatorship that had made silence routine, that was when Miguel Rubio (the director of the group) and I decided to attempt our search for Antigone.

Studying the Text

We began to study Sophocles' text, at first strange and distant to me. We had already given a name to this project: Antigone Huanca, which refers to a mountainous zone in Peru. Miguel asks me for Antigone's tale or fable, retold in the third person. At this stage in our investigation, I feel that we are gathering strength to enter the studio, which waits for us, completely empty. Miguel keeps proposing more exercises: writing Analogs, reconstructing the genealogical tree of the entire family of Antigone.

 The House of Labdacus, the family of Antigone, her father Oedipus, her mother Jocasta, her grandmother Jocasta, her grandfather Laius. Her brothers Eteocles and Polynices. All dead. The only one left, still alive, is

the silent Ismene. Silent. I think of the curse on the House of Labdacus. Aren't my people, perhaps, a House? With wise ancestors, the creators of so many marvels? With strong, warlike women? And when did the curse fall upon this House? When exactly did Peru fuck up? ". . . an ancient curse fell upon my father and mother, and misfortune, like the waves of the sea, will be passed along from one generation to the next." It seems that we Peruvians are living through all the ravages of a curse, when we see that after one social upheaval comes another and another, and we forget yet again and allow it all to happen once more. Here, when people let out a cry of helplessness when faced by some misfortune, they often say, "It's a curse!"

We immersed ourselves in Sophocles' text. It was an extraordinary apprenticeship, difficult, rich in discoveries. I began to make the text mine. I couldn't take parts out, mutilate it. We are a theatre group dedicated to investigations in all languages, immersed in action as words, in creative collaborations as a premise for action. Now I confronted a monster, a text that seemed to be written for us, here and now. Discovering the music in each syllable, the importance of one word and not another, the structure of a thought put into words, the inner world of the characters expressed in each speech.

The exercise of sitting down in front of my colleagues and telling them the story of the House of Labdacus, starting with King Laius until the final moments in the life of Antigone, was essential for me. My gestures were minimal, just enough to tell the story. It was then that I began to value the action in the word, not only through its meaning, but also through its sound. I knew I could capture the attention of my listeners, first because the story itself was fascinating, and second, because they would become caught up in my words. Through this exercise, I appropriated the entire story, I made it mine. I knew everything that happened between the characters, and I began to fantasize about them. In our studio, we collected material, we pursued the text in thousands of ways; we were looking for a device, a convention; if we found one, we could tell the story. Would I, alone, be able to speak of so much life, so much conflict, so many feelings?

Looking for a Convention

My first improvisation. June, 1998. Alone in the studio. I don't think too much about it; my point of departure is the fundamental act of Antigone— covering her dead brother with earth. How is it possible to bury such a large man? To perform the ritual, to spread earth over his body—an act

that today many would like to perform for loved ones who have disap-
peared. To cover their loved ones, tuck them into the warm earth, rock
them to sleep, give them the dignity of a burial, define a space for them. I
automatically define a space for her as well. It's time to start asking ques-
tions. Who carries the story ahead—in my story? Antigone? Tiresias? Why
him? He's also covered in dust, he's come from many wars, a defeated
soldier. Defeated? Yes, because he's always known about everything, but
hasn't been able to change anything. What is the dramatic action? Does
it start with the actress? What does she want to achieve, respond to, dem-
onstrate?

As we searched for a way to tell the story, we created various versions,
ranging from one where I sat and told the entire story (which Miguel liked
the most), to another in which we built a radio broadcasting studio for
a woman journalist who told the news about the war in Thebes. Miguel
thought that Tiresias could tell the story. Yet I always knew that a woman
should be the one to speak and tell everything. Who would take part in
the dialogue? A group of students at MIT? Students from the Humanities
Department of the Universidad de San Marcos, the university with the
largest enrollment in Peru? Schoolchildren? A group of women displaced
by the internal war? We began to investigate each character's world, ana-
lyzing what they said as well as understanding them within their rela-
tionships.

We worked in the studio for a long time, drawing closer and closer to
the presence of Creon, Tiresias, Antigone. Searching for their energies.

Tiresias: a mystery. He has the key, he knows how he learned, how he
began seeing with other eyes after he lost his sight. (It's necessary to lose
your sight to turn your vision inward.) Every age has its Tiresias; perhaps
Tiresias is a journalist? A contemporary historian, watchful and vigilant,
but powerless to take any action? Tiresias suddenly sees what he must
say, he enters into a certain trance-like state. He smells, listens, perceives,
feels. And we are ALL open to listening to a Tiresias; we all have a desire,
perhaps hidden, to know the future.

Creon: severe, stiff, solemn, rigid (Hitler, Lenin, Mussolini?) But also
devious, always doubting. But it's to his advantage to doubt; it's a calcu-
lated move. He's an old tiger, the great antagonist. About this same time I
find myself practicing a Noh dance. With a fan. The fan turns into Creon's
dagger, the Noh sequence becomes a structure in which I begin to make
Creon walk, with solemn, slow steps, yet he's still able to jump if it's nec-
essary.

I can find Creon in my reality today. I can identify Tiresias in my
present world. Both are characters that send me to my reality.

And Antigone: what is she like? She originates in tranquillity. Light. Emphasis on the solar plexus towards the sky. A breeze on the back of her neck. Her gaze is slightly vacant, as if floating. Few signs of grief. Not the wildly excessive grief of the wives of dead policemen, whose photographs appear in the newspapers. She has kept her smile. There's a madness in her eyes, but also determination. She has FAITH. Gestures connect her to a not-so-distant childhood: she wipes her tears away. She has an ideal. But also fear, expressed by her soft-spoken voice, even though she's able to scream like crazy. Also, she's a virgin: Antigone hasn't been with any man. There's a delicate obstinacy, a protectiveness, around her womb. That also is Antigone. She is a doe. And yet Antigone has a thousand faces.

> *In the studio: our exercise is to inhabit a situation and then step out of it and observe ourselves, turning around to "look" at the steps the character takes, how she or he approaches and then enters me again. It's like watching a ghost come closer who "traps me once more," and like a collision or an electrical shock, it "takes" me and I'm no longer the one who's walking, it's the character. I rehearse this action over many days. I, the actress, take the space, and in each zone discover someone, a world, and with a shout, a gesture, a word, suddenly I ENTER into another state, I am she, Antigone, or I am Creon, or I am Tiresias. I can feel my muscles change, my breathing, my backbone shifts automatically to allow the other to enter. My feet connect with the earth in a different way, as the weight of my body changes. It's like an instantaneous trance, a rapture. Yet at a distance, I observe, because I understand what is happening.*

Antigone Knocks on My Door

Two years earlier, in 1996, the Tupac Amaru Revolutionary Movement seized the Japanese Embassy at about 7:15 one evening. It all happened on the block where I live. For four months and seventeen days I witnessed countless scenes, and from my balcony watched all types of characters pass by. For four months and seventeen days, when I went out of my home I could only walk to the left (after showing my pass); the seized Embassy was to the right. To the left, yellow tape cordoned off the prohibited area within which I lived. Every day, more and more journalists pointed their cameras in all sizes and models, waiting for any movement that would signal a change in the situation. Every day under my balcony, the families of the hostages: bringing bands to play on hostages' birthdays; ladies with gigantic crosses praying for forgiveness; *curanderos* with maracas praying for an end to the ordeal; demonstrations; street children singing; tele-

visions set up outside tuned to the final round of a soccer championship; journalists falling in love; women selling t-shirts about the Embassy take-over. But above all else, the windows of the mansion, the Embassy, the curtains which opened to reveal the face of a woman, a young girl, a rifle at her side. Placards early in the morning. At dawn, loudspeakers boom-ing out military marches at an unspeakable volume (later we discovered that it was in order to drown out the noise of tunnels being built by the government). And most importantly, every day during those four months, listening during the night and waking up each morning, startled, wonder-ing: Did it happen? Did something terrible happen? Did they surrender? We lived as prisoners of anguish and misinformation. Watching the First Lady bring food rations every day, letting herself be photographed by the entire world—humanitarian, opportunistically charitable—and then im-mediately leaving, while the food sat there and baked in the scorching sun of Lima's hottest summer. And suddenly, one day, the end, the bombs, the destruction, the soldiers' cries of victory. Fujimori parked under my balcony, standing on the roof of a truck, his eyes welling with tears over the death of . . . two brave soldiers . . . without even mentioning that they had wiped out seventeen of the enemy (including the young girl with the rifle by the window) who had already surrendered. In the midst of the crowds clamouring to hear Fujimori-Creon, was Antigone perhaps among them, a small woman, trying to discover if her young brother was among the dead bodies?

Now we were searching, exploring, writing in the studio. Circling in on the atmosphere of the palace, on the sobbing Creon who would now, yes, free Antigone from the cave, on Tiresias who announced the catas-trophe. Now all that we had lived through emerged in every gesture, every movement.

> In the studio, I search for the image of the woman who narrates the en-tire story: the war in Thebes has just ended. Suddenly, a woman journal-ist appears to me, the women journalists, the ones I've seen for so long under my window. Afterwards, I feel that I, who live on the fifth floor of a building on the same block as the Embassy, am reporting what I see down there below.

Ismene's Shadow

The moment arrived during the creative process when we had to bring Sophocles' text closer to our own lives, to make it contemporary: we had to make our own version. We had a lot of scenic material, improvisations, character studies. Yet we couldn't find a way to make these elements

enter into a dialogue with each other through one actress. We invited José Watanabe, an extraordinary poet and screenwriter, into our group because his works already felt close to us. We showed him all our material, and from that point on, a new stage in our work began. We put the entire story on index cards and summarized the conflicts, which helped me to establish an order and bring together the improvisations. Then Watanabe proposed that we turn the cards into poems. My fantasy was always to use contemporary texts that spoke almost directly to my daily life, so taking up this proposal was a difficult challenge for me. The hardest point in our search for language was when we needed to answer the question, who was this woman telling the story? First it had been an actress, then a woman journalist, and now another possibility arose: who would be interested in narrating the story, in recovering this memory, who would be so heavily invested in it, in making each character live again? Who was still alive to tell the tale? Ismene. Deciding on this convention was a detonator.

It was at that precise moment that we resolved to get much closer to the Antigones of my country. To listen to them, talk with them . . .

We decided to interview women—mothers, wives, sisters—from the families of the desaparecidos in Peru. They were of all ages. Gisela, whose brother, a university student, disappeared in the early 1990s when Gisela was seventeen years old. We went from there up to mothers who were ten years older when we interviewed them, for example sixty years old. We did these interviews individually, and we personally invited each woman. The interviews took place in our house, in the theatre itself, on the stage where I was creating the work. First I sat on stage and told the woman I was interviewing about the story of Antigone, about what had happened over 2,500 years ago. Then I asked her to sit in my place and tell me her story.

Each story was hard, brutal. What all the testimonies had in common, I realized, was the way in which the women narrated how their lives had changed completely. One of these mothers, Raida Cóndor, later became president of the Committee of Family Members. The day I met her she was sitting serenely on the chair I would later use in the performance. In a very soft voice, she told her story to me:

> I was a woman who woke up early every morning to go to the market. I bought food and cooked it, I prepared my children's meals, I washed their clothes. Sometimes I watched the news. That's what my life was like. Then one day, my son didn't come home. The moment I realized that they had taken my son from me and I wouldn't see him anymore, my life changed. I had to learn how to read—I couldn't read—and I went to school. I had

to read legal documents, I had to start knocking on doors when no one opened them, I had to learn to speak, loud and clear.

Her life, then, was transformed; that's what she told me. And as she spoke her appearance, her whole image, all her gestures, had an incredible fragility. And yet she had an inner strength of such magnitude that she was able to change, at the age of forty-five or fifty, the entire horizon of her life with the sole objective of achieving justice for herself, her son, and for other mothers. I began to search through my memory, to confirm again that according to the existing image, the woman who fights for something must adhere to certain standards of behavior, that is, she must always be strong, she must always know what she has to do, she must always be moving forward. Reality is much more complicated than that. Within fragility there is often a hidden strength.

I've looked at these women with eyes that are perhaps deep within my soul. I've listened to each of their words as if they were making a confession to me. And maybe that's what it was like after so many years of demanding justice: they had turned their demands into a role as well, one they play tirelessly. This time we were alone, she and I. Each one of her brief gestures spoke to me so deeply of her life. And the best homage I could give her would be to feel all the memories inscribed on their bodies and thus confer them unto Antigone.

That's how another image of Antigone was born. Not the strong Antigone who has appeared throughout the history of Antigones. There have been warrior Antigones, furious Antigones (there's a version called *Antigona Furiosa* by Argentine dramatist Griselda Gambaro). Antigone, it's believed, is strong; she will stand firm until the end. My Antigone is fragile; even her voice breaks, a soft voice not used to confronting others or making demands. Out of this fragility (which she'll never lose), a limitless strength and determination emerge.

Objects

The loneliness in the workspace can be dreadful. Luckily for me, objects exist, my partners, which keep me company, have meaning for me, reveal secrets to me. I hide behind them when things don't flow. From the time I began working on Antigone to the end, I enclosed myself in a space that was well-supplied with objects; some I struggled to keep while others I abandoned along the way; others were transformed. A cane for Tiresias, a blindfold for his face, Creon's three-piece suit and his insolent fan, Tiresias's dark glasses and epaulettes when he seemed like an aged gladiator who had survived a thousand wars. A large piece of cloth, like

a shroud, that for me represented Antigone's territory; even after it disappeared I felt it still defined territories. A diaphanous, gigantic curtain, like those used in hospitals, crossing the stage and creating small spaces, balconies, living areas, between its panels, its translucency allowing the audience to "peek inside." A large wooden cup for Antigone to pour the three libations. And a mask, which I carried onto the stage and wrapped in a gauzy fabric on the first day. I'm not sure why, but this mask always had to be with me. Perhaps it represented "the Greek" for me. By the end of the process, this hidden mask would find the meaning it had been looking for all along. It was Polynices' death mask, kept safe by Ismene, which would finally allow her to perform a symbolic burial. And from the beginning up to the present, the chair. It is my tomb, my bridal bed, the balcony, the characters I look at as they sit there, it is my dead brother, an explosive rage, the caress of a remembered love, the blindfold inherited from Oedipus that covers Antigone's eyes, it is Antigone's senseless body, which Haemon gently embraces around the waist, it is a savage dance in the implacable presence of death. And, above all else, it is waiting, waiting, waiting. My partner in the loneliness of this empty space.

The Process Ends, the Journey Begins

When we first performed the work in February 2000, the Truth Commission hadn't yet come into existence, but the downfall of the dictator Fujimori, along with his notorious assistant Montesinos, had already begun. Slowly, years and years of deception, crime, and corruption began to unravel. This was before the newspapers started reporting all that would happen later. For me, the end of our road was clear: we wanted to perform Antigone because it was only through a story that happened 2,500 years ago that we could talk about what was happening to us at that moment. We had to recognize, all of us, as citizens, that we had maintained a "despicable silence" before thousands of corpses spread throughout all of Peru. The bodies had been silenced, yet they waited to be buried so that they could rest in peace. As our tradition tells us, those who are not buried are doomed to wander without rest, "haunted spirits, who look in sadness or anger at their own bodies."

Antigone's act, her attempt to bury her brother, was now symbolically completed by Ismene's act which, though perhaps late, was still necessary and urgent. We Peruvians were all Ismene; we all needed to start making that symbolic gesture to complete the burial. Some might believe that *to bury* means to cover, forget, conceal. Maybe. However, in its most important sense, a burial is an acknowledgment that someone is there,

1. Teresa Ralli, as
Ismene, finally buries
her dead in *Antígona*.
Photo courtesy of
Grupo Cultural
Yuyachkani.

because you put a name on the grave of the person you bury and say, he or she is there. And then both of you can rest in peace. You come and visit, and you remember that person in a place where slowly, as time passes, traces of pain will be washed away, only leaving memory, now put in its proper place. Those who haven't been able to bury their dead have been stripped of their right to determine a site, to name the absent one, to enact the necessary farewell. For almost twenty years, half the country lived in that reality. Antigone, the performance, arrived as a necessary act of cleansing.

Now she travels all over Peru. In Huanta, a city in the province of Aya-cucho, I perform outside one night because the theatre isn't working. Dur-ing the performance I look at the sky and see the stars above me. And I feel Antigone's energy and her message reaching the people of this battered city in Peru.

I only wish to add that from the start up to the present, there hasn't been a day when I haven't lit a candle to my ancestors, nor a day when I haven't prayed for my dead; I always feel they are with me.

Excerpts from *Antígona*

JOSÉ WATANABE

Translated by Margaret Carson

IV

NARRATOR

The girl, more child than woman, sitting in a patio . . .
her despair borne so serenely.
Sister to the two dead soldiers, one honored with a burial while the
 other,
disgraced, has none,
she watches us pass from a distance. The guilt we feel inside,
people of Thebes,
is not caused by her gaze,
for no one, not even the wisest advisor, dared to defy
Creon's decree
and that is what has damaged our soul.

What burns within your heart, Antigone?
Where does your resentment fly, young girl?
To Zeus, who unleashed all the pain
that exists in the world on your family
or to the king who now treats your brother so cruelly?

2. Teresa Ralli as Antígona. The only prop she uses is the chair. Photo courtesy of Grupo Cultural Yuyachkani.

VIII

ANTIGONE

Oh gods, you could have created us as invisible beings, or from stone
 needing no burial,
then why did you create us from matter that decomposes, of flesh
that cannot withstand the invisible forces of decay?

How shameful, how obscene
to die and not be buried, exposing
soft flesh and viscera to the eyes of the living. My brother suffers
such a punishment
and worse,
for he is food for wild beasts, vultures, and dogs to tear at.

Tall pines that watched me pass when I was a child,
can you see my brother? Was it the wind at sunrise that blew away
 the fine
dust I used to cover his naked body?
Will I have the courage again to fool the guards, now reinforced,
or should I resign myself that once autumn comes, his body
will be only bones and an oily stain on the ground?

X

I've seen Antigone, running cautiously from one column to another,
 from one corner to another,
as if hiding from no one.

As she passes through the Boreas gate
her flowing white dress seems to move on its own, like a billowing
 sheet on
a clothesline.

I lost sight of her when she crossed the plain, but a thought
transfigured her face and magnified her beauty
as she made haste
under the midday sun.

ANTIGONE

Polynices, my brother, you must wonder how I found my way to you.
Arrogance undoes all men, and
the sentries believed that in broad daylight no one could be so daring.
And I thank the northern winds
that curl into whirling storms and sweep the hills, lifting columns
 of dust
that rise to the clouds.
I have come, hidden by a dust storm. I am covered with leaves and
 nettles,
but the wine in my urn is clean.

How cruelly they scraped away the dust
I poured on you the night before last. The worst of the elements
is your punishment
but I've come to open the earth for you.

(A guard catches her by surprise.)

I risked being caught, guard, but let me finish opening the earth
so that I can be a mother and shelter Polynices as Eteocles was
 sheltered.

They are brothers, guard, their bond unbreakable, with no dispute or
conflict between them.
Perhaps they are calling each other now.

In your heart you know
it is not good for one brother to be protected by the earth while the
 other
still wanders, a soul in torment looking at his own body in sadness or
 rage.

I want all the dead to have a funeral
and then,
after that,
forgetfulness.
I'm caught in your snare, guard. My death begins.
Remember my name—
one day I'll be known as the sister who never forsook
her brother:
My name is Antigone

XI

CREON

My sister's womb bore you, and
love bonds you to Haemon, my son.
You are more family to me than most.

My soul burns with twice the pain and anger.
It is just, therefore, that I be twice as severe with you.

My son Haemon wanders in a daze through corridors and rooms
knowing his bride is surely condemned.
For your doom was sealed once the decree
and the punishment were made public.

Still, you laugh, and this insolence is even worse than the burial,
for then you made fools of mere guards, and now you mock
and sneer at your king.

It is always easier to order the death
of one who commits a crime and feels proud of it.
Your laughter makes it a pleasure to sentence you.

But who else is laughing with you?
What accomplices are hiding at home, reveling in your audacity? Did
 Ismene,
your sister, also help you? Is she the other head of the two-headed
 serpent?

368 Teresa Ralli

XX

The dead in this story come to me
not so that I can speak of distant sorrows. They come to me
so vividly because they are my own sorrow:
I am the sister whose hands were tied by fear.

Antigone came into my home like a sudden, wild flash of light, and
 said:
"Ismene, your hands must help me bury the corpse of
our beloved brother,
I trust
that since you are nobly born
evil has not conquered you."

Her words burned, but my spirit was like that of a small trapped
 animal.
I knew she was right, but I told her she was delirious,
that a mad idea
had possessed her.
It was fear, Antigone, because death was the penalty
we would pay for burying him.
Come sister, I begged you, let us ask the dead to forgive us
and obey the orders of those in power, the living.
But you reproached me. You said, "Ismene, go seek the favor of the
 tyrant.
I will seek the grace of the gods," and you went to the mound of our
 dead brother.

*(She unties a small bundle and reveals Polynices' death mask. As she
speaks, she pauses to pour the three libations.)*

Antigone,
do you see the world down below?
The palace is as deeply silent as a mausoleum
A breathing corpse rules us, a tormented king
who quickly grows old.

Look, my sister:
this is our brother's face before the dogs
and vultures came, before rot set in.
These belated libations are from my small guilty soul.

From your exalted kingdom
ask Polynices to forgive me for not performing this task at the proper
 time.
I was frightened by the scowling face of the king. And tell him
how great my punishment is:
to remember your act every day—a torture
and shame for me.

ROSA LUISA MÁRQUEZ

(Puerto Rico)

Rosa Luisa Márquez is one of Puerto Rico's (and Latin America's) most promi-
nent theatre artists and educators. She has experimented with a wide variety
of forms—from avant-garde theatre (*Godó*), to popular theatre (*La leyenda de
Cemí*), to installations (*Foto-estáticas*), to workshops on the role of performance
in political activism (*Carivé*). She has developed workshops for AIDS education
in schools and street theatre to protest current issues such as homelessness or
egregious eruptions of U.S. imperialism. She has worked with many major Latin
American and U.S. theatre practitioners (from Augusto Boal to Bread and Puppet)
and has trained several generations of Puerto Rican and Latin American students.
Her book, *Brincos y saltos* (Leaps and Bounds), describes her pedagogical goals
and techniques.

1. Rosa Luisa Márquez. Photo courtesy of the artist.

Between Theatre and Performance

ROSA LUISA MÁRQUEZ

Translation and photos by Miguel Villefañe

I began my work in theatre in Sunday school during my elementary
school years. I must have been eight. As a child I was exposed to musical
theatre, drama, puppetry, and even saw the great French mime, Marcel
Marceau. Theatre fascinated me in a very special way. I was afraid the
actors would transgress the fourth wall and join the audience. Once, they
actually did and scared me half to death. I was captivated by the mys-
tery contained inside the picture frame. From that time on, it seems The
Theatre chose me. At least that is what I wish to remember.

Having immersed myself in Spanish playwrights such as Valle Inclán
and Lorca in high school, there was no other option but theatre when I
finally went to college. The University of Puerto Rico's Theatre Program
provided a safe place to gather together and express our dreams. We prac-
tically lived in the University Theatre building, a huge structure with over
two thousand seats which was the largest and most important theatre on
the island.

We used any excuse to create theatre: Osvaldo Dragún's *Stories to be
Told*; Chekhov's *The Seagull*; Gorki's *Lower Depths; The Shoemaker's
Prodigious Wife* by Lorca, Williams's *Rose Tattoo; Absurdities in Lone-
liness* by Myrna Casas. Latin America, Europe, the United States and
Puerto Rico were contained in a single time capsule. During this period,
too, I became immersed in the work of Gilda Navarra, professor of mime,
who was the most rigorous and disciplined artist around. She had devel-
oped a clear and precise methodology for body awareness and training.
Her discipline came from her training as a dancer and was enriched by

her studies at the Jaques Le Coq Mime School in Paris during the sixties. Her mime dramas took no less than a year to develop and required the active collaboration of her company. With Gilda, rehearsals were veritable laboratories of group creativity and individual improvisation. But, she was always in control of final decisions. She is still the grand lady of Puerto Rican theatre. Unfortunately, since her mime-dramas did not generate written texts, Gilda Navarra has not been allotted the recognition she deserves as a national dramatist. Her work was always seamless. I consult with her often while directing. At seventy-six years of age, she is still as sharp as a whistle.

I acquired a taste for realism and the absurd through the academic courses and the stage work of Myrna Casas. Although Casas taught theory, she also directed. She required that the actors find organic pathways for the development of their characters. Because each actor defined her own blocking, she was more comfortable with herself as well as with her colleagues on stage. Casas encouraged role-playing and improvisations during rehearsals.

Part of what defines me and my professional work was coming of age during the Vietnam War years. The life and death framework established by the war elicited a very strong sense of urgency in our development as theatre artists. It was a highly challenging time, personally, culturally, and politically. We required quick answers and needed to connect with others who shared a similar vision. We shunned traditional theatre spaces—because these were not open to everyone—and performed in hallways, streets, and public squares. While traditional spaces limit the possibilities of democratic exchange, theatre practice, at its best, is a generous experience that heightens sensibilities, an act of communication that requires moving into the realm of the "other" in order to establish meaningful contacts. Theatre practice presupposes risk. Leaving the four walls of the traditional spaces created new conditions for dialogue. It was necessary to make adjustments. We had to speak louder, exaggerate our gestures, or get closer to our audience. We had to learn to listen and to take into account the spontaneous reactions of the audience and its critical comments. We began to observe our immediate surroundings with the purpose of learning from them. This enriched our endeavor; it sensitized us to new stimuli and forced us to include the elements of chance such as the eloquent reactions of our spectators, ambient sounds, natural light, wind, rain . . .

We worked within the context of labor and student strikes, political events, protests and marches. Because we shared issues with our many collaborators, we integrated actors as well as non-actors into our per-

formances. We scripted texts collectively; we manufactured masks, costumes and posters; we composed music. We were multi-faceted actors and total theatre people, even before we knew the meaning of such terms.

The war led us to defend life. Puerto Ricans were drafted into the U.S. armed forces. We struggled against the war in Vietnam as well as colonialism. Theatre was the preferred means of communication to confront both issues. Ours was poor, vital, and immediate. It took the form of popular street theatre.

In 1971, we founded the Anamú Theatre Group. *Anamú* is a weed so bitter and hard that even goats are reluctant to eat it. And we built a small theatre in a low income barrio of San Juan in 1973. Our approach to performance was playful, warm, and humorous. We strove to convince and seduce our audiences. We needed supporters for our cause.

We met Pablo Cabrera who became our teacher and artistic director. From him I learned to direct on the fly during rehearsals, as opposed to figuring things out in my head beforehand. I became aware that the performance space is the true locus of theatrical scripting. Cabrera directed our group in *Preciosa y otras tonadas que no llegaron al Hit Parade* (Preciosa and Other Tunes that Never Made It to the Hit Parade 1971) which was a staging of Puerto Rican short stories interlaced with songs and conducted by a disc jockey who made political comments. This experience made us aware of the importance of live music onstage, which has become a constant element of my craft and consolidated our work as a group. Later Cabrera directed us in *Pipo Subway no sabe reír* (Pipo Subway Does Not Know How to Laugh 1972), the story of a Nuyorican child obsessed with a bicycle. Our tallest actor used a half mask to play the part of Clota, Pipo's mother, while we—young adults—enacted the children. The power of the mask to change gender and to make the audience accept an unconventional point of view opened for me new perspectives in the realm of play.

Spongelike, we absorbed all manner of stimuli. We were influenced by the Living Theatre of the United States, especially its invitation for audience participation. The company broke with playwriting, the primacy of the author, the rigid separation between actor and spectator and the proscenium stage.

From the Bread and Puppet Theatre we borrowed the monumental sense of scale in order to attract audiences that would not normally attend a performance and to take over spaces that were not considered theatrical. In 1973 we were hosts to the Teatro experimental de Cali, Colombia, from whom we learned the methodology of Latin American–style collective dramaturgy, largely based on a Marxist approach to impro-

visation, analysis of dramatic conflict and group decision making. We were drawn to the playwriting techniques of Argentinian author/director Osvaldo Dragún who established the actor as the central narrator of the story. This greatly facilitated a more direct communication with the spectator. His technique ensured meaningful contact, as the spectator felt connected to the storyline. From the events of "May of '68" in Europe we had derived not just a new way of approaching the arts but a liberating attitude towards life. "Power to the imagination" also became our slogan. Additionally, we were mobilized by Ché Guevara's transcendent project as well as the Cuban Revolution that inspired him.

The impact of this artistic adventure was so compelling that I decided to continue my academic studies in theatre. By this time it had become clear to me that the theatre profession was not a viable alternative in Puerto Rico and I was moving farther away from conventional forms. This led me to embrace theatre as a tool for education. I became interested in approaching art from the sidelines, as a way of enhancing the quality of life and as a place where life could be lived more intensively.

The year I did my Master's Degree in Theatre and Education at NYU (1969–1970), the students sequestered the university's computer system. That was a fascinating event for our theatrical imagination because heretofore only people were sequestered. The police surrounded the school buildings. Classes abruptly ended in March. We spent the rest of the semester designing ways in which to do "theatre for peace." We staged various "guerrilla theatre" pieces which provoked positive reactions as well as a shower of soda cans from a New York skyscraper, as a response to our singing of: "and the rockets red glare, the bombs bursting in air, bombs bursting in air, bombs bursting in air . . ."

While completing my Ph.D. at Michigan State University, I wrote my doctoral thesis on the Puerto Rican Traveling Theatre, an itinerant theatre produced by the community of Puerto Ricans living in New York. Since its founding in 1967, PRTT has toured Latino neighborhoods performing theatre in Spanish and English. Today it is housed in a former fire department building on 48th Street. For many years PRTT performed for Nuyorican audiences the most significant theatre that was generated in Puerto Rico. While researching this group, I had the opportunity to review two distinct subjects: Puerto Rican theatre history and the economic and political causes of a mass migration of islanders to the United States—half of the Puerto Rican population which arrived on the mainland bringing with it a distinct cultural identity that provided an ideal audience for Nuyorican theatre.

Nevertheless, the most important experience of my graduate years

was to create and participate in the Lansing Team of Four, a theatre-in-education initiative that generated performances aimed at elementary school students. The group played in classrooms and gyms in the Lansing School District, a district plagued by violence. The idea was that students see the pieces, participate in theatre games, and select and reenact their favorite play in their homerooms. The initial working model stimulated active participation during the course of the performance. To be able to generate three performances and/or workshops per day for these children provided extraordinary training. Our main objective was to integrate them into a dynamic and imaginative experience. The great lesson from this project was to realize the effectiveness of the arts in channeling the creative energies of children. We became a truly athletic theatre team: agile, communicative, playful, and enthusiastic. I developed an ample vocabulary of theatre games; these games, added to those I later learned from Augusto Boal, have served me well in the task of stimulating creativity and uninhibiting my college students. By 1978, I had finished my Ph.D. and had accepted a teaching position in the Drama Department of the University of Puerto Rico.

At the university, I developed a piece with several casts that was performed in diverse spaces. *La leyenda del Cemí* (The Legend of the Cemí [an indigenous god]), based on a short story by the Argentine/Puerto Rican author Kalman Barsy, narrates the mythical birth of the island of Puerto Rico.

In 1983 I went to Paris to study under Boal at his Center for the Investigation of Active Techniques of Expression. I joined him when he returned to Rio de Janeiro in 1986 and worked on an educational project aimed at children from the favelas. From Boal, I borrowed two key techniques: his use of games and his pursuit of audience participation. The actor/spectator dialogue he sponsors, the high energy he generates in the spectator, his development of a liminal theatre which connects sociology, psychology and the ambiguity derived from bringing theatre into the street and reality to the stage, are all important elements of his methodology which I take into account. Each of his stagings is a unique and unforgettable event for performers as well as for spect-actors, as Boal himself defines the members of his audience.

My experience with Peter Schumann of the Bread and Puppet Theatre has also been extremely valuable. The manner in which Schumann organizes the daily experience of art, transforming it into a way of life and not just an aesthetic event is very compelling. I learned not to worry about results and rather to participate intensely in process, greatly reducing my anxiety regarding final product.

2, 3, 4, and 5. The staging of *The Legend of Cemí*, which narrates the mythical birth of the island of Puerto Rico. This particular performance took place in an elementary school. *Cemí* had more than one hundred performances in Puerto Rico, the Caribbean, the United States, Mexico, and Brazil. Photos courtesy of Rosa Luisa Márquez.

Since 1989 I have researched the work of Grupo Cultural Yuyachkani of Peru, which has developed a rigorous actor's dramaturgy based on Peruvian roots. The actors are the creators of their own characters and storylines under the strong hand of the director, Miguel Rubio. I also investigate the creative process of Grupo Malayerba of Ecuador, particularly its form of collective authorship, which occurs under the strong supervision of its director/playwright, Arístides Vargas, and his poetics of exile. I have followed the work of MECATE of Nicaragua (Artistic and Testimonial Campesino Movement) which uses art as an instrument of communication for the benefit of campesino communities. Their pieces deal with subjects such as ecology, agriculture, economics, health and social change. Its members are active cultural promoters and have no intentions of becoming professional artists.

Popular festivities also interest me enormously because they contain the essence of theatricality. I have closely followed the ritual in honor of Our Lady of Carmel in Paucartambo, Peru; Carnival in Brazil; and the Day of the Innocents in Hatillo as well as the festivity of Saint James the Apostle in Loiza, both in Puerto Rico. I'm attracted to the elements of spectacle and the fluid relationship between spectators and performers. We adapt these basic principles of these popular performances to our projects to reflect artistically on urgent matters: the Caribbean, peace, AIDS, human rights, Vieques.

Since 1989 I have been a teacher and workshop participant in the International School of Theatre for Latin America and the Caribbean, an itinerant school founded by Osvaldo Dragún. Its objective is to explore and divulge successful modes of theatrical production in Latin America through the coordination of international workshops, seminars, round tables and conferences headed by highly recognized teachers and groups. Twenty-five such encounters have been held with theatre companies such as La candelaria of Colombia, Yuyachkani of Peru, the Odin Teatret of Denmark, and Macunaíma of Brazil. The encounters have been hosted by teachers of the stature of Antunes Fihlo, Eugenio Barba, Roberta Carrieri, Sanchís Sinesterra, Peter Schumann, Miguel Rubio, Santiago García and Arístides Vargas.

In short, I am fascinated by theatricality in all its forms, from external manifestations (masks, costumes, movement, text, light and sound) to its most essential elements—its capacity for communication and transformation through ritual and sensual pleasure. I help students observe life as a theatrical event. We investigate daily occurrences as performance, the language of the senses, the relationship between "actors and spectators," and the dramaturgy of reality and hyperreality.

6. Antonio Martorell and Rosa Luisa Márquez.

My Collaborative Work with Antonio Martorell since 1984

How to describe the nature of our work when it's so circumstantial, constantly adapting to time and space considerations? "We" is Antonio Martorell, a multi-faceted graphic artist and performer and I, a *teatrera* or theatre person. We have created theatricalized lectures as well as performance events to defend our political preferences and have performed them as a duo. We have also developed huge parades celebrating peace as well as commentaries on the Fifth Centennial of the Discovery of the Americas in which hundreds of participants have created the props and scenic elements as well as the different choreographies. Our work with groups is usually developed over a short but intense period of collective creation of graphic materials as well as concepts. We recycle garbage, spaces, and ideas. We discuss issues such as prejudice, AIDS, harassment, domestic violence, the state of the arts as well as our dreams and nightmares. Commitment to issues, time, space, working materials and the skills of the performers are the main elements in the development of these projects.

An example of my work with Martorell include *Foto-estáticas* (1985), a sequence of tableaux on the subject of the Puerto Rican family, built with Augusto Boal's "Image Theatre" techniques and staged as a living photo album. The audience collaborates in an unconventional way. One

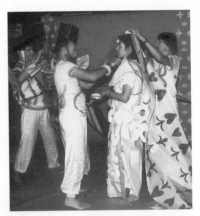

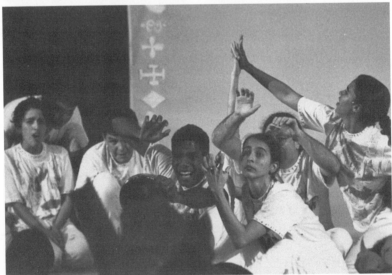

7, 8, 9, 10, and 11. In *Foto-estáticas*, a series of tableaux vivants are staged as a "living" family photo album. Photos courtesy of M. L. Márquez.

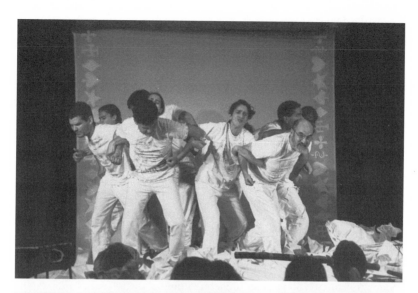

hour before the performance, audience members are invited to collaborate with the actors in the creation of paper costumes—a workshop process which can occur in the street as well as in enclosed spaces. Audience members develop skills in *frotage* (paper rubbing), Mexican cut-paper techniques, and wood-block printing. The actors are lavishly dressed for a wedding. But the wedding costumes are made out of paper, paint, and masking tape. At the beginning of the performance, audiences are shown a sequence of "tableaux vivants" of the wedding which are presented as photographs: the bride in front of the mirror, the wedding march, communion, the kiss and the family in front of the altar. The groom turns to the bride and tears away her paper wedding gown. At this point, a gasp of disbelief is always heard from the audience, after which there ensues a slow motion fight between all the actors that ends in the destruction of the costumes. From the inert mound of paper onstage a new version of the Puerto Rican family is born. It grows and quickly passes through emblematic social and political situations: traffic jams, unemployment and supermarket lines, compulsory military service; traditional family scenes in front of the TV set, domestic violence, births and deaths. A full cycle of life for the entire family/ensemble composes a huge family portrait in constant and rhythmic flow. The photographer of the wedding sequence takes the last photo through his paintbrush camera and traces the family's silhouette on the cyclorama. A huge white sheet is flown over the family portrait. A cymbal crash is heard and the family collapses under the sheet leaving the traced memory of their bodies. I acted as a music conductor. Seated downstage, with my back to the audience, I directed the rhythms of the play, establishing movements, sounds and silences. I usually perform in my pieces, sometimes as a protagonist and at other times as a secondary presence.

With *Foto-estáticas*, we began utilizing *performance* instead of theatre as a term that better defined our work. Each staging of this piece had a completely different character. Colors, textures, rhythms varied depending on who was involved in the process. We have since created more than one hundred events which include book presentations, lecture demonstrations, political debates, parades, banquets, museum pieces, installations, as well as more traditional proscenium performances. Often we take over and transform empty lofts with the help of interested participants. Cardboard, newsprint, cloth and other inexpensive recyclable materials serve us well in the construction of environments for performances or for the making of "performas," as Mexican artist Felipe Ehrenberg has baptized such events in Spanish. An enormous dosage of serious playfulness surrounds the nature of the experiences described.

TERESA HERNÁNDEZ

(Puerto Rico)

Teresa Hernández is an actress and dancer. She has performed contemporary dance and theatre in her native Puerto Rico for the past fifteen years. She creates her own work, which she produces under the name Producciones Teresa no Inc. Hernández's artistic work employs multiple languages: theatre, costumes, dance, and video. Her verbal and corporeal texts have been characterized by the creation of characters that are pertinent to the everyday reality of Puerto Rico. She integrates scenic space as a fundamental element for the development of her theatrical concepts and performs her shows or short pieces in nonconventional spaces as well as in conventional theatres. One of the characteristics of her work is that it adapts to changing circumstances; it transforms itself according to the physical space and the moment in which she performs. Her repertory includes three video pieces: *Doña Teatro* (Ms. Theatre), *Milagros Vélez*, and *La película extranjera* (The Foreign Film), which was screened at the San Juan Cinemafest in 2000. Hernández also enjoys an ongoing collaboration with choreographer Viveca Vásquez and the Taller de Otra Cosa, with whom she has created experimental dance and performance projects during the past fourteen years. Teresa Hernández has presented her work in the United States, Mexico, Venezuela, Argentina, Ecuador, and the Dominican Republic. She has received fellowships from the Instituto de Cultura Puertorriqueña (Institute for Puerto Rican Culture), the Puerto Rico Community Foundation, and the Sally Van Lier Foundation of New York.

1. Teresa Hernández as Senator Pardonme. Photo by Luisa Buxeda.

How Complex Being Is, or, The Complex of Being

TERESA HERNÁNDEZ

Translated by Marlène Ramírez-Cancio

Beginning (description): Senator Pardonme enters the theatre and takes a seat in the audience. She is an obese, asthmatic, and hypochondriac woman. It seems she could collapse at any moment. She uses a walking stick and wears a conservative outfit consisting of a skirt, a blazer, and a scarf, which makes her look like an Evangelical fundamentalist. But she isn't one. As soon as she takes her seat, we hear the beginning of the Puerto Rican national anthem, "La Borinqueña." A voice-over abruptly cuts off the music: "Joining us now, please welcome Senator Pardonme of Puerto Rico." (Recorded applause.)

Senator Pardonme gets up, exchanges her walking stick for a microphone stand, and walks onstage. Speaking into the mic with a shaky voice, she begins her speech.

SENATOR PARDONME: Thank you very much. Good morning, thank you . . . Before I receive this honor, I would like to thank Our Lord the Creator *(An asthmatic wheeze kicks in)* Jehovah, The Man Upstairs . . . Pardon me, however you prefer to call him. I would like to thank that almighty being, because without Him, none of this would be possible. Forgive me for speaking a little about religion, but I do believe that's where we need to begin . . . Amen.

With the authority bestowed upon me by the Law and by the Free Associated Statutory ra—. . . I'm sorry, State, of Puerto Rico . . . I gratefully and proudly accept this recognition awarded to us by UNESCO and the Com-

mission for the Protection of Tiny Countries, for being the only pre-state country in existence. We are very proud to . . . *(She interrupts herself.)* I'm sorry, if anyone here doesn't understand what I'm saying, please interrupt me, really, I mean, since we don't speak Spanish the way you do, I apologize, and with all this going back-and-forth between official languages—a few years with this one and a few years with that one—it's a real mess. Sometimes, when I have to speak "officially" at some function, I don't know whether to say "Welcome," "Hello," "Alou," "Hola" . . . and I get all confused . . . *(Her asthmatic wheezing becomes more and more persistent and uncomfortable.)* It's such a mess, this thing with the . . . thing, what's it called . . . language. So, please, if anyone doesn't understand, just tell me, I'll repeat it any way you'd like, it's my pleasure to be whoever you want me to be . . . Mom always told me: "you should serve, because the server always gets to eat." That's why I became a public servant. I count on you!

The fact that we merit such a high distinction has elevated the name of our beloved little land to almost-skyscraper heights. Because of this recognition . . . Pardon me . . . *(She gets an asthma attack. Discreetly, she takes out her medicine, inhales twice, and continues.)* I have a little asthma this morning . . . This time of year always makes me crazy . . . Ever since I was a little, little girl, when I was nothing, as Mom used to say, "you're nothing" . . . because as you know, little things are nothing . . . I'd suffer from terrible asthma . . . worse than now, but I feel better already, thank you, *(She scratches her throat.)* my apologies.

As I was saying, because of this recognition, and in light of our Miss Universe victory . . . We won! *(In a colloquial tone)* I'm sorry, I know everyone would like to win, but you know, they had to give us the prize because we were the hosts this year, the show was made there, aha. Mr. Donald Trump was really happy, you can imagine, we treated him like a king . . . We already have four, four Miss Universes and a saint, may he rest in peace, he just got beatified, Saint Charlie, that's his name. Actually, his real name is Carlos, but everyone called him Charlie since he was little, so Saint Charlie it is . . . Well, let's see if these true representatives finally "get us on the map," so to speak . . . Really, because, I mean, I'm sorry but sometimes I get to certain countries and they have no clue where we are, I guess it's not their fault, I mean, we're just a teeny speck . . . *(She switches to a political oratory tone.)* And this is why I have decided, through the legislative commission over which I preside, that I will push for a law that advocates the mandatory inclusion of a magnifying glass along with every map that is manufactured . . . ! Well actually, not every map, I mean,

just the maps we have access to, the maps of the United States . . . ! We're already requesting permission from Congress, and if they say yes . . . forget it, we'll use our Miss Universe and our Saint Charlie and I assure you there won't be a country or a heaven that won't know where we are . . .

Oh Sweet Jesus! I may be standing here, but I'm very ill, I'm seeing double, I'm dizzy, dizzy . . . I hope everyone can hear me okay, *(Almost crying, desperate)*, I'm sorry I can't speak any louder, I had surgery on my vocal chords, and I have no tonsils, and I had my spleen removed, and a kidney too, and my liver is . . . I practically have no insides, and it's so hard for me to keep a train of thought . . . *(She's on the verge of a nervous breakdown.)* Oh, Lord Almighty! I forgot what I was saying . . . I don't know why I'm here! . . . Lament! Where's Lament? Dear Christ, forgive me! I went blank . . . This has happened to me before, there's times when Lament, my secretary, has to escort me out of places and I look at her and say, "Who are you?" . . . Can you imagine? I don't even recognize my Lament! Lord have mercy! *(Desperate, she finds someone in the audience and asks her for help.)* Ma'am, if you would be so kind as to tell me where I am . . . *(And, as if she had been illuminated by the Holy Spirit, she energetically says:)* Fuente de Agua Viva Church, I'm yours! *(Her asthmatic wheezing returns.)* The recognition! Brothers and sisters, we'd like to thank UNESCO and the Commission for the Protection of Tiny Countries for having chosen us as the only pre- . . . *(Out of breath, she collapses to the floor.)*

VOICE-ACTRESS-NARRATOR: Oh! This country suffocates me. It's so hot! This country chokes me. *(The actress begins to take Senator Pardonme's clothes off, and asks someone in the audience:)* Give me a hand, would you? Help me take off my patrimony . . . Did I say patrimony with a P? If I don't take this off I can't tell you the story . . . *(By now she has taken off her clothes and is standing with Senator Pardonme's body in underwear; this body is made of foam and is divided into two parts, upper and lower body. With the help of the audience member, she removes the upper body as she talks.)* How can I distance myself if I'm inside? It isn't a story I'm going to tell you, it's more like a comment, a puny little comment . . . Did I say puny with a capital P, or was it lowercase? *(She walks to a chair upstage right, and sits down to take off Senator Pardonme's lower body.)*

There's three of them, three sisters—and I say three so as not to say ten or twenty or three million—there's three sisters. No allusion to theology or mythology. No, no, no, no relation to the three "parkas" of Scandinavian mythology, those three deities of destiny: Past, Present, and Pos-

terity, as they were called. They were made of time. But not these, not the sisters I'm telling you about, Pardonme, Pragma, and Perpetua, they're not made of time. *(She walks downstage, close to the audience.)* Instead, their bodies are made of complexes, junk food, denial, passion, pain . . . *(She puts on a vaporous, black and red evening gown, which has been on the floor from the beginning. It is Perpetua's costume.)* They are three sisters, all with a similar face but different bodies. Three sisters: Senator Pardonme, Pragma "La Continental" (as she likes to be called), and Perpetua the singer. Each one carries her own lament: the Senator with her secretary Lament; Pragma with her assistant Lament; and Perpetua with her accordion player Lament. *(She crouches down to put lipstick on.)* Pragma couldn't come on this trip, did I tell you that already? She didn't want to . . . Her motivational talk, "Shame on You for Being Small," has enjoyed tremendous success, and you know she believes in progress . . . *(Slowly, she fixes her wig, completing her transformation into Perpetua.)*

PERPETUA *(Grabbing the microphone stand, she dances her way to the opposite corner.)* How much joy I can breathe in this petite room, petite with a capital P! Eh! How are your seats, audience? Are they square or are they round . . . or does the audience not have a tongue . . . Audience, you must to exercise your tongue! . . . so you can enjoying with your singer, Perpetua, who will make you to live the music with the songs that fill your soul down to the sole of your shoes . . . ! *(Perpetua speaks Spanish with a Portuguese-Italian accent. She is a singer who doesn't sing: when she announces a song, she dances. Her body language is made of fluid movements, slides, falls, and floor movements. She is passionate and intense, although she also reveals her fragility.)*

Before we begin, it is important to giving an explanation, no excuses like my older sister Pardonme, no excuses, but still for me it is important a clarification. If a person in the audience does not comprehend some word that I emit, please raise your arms and I will quickly *(She slides with the microphone to the floor)* translate into local version . . . Simple, I cannot speak in local voice, my vocal chords have been intervened . . . operated . . . When I was piccola with a capital P . . . they changed my voice for a global voice . . . Por qué? . . . *(Getting up)* So that I could reach a wider latent audience . . . But however, inside my vocal chords is still remaining pre- and post-national territories . . . But we are not here for speaking of serious things, nor of nations, we are here to *(moving all around the stage)* living the music with the songs that fill your soul down to the sole of your shoes . . . ! *(She finishes her movements and takes her place upstage left, ready to "sing.")*

I cannot explain you my presence in this activity, but this is not important, everything does not has the justified explanations of reason, the wisdom of the body has answers that I like to hear . . . This first song that I will interpret is dedicated to all the local voices that have been locked inside a box, for you, my song: "Escape the Local" . . . *(We hear the piano number "Noliu" by Chucho Valdés, and Perpetua dances her first "song" to the music. Gradually, the music fades and the dance ends in silence, with Perpetua on the floor holding the microphone.)* Grazie, molto grazie . . . I love to singing! . . . I never do the same way twice, eh? This is the joy of the stage . . .

Always I sing this song, I remember one of my sisters. My sister Pragma. But Pragma does not liking the local, oh no, it is the opposite . . . Pragma, she is continental . . . She is ashamed to be with Pardonme or with my own person . . . Pragma does not accepting . . . Bom, but these are the private stories of the family . . . *(She kneels and, still holding the microphone, walks as though she were a dwarf.)* Mamma and Papai always used to say: "Pretend, do not give yourself away: você não capisci who you are, you are not what you are . . ." *(She is now in a melancholy mood, and she continues speaking in a confessional tone.)* All the three of us have been operated, in different ways, but operated. *(She stands up.)* Without consulting, without explicação, we domestically learned how to forget, but forgetting becomes a burden or a lament, one lament, two laments, one thousand laments . . .

Oh! I think the audience is believing what I am saying. Audience, we are not here to believing! Why are we here? *(She again switches moods, and is now euphoric, anxious.)* To live the music with the songs that fill . . . ! *(Brief pause. She realizes she has gone overboard, and calmly approaches the audience.)* Audience, I think I have reached the finale, the finale of the week?, of the month?, of the millennium? The finale alone is no good, audience, for knowing that at some moment we have to begin . . .

This last song I will interpret to you needs the accompaniment of my audience . . . What do you say, do you dare to accompany your Perpetua? Nothing better than to singing by acompanhamento, absolutely, nothing better . . . This song is dedicated to all the latent audiences, the visible and the invisible, minha audiência, to tell this song you need strength to sing . . . So then, with you and for you, la mia canzone . . . "Carry My Weight." *(She offers herself to the audience so they can carry her. As she is passed from person to person, she improvises with the following phrases.)* Nothing better than to sing with acompanhamento! Let everybody singing with your Perpetua! Che bello canta la audiencia, don't be

afraid to singing with your Perpetua! Let yourself go in the música! . . . *(She leaves the audience and, walking on her knees, says:)* How much joy I can breathe in this petite room, petite with lowercase P! *(Pause. The actress gets up, beginning her movement by removing her wig. With the voice of another character, she continues.)*

VOICE OF ISABELLA: A body on top of another body is not copulation. *(The actress takes off Perpetua's costume, and begins to put on Isabella's: a long, dark blue cape, fashionable eyeglasses, and a very "chic" wig . . .)* They are layers of voices that free the creator-being. A body that wants to speak from the body: artistic or artificial body? No. It is a body inhabited by other bodies so she can make herself comfortable or uncomfortable before the audience . . . *(She has finished her transformation into Isabella.)* Now that I have my body, allow me to introduce myself:

(She walks upstage center, grabs her pink heels from the floor, and as she puts them on with great flair, she speaks.)

ISABELLA: My name is Isabella Fernández, art critic, specialist in performative experiences, post-doctoral studies in multibilingualism, identity, and sexual acts in Latin America and the Netherlands . . . *(She moves around the stage as if she were on a runway: she is a "fashion intellectual.")* Let's go right to my talk . . .

We are currently in this hemispheric institutional bubble to scratch and scrutinize among ourselves the topic at hand, namely, Performance and Politics in the Americas: Memory, Atrocity, and Resistance. Quite a touching title to frame us . . .

This title immediately evokes, that is, I re-think once more about my native country. Puerto Ricans have an atrocious resistance to memory. Each day that passes marks a new forgetting in our 100-by-35 mile island. An oblivion imposed and sometimes chosen as a survival mechanism. At times it becomes necessary to "hit the reset button" to avoid suffering the political de-culturizing bestialities. Nonetheless, the days go by, then the years, and we eventually go blank like Senator Pardonme in her speech.

(Brief pause. With her assertive model walk, she moves upstage right, and sits down on her chair to continue her dissertation.) Let's discuss the performance we saw a few moments ago . . .

We have a government employee *(Points to the Senator's body, which is still on the floor)*, obese from superfluous excesses, mediocrity, hypochondria, literally a ball of complexes. The poor woman never received affirmation of her inner self. As a national counterpoint, we have a singer

who doesn't sing. Perpetua's being is complex: it is, and yet, it is not. A middle sister who didn't come with them, pragmatized before the positivism of progress, denying her family origins . . .

It seems to me, ladies and gentlemen, that we are witnessing one of the most debated paradigms of all times: "To be or not to be," it's not that easy, Shakespeare. As you all know, we've been a colony for a little while now, and this type of "psyche" manifested by the sisters is symptomatic of the colonial experience. Many Puerto Ricans are ashamed to touch upon this subject, especially those in the academic circles, who think it's passé, and I understand them. I felt that way for many years, but then, after undergoing the experience of colonial therapy, I was able to face this reality more bravely, to confront the multiplicity of identities. We have refined colonized subjects, angry colonized subjects, ambiguous colonized subjects, happy ones, colonized subjects who believe they have overcome being colonized . . . Anyway, there's nothing like understanding the colonizing experience. *(Dramatic pause. She stands up and walks center stage.)* Ladies and gentlemen, I think I have succinctly discussed the topic at hand. Many thanks for your attention, and I'll see you in the cyber world . . . Goodbye . . . ! "Taxi!" *(She freezes for a second. End.)*

Teresa Hernández vs. the Puerto Rican Complex

VIVIAN MARTÍNEZ TABARES

Translated by Margaret Carlson

About "small" with a small "s"

I like smallness because it gives me room to make mistakes. Being small, it can't enter "established and official" spaces. The question is, how to make something transcendent out of this. Choosing smallness is to pay homage to the intimate, because it allows for a doing, the unanswerable question, the delight in the imagination, and control over your franchises. The bigger you are, the more franchises you have, and I'm not happy with that equation.

It took me several years to decide to become a small artist . . . Sometimes I regret it, but I enjoy my small artistry, and try to be realistic, without losing my sense of humor or my ideology.

Vindicating smallness is my newest calling. They've made us believe that small isn't enough, isn't complete. By recognizing the strength of being "incomplete," by valorizing it, I'm taking a stand for what I believe is our essence: we're almost . . . but . . .

That's the reason why I'm a small, local artist.
—Teresa Hernández

Teresa Hernández writes, acts, dances, and sings if necessary. She thinks with her body and gesticulates with her hands and face. She moves while constructing phrases from motions and forming chains of actions that don't tell a story in a conventional way. Rather, they trigger associations and provoke new sensations towards the live event that takes place before our eyes. She shapes her own space or invades another one and in-

habits it, while underneath she inherits, processes, and reformulates the scenic, literary, and cultural traditions that make up Puerto Rico and the Caribbean, as well as the countless difficulties that have defined the era she lives in.

The actress-dancer trained in dance and dance theatre at the University of Puerto Rico with her fellow Puerto Ricans Petra Bravo and Maritza Pérez (in the groups Danza brava and Pisotón, respectively) and then with the dance and performance group Pepatián, formed by the artists Merián Soto and Pepón Osorio. Her greatest influence, however, has been the dancer and choreographer Viveca Vázquez, with whom Hernández has had an ongoing collaboration in the Taller de otra cosa (Something Else Workshop).[1] From Vázquez (an heir of Merce Cunningham and John Cage), Hernández learned a concept of dance that values silence, recovers the origins of movement, and is nurtured by such everyday actions as walking, running, or jumping. She learned how to link movements together that seem contorted, disconnected, and fragmented, yet which are extremely effective in eliciting sensations and feelings that stay with the audience during and after the performance. She discovered the liberating power that comes from accepting her body as it is, and recognized that she could think with her body and translate any intellectual material with her physical weapons.

Hernández also studied post-Brechtian theatre with Rosa Luisa Márquez, with whom she has developed sites of theoretical and practical exchange, such as her performance in Márquez's production of *Godot* (1997).[2] From Márquez, one of the most dynamic directors on the theatrical scene, Teresa learned about the theoretical referents of theatre, and widened her horizons to include other perspectives on the Latin American scene, such as those of Miguel Rubio and the actors in the Peruvian group Yuyachkani (with whom she has taken workshops and who have inspired some of her projects) as well as other approaches presented in workshops at the Escuela Internacional de Teatro de America Latina y el Caribe (EITALC), or in conferences at the Escuela Internacional de Antropología Teatral (ISTA) under the direction of Eugenio Barba. With Márquez she also came to understand the living, perishable nature of theatre, a concept similar to the ideas put forward by the most demanding theoreticians of performance.

In *Lo complejo del ser o el complejo de ser* (How Complex Being Is, or, The Complex of Being), Hernández, starting with the title itself—uncertain and ambiguous, thought-provoking and incomplete, hesitant, suggestive of Hamlet—touches a raw nerve by focusing on the sociocultural and human context in which the performance develops. *Lo complejo del ser* is a hybrid that recycles or reformulates two characters from an

earlier project (*La nostalgia del quinqué . . . una huida* [Nostalgia for Oil Lamps . . . An Escape], which also utilizes multimedia language) and introduces a third character from a different source: Isabella, the unquestionable queen of *Acceso controlado* (Limited Access 1995), who had been created for Viveca Vázquez's performance piece *Kan't translate: Tradúcelo* (Can't Translate: Translate It 1992), and who later reappeared in *Isabella "en partes"* (Isabella "In Parts" 1993).

This modular conception of characters, who are constructed in ways that allow them to adapt to different contexts, is a defining feature of Hernández's work. In *Kan't translate*, Isabella, a caricature of the conceptual void that conceals the false erudition of some art critics and theoreticians, litters her speech with "labels" and "isms." She and her companion Fernando are suggestive of the King and Queen of Castile, symbols of the first colonial power that still weighs down on Puerto Rico. In *Isabella "en partes,"* Hernández returns to cultural themes and inserts numerous references to Latin American literature and popular culture.[3] She pays homage to important figures in contemporary Puerto Rican theatre such as Luis Rafael Sánchez and Victoria Espinosa, and addresses the crisis facing the theatrical world she is part of, with a "closing ceremony" that bluntly describes the here and now:

> 1972, Teatro cooparte, burned down. 1984, Teatro corral de la cruz and its workshop, closed. 1987, Teatro Sylvia Rexach, closed. The original movie theater in Viejo San Juan, Teatro mascarada, closed. Theater-cafés: Los campos alegres, La tea, Café Vicente, Casa de Teo, closed. Teatro riviera, neglected and abandoned. Teatro matienzo, still waiting for a new owner. The old telegraph office in Santurce, Teatro savador brau, beautifully restored and mysteriously closed. 1993, Our Theater closes . . . (*Lights suddenly go out*).

In *Acceso controlado*, perhaps her most polished project, theatre itself is once again the fulcrum, but more in terms of the work's composition than its theme.[4] Isabella has transformed herself into the queen; she is, without a doubt, Isabel de Castilla, hysterical, xenophobic, out of place in a century she doesn't understand, a character inspired by Jean-Marie Le Pen and authoritarian theatre directors. In an act of personal rebellion, the performance artist takes aim at her social and professional conditions through carefully devised transformations: she metamorphoses into Lieutenant Cortés, a security guard at a condominium, a simple, ordinary woman who represents the "voice of the street"; Milagros Vélez, solitary and methodical, overwhelmed by routine, and suicidal (seen in a video transmission, to create a more distanced reception); "Primera plana" (Front Page), a marginalized teenager, in detention and in the pro-

396 Teresa Hernández

cess of being "reeducated," someone who listens to others but who can only express himself through body language; and the First Lady, ethereal, a prima donna, elevated and distant, operatic and politically correct.[5]

The Isabella in the text that follows is the direct offspring of Pardonme and Perpetua. She thus inherits the submissive, servile humility and permanent stress of the obese Pardonme, a religious fanatic who always feels she has sinned, *eñangotada*,[6] a victim of the war of languages (who maybe can't recall which is the official one). Isabella also takes after the silent Perpetua, "a singer who doesn't sing," a Boricua who by using Anglicisms and other linguistic grafts, compensates for her "smallness" complex with a hybrid accent, somewhere in between Italian and Portuguese.[7] On her way back from the Old World, she visits the motherland, Spain, to help groom her global voice, although her vocal cords still show traces of "pre- and post-national territories."

While Pardonme can hardly stand on her feet and collapses to the floor, choking, and Perpetua slips, falls, and slides herself forward on the stage, Isabella stands tall on high heels and strides elegantly forward as if on a fashion runway. She liberates herself to become a panelist in the Hemispheric Institute of Performance and Politics, addressing the theme "Memory, Atrocity, and Resistance" (Mexico City, 2001). "The atrocity is that we have lost our capacity for resistance and memory," she declared. Using corrosive sarcasm, she once more speaks about being small and about the lack of memory that undermines the colonized subject, who is not a univocal being but is divided into a multiplicity of identities.

The text is full of local and global references, real and fictional. Interestingly, the majority of Hernández's characters move in public spaces: Pardonme is a senator; Perpetua is a singer; Isabella is an art critic. Milagros Vélez is, I believe, the only character who inhabits an exclusively domestic space, although she reaches the outer world through video projection. And the types of local references—including the national anthem "La borinqueña," Jehovah, Chuíto (a popular and affectionate nickname for Jesus), the Commonwealth or "Free Associated State" (also called the only pre-state country), UNESCO, the Commission for the Protection of Tiny Countries, the controversial real estate magnate Donald Trump and his Miss Universe pageant (on the small Island of Enchantment that has already had four winners!), Saint Charlie, the secular Puerto Rican apostle, the first native-born saint (recently canonized) and, coincidentally, a possible allusion to a well-known politician belonging to the pro-statehood party, the Fuente de Agua Viva Church, a new homegrown congregation of growing influence—form an eloquent nexus of imagined spaces.

From the text alone (although we can't fully enjoy it without Her-

nández's presence), we can perceive how the author desires to speak through the body, which is submerged in a body-country that suffocates, or in another body that is objectified and wears a mask. She speaks through a body that can be inhabited by other bodies, and can conceptualize paralysis in gestures and movements. Because with her body, or with the bodies she transforms herself into, Teresa Hernández performs her place-in-the-world, in this world.

Notes

1. With Vázquez she has performed in "Mascando inglés," "Tribu-To," "Capicú," "En-tendido," and in the video "Las playas son nuestras," part of the show *Riversa 1997*, which was a retrospective of Vázquez's choreography—solo or collaborative—between 1980 and 1989; for *Conciente privado o Mamagüela*, Hernández was also artistic assistant and the author of the theatrical segment "Brenda prenda"; and she coauthored (along with Vázquez and Eduardo Alegría) *Kan't translate: Tradúcelo*.

2. In March 2002, five years after the opening of *Godot* (the final production at the Teatro de la Universidad de Puerto Rico, which still remains closed), Hernández and the actor Antonio Pantojas presented the book *Osvaldo Dragún: Stories To Be Told, Staged by Rosa Luisa Márquez*. They performed as Gogo and Didi, who had been shut inside the theatre ever since it closed, and were waiting for Godot to come and begin the promised restoration.

3. She makes references to the character in the short story "En el fondo del año hay un negrito" by the Puerto Rican writer and essayist José Luis González, to Gabriel García Márquez's magic realism, and to Eduardo Galeano's images, as well as evoking the popular local legend, *La virgen del Pozo*.

4. Hernández reprocesses the monologue structure of *Quintuples*, by Luis Rafael Sánchez, with six characters from the Morrison family written for two different actors. She raises the ante by playing five characters herself and appearing as the sixth at the final curtain.

5. A closer analysis of this and other projects can be found in my essay "Teresa Hernández: Artista de la acción, performera caribeña," included in the book *Lo mío ese otro teatro* (San Juan: Ediciones Callejón, forthcoming).

6. According to the noted playwright, writer, and essayist René Márquez—who gave sociological importance to this adjective by linking it to the national identity—*eñangotado* or *ñangotado* (meaning stooped or bent over) is a linguistic term invented by Puerto Ricans "when they still enjoyed the privilege of being frank with themselves." See his essay "El puertorriqueño dócil (Literatura y realidad psicológica)," in *El puertorriqueño dócil y otros ensayos, 1953–1971* (San Juan: Editorial Antillana, 1977).

7. As with Pardonme and Perpetua, the colonial dichotomy between "big" and "small" comes from *La nostalgia del quinqué . . . una huida* (1999) and before that, *La gran tragedia y las personas calzadas* (1996).

TANIA BRUGUERA

(Cuba)

Born in Havana in 1968, Tania Bruguera received her B.A. in 1992 from the Instituto Superior de Arte in Havana, and an M.F.A. in performance from the Art Institute of Chicago in 2001. Her performances, installations, and videos have been featured at the Forty-ninth Venice Biennale (2001), Havana Biennial (2000), Kwangu Biennial (2000), SITE Santa Fe (1999), Johannesburg Biennial (1997), and XXIII Biennial of São Paulo (1996), as well as in Spain, the United States (Chicago, Boston, New York), Holland, Finland, and England. A 1998 Guggenheim fellow, Bruguera taught during spring 2002 at the San Francisco Art Institute's New Genres department.

Through her performance practice, she describes the chaos and pain, as well as the beauty, that is Cuba. Coming of age in communist Cuba, Bruguera is of a new generation of artists choosing to stay on the island rather then emigrate as did many artists before her. *El peso de la culpa* (The Burden of Guilt 1995), the subject of José Muñoz's essay, explores conflictive feelings produced by staying. As Muñoz argues, Bruguera's work is a critical retention of shame instead of a more familiar Cuban negotiation of shame, that includes rejection, outward projection, or cleansing. *Cabeza abajo* (Head Down), for instance, displays a posture other than the direct or simplistic rejection of shame. The critical nature of her controversial work has produced an ambivalent response in Cuba, fueling both censorship by the Cuban government and admiration.

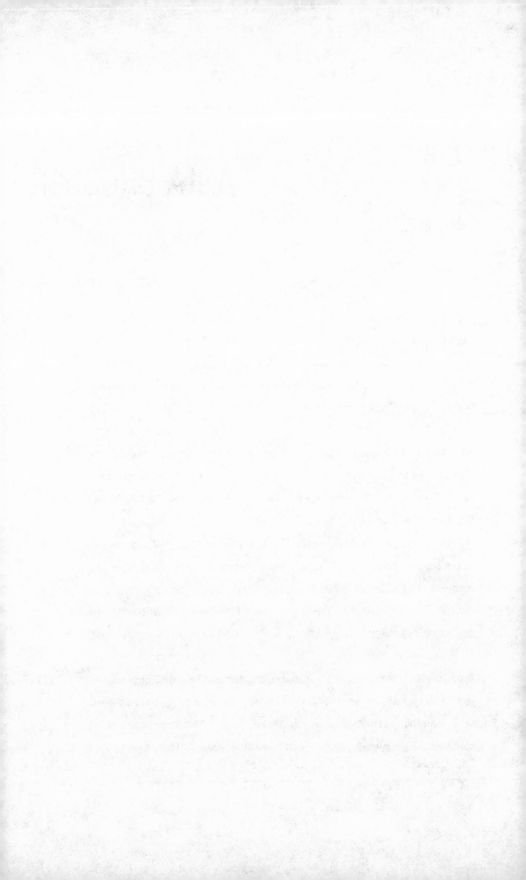

Performing Greater Cuba:
Tania Bruguera and the Burden of Guilt

JOSÉ MUÑOZ

Sitting in a lower Manhattan bar with two dear Cuban American friends in the spring of 2000, we found ourselves somewhat overwhelmed with the psychic and political ordeal of simply being Cuban at that particular historical moment. We fumbled for the proper word to describe what we were feeling at that vexed time. We had spent weeks compulsively tracking the case of Elian Gonzalez, the six-year-old boy who was rescued by fishermen off the coast of South Florida in November of 1998. The irony that this was happening almost exactly on the twenty-year anniversary of another infamous Cuban immigration scandal, the Mariel boatlift, did not escape us. By this point in the ordeal the entire nation was familiar with the boy's tale: his tragic flight, the death of his mother at sea, and various magical realist details that punctuate the case, like the account of benevolent dolphins keeping the boy aloft on the inner tube and the manifestation of the Virgin Mary in the contours of a cracked mirror in Elian's bedroom in his Miami relatives' home. Miami Cubans rallied around the boy's Miami kin, who fought for custody of the boy. Cuban leader Fidel Castro, not one to miss the challenge of any symbolic war, pressed for the boy's return. As the situation escalated, the comportment of Cubans seemed odd and fantastic to non-Cuban viewers. Despite media representations to the contrary, Cuban Americans are not a monolithic bloc of right-wing zealots. There is in fact a Cuban American left, networks of people and individuals who believed that the boy should be allowed to return to his father and who furthermore—and even more scandalously—do not demonize the revolution but instead view it ambivalently.[1]

That night, at the bar with Northern Cubans, I realized that we felt a structure of feeling that I can only call communal guilt. I realized that perhaps this structure of feeling linked Cuban Americans and Cubans. Certainly my right-wing relatives feel a sort of survivors' guilt in relation to those Cubans on the island, who they perceive as living in the shadow of a tyrant in a communist inferno. Cuban children in the United States are scolded for being wasteful and reminded of all the material possessions they have compared to their cousins who are deprived of capitalism's trinkets. As a Cuban American who believes in the importance of materialist analysis, the ultraconservative dominance of the community I grew up in has been a source of shame and guilt for me as an adult. As a proponent of pan-Latino coalition politics I feel this familiar structure of feeling in relation to the historical preferences and advantages Cuban immigrants enjoy in relation to the state-sponsored harassment that other Latino groups such as Mexicans, Dominicans, and Puerto Ricans encounter. Guilt envelops the Cuban American tradition. Guilt, according to the theorist of affect Silvan Tompkins, is a subcategory of shame (142). Guilting other people is akin to shaming others, and guilt itself is one way in which we introject shame.

In this essay I wish to use this commonality in guilt to do decidedly different taxonomical work than I did in the above paragraph. Rather than differentiate between different kinds of Cuban Americans—us and them, myself and the Other Cuban—I want to consider the way in which there are structures of feeling that knit *cubanía* together despite different national pedagogies and ideological purchases. Furthermore I am interested in putting pressure on the inside/outside Cuba binary that has become so central since the revolution. By focusing on guilt's relation to all of *cubanidad* I am attempting to render an analysis of what I will call, after the film theorist Ana López, Greater Cuba. López uses the term to talk about cinematic cultural productions by Cuban Americans outside of the island in relation to work from the island. Her expanded rendering of cubanía functions as a challenge to cold war rhetorics that are interested in a strict binarization of cubanía. While it is important in the case of other Latin American immigrant histories, such as the case of the Chicano, to differentiate between over there (Mexicans) and over here (Chicanos), I am arguing that this is not axiomatic for all Latino groups. Since the antagonisms that Chicanos have faced are remarkably different from the lesser state-sponsored obstacles that Cubans have overcome, it is safe to conclude that both cases are decidedly divergent. This makes different protocols necessary to properly understand different Latino groups, groups that nonetheless potentially work in coalition formation as *latini-*

dad. It seems that thinking past the stultifying rhetorics of what Gustavo Pérez-Firmat has called "life on the hyphen" will lead us to a more nuanced understanding of the affective contours of what it means to be Cuban in the extended and somewhat pretended geography that we will call Greater Cuba. (This map would include the island and South Florida but also highlight other hubs of Cuban production in New York and New Jersey, as well as spots in California and elsewhere in the Americas.) This geography is calculated in relation to affective considerations of space. I will propose that Cubans live in guilt, and that an affective geography of cubanía, built on this analysis of guilt as a structure of feeling, is particularly important at this historical moment. To this end I will consider the work of Cuban national artist Tania Bruguera.

Bruguera came to my attention after her work had been censored by the Cuban state in 1994. The offending art object was a journal that had the format of a newspaper and was titled *Memoria de la postguerra* (Memory of the Post War) that included Cubans inside and outside of the island expressing their feelings on the Cuban state at the moment. The government in turn did not invite her to perform at the 1997 Biennial. Bruguera nonetheless performed at her own residence during the exhibition as international visitors and local neighbors watched. Though Bruguera graduated from the Art Institute of Chicago in 2001, she considers herself to be a Havana-based artist and is returning to the island this fall to inaugurate a performance studies department at the Instituto Superior de Arte (the Havana Art Institute). I will consider her performance work, especially a piece titled *El peso de la culpa* (The Burden of Guilt), as a greater Cuban intervention that meditates and theorizes guilt and the Cuban condition.

Introjecting Guilt

The Burden of Guilt, a performance that was debuted in 1997 in Havana, is part of a series of performances that Bruguera calls *Memorias de la postguerra.*[2] The artist's own description about the themes she is attempting to foreground stresses a history of guilt in relation to the nation's foundation:

> In this piece I specifically refer to the collective suicides of indigenous Cuban people during the Spanish occupation. The only way that some of them could rebel—as they didn't have any weapons and they weren't warriors by nature—was to eat dirt until they died. This gesture, which remained with us more as a historical rumour, struck me as hugely poetic. In a way, it speaks to our individuality as a nation and as individuals. Eat-

ing dirt, which is sacred and a symbol of permanence, is like swallowing one's own traditions, one's own heritage, it's like erasing oneself, electing suicide as a way of defending oneself. What I did was take this historical anecdote and update it to the present. ("Tania Bruguera")

The basis of this performance is a mythological origin story of Cuban guilt. The factual nature of this origin is partially relevant. We do know that Spanish colonization of Cuba was especially genocidal in relation to indigenous people. Nearly all indigenous people were wiped out during the shock of the colonial encounter. The eradication of indigenous people is the condition of possibility for Cuba's foundation. Bruguera describes the foundation of Cuban national consciousness as being formed by guilt over colonial brutality and mass killing. Guilt thus organizes and forms this particular origin narrative of Cuban consciousness. Bruguera's foregrounding of this tale calls on Greater Cuba to understand its formation in this scene of racialized violence. Stressing the tragic shock effects of the colonial encounter pulls Cubans away from the problematic and short-sighted understanding of the 1959 revolution as the crowning or central moment in Greater Cuba's history. Bruguera's work offers an expanded timeline of cubanía. Such an expanded historical mapping (which is also an affective cartography) displaces the 1959 revolution's central and organizing position, offering a more productive mapping of Greater Cuba.

The performance titled *El peso de la culpa* was performed in various sites and modified for each performance. The first version of the performance was staged at the Sixth Havana Biennial (1995). While Bruguera was not officially allowed to perform during this Biennial, she nonetheless staged an alternate performance inside her house in Havana. In this version of the performance, Bruguera awaits her audience inside her house. Behind her is a large and expansive Cuban flag that the artist has made out of human hair. She wears the headless carcass of a lamb like a vest of armor atop a white outfit. She is barefoot. There is a pot of Cuban earth in front of her, along with a deep plate of water and salt. She bows in front of the containers in a slow, mechanical fashion and carefully mixes the dirt and the salt water in her hand. She proceeds to eat the dirt slowly. Bruguera continues to eat dirt for about an hour. Eating dirt slowly in a ritualistic fashion is a performance of empathy where she identifies with the lost indigenous Cuban. The actual consumption of earth is an act of penance that connects the artist with the actual island itself. The salt water signifies tears of regret and loss. She consumes this charged symbol, too. In this performance the lamb is less a symbol of Christian cosmology and more nearly signifies syncretic African belief systems like Santería where the goat or lamb is a ritualistic creature of sacrifice. "For

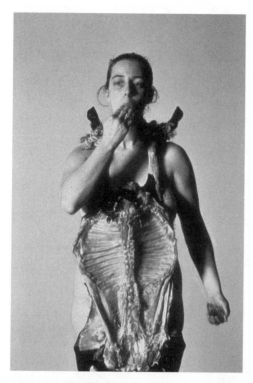

1 and 2. Tania Bruguera,
The Burden of Guilt,
1997–1999. Photos courtesy
of Tania Bruguera.

me," she states, "the relation that exists with the Afro-Cuban religion is that the lamb is charged with energy rather than just symbolism. But I also play with the socially saturated sense in which the lamb becomes a Eurocentric, and hence 'universal,' symbol of submission. In other words, it's less local in its intent than it might seem. A sheep or lamb as everybody everywhere knows, lies down, just like the Cuban indigenous and like Cubans in the island" (Letter). The flag that hangs behind her is made out of the nation's actual body, or at least a part of that national body. Bruguera's work literalizes the metaphors of national identity and nationality. The function of this literalization reveals the material and corporeal weight of metaphors. As the case of Elian makes clear, the symbolic is routinely deployed within the rhetoric of Greater Cuba. Elian became a symbol for both the Cuban government and Miami-based Cubans. The boy's welfare and actual physical well-being were overwhelmed by the abstraction of becoming a national symbol. Bruguera's insistence on corporeal literalization makes us cognizant of the actual stakes of making people and bodies mere symbols. The stakes, as the performance's title suggests, are weighty.

If we consider the attachment of symbols of guilt to the body and the actual consumption of these symbols—native soil and salty tears—through the lens of psychoanalytic theory, we can determine a significant reversal that contributes to an understanding of the interventionist nature of Bruguera's performance. When considering the question of guilt in a reading of classical Hollywood cinema, Slavoj Žižek explains:

> In psychoanalytic theory, one talks a lot about the transference or projection of guilt onto the Other (the Jew, for example); perhaps, we should rather reverse the relationship and conceive the very act of assuming guilt as an escape from the real traumatism—we don't only escape from guilt as we escape into guilt, take refuge in it. (38)

Cubans across the nationalist divides of the island and exile project guilt on each other and constitute each other as what Žižek would call the big Other. Certainly Castro is continually constructed as the big Other of Miami-based right-wing Cuban American rhetoric. Similarly the *gusano* (derogatory term used for Cubans who left Cuba after the 1959 revolution; literally "worm") is construed as the revolution's Other. Bruguera's work dramatically renders the challenge and political imperative to resist the urge to project guilt out on the Other and instead understand its incorporation into the Greater Cuba's disparate body. Elsewhere I have claimed that Cuban Americans live in memory. While I do not recant that particular formulation, I would layer another analysis. Greater Cuba, whose spa-

tial geography is an affective one, is also fractured by crisscrossing projections of guilt. But guilt is in fact the very affective terrain of the Cuban and not something to simply be deployed against the phantasmatic big Other. Bruguera's performance is a form of materialist critique that asks us to feel the weight of guilt and understand it as something incorporated into the Cuban body and the nation's body. Indeed, I would amend my previous statement by suggesting that Cubans also live in guilt.

In another performance, *The Burden of Guilt II*, part of the same series of work, this one performed in Santa Fe, New Mexico, and Antwerp, Bruguera kneels nude on the floor before a dish containing lamb's fat. She slowly and methodically wrings the animal fat through her hands. At first it appears as though she is washing her hands with the substance and then it begins to look as though she is actually rubbing the strong smelling substance into her skin, giving one the sense that she wants to incorporate the substance into her physical being. She next kneels behind a lamb's head. She is positioned behind the neck of the animal as its eyes look out. She bows in the direction of the animal head and, as her head recedes into her body, the animal's head appears to look out into the audience. The sacrificial beast's head is now her own and she is becoming this creature, or at least suturing the symbol onto her own body. In this instance we hear Žižek's suggestion that we not project guilt out but instead understand the need for the interjection of guilt. To see the way in which guilt is always already inside us, and furthermore, a Kantian condition of possibility for the current situation of cubanía.

Psychoanalysis is useful as a heuristic tool. It narrates stories about subject formation that we can potentially harness to discuss group formations. Such a tactic is not always effective or even compelling. There is nonetheless a time and a place for such inquiry. Take for example Jean LaPlanche and J. B. Pontalis's useful description of the psychoanalytic project known as projection:

> In the properly psycho-analytic sense: (it is an) operation whereby qualities, feelings, wishes or even objects, which the subject refuses to recognise or rejects in himself, are expelled from the self and located in another person or thing. Projection so understood is a defence of very primitive origin which may be seen at work especially in paranoia, but also in normal modes of thought such as superstition. (349)

This definition is useful to understand how the individualistic psychic process is relevant to larger formations within the social. The above explication, for instance, seems an especially apt definition to bring to bear on issues of ethnicity of affect. Affect is not only located in a particular

sense of self—but it is often projected onto the world. Affect, like shame and its offspring, guilt, are often projected onto a world, often contributing to a large social imbalance that can be described as a mass paranoia. Eve Sedgwick has talked about a particular imbalance in many of our critical practices, one in which paranoid readings have taken precedence over other interpretive strategies. Sedgwick instead calls for reparative readings ("Paranoid Readings and Reparative Readings"). A reparative reading is a mode of analysis that is not simply concerned with unveiling conspiracies and the secret (and seemingly always nefarious) mechanisms of power. Reparative readings are calibrated to call attention to the ways in which individuals and groups fashion possibility from conditions of (im)possibility. Reparative readings are about building and potentiality. People of color and other minoritarian citizen-subjects must continue to call on paranoid readings—some modes of paranoia are well-founded while others are simply rote and by now stale critical reflexes. Sedgwick is not calling for a simple reversal of critical methodologies; she is instead making a case for a diversification of critical approaches. Such a diversification seems equally true for the emergent body of knowledge that we can tentatively call Greater Cuban studies. Bruguera's performance signals a potentiality for a new formation, another understanding and sense of cubanía that is not organized by routine and predictable antagonisms. Bruguera's work signals another way of working with and through guilt that is not simply a cleansing of that affect or the traditional paranoid projection of such an affect.

Holding Guilt: Bruguera with Albita

Ricardo Ortiz, one of Greater Cuba's most dynamic critics, has written about guilt in relation to the music of Albita Rodriguez, famed Miami-based recording artist and cabaret performer. Ortiz explains that Cubans are fueled by particular addictions—*café* and *culpa* (guilt). He writes, "One's Cubanness should become the marker of one's guilt, the incontrovertible sign of one's culpability, results precisely from the necessity of bearing that mark, of confessing to one's Cubanity outside Cuba" (69). This formulation is produced in relation to an astute textual analysis of Rodriguez's lyrics, especially the third track on her album, *Qué culpa tengo yo*. I have often heard that sentimental anthem in a room full of Cubans, noticing how it stirs and unites groups of listeners. There is a certain force behind lines like "Qué culpa tengo yo que mi sangre suba? / Qué culpa tengo yo de haber nacido en Cuba? [What fault is it of mine that my blood rises? / What fault of mine to be born in Cuba?]." This invocation of Cubanness and guilt, in my experience, hits a note and ac-

cesses a structure of feeling. While Albita is older than Bruguera, she, like the performance artist, came of age in communist Cuba, and now both of these performers, newly internationalized and performing within the sphere of Greater Cuba, testify to the guilt that permeates cubanía. But any comparison between the way in which both artists negotiate cubanía and guilt is limited. In fact the two negotiate the affect of guilt quite differently. Ortiz explains how the song soars beyond self-torturing guilt. His expert reading of the song is worth citing: "Instead the tone of the song is pure defiance: to be Cuban is in part to love freedom, to bear adversity with optimism. It is also to bear in oneself a kind of blood that pulses and rises, that both captures one and sustains one at a level of passionate corporal intensity equal to the demands and challenges of having been born Cuban in this historical moment" (72). This song of defiance is extremely powerful and effective. The song's affective stance does indeed surpass simple self-inflicted and tortured guilt. Ortiz adroitly connects this defiance around cubanía to Albita's lesbian defiance. He reads the culpa of cubanía alongside the culpa of homosexuality. While I agree and am persuaded by Ortiz's argument, I am not certain that having one's blood rise under such particular terms helps cubanía surpass that impasse around guilt that I have described. While Albita's lesbian defiance seems especially necessary on either side of Greater Cuba, where queer possibility and visibility are often met with phobic antagonism, this defiance to the guilt of cubanía seems to not really function as a break with divisive Cuban nationalisms. I would suggest that Albita, who never fully comes out in the press or media, uses cubanía as an analogy for queerness. The genius of the song has much to do with the way in which it speaks queerness differently and potentially undermines homophobic ideologies. She addresses these Cubans by speaking to them of a shaming they think they know. But, like many analogies, this rhetorical move does present some dangers. What sort of defiant and perhaps unthinking nationalism does Albita reproduce through this analogical move? Perhaps when it comes to the culpa of cubanía we should do more than simply deflect it with the force-field of a defiant posture. Perhaps it is important to actually hold onto the guilt that shadows cubanía and not simply cast it out through a process of projection. What would it be to hold guilt? What knowledge of historical positionality avails itself to us when we attempt to know, interrogate, and actually hold the burden of guilt?

Toward A Politics of Introjection

Bruguera's performance practice entails just such a holding. It is a critical retention of shame instead of a more familiar and routine Cuban negotia-

tion of shame: rejection, outward projection, or cleansing. To hold shame looks very different than the defiance that Albita performs. A survey of Bruguera's performances that predate *The Burden of Guilt* is instructive when trying to understand the critical moves she makes. *Cabeza abajo* (Head Down), for instance, also displays a posture that is different than that of direct or simplistic rejections of shame. This performance, staged in December 1996 in the Espacio Aglutinador gallery, began with an invitation to local artists and critics. The participants were asked to lie down on the floor. Bruguera was dressed in a white robe of a false wool fabric and covered with a white Kabuki-like makeup. She carried a red flag on her back, like those used in Japanese feudal wars. She walked on top of her prostrate participants. Potato sack trenches separated the audience from the participants, further instilling a sense of battle, warfare, and conquest. The artist proceeded to mark her participants with red flags. Revolutionary anthems from the sixties and seventies played. In an interview, Bruguera describes the performance as being about the relationship between artists and power and as a general statement about the art world (29). This performance was staged at a moment in which the state was particularly interested in censoring any art that could be construed as antirevolutionary. Bruguera's journal/newspaper, *Memorias de la postguerra*, at this point was censored by the state. Each body becomes a colonized territory. But certainly other meanings can be deciphered if we attempt to understand the affective dimension of the performance. The art world denizens are conquered by an imperial specter. In the highly metaphoric field of Greater Cuba, this scene can potentially be read as depicting the colonizing force of the United States, Miami, or Castro, depending on one's particular ideological position. But that aspect is left open. The work does not target any one culprit; it is instead interested in unpacking a particular affective scene. Her work is a study of the ways in which Cubans are confronted by colonizing exterior force. Like the Indians invoked in *El peso de la culpa*, the participants in *Cabeza abajo* are not taking on a posture of defiance but instead performing a passive resistance. This performance can be seen as a rehearsal of sorts for the affective stance that Bruguera embodies in *El peso de la culpa*. In *Cabeza abajo*, the whitened artist plays the embodiment of power from above while her participants embody the passive masses. It would be a mistake to see this position as simple passivity. *Cabeza abajo* is a descriptive performance, rendering the ways in which a people survive their historical situation. The performance is not prescriptive, it does not suggest that the performed behavior is desirable; instead, it illustrates how Cubans withstand particular conditions of possibility assuming certain poses.

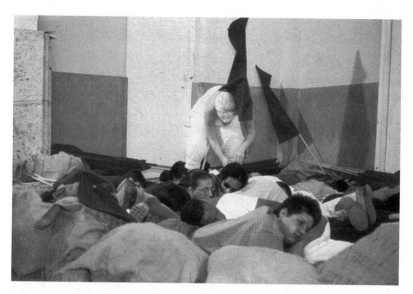

3. In *Cabeza abajo*, Tania Bruguera asked participants to lie down on the floor. Photo courtesy of Tania Bruguera.

Another performance, *Destierro* (Displacement) depicts a further representation of the Cuban condition, this time in the form of an object associated with the Congo religious roots of Cuban Santería, the *nkisi nkonde*. The mythical figure is a mystical object in which believers invest their hopes and desires. The object has a powerful performative nature. The objects are performative insofar as they can perform, for example, such as a speech act according to J. L. Austin. Two dolls tied together for example can function in the same way as the linguistic speech act, "I now pronounce you man and wife," insofar as it contractually joins two entities. Not all nkisi nkonde objects are anthropomorphic, at times they may simply appear to be a pouch. The contents of the pouch may spell out a subject's name or some other aspect of her or his identity. The object in Bruguera's case does represent a human form. The object's performative nature has been transformed in the diaspora and it is not uncommon to hear stories of people investing certain desires and wishes in the object, for example someone who may wish to win the lottery could very well sew money into the doll's lining. The object thus becomes a receptacle and symbol for projected desires. When Bruguera wears her nkisi nkonde outfit, a massive uniform made of wooden and metal nails and a mud-covered lycra material, she represents an aspect of Cuban syncretic culture. Each nail represents a desire hammered into the object's form. In this massive costume Bruguera tours public spaces as part of the

Destierro performance. She confronts Cubans and tourists as she tours old Havana's most historic sections. In the dilapidated beauty of rustic town squares, the figure of Cuba's syncretic nature confronts its populace. Those inside the object's epistemology recognize it and quickly form an identification to it that is calibrated by their own relationship to the belief network, while for others outside that loop it appears to be some ancient musty relic come to life, perhaps a Caribbean mummy emerged from a hidden tropical crypt. When confronting the nkisi nkonde those in the know can perhaps understand each *clavo* or nail as a desire that has been literally introjected into the object. While introjected into the object it is still visible, a desire that is literally worn on the sleeve. Perhaps the desire that is made visible on the figure is one of flight, or maybe a wish for the island, a desire to stay. It is significant that this performance was first staged on Castro's birthday, a holiday that calls the nation to embrace its leader and his status as a literal representative of the nation. For those who believe in the revolution's infallible glory, Castro almost functions as a nkisi nkonde, a symbolic figure in which the populace invests its hopes and desires. For those who denounce the leader, he is the fetish, the juju, the ultimate Other, also potentially represented in the performance. Again, Bruguera's performance explicates the ways in which the Cuban people, arguably inside and out of the island, participate in an economy of projection, investing desire and guilt in outside objects rather than understanding the potential transformation available through a politics of introjection.

What would the contours of this politics of introjection be? What possibilities could it suggest? What potentialities avail themselves? To this end it is important to pick up the psychoanalytic thread that this paper produces. It is equally important to be explicit about this thread, its nature, and exactly what it is not. The psychoanalytic inquiry I am attempting to compose here is decidedly non-Lacanian, or rather it represents a turn away from a particular North American reception and utilization of Jaques Lacan's project. In Lacan's paradigm, there is overarching and indeed terrible otherness to the other. Lacan develops the thematic of projective identification, a motif first located in British psychoanalyst Melanie Klein's work, and uses it to describe the rage that develops when the infant realizes she can not break through the mirror and that instead her own image is merely refracted upon her. In Klein's theory of introjection, the ego consumes the lost object or ideal through a process of introjection. Once introjected the ego cannibalizes the lost object and it is lost anew. The story of introjection that Klein tells is called into question by French psychoanalytic theorists Nicolas Abraham and Maria Torok,

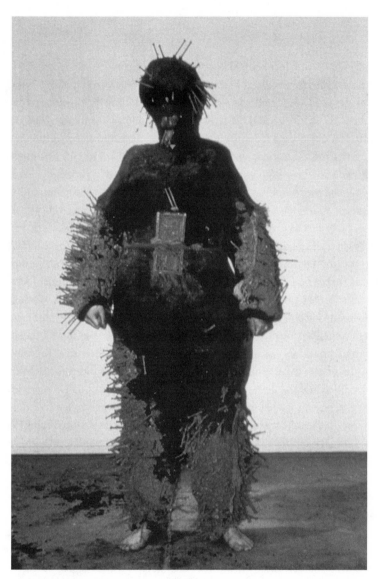

4. In *Destierro*, Bruguera wears a nkisi nkonde outfit, a massive uniform made of wooden and metal nails and a mud-covered lycra material. Photo courtesy of Tania Bruguera.

who take issue with Klein's assignment of introjection as a primary process. They take issue, for example, with the fashion in which Klein positions fantasy: "We are astonished Melanie Klein sees fantasy—a product of the ego—as predating the process, which is the product of the entire psyche" (125).

Abraham and Torok are also attracted to a notion of introjection. They note that introjection was first invented by Freud's collaborator, Sandor Ferenczi, who described it as a process of broadening the ego. The psychoanalytic duo explain that the process of introjection first manifests itself when the child discovers the emptiness of its mouth in relation to the presence and then absence of the breast. The oral void, once discovered, is filled with language and words. Eventually words replace cries and the pleasure and satisfaction of the breast give way to the satisfaction of possessing language. They explain that the transition from a mouth filled with the breast to a mouth filled with words occurs by virtue of the intervening experiences of the empty mouth. Language would not exist without the satisfaction of the breast. Abraham and Torok then take a rather poetic turn when they discuss language itself as the communion of empty mouths. Thus a politics of introjection would be something like the communion described above. If we introjected feelings like guilt, things that we too easily project, they will not reductively fill a void but the process will make us cognizant of our shared affective nature, the empty mouths of cubanía. When we acknowledge that our mouths are empty, that neither ideal—here or there—can permanently replace our loss, we can only begin the absolutely necessary process of communion. To do so it seems important to visit other spots in the firmament of psychology and psychoanalysis that are not the reified dialectics of negation that dominate Lacanian paradigms.[3] Abraham and Torok tell us a story of a collective negation that we can, following the work of LaPlanche, describe as allogenic as opposed to what he has described as auto-centric(ally) eschewed theories of relationality for circumscribed theories of the self. According to LaPlanche, the latter have imposed their hegemony on all of meta-psychology, both clinical and theoretical. He calls for the revision of our approaches to the question of the psychic when he proposes giving a full place in metapsychology to a process that is irreducible to an auto-centricism: those whose subject is quite simply the other (136). This allogenic assertion certainly speaks to the communion of empty mouths that Abraham and Torok describe. It is also relevant in a recent turn to the psychic in critical race theory that Hortense Spillers has called for ("All the Things You Could Be"). Spillers justifies her own escalating interest in psychological approaches to the social by describing them as potential

intramural protocols. Intramural insofar as they may shed light on our relationship to each other within communities of color. Again, not some little other out of Lacan, but instead each other. Bruguera's performances are also intramural exercises, allogenic acts that let us see beyond the self resisting to project. I have explicated the ways in which Bruguera's performance eschews auto-centric cubanía for a Greater Cubanía. Which returns me to the scene at the bar, and my friends, sharing our shame and guilt about Elian, finding ourselves speechless (an infrequent phenomenon for Cubans in general) and perhaps finding ourselves in our speechlessness. Which is to say we were taking comfort in the communal nature of empty mouths, wishing and desiring a moment when Greater Cuba discovers its own communion of empty mouths.

Notes

1. This ambivalence is not a passive ambivalence. It is more nearly a passionate investment in Cuba that sees the promise of the revolution, its potential, and its various failures and shortcomings. The ambivalence of the Cuban American left is perhaps as passionate as the obsessive rejection continually performed by a Miami-based Cuban American right wing.

2. The phrase "memorias de la postguerra" was originally used by Bruguera as the title of a journal/newspaper/artwork that was initially censored by the Cuban cultural authorities. Later, it was used to describe the publication and a series of performances.

3. By psychology here I mean quite a bit more than the Lacanian paradigms that dominate psychological approaches to cultural critique in the United States and Britain. I am in fact more interested in the still underexplored work of psychologists like Melanie Klein and Donald Winnicott.

Works Cited

Abraham, Nicolas, and Maria Torok. *The Shell and the Kernel: Renewals of Psychoanalysis.* Chicago: University of Chicago Press, 1994.
Birringer, Johannes. "Art in America (The Dream)." *Performance Research* 3.1 (1998): 24–31.
Bruguera, Tania. "Tania Bruguera in Conversation with Octavio Zaya." *Cuba, Maps of Desire.* Kunsthalle Wien Catalog. Berlin, 1999.
———. Letter to the author. 1999.
Klein, Melanie. *The Selected Melanie Klein.* Ed. Juliet Mitchell. New York: Free Press, 1987.
Laplanche, Jean. *Essays on Otherness.* New York: Routledge, 1999.
Laplanche, Jean, and J. B. Pontalis. *The Language of Psycho-Analysis.* New York: Norton, 1974.
López, Ana. "Film and Video in Greater Cuba." *The Ethnic Eye: Latino Media Arts.*

Ed. Chon A. Noriega and Ana M. López. Minneapolis: University of Minnesota Press, 1994.

Ortiz, Ricardo. "Cafe, Culpa and Capital: Nostalgic Addictions of Cuban Exile." *Yale Journal of Criticism* 10.1 (1997): 63–84.

Pérez Firmat, Gustavo. *Life on the Hyphen: The Cuban-American Way*. Austin: University of Texas Press, 1994.

Sedgwick, Eve Kosofsky. "Paranoid Readings and Reparative Readings; or, You're So Paranoid, You Probably Think This Essay Is about You." *Novel Gazing: Queer Readings in Fiction*. Durham: Duke University Press, 1997.

Spillers, Hortense. "All the Things You Could Be by Now if Sigmund Freud's Wife Was Your Mother: Psychoanalysis and Race." *Critical Inquiry* 22.7 (1996): 710–34.

Tompkins, Silvan. *Shame and Its Sisters: A Silvan Tompkins Reader*. Durham: Duke University Press, 1995.

Žižek, Slavoj. *Enjoy Your Symptom!: Jaques Lacan in Hollywood and Out*. New York: Routledge, 1992.

Selected Bibliography

SABINA BERMAN

Published Plays

The Agony of Ecstacy. One (The Mustache). Trans. Adam Versenyi. *Women and Performance: A Journal of Feminist Theory*: 11.2 (2000): 217–26.

Bill. Teatro joven de México. Ed. Emilio Carballido. Mexico City: Editores Mexicanos Unidos, 1979.

Caracol y colibrí. 1st ed. Mexico City: Instituto Nacional de Antropología e Historia, 1996.

Entre Villa y una mujer desnuda. Mexico City: SOGEM, 1992.

Entre Villa y una mujer desnuda, Muerte súbita, El suplicio del placer. Mexico City: Grupo Editorial Gaceta, 1994.

La grieta. Tramoya antología: Teatro mexicano. Vol. 2. Mexico City: Tramoya, 1990. 7–40.

Moliere. Mexico City: Plaza Janés, 2000.

Muerte súbita. Mexico City: Editorial Katún, 1988.

Rompecabezas. Mexico City: Editorial Oasis, 1983.

Teatro de Sabina Berman. Mexico City: Editores Mexicanos Unidos, 1985. [Contains *Yankee, Herejía, Rompecabezas, Aguila o sol, El suplicio del placer*.]

The Theatre of Sabina Berman: The Agony of Ecstasy and Other Plays. Trans. Adam Versényi. Carbondale: Southern Illinois University Press, 2002.

Principal Performances

Aguila o sol. Grupo BOCANA, 1988.

Bill. Dir. Mercedes de la Cruz, Compañía Nacional de Teatro, 1988; dir. José Caballero, Teatro Granero, 1980. *Award*: INBA National Award for Theatre, 1979.

Eagle or Sun. Dir. Amie Brockway, The Open Eye New Stagings of New York, 1991.

El árbol de humo. 1986. *Award*: Celestino Goroztiza Award for Children's Theatre, 1986.

En el nombre de Dios (antes Herejia). Dir. Rosenda Monteros, Teatro Reforma del
IMSS, 1996.

Entre Villa y una mujer desnuda. Santiago, Chile, 1997; University of Kansas at
Lawrence; Teatro de la Luna, Washington, D.C.; dir. Margarita Galván, Bilin-
gual Foundation, Los Angeles, 1995; dir. Sabina Berman, Teatro Helénica, 1993.

Feliz año nuevo Doktor Freud. 2000.

Herejia [originally *Anatema*]. Dir. Abraham Oceransky, 1984; INBA, 1983. *Award*:
INBA National Award for Theatre, 1983.

Krisis. Dir. David Jones, University of New Mexico; dir. Sabina Berman, Teatro
Telón de Asfalto, 1996.

La grieta. Dir. Carlos Haro, Foro de la Conchita, 1997. *Award*: Rodolfo Usigli Award
for Best Playwright of the Year, 1998.

Los ladrones del tiempo. 1988. *Award*: Critics' Association Best Children's Play,
1993.

Maravillosa historia del chiquito pingüica. Dir. Sabina Berman, Mexico City,
1997; dir. Abraham Oceransky, SEP del Edo. de Veracruz, 1995; dir. Abraham
Oceransky, Teatro Independencia, 1983. *Award*: INBA National Award for Chil-
dren's Theatre, 1982.

Moliere. Dir. Antonio Serrano, Teatro Julio Castillo, IMBA Compañía Nacional,
1999; dir. Antonio Serrano, Teatro Julio Castillo, 1998. *Awards*: Rodolfo Usigli
Award for Best Playwright of the Year, 1999; The Society of Critics' Award for
Best Play of the Year, 1999; Banquels Award for Best Playwright, 1999.

Muerte súbita. Dir. Francisco Francia, Foro Shakespeare, 1998; dir. Héctor Men-
doza, University of New Mexico, 1988.

Rompecabezas. Dir. Carlos Haro, Casa Museo de León Trotsky, 1996; dir. Abraham
Oceransky, Universidad Veracruzana, 1983.

Film

Cortometrajes (Film Shorts). Mexico City: Ediciones El Milagro Instituto Mexi-
cano de Cinematografía, 1997.

El árbol de la música. Screenplay and direction by Sabina Berman and Isabelle
Tardan, 1996. *Awards*: Oscar nominee 1995; Short-Film Award, Cartegena
(Columbia) Film Festival, 1995; Film Award, Chicago's International Film Fes-
tival, 1995; MacArthur-Rockefeller Fellowship for production, 1994.

Entre Villa y una mujer desnuda. Screenplay and direction by Sabina Berman
and Isabelle Tardan, 1995. Distributor: Facets Video. *Awards*: Best Picture of
Cinemasfest Theatre Festival of Puerto Rico, 1996; Oscar nominee, Best For-
eign Film, 1996; Unanimous Press Award of the International Film Festival of
Cancún, 1995; Heraldo Award for Best Picture of the Year, 1995; Critics' As-
sociation Award for Best Picture of the Year and six awards for acting and
script, 1996.

Tía Alejandra. Dir. Arturo Ripstein, 1979. Distributor: Madera CineVideo. *Award*:
The Mexican Academy of Cinema Arts Ariel Award for Best Film Script, 1979.

Criticism about Her Work

Berman, Sabina. "Y alzaron los ojos de la tierra: Teatro campesino maya de
X'Ocen." *Latin American Theatre Review* 24.1 (1990): 77–80.

Bixler, Jacqueline Eyring. "The Postmodernization of History in the Theatre of Sabina Berman." *Latin American Theatre Review* 30.2 (1997): 45–60.

———. "Power Plays and the Mexican Crisis: The Recent Theatre of Sabina Berman." *Performance, pathos, política de los sexos: Teatro postcolonial de autoras latinoamericanas.* Ed. Heidrun Adler and Kati Rottger Kat. Frankfurt: Vervuert Iberoamericana, 1999. 83–99.

Burgess, Ronald D. *The New Dramatists of Mexico: 1967–1985.* Lexington: University Press of Kentucky, 1991. 90–91.

———. "Nuestra realidad múltiple en el drama múltiple de Sabina Berman." *Texto crítico* 2.2 (1996): 21–28.

———. "Sabina Berman's Act of Creative Failure: *Bill.*" *Gestos* 2.3 (1987): 103–13.

Costantino, Roselyn. "El discurso del poder en *El suplicio del placer* de Sabina Berman." *De la colonia a la postmodernidad: Teoría teatral y crítica sobre teatro latinoamericano.* Ed. Peter Roster and Mario Rojas. Buenos Aires: Galerna & IITCTL, 1992. 245–52.

———. "Resistant Creativity: Interpretative Strategies and Gender Representation in Contemporary Women's Writing in Mexico." *DAI* 53.3 (1992): 824A-25A.

———. "Sabina Berman." *Latin American Writers on Gay and Lesbian Themes. A Bio-Critical Sourcebook.* Ed. David Foster. Westport, Conn.: Greenwood Press, 1994. 59–63.

Cypess, Sandra Messinger. "Dramaturgia femenina y transposición histórica." *Alba de América: Revista literaria* 7.12–13 (1989): 283–304.

———. "Ethnic Identity in the Plays of Sabina Berman." *Tradition and Innovation: Reflections on Latin American Jewish Writing.* Ed. Robert E. DiAntonio and Nora Glickman. Albany: State University of New York Press, 1993. 165–77.

Cypess, Sandra Messinger, David R. Kohut, and Rachelle Moore. *Women Authors of Modern Hispanic South America: A Bibliography of Literature, Criticism, and Interpretation.* Metuchen, NJ: Scarecrow, 1989.

Day, Stuart A. "Berman's Pancho Villa Versus Neoliberal Desire." *Latin American Theatre Review* 33.1 (1999): 5–23.

France, Anna Kay, and P. J. Corso, eds. *International Women Playwrights: Voices of Identity and Transformation.* Metuchen, N.J.: Scarecrow, 1993. 238–47.

Gil, Lydia M. "Entre fronteras: Entrevista con Sabina Berman." *Dactylus* 13 (1994): 29–36.

———. "Sabina Berman: Writing the Border." *Occasional Papers* 5 (1994): 39–55.

Gladhart, Amalia. "Nothing's Happening: Performance as Coercion in Contemporary Latin American Theatre." *Gestos* 9.18 (1994): 93–112.

———. "Playing Gender." *Latin American Literary Review* 24.47 (1996): 59–89.

Hind, Emily. "Entrevista con Sabina Berman." *Latin American Theatre Review* 33.2 (2000): 133–39.

———. "Historical Arguments: Carlos Salinas and Mexican Women Writers." *Discourse: Journal for Theoretical Studies in Media and Culture* 23.2 (2001): 82–101.

Magnarelli, Sharon. "Masculine Acts/Anxious Encounters: Sabina Berman's *Entre Villa y una mujer desnuda.*" *Intertexts* 1.1 (1997): 40–50.

———. "Tea for Two: Performing History and Desire in Sabina Berman's *Entre*

Villa y una mujer desnuda." *Latin American Theatre Review* 30.1 (1996): 55–74.

Martínez de Olcoz, Nieves. "Decisiones de la máscara neutra: Dramaturgia femenina y fin de siglo en América Latina." *Latin American Theatre Review* 31.2 (1998): 3, 5–16.

Medina, Manuel F. "La batalla de los sexos: Estrategias de desplazamiento en *Entre Villa y una mujer desnuda* de Sabina Berman." *Revista fuentes humanísticas* 4.8 (1994): 107–11.

Meléndez, Priscilla. "Co(s)mic Conquest in Sabina Berman's *Aguila o sol*." *Bucknell Review* 40.2 (1996): 19–36.

Nigro, Kirsten. "Inventions and Transgressions: A Fractured Narrative on Feminist Theatre in Mexico." *Negotiating Performance: Gender, Sexuality, and Theatricality in Latin/o America*. Ed. Diana Taylor and Juan Villegas. Durham: Duke University Press, 1994. 137–58.

Vargas, Margarita. "Entre Villa y una mujer desnuda de Sabina Berman." *Revista de literatura mexicana contemporánea* 2.4 (1996): 76–81.

TANIA BRUGUERA

Criticism about Her Work

Bruguera, Tania. "Tania Bruguera in Conversation with Octavio Zaya." *Cuba, Maps of Desire*. Kunsthalle Wien Catalog. Berlin, 1999.

Muñoz, José. "Performing Greater Cuba: Tania Bruguera's Burden of Guilt." *Women and Performance: A Journal of Feminist Performance* 11.2 (2000): 251–65.

PETRONA DE LA CRUZ CRUZ AND ISABEL JUÁREZ ESPINOSA — FOMMA

Petrona de la Cruz Cruz Creative Works

Desprecio paternal. Unpublished ms., n.d.
Infierno y esperanza. Unpublished ms., n.d.
La tragedia de Juanita. Unpublished ms., n.d.
Madre olvidada. Unpublished ms., n.d.
Una mujer desesperada. Unpublished ms., 1992.

Isabel Juárez Espinosa Creative Works

Corre, corre que te alcanzo. Unpublished ms., n.d.
Cuentos y teatro tzeltales / A 'yejetik sok Ta 'imal. Mexico City: Editorial Diana, 1994.
La familia, drama en dos actos. Unpublished ms., n.d.
La familia rasca rasca. Unpublished ms., n.d.

Works Created Collectively by FOMMA without Written Scripts

El sueño del mundo al revés, 1997.
Ideas para el cambio, 1997.
Víctimas del engaño, 1998.

Criticism about Their Work

De la Cruz Cruz, Petrona. "La educación, el teatro y los problemas de las mujeres en los Altos de Chiapas." Lecture at Texas Christian University. April 1993.

Erdman, Harley. "Gendering Chiapas: Petrona de la Cruz Cruz and Isabel J. F. Juárez of la FOMMA (Fortaleza de la Mujer Maya/Strength of the Mayan Woman)." *The Color of Theatre: Race, Ethnicity and Contemporary Performance*. Ed. Roberta Uno with Lucy Mae San Pablo Burns. London: Athlone Press, 2002. 159–70.

Frischmann, Donald H. "Active Ethnicity: Nativism, Otherness and Indian Theater in Mexico." *Gestos* 6.11 (1991): 113–26.

———. "Contemporary Mayan Theatre and Ethnic Conflict, The Recovery and (Re)Interpretation of History." *Imperialism and Theatre: Essays on World Theatre, Drama and Performance 1795–1995*. Ed. Ellen Gainor. London: Routledge, 1995. 71–84.

———. "New Mayan Theater in Chiapas: Anthropology, Literacy, and Social Drama." *Negotiating Performance: Gender, Sexuality, and Theatricality in Latin/o America*. Ed. Diana Taylor and Juan Villegas. Durham: Duke University Press, 1994. 213–38.

Marrero, Maria Teresa. "La construcción visual de la Nueva Revolución Mexicana: El Ejército Zapatista de Liberación Nacional." *Gestos* 13.25 (1998): 75–104.

Myers, Robert. "Mayan Indian Women Find Their Place Is on the Stage." *New York Times* 28 September 1997.

Steele, Cynthia. "'A Woman Fell into the River': Negotiating Female Subjects in Contemporary Mayan Theater." *Negotiating Performance: Gender, Sexuality, and Theatricality in Latin/o America*. Ed. Diana Taylor and Juan Villegas. Durham: Duke University Press, 1994. 239–56.

Underiner, Tamara. "Incidents of Theater in Chiapas, Tabasco, and Yucatán: Cultural Enactments in Mayan Mexico." *Theater Journal* 50 (1998): 349–69.

DIAMELA ELTIT

Creative Works

"Cuerpos nómadas." *Feminaria literaria* 6.11 (1996): 54–60.

"Cuerpos nómadas." *Hispamérica: Revista de literatura* 25.75 (1996): 3–16.

El cuarto mundo. Santiago: Planeta Chilena, 1996.

El infarto del alma. With Paz Errázuriz. Santiago: Francisco Zegers, 1994.

El padre mío. Santiago: Francisco Zegers, 1989.

E. Luminata. Trans. Ronald J. Christ with Gene Bell-Villada, Helen Lane, and Catalina Parra. Sante Fe: Lumen, 1997.

Emergencias: Escritos sobre literatura, arte y política. With Leonidas Morales. Santiago: Planeta/Ariel, 2000.

"Ficción y lo otro: Apuntes en torno a la diferencia." *Torre: Revista de la Universidad de Puerto Rico* 4.12 (1999): 353–58.

The Fourth World. Trans. Dick Gerdes. Lincoln: University of Nebraska Press, 1995.

Los trabajadores de la muerte. Santiago: Editorial Planeta Chilena, 1998.

Los vigilantes. Providencia, Chile: Editorial Sudamericana, 1994.

Lumpérica. Santiago: Las Ediciones de Ornitorrinco, 1983; 3rd ed. Santiago: Seix Barral, 1998.

Por la patria. Santiago: Las Ediciones de Ornitorrinco, 1986; 2nd ed. Santiago: Editorial Cuarto Propio, 1995.

"Quisiera." *Taller de letras* 24 (1996): 205–8.

"Resisting." With Alfred MacAdam. *Review: Latin American Literature and Arts* 49 (1994): 19.

Sacred Cow. Trans. Dick Gerdes. London: Serpent's Tail, 1995.

Vaca sagrada. Buenos Aires: Planeta, 1991.

Criticism about Her Work

Austin, Kelly. "About Face: Translating Diamela Eltit." *Women's Studies: An Interdisciplinary Journal* 29.1 (2000): 71–91.

Avelar, Idelber. "An Anatomy of Marginality: Figures of the Eternal Return and the Apocalypse in Chilean Post-Dictatorial Fiction." *Studies in Twentieth Century Literature* 23.2 (1999): 211–37.

Burgos, Elizabeth. "Palabra extraviada y extraviante: Damiela Eltit." *Quimera: Revista de literatura* 123 (1994): 20–21.

Burgos, Fernando. "La cuarta escritura de Diamela Eltit." *Revista de estudios hispánicos* 22 (1995): 135–45.

Burgos, Fernando, and M. J. Fenwick. "*L. Iluminada* en sus ficciones: Conversación con Diamela Eltit." *Inti: Revista de literatura hispánica* 40–41 (1994): 335–66.

Canovas, Rodrigo. "Apuntes sobre la novela *Por la patria* (1986) de Diamela Eltit." *Acta Literaria* 15 (1990): 147–60.

Christ, Ronald. "Extravag(R)Ant and Un/Erring Spirit." *Taller de letras* 24 (1996): 7–29.

Castro Klarén, Sara. "The Lit Body: Or, the Politics of Eros in *Lumpérica*." *Indiana Journal of Hispanic Literatures* 1.2 (1993): 41–52.

Cróquer Pedrón, Eleonora. *El gesto de Antígona o la escritura como responsabilidad (Clarice Lispector, Diamela Eltit y Carmen Boullosa)*. Santiago: Editorial Cuarto Propio, 2000.

Eltit, Diamela, and Alfred MacAdam. "Resisting." *Review: Latin American Literature and Arts* 49 (1994): 19.

Falabella, Soledad, et al. "Entrevista con Diamela Eltit." *Lucero: A Journal of Iberian and Latin American Studies* 7 (1996): 3–12.

Gálvez Carlisle, Gloria. "Los vigilantes: El mundo postmoderno y la rearticulación del 'Panopticon' en la reciente novela de Diamela Eltit." *Acta literaria* 23 (1998): 131–37.

Garabano, Sandra. "*Vaca sagrada* de Diamela Eltit: Del cuerpo femenino al cuerpo de la historia." *Hispamérica: Revista de literatura* 25.73 (1996): 121–27.

García Corales, Guillermo. "Disenchantment and Carnivalization: A Bakhtinian Reading of the *Fourth World*." *Intertexts* 1.1 (1997): 104–12.

———. "Entrevista con Diamela Eltit." *Chasqui: Revista de literatura* 27.2 (1998): 85–88.

Gómez, Jaime P. "La representación de la dictadura en la narrativa de Marta Traba, Isabel Allende, Diamela Eltit y Luisa Valenzuela." *Confluencia: Revista hispánica de cultura y literatura* 12.2 (1997): 89–99.

Kadir, Djelal. *The Other Writing: Postcolonial Essays in Latin America's Writing Culture.* West Lafayette: Purdue University Press, 1993.

Lagos Pope, María Inés. *Creación y resistencia: La narrativa de Diamela Eltit, 1983–1998.* Santiago: Editorial Cuarto Propio, 2000.

Lértora, Juan Carlos. *Una poética de literatura menor: La narrativa de Diamela Eltit.* Santiago: Para Textos/Editorial Cuarto Propio, 1993.

Loach, Barbara Lee. *Power and Women's Writing in Chile.* Madrid: Editorial Pliegos, 1994.

Luttecke, Janet A. "*El cuarto mundo* de Diamela Eltit." *Revista iberoamericana* 60.9 (1994): 1081–88.

Martínez, Luz Angela. "La dimensión espacial en *Vaca Sagrada* de Diamela Eltit: La urbe narrativa." *Revista chilena de literatura* 49 (1996): 65–82.

Morales T, Leonidas. "Los trabajadores de la muerte y la narrativa de Diamela Eltit." *Atenea: Revista de ciencia, arte y literatura de la Universidad de Concepción* 478 (1998): 243–50.

———. "Narración y referentes en Diamela Eltit." *Revista chilena de literatura* 51 (1997): 121–29.

Neustadt, Robert. *(Con)Fusing Signs and Postmodern Positions: Spanish American Performance, Experimental Writing, and the Critique of Political Confusion.* New York: Garland Publishing, 1999.

———. "Diamela Eltit: Clearing Space for Critical Performance." *Women and Performance: A Journal of Feminist Theory* 7–8 (1995): 218–39.

———. "Incisive Incisions: (Re)Articulating the Discursive Body in Diamela Eltit's *Lumpérica.*" *Cincinnati Romance Review* 14 (1995): 151–56.

———. "Interrogando los signos: Conversando con Diamela Eltit." *Inti: Revista de literatura hispánica* 46–47 (1997–1998): 293–305.

Niebylski, Dianna C. "Against Mimesis: *Lumpérica* Revisited." *Revista canadiense de estudios hispánicos* 25.2 (2001): 241–57.

Norat, Gisela. *Marginalities: Diamela Eltit and the Subversion of Mainstream Literature in Chile.* Newark, Del.: University of Delaware Press, 2002.

Olea, Raquel. "El cuerpo-mujer: Un recorte de lectura en la narrativa de Diamela Eltit." *Revista chilena de literatura* 42 (1993): 165–71.

Oquendo, Carmen L. "Yo nunca querría ser una vaca sagrada: entrevista con Diamela Eltit." *Nómada: Creación, teoría, crítica* 2 (1995): 113–17.

Ortega, Julio. "Diamela Eltit Interview." Trans. Marina Harss. *Bomb* 74 (2001): 38–41.

———. "Resistencia y sujeto femenino: Entrevista con Diamela Eltit." *La Torre: Revista de la Universidad de Puerto Rico* 4.14 (1990): 229–41.

Pino Ojeda, Walescka. "Diamela Eltit: El letrado y el lumpen." *Journal of Iberian and Latin American Studies* 5.2 (1999): 23–43.

Pratt, Mary Louise. "Overwriting Pinochet: Undoing the Culture of Fear in Chile." *Modern Language Quarterly: A Journal of Literary History* 57.2 (1996): 151–63.

Richard, Nelly. *Margins and Institutions: Art in Chile since 1973.* Melbourne: Art & Text, 1986.

Riquelme, Sonia. "Narrativa chilena joven: Diamela Eltit y su novela *Lumpérica*." *Foro Literario: Revista de literatura* 11.11 (1989): 46–50.

Santos, Susana. "Diamela Eltit: Una ruptura ejemplar." *Feminaria literaria* 2.3 (1992): 7–9.

Schultz Cruz, Bernard. "*Vaca sagrada*: El cuerpo a borbotones de escritura." *Hispanófila* 123 (1998): 67–72.

Skar, Stacey D. "La narrativa política y la subversión paradójica en *Por la patria* de Diamela Eltit." *Confluencia: Revista hispánica de cultura y literatura* 11.1 (1995): 115–25.

Tafra Sturiza, Sylvia. *Diamela Eltit: El rito de pasaje como estrategia textual*. Santiago: DIBAM RIL Editores Centro de Investigaciones Diego Barros Arana, 1998.

———. "Re-Making the Margins: From Subalterity to Subjectivity in Diamela Eltit's *Por La Patria*." *Monographic Review–Revista Monográfica* 8 (1992): 205–22.

Tierney-Tello, Mary Beth. "Testimony, Ethics and the Aesthetic in Diamela Eltit." *PMLA* 114.1 (1999): 78–79.

Tompkins, Cynthia M. "Aporia: *La vaca sagrada* de Diamela Eltit." *Explicación de textos literarios* 27.1 (1998–1999): 50–61.

Uribe, Olga T. "Breves anotaciones sobre las estrategias narrativas en *Lúmperica, Por la patria* y *El cuarto mundo* de Diamela Eltit." *Hispanic Journal* 16.1 (1995): 21–37.

GRISELDA GAMBARO

Published Plays

Antígona furiosa. Gestos 5 (1988): n.p.

Bad Blood. Trans. Marguerite Feitlowitz. Woodstock: Dramatic Publishing Company, 1994.

Conversaciones con chicos. Buenos Aires: Timerman Editores, 1976; 2nd ed. Buenos Aires: Ediciones Siglo XX, 1983.

Decir sí. Antología de teatro hispanoamericano del siglo XX. Vol. 5. Ottawa: Girol Books, 1983.

Después del día de fiesta. Buenos Aires: Seix Barral, 1994.

Dios no nos quiere contentos. Barcelona: Lumen, 1979.

El desatino. Buenos Aires: Editorial del Instituto di Tella, 1965.

El despojamiento. Tramoya 21:22 (1981): n.p.

El nombre. Hispanamérica 38 (1984): n.p.

Escritos inocentes. Barcelona: Grupo Editorial Norma, 1999.

Ganarse la muerte. Buenos Aires: Ediciones de la Flor, 1976.

Information for Foreigners. Trans. Marguerite Feitlowitz. *W. B. Worthen Modern Drama: Plays/Criticism/Theory*. New York: Harcourt Brace, 2000.

Information for Foreigners: Three Plays by Griselda Gambaro. Trans. Marguerite Feitlowitz. Afterword by Diana Taylor. Evanston: Northwestern University Press, 1992.

The Impenetrable Madam X. Trans. Evelyn Pacon Garfield. Detroit: Wayne State University Press, 1991.

La cola mágica. Buenos Aires: Ediciones de la Flor, 1976; 2nd ed. 1985.

La gracia. El Urogallo. (Madrid) (1972): 17.

Lo impenetrable. Buenos Aires: Torres Agüero Editor, 1984.

Lo mejor que se tiene. Barcelona: Grupo Editorial Norma, 1998.

Los siameses. 9 Dramaturgos hispanoamericanos. Antología del teatro hispanoamericano del siglo XX. Vol 2. Ottawa: Girol Books, 1979.

Madrigal en ciudad: La infancia feliz de Petra. El nacimiento. Madrigal en ciudad. Buenos Aires: Editorial Goyanarte, 1963.

Nada que ver con otra historia. Buenos Aires: Ediciones Noé, 1972.

Stripped. (El Despojamiento, 1974). Trans. Ana Puga. Introduction by Diana Taylor and Roselyn Costantino. *Women & Performance: A Journal of Feminist Theory* 11.2 (2000): 95–106.

Teatro: Atando cabos. La casa sin sosiego. Es necesario entender un poco. Vol. 6. Buenos Aires: Ediciones de la Flor, 1994.

Teatro: Dar la vuelta. Información para extranjeros. Puesta en claro. Sucede lo que pasa. Vol. 2. Buenos Aires: Ediciones de la Flor, 1987.

Teatro: Las paredes. El desatino. Los siameses. El campo. Nada que ver. Vol. 4. Buenos Aires: Ediciones de la Flor, 1990.

Teatro: Real envido. La malasangre. Del sol naciente. Vol. 1. Buenos Aires: Ediciones de la Flor, 1984.

Teatro: Viaje de invierno. Sólo un aspecto. La gracia. El miedo. Decir sí. Antígona furiosa y otras piezas breves. Vol. 3. Buenos Aires: Ediciones de la Flor, 1989.

Una felicidad con menos pena. Buenos Aires: Editorial Sudamericana, 1968.

Critical Writings

"Algunas consideraciones sobre la mujer y la literatura." *Revista iberoamericana* 51.132–33 (1985): 471–73.

"¿Es posible y deseable una dramaturgia específicamente femenina?" *Latin American Theatre Review* 13 (1980): 17–21.

"Los rostros del exilio." *Alba de América* 7.12–13 (1989): 31–35.

"Voracidad o canibalismo amoroso." *Quimera* 24 (1982): 50–51.

Criticism about Her Work

Araujo, Helena. "El tema de la violación en Armonia Somers y Griselda Gambaro." *Plural* 15.11 (1986): 21–23.

Arlt, Mirta. "Los '80 - Gambaro-Monti - y más allá. . . ." *Latin American Theatre Review* 24.2 (1991): 49–58.

Avellaneda, Andrés. "Construyendo el monstruo: Modelos y subversiones en dos relatos (feministas) de aprendizaje." *Inti* 40.41 (1994–1995): 219–31.

Betsko, Kathleen, and Rachel Koenig. "Interview with Griselda Gambaro." *W. B. Worthen Modern Drama: Plays/Criticism/Theory*. New York: Harcourt Brace, 2000.

Boling, Becky. "From Pin-Ups to Striptease in Gambaro's *El despojamiento*." *Latin American Theatre Review* 20.2 (1987): 59–65.

Bulman, Gail Ann. "El grito infinito: Ecos coloniales en *La malasangre* de Griselda Gambaro." *Symposium* 48.4 (1995): 271–76.

Burgess, Ronald D. "El sí de *Los siameses.*" *Studies in Modern and Classical Languages and Literature, I.* Ed. Fidel Criado Lopez. *Orígenes* (1988): 65–71.

Carballido, Emilio. "Griselda Gambaro o modos de hacernos pensar en la manzana." *Revista iberoamericana* 36.73 (1970): 629–34.

Castellvi de Moor, Magda. "Del objeto al sujeto mujer: Penas sin importancia de Griselda Gambaro." *La nueva mujer en la escritura de autoras hispánicas: Ensayos críticos.* Ed. Juana A. Arancibia and Yolanda Rosas. Montevideo: Instituto Literario y Cultural Hispánico, 1995. 179–95.

Castro, Marcela, and Silvia Jurovietzky. "Decir no: Entrevista a Griselda Gambaro." *Feminaria Literaria* 6.11 (1996): 41–45.

Colleran, Jeanne. "Disjuncture as Theatrical and Postmodern Practice in Griselda Gambaro's *The Camp* and Harold Pinter's *Mountain Language.*" *Pinter at Sixty.* Ed. Katherine H. Burkman and John L. Kundert Gibbs. Bloomington: Indiana University Press, 1993. 49–63.

Contreras, Marta. "Diagnosis teatral: Una aproximación a la obra dramática de Griselda Gambaro." *Acta Literaria* (Chile) 22 (1997): 19–25.

Correas Zapata, Celia. "La violencia en *Miralina* de Marcela del Río y *Los siameses* de Griselda Gambaro." *Plural* 212 (1989): 46–52.

Cortes, Jason. "La teatralización de la violencia y la complicidad del espectáculo en *Informarción para extranjeros* de Griselda Gambaro." *Latin American Theatre Review* 35.1 (2001): 47–61.

Cypess, Sandra Messinger. "Dramatic Strategies Made Clear: The Feminist Politics in *Puesta en claro* by Griselda Gambaro." *Studies in Twentieth Century Literature* 20 (1996): 125–45.

———. "Frankenstein's Monster in Argentina: Gambaro's Two Versions." *Revista canadiense de estudios hispánicos* 14.2 (1990): 349–61.

———. "The Plays of Griselda Gambaro." *Dramatists in Revolt: The New Latin American Theater.* Ed. Leon F. Lyday and George W. Woodyard. Austin: University of Texas Press, 1976. 95–109.

———. "Titles as Signs in the Translation of Dramatic Texts." *Translation Perspectives II: Selected Papers, 1984–1985.* Ed. Marilyn Gaddis Rose. Binghamton: State University of New York, 1985. 95–104.

Feitlowitz, Marguerite. "Crisis, Terror, Disappearance: The Theater of Griselda Gambaro." *Theater* 21.3 (1990): 34–38.

———. "Griselda Gambaro." *Bomb* 32 (1990): 53–56.

Fleming, John. "Argentina on Stage: Griselda Gambaro's *Information for Foreigners* and *Antígona furiosa.*" *Selected Proceedings: Louisiana Conference on Hispanic Languages and Literatures.* Ed. Joseph V. Ricapito. Baton Rouge: Louisiana State University Press, 1994. 71–82.

Foster, David William. "Argentine Sociopolitical Commentary, The Malvinas Conflict and Beyond: Rhetoricizing a National Experience." *Latin American Theatre Review* 22.1 (1979): 7–34.

———. "El lenguaje como vehículo espiritual en *Los siameses* de Griselda Gambaro." *Escritura* 4.8 (1979): 241–57.

———. "Pornography and the Feminine Erotic: Griselda Gambaro's *Lo impenetrable.*" *Monographic Review –Revista Monográfica* 7 (1991): 284–96.

———. "The Texture of Dramatic Action in the Plays of Griselda Gambaro." *Hispanic Journal* 1.2 (1980): 57–66.

Foster, Virginia Ramos. "María Trejo and Griselda Gambaro: Two Voices of the Argentine Experimental Theater." *Books Abroad* 62.4 (1989): 534–35.

Franco, Jean. "Self-Destructing Heroines." *Minnesota Review* 22 (1984): 105–15.

Garfield, Evelyn Picon. *Women's Voices from Latin America: Interviews with Six Contemporary Authors*. Detroit: Wayne State University Press, 1985.

Gandini, Gerardo, and Griselda Gambaro. *La casa sin sosiego: Opera de cámara sobre un libreto de Griselda Gambaro*. Buenos Aires: Ricordi, 1992.

Gerdes, Dick. "Recent Argentine Vanguard Theatre: Gambaro's *Información para extranjeros*." *Latin American Theatre Review* 11.2 (1978): 11–16.

Giella, Miguel Angel. "El victimario como víctima en *Los siameses* de Griselda Gambaro: Notas para el análisis." *Gestos* 2.3 (1987): 77–86.

Giordano, Enrique A. "Ambiguedad y alteridad del sujeto dramático en *El campo* de Griselda Gambaro." *Alba de América* 7.12–13 (1989): 47–59.

———. "*La malasangre* de Griselda Gambaro: Un proceso de reconstrucción y recodificación." *Teatro argentino durante El Proceso (1976–1983)*. Ed. Juana A. Arancibia and Zulema Mirkin. Buenos Aires: Vinciguerra, 1992. 57–74.

Gladhart, Amalia. "Nothing's Happening: Performance as Coersion." *Gestos* 9.18 (1994): 93–112.

———. "Playing Gender." *Latin American Literary Review* 24.47 (1996): 59–89.

Graham Jones, Jean. "Decir 'No': El aporte de Bortnik, Gambaro y Raznovich al Teatro Abierto '81." *Teatro argentino durante El Proceso (1976–1983)*. Ed. Juana A. Arancibia and Zulema Mirkin. Buenos Aires: Vinciguerra, 1992. 181–97.

Heredia, Lucía, et al. *Griselda Gambaro*. Videocassette. Lucia Heredia Productions, 1988.

Holzapfel, Tamara. "Griselda Gambaro's Theatre of the Absurd." *Latin American Theatre Review* 4.1 (1970): 5–11.

Jehenson, Myriam Yvonne. "Staging Cultural Violence: Griselda Gambaro and Argentina's 'Dirty War.' " *Mosaic* 32.1 (1999): 85–104.

Jurewiez, Liliana Elizabet. "Una explicación de encadenamiento físico y emocional en *El desatino* de Griselda Gambaro." *Visión de la narrativa hispánica: Ensayos*. Ed. Juan Cruz-Mendizabal and Juan Jiménez Fernández. Indiana: Indiana University of Pennsylvania, 1999. 131–40.

Krajewska Wieczorek, Anna. "Two Contemporary Antigones." *New Theatre Quarterly* 10.40 (1994): 327–30.

Lasala, Malena. *Entre el desamparo y la esperanza: una traducción filosófica de la estética de Griselda Gambaro*. Buenos Aires: Editorial Biblos, 1992.

Laughlin, Karen L. "The Language of Cruelty: Dialogue Strategies and the Spectator in Gambaro's *El desatino* and Pinter's *The Birthday Party*." *Latin American Theatre Review* 20.1 (1986): 11–20.

Lockert, Lucia. "Aggression and Submission in Griselda Gambaro's *The Walls*." *Michigan Academician* 19.1 (1987): 37–42.

Lockhart, Melissa. "The Censored Argentine Text: Griselda Gambaro's *Ganarse la Muerte* and Reina Roffe's *Monte de Venus*." *Interventions: Feminist Dia-*

logues on Third World Women's Literature and Film. Ed. Bishnupriya Ghosh and Brinda Bose. New York: Garland Press, 1997. 97–117.

Lorente Murphy, Silvia. "La dictadura y la mujer: Opresión y deshumanización en *Ganarse la muerte* de Griselda Gambaro." *La nueva mujer en la escritura de autoras hispánicas: Ensayos críticos.* Ed. Juana A. Arancibia and Yolanda Rosas. Montevideo: Instituto Literario y Cultural Hispánico, 1995. 169–78.

Magnarelli, Sharon. "Acting/Seeing Woman: Griselda Gambaro's El despojami-ento." *Latin American Women's Writing: Feminist Readings in Theory and Crisis.* Ed. Anny Jones Brooksbank and Catherine Davies. New York: Oxford University Press, 1996. 10–29.

———. "Authoring the Scene, Playing the Role: Mothers and Daughters in Griselda Gambaro's La malasangre." *Latin American Theatre Review* 27.2 (1994): 5–28.

———. "Griselda Gambaro habla de su obra más reciente y la crítica." *Revista de estudios hispánicos* 20.1 (1986): 123–33.

Martínez de Olcoz, Nieve. "Cuerpo y resistencia en el reciente teatro de Griselda Gambaro." *Latin American Theatre Review* 28.2 (1995): 7–18.

McAleer, Janice K. "*El campo* de Griselda Gambaro: Una contradicción de mensajes." *Revista canadiense de estudios hispánicos* 7.1 (1982): 159–71.

Méndez Faith, Teresa. "Sobre el uso y abuso de poder en la producción dramática de Griselda Gambaro." *Revista iberoamericana* 51.132–133 (1985): 831–841.

Molinaro, Nina L. "Discipline and Drama: Panoptic Theatre and Griselda Gambaro's *El campo.*" *Latin American Theatre Review* 29.2 (1996): 29–41.

Morell, Hortensia R. "*Ganarse la muerte* y la evolución de los personajes de Griselda Gambaro." *Monographic Review–Revista Monográfica* 8 (1992): 183–96.

———. "La narrativa de Griselda Gambaro: *Dios no nos quiere contentos.*" *Revista iberoamericana* 57.155–156 (1991): 481–94.

———. "*Penas sin importancia* y Tío Vania: Diálogo paródico entre Chekhov y Gambaro." *Latin American Theatre Review* 31.1 (1997): 5–14.

Moreno, Iani del Rosario. "La recontextualización de Antígona en el teatro argentino y brasileño a partir de 1968." *Latin American Theatre Review* 30.2 (1997): 5, 115–29.

Moretta, Eugene L. "Reflexiones sobre la tiranía: Tres obras del teatro argentino contemporáneo." *Revista canadiense de estudios hispánicos* 7.1 (1982): 141–47.

———. "Spanish American Theatre of the 50's and 60's: Critical Perspectives on Role Playing." *Latin American Theatre Review* 13.3 (1980): 5–30.

Muxo, David. "La violencia del doble: *Los siameses* de Griselda Gambaro." *Prismal cabral* 2 (1978): 24–33.

Nuetzel, Eric J. "Of Melons, Heads, and Blood: Psychosexual Fascism in Griselda Gambaro's *Bad Blood.*" *Modern Drama* 39.3 (1996): 457–64.

Parsons, Robert A. "Reversals of Illocutiary Logic in Griselda Gambaro's *Las paredes.*" *Things Done with Words: Speech Acts in Hispanic Drama.* Ed. Elias L. Rivers. Newark, Del.: Juan de la Cuesta, 1986. 101–14.

Pellarolo, Silvia. "Revisando el canon/la historia oficial: Griselda Gambaro y el heroísmo de Antígona." *Gestos* 7.13 (1992): 79–86.

Picon Garfield, Evelyn. "Una dulce bondad que atempera las crueldades: *El campo* de Griselda Gambaro." *Latin American Theatre Review* 13 (1980): 95–102.

Podol, Peter L. "Reality Perception and Stage Setting in Griselda Gambaro's *Las paredes* and Antonio BueroVallejo's *La fundación*." *Modern Drama* 24.1 (1981): 44–53.

Postman, Rosalea. "Space and Spectator in the Theatre of Griselda Gambaro: *Información para extranjeros*." *Latin American Theatre Review* 14.1 (1980): 35–45.

Pozzi, Dora. "Feminine Classical Figures in the Twentieth-Century Latin American Theater." *Text and Presentation* 13 (1992): 31–37.

Roffe, Reina. "Entrevista a Griselda Gambaro." *Cuadernos hispanoamericanos* 588 (1999): 111–24.

Salzman, Patricia, and Eleonra Tola. "El camino órfico en la literatura argentina: *La casa sin sosiego* de Griselda Gambaro." *Primeras jornadas internacionales de literatura Argentina/comparística: Actas.* Ed. Teresita Frugoni de Fritzsche. Buenos Aires: Facultad de Filosofia y Letras, Universidad de Buenos Aires, 1996. 325–33.

Sandoval, Enrique. "Teatro latinoamericano: Cuatro dramaturgas y una escenógrafa." *Literatura chilena* 3.1–4 (1989): 47–50, 171–187.

Schnaith, Nelly. "Imaginar: ¿Juego o compromiso?: Conversación con Griselda Gambaro." *Quimera* 24 (1982): 47–50.

Schutzman, Mady. "Calculus, Clairvoyance, and Communitas." *Women and Performance* 10.1–2 (19–20) (1999): 117–33.

Scott, Jill. "Griselda Gambaro's *Antígona furiosa*: Loco(ex)centrism for 'jouissan(SA).' " *Gestos* 8.15 (1993): 99–110.

Taylor, Diana. "Border Watching." *The Ends of Performance.* Ed. Peggy Phelan and Jill Lane. New York: New York University Press, 1998. 178–85.

———. *Disappearing Acts: Spectacles of Gender and Nationalism in Argentina's "Dirty War."* Durham: Duke University Press, 1997.

———. "Rewriting the Classics: *Antígona furiosa* and the Madres de la Plaza de Mayo." *Bucknell Review* 40.2 (1996): 77–93.

———. "Theater and Terrorism: Griselda Gambaro's Information for Foreigners." *Theatre Journal* 42.2 (1990): 165–82.

———. *Theatre of Crisis: Drama and Politics in Latin America.* Lexington: Kentucky University Press, 1990.

Taylor, Diana, ed. *En busca de una imagen: Ensayos críticos sobre Griselda Gambaro y José Triana. Textos inéditos de Gambaro y Triana.* Ottawa: Girol Books, 1989.

Tompkins, Cynthia. "El poder del horror: Abyección en la narrativa de Griselda Gambaro y de Elvira Orphee." *Revista hispánica moderna* 46.1 (1993): 179–92.

Torell, Hortensia R. "*Después del día de fiesta*: Reescritura y posmodernidad en Griselda Gambaro." *Revista iberoamericana* 63.181 (1997): 665–74.

Ure, A., and Nora Mazziotti. *Poder, deseo y marginación: Aproximaciones a la obra de Griselda Gambaro.* Buenos Aires: Puntosur Editores, 1989.

Valerie, Enid. "Entrevista con Griselda Gambaro." *Alba de América* 10.18–19 (1992): 407–18.

———. "Una nueva interpretación de *Las paredes* de Gambaro." *Latin American Theatre Review* 26.1 (1992): 69–77.

Woodall, Natalie Joy. "Landscape and Dystopia in Gambaro's *La malasangre*." *Re-*

Naming the Landscape. Ed. Jurgen Kleist and Bruce A. Butterfield. New York: Peter Lang, 1994. 147–58.

Woodyard, George W. "The Theatre of the Absurd in Spanish America." *Comparative Drama* 3.3 (1969): 183–92.

Zalacain, Daniel. "El personaje 'fuera del juego' en el teatro de Griselda Gambaro." *Revista de estudios hispánicos* 14.2 (1980): 59–71.

Zambrano, Wa Ki Fraser de. "*Lo impenetrable*: La ruta al paraíso terrenal." *Monographic Review–Revista Monográfica* 12 (1996): 393–405.

Zee, Linda S. "*El campo, Los siameses, El señor Galíndez*: A Theatrical Manual of Torture." *Romance Languages Annual* 2 (1990): 604–8.

ASTRID HADAD

Publications

"Lyrics and Monologue Fragments." Trans. Roselyn Costantino. *Women and Performance: A Journal of Feminist Theory* 11.2 (22): 2000. 145–48.

Performances

Cartas a Dragoberta (Letters to Dragoberta)
Del rancho a la ciudad (From the Country to the City)
Faxes a Rumberta
Heavy Nopal (*Ode to Lucha Reyes*)
La mujer del Golfo Apocalípsis (The Woman of Apocalypse Golf)
La mujer multimedia (The Multimedia Woman)
La multimamda (Multibreasted Woman or The Mass Suckle)
La ociosa . . . O Luz levántate y lucha (The Lazy One . . . or Oh Luz, Get Up and Fight)
Nostalgia arrabalera (Gutter Nostalgia)
Pecadora (The Sinful Woman)

CDs

¡Aye! Mexico: Discos Cabaret, 1990; Madrid: Nubenegra, 1994.
Corazón sangrante. Mexico: Discos Cabaret, 1997.
Pecadora. Forthcoming, 2003.
La cuchilla. Mexico: Discos Continental, 2003.

Video

Cuarón, Alfonso, et al. *Solo con tu pareja.* VHS. New York Latin American Video Archives, 2000.

Cuevas, Ximena, and Astrid Hadad. *Corazón sangrante.* VHS. New York Latin American Video Archives, 1993.

Huacuja, Mal'u, Astrid Hadad, and Ximena Cuevas. *Half-Lies, Paper Illusions: A Selection of Videos.* VHS. Mexico City, 1997.

Ipiotis, Celia, et al., dirs. *Luciana Proaño, Astrid Hadad.* VHS. ARC Videodance, 1992.

Criticism about Her Work

Alzate, Gastón Adolfo. "Expandiendo los límites del teatro: Una entrevista con Astrid Hadad." *Latin American Theatre Review* 30.2 (1997): 153–63.

Beltrán, Rosa. "Entrevista con Astrid Hadad." *La jornada semanal* 205 (1993): 16–19.

Costantino, Roselyn. "'And She Wears it Well': Feminist and Cultural Debates in the Performance of Astrid Hadad." *Latinas on Stage*. Ed. Norma Alarcón and Lillian Manzor. Berkeley: Third Woman Press, 2000. 398–421.

———. "Memoria colectiva y cuerpo individual: Política y performance de Astrid Hadad." *Conjunto* 121 (2001): 40–49.

———. "Politics and Culture in a Diva's Diversion." *Women and Performance: A Journal of Feminist Theory*. 11.2 (2000): 149–73.

———. "Through Their Eyes and Bodies: Mexican Women Performance Artists, Feminism, and Mexican Astrid Hadad." 1995. <http://www.lanic.utexas.edu/project/lasa95/costantino.html>.

Dávila, María del Mar. "La mujer nocturna." *X / Equis: Cultura y sociedad* 19 (1999): 36–42.

Nigro, Kirsten. "Women and Mexican Society: A Few Exemplary Cases." *Bucknell Review: Perspectives on Contemporary Spanish American Theatre*. Ed. Frank Dauster. Lewisburg, Pa: Bucknell University Press, 1996. 53–66.

TERESA HERNÁNDEZ

Performances

Acceso controlado (Limited Access), 1995.

"Brenda prenda." *Conciente privado o Mamagüela*, n.d.

Isabella "en partes" (Isabella "In Parts"), 1993.

La gran tragedia y las personas calzadas, 1996.

La nostalgia del quinqué . . . una huida (Nostalgia for Oil Lamps . . . An Escape), 1999.

Lo complejo del ser o el complejo de ser (How Complex Being Is, or, The Complex of Being), n.d.

With Viveca Vázquez and Eduardo Alegría. *Kan't translate: tradúcelo* (Can't Translate: Translate It), 1992.

Criticism about Her Work

Martínez Tabares, Vivian. "Teresa Hernández: artista de la acción, performera caribeña." *Lo mío ese otro teatro*. Puerto Rico: Ediciones Callejón, forthcoming.

ROSA LUISA MÁRQUEZ

Original Performance Pieces, with Antonio Martorell

Carivé. Casa de América, Madrid, 1998.

El desahucio, 1981.

El sí-dá, 1988.

Foto-estáticas, 1985.

Godot. University of Puerto Rico Theatre, 1997; Segura Theatre of Lima, 1998.

If a Grain Does Not Die: A Very Foolish Tail. MIT School of Architecture, Cambridge, Mass., 1992.

Ligia Elena estácontenta, 1987.

Performances: Direction and Adaptation

Cuentos, cuentos y más cuentos by Gerard Paul Marín, 1979.

Denucaacabar by Kalman Barsy, Ana Lydia Vega, Mayra Santos, Magaly García Ramis, 1995.

El león y la joya by Wole Soyinka, 1988.

Esperando a Godot by Samuel Beckett, 1997.

Foto-estáticas, 2002.

Historias para ser contadas by Osvaldo Dragún, 2001; *Historias para ser contadas de Osvaldo Dragún, Rosa Luisa Márquez del texto al montaje teatral*. San Juan: Ediciones Callejón, 2002.

Jardín de pulpos by Arístides Vargas, 1996.

La leyenda del Cemí by Kalman Barsy, 1982.

Otra maldad de Pateco by Ana Lydia Vega, 1987.

Pequeña serenata "a la Brecht," by Bertolt Brecht, 2000.

Procesión de Badal Sircar, 1999.

Critical Writings

The Actor Speaks. Ed. Janet Sonenberg. New York: Crown Publishers, 1996.

"Augusto Boal, al rescate del lenguaje y la comunicación." *Revista interamericana* 7.2 (1982): 221–27.

"The Bread and Puppet Theatre in Nicaragua, 1985." *New Theatre Quarterly* 5.17 (1989): 3–7

"Conferencia dramatizada sobre teatro puertorriqueño." *Conjunto* 83 (1990): 40–54.

"Creación colectiva: Con y sin texto (1988–1989)." *Ollantay* 2.2 (1994): 16–19.

"Cuarenta años después de 'Lo que podría ser un teatro puertorriqueño' (1939–1979)." *Revista interamericana* 9 (1979): 300–06.

"El desahucio, pieza teatral." *Reintegro* 2.1–2 (1981): 20–21.

"El quehacer de un taller." *Polimnia: Taller de histriones 1971–1985*. Ed. Gilda Navarra. Barcelona: Romargraf, 1988. 23–28.

"Machurrucutu y el humo de la memoria." *Sargasso* 7 (1991): 14–18.

"The Play is the Thing, The Thing is to Play." Odin Theatre Forlag, Denmark. *The Open Page* 4 (1999): n.p.

"Puerto Rico: Teatro" *Diógenes-anuario crítico de teatro latinoamericano*. Ed. Marina Pianca. Ottawa, Ontario: Girol Books, 1988.

"The Puerto Rican Traveling Theatre Company: The First Ten Years." *DAI* (1978): 39, 26A.

"Taller de histriones: teatro puertorriqueño." *Cuadernos* 8 (1981): n.p.; *Conjunto* 58 (1982): n.p.

"Teatro en vivo y a todo color." *El tramo ancla: Ensayos puertorriqueños de hoy*.

Ed. Ana Lydia Vega. Rio Piedras: University of Puerto Rico-Editorial Universitaria, 1989. 121–59.

"¿Un triunfo de la memoria? Gloria María Martínez, pedagogía y experimentación en el teatro latinoamericano." *Escenología* (Mexico) (1996): n.p.

Márquez, Rosa Luisa, and Antonio Martorell. "Uno, dos, tres . . . probando—variaciones sobre el mismo tema que nos obsesiona: La representación- por un gráfico y una teatrera." *Conjunto* 82 (1990): 60–70.

Márquez, Rosa Luisa, with Antonio Martorell and Miguel Vilafañe. *Brincos y saltos: El juego como disciplina teatral: ensayos y manual de teatreros ambulantes.* Cayey, Puerto Rico: Ediciones Cuicaloca, Colegio Universitario de Cayey, 1992; 2nd ed. 1996.

Márquez, Rosa Luisa, and Lowell A. Fiet. "Puerto Rican Theatre on the Mainland." *Ethnic Theatre in the United States.* Ed. Maxine Schwartz Seller. Westport, Conn.: Greenwood Press, 1983. 419–46.

Criticism about Her Work

Martínez Tabares, Vivian. "Rosa Luisa Márquez, *de Jardín de pulpos* a *Godot.*" *Conjunto* 106 (1997): n.p.

DIANA RAZNOVICH

Published Plays

Casa matriz. Salirse de madre. Buenos Aires: Editorial Croquiñol, 1992.

Defiant Acts: Four Plays by Diana Raznovich/Actos desafiantes: Cuatro obras de Diana Raznovich. Ed. Diana Taylor and Victoria Martínez. Lewisburg, Pa.: Bucknell University Press, 2002.

Desconcierto. Teatro Abierto '81. Buenos Aires: Adans Editora, 1981.

From the Waist Down. Trans. Shanna Lorenz. *Women and Performance: A Journal of Feminist Theory.* 11.2 (2000): 43–72.

Jardín de otoño. Buenos Aires: Subsecretaría de Cultura, Dirección de Escuelas y Cultura, Provincia de Buenos Aires, 1985.

"Manifesto 2000 of Feminist Humor." Trans. Marlène Ramírez-Cancio and Shanna Lorenz. *Women and Performance: A Journal of Feminist Theory* 11.2 (2000): 25–41.

Paradise y otros monólogos. Buenos Aires: Nuevo Teatro, n.d.

Personal Belongings. Argentine Jewish Theatre. A Critical Anthology. Ed. and trans. Nora Glickman and Gloria Waldman. Lewisburg, Pa.: Bucknell University Press, 1996.

Plumas blancas. Buenos Aires: Ediciones Dédalos, 1974.

Staged Plays

Autógrafos. Dirs. Ricky Pashkus and Diana Raznovich, Teatro Lorange, Buenos Aires, 1983.

Buscapies. Dir. Mario Rolla, Sala Casacuberta, Teatro Municipal General San Martín, Buenos Aires, Argentina, 1968.

Casa matriz. Dir. Saviana Scalffi, Teatro Studio, Rome, 1986; Nuremberg Theater,

Nuremberg, 1992; Teatro Nacional de Suecia, Estocolmo, 1992; dir. Tina Serrano, Teatro Bauen, Buenos Aires, 1993.

Contratiempo. Dir. Ricardo Monti, Teatro Payró, Buenos Aires, 1971.

El desconcierto. Dir. Hugo Urquijo, Ciclo Teatro Abierto, Teatro Picadero, Teatro Tabaris, Buenos Aires, 1981; Nuremberg Theater, Nuremberg, 1991.

El guardagente. Dir. Rudy Chernicoff, Teatro de la Sociedad Hebraica, Buenos Aires, 1970.

Jardín de otoño. Teatro Rex, Madrid, 1977; dir. Hugo Urquijo, Teatro Olimpia, Buenos Aires, 1983; Konstanze Theater, Konstanz y Berlin Festival, Germany, 1990; Vienna, Austria, 1992; Teatro Uno di Roma, Rome, 1993.

Marcelo el mecánico. Teatro Del Globo, Buenos Aires, 1975.

Máquinas divinas. Dir. Maricarmen Arnó, Sala ETC, Centro Cultural San Martín, Buenos Aires, 1996.

Personal Belongings. Dir. Ross Horin, Sydney, Australia, 1984.

Plaza hay una sola [Series of eight short pieces for outdoor space]. Dir. Mario Rolla, Teatro al aire libre, Plaza Roberto Arlt, Buenos Aires, 1969.

Texas en carretilla. Teatro Odeón, 1972.

Cartoons: Selected Collections

Cables pelados. Vol. 1. Buenos Aires: Ediciones Lúdicas, 1987.

Cables pelados. Vol. 2. Buenos Aires: Ediciones Lúdicas, 1989.

Criticism about Her Work

Castillejos, Manuel. "El valor del sonido en Buscapies de Diana Raznovich." *Mujer y sociedad en America: IV simposio internacional.* Vol. 1. Westminster, Calif.: Instituto Literario y Cultural Hispánico, 1988. 233–40.

Consentino, Olga. "El teatro de los setenta: Una dramaturgia sitiada." *Latin American Theatre Review* 24.3 (1991): 31–39.

Esteve, Patricio. "1980–1981: La prehistoria de Teatro Abierto." *Latin American Theatre Review* 24.2 (1991): 59–68.

France, Anna-Kay and P. J. Corso, eds. *International Women Playwrights: Voices of Identity and Transformation.* Metuchen, N.J.: Scarecrow Press, 1993.

Giella, Miguel Angel. "Desconcierto." *Teatro Abierto 1981.* Vol. 1. Ed. Osvaldo Pellettieri. Buenos Aires: Corregidor, 1992. 237–44.

Graham Jones, Jean. "Decir 'No': El aporte de Bortnik, Gambaro y Raznovich al Teatro Abierto '81." *Teatro argentino durante El Proceso (1976–1983).* Ed. Juana A. Arancibia and Zulema Mirkin. Buenos Aires: Vinciguerra, 1992.

Glickman, Nora. "Parodia y desmitificación del rol femenino en el teatro femenino de Diana Raznovich." *Latin American Theatre Review* 28.1 (1994): 89–100.

Jansen, Ann, and Anne Chislett. *Airborne.* Winnipeg: Blizzard, 1991.

López, Liliana. "Diana Raznovich: Una cazadora de mitos." *Drama de mujeres.* Ed. Halima Tahan. Buenos Aires: Ediciones Ciudad Argentina, n.d.

Martínez, Martha. "Tres nuevas dramaturgas argentinas: Roma Mahieu, Hebe Uhart y Diana Raznovich." *Latin American Theatre Review* spring (1980): 39–45.

Taylor, Diana. *Disappearing Acts. Spectacles of Gender and Nationalism in Argentina's "Dirty War."* Durham: Duke University Press, 1997.

————. "Fighting Fire with Frivolity: Diana Raznovich's Defiant Acts." *Performance, pathos, política de los sexos: Teatro postcolonial de autoras latino-americanas*. Ed. Heidrum Adler and Kati Rottger. Frankfurt: Vervuert Ibero-americana, 1999.

————. Introduction. *Defiant Acts: Four Plays by Diana Raznovich / Actos desafientes: Cuatro obras de Diana Raznovich*. Ed. Diana Taylor and Victoria Martínez. Lewisburg, Pa.: Bucknell University Press, 2002.

————. "What Is Diana Raznovich Laughing About?" *Women and Performance: A Journal of Feminist Theory* 11.2 (2000): 73–93.

JESUSA RODRÍGUEZ

Published Performances

El génesis. debate feminista 8.16 (1997): 401–13.

El vuelo de la rata: Una apasionada historia de México. debate feminista 6.11 (1995): 389–96.

Excerpts. "Genesis," "Barbie: The Revenge of the Devil," "Censorship: The Bald Rat in the Garbage." Trans. Roselyn Costantino. *Women and Performance: A Journal of Feminist Theory* 11.2 (2000): 175–82.

La gira mamal de la Coatlicue. debate feminista 1.2 (1990): 401–3.

La Malinche en "Dios TV." debate feminista 2.3 (1991): 308–12.

La mano que mece el pesebre: Una pastorela. debate feminista 8.15 (1997): 383–99.

Pokar de gases de Jesusita Descalza. debate feminista 3.6 (1992): 363–74.

Sor Juana en Almoloya: Pastorela virtual. debate feminista 6.12 (1995): 395–411.

Rodríguez, Jesusa, and Liliana Felipe, lyrics. (Music by Liliana Felipe.) *A nadie. (Opus 136). debate feminista* 6.11 (1995): 397–400.

Rodríguez, Jesusa, and Liliana Felipe. *Lilith: El segundo fracaso de Dios. debate feminista* 4.8 (1993): 434–48.

Rodríguez, Jesusa, with Malú Huacuja and Armando Morón. *Fue niña: Pastorela. debate feminista* 4.7 (1993): 385–405.

Rodríguez, Jesusa, with Carlos Pascual. *Derecho de abortar: Pastorela. debate feminista* 10.19 (1999): 329–57.

Rodríguez, Jesusa, with Luz Aurora Pimentel. *El Rey Lear: Una puesta en escena*. Mexico: Ediciones El Hábito, 1996.

Video

Così fan tutte (o La escuela de los amantes). Opera by W. A. Mozart and L. Da Ponte, adapted and directed by Jesusa Rodríguez. Mexico City: El Hábito, 1996.

Essays, Lyrics, Graphics, and Other Texts

"Censura: La rata pelona en la basura." *debate feminista* 5.9 (1994): 479.

"Cruz y drama." *debate feminista* 4.8 (1993): 431–33.

"Cuerpo y política." *debate feminista* 5.10 (1994): 323–24.

"Degradarlo todo jubilosamente." *debate feminista* 9.17 (1998): 397–401.

"El género de los géneros." *debate feminista* 10.20 (1999): 369–72.

"Identidad gráfica: México turístico." *debate feminista* 7.14 (1996): 423.

"Informe arqueológico." *debate feminista* 3.5 (1992): 417–22.

"Los ejes de mi Suburban: Una telenovela para verla hoy y vomitarse toda la quincena." *debate feminista* 2.4 (1991): 383–89.

"Otredad, alteridad y extranjería." *debate feminista* 7.13 (1996): 445–49.

Salsa de molcajete (302). debate feminista 12.24 (2001): 367–70.

"30 años de feminismo." *debate feminista* 11.22 (2000): 335–37.

Rodríguez, Jesusa, with Liliana Felipe. "Chupamos faros." *debate feminista* 9.18 (1998): 455–68.

Rodríguez, Jesusa, with María Teresa Priego (lyrics) and Liliana Felipe (music). *Las Histéricas. debate feminista* 11.21 (2001): 317–20.

Criticism about Her Work

Alzate, Gastón A. "Jesusa Rodríguez: Cabaret, disidencia y legitimación en el teatro mexicano contemporáneo." *Gestos* 14.28 (1999): 81–102.

Alzate, Gastón A., and Paola Marín. "Reinventando el cabaret: Entrevista con Jesusa Rodríguez." *Gestos* 14.28 (1999): 140–48.

Aviles, Jaime, Hermann Bellinghausen, and Bruce Swansey. "Jesusa critica al país." *Anuario de teatro en México 1983.* Mexico City: Universidad Nacional Autónoma de México, 1983. 127–29.

Castellanos, Patricia. "Entrevista con Jesusa Rodríguez." *La jornada semanal* 189 (1993): 21–24.

Costantino, Roselyn. "Embodied Memory in *Las Horas de Belen/ A Book of Hours.*" *Theatre Journal* 53:4 (2001): 607–32.

———. "Jesusa Rodriguez: An Inconvenient Woman." *Women and Performance: A Journal of Feminist Theory* 11.2 (2000): 183–212.

———. "Mujeres en el teatro mexicano: El caso de Jesusa Rodríguez." *El centavo* 17 (1994): 6–7.

———. "Performance in Mexico: Jesusa Rodríguez's Body in Play." *Corpus Delecti: Performance in Latin America.* Ed. Coco Fusco. London: Routledge, 2000. 63–77.

———. "Uncovering and Displaying Our Universes: Jesusa Rodriguez in/on Mexico." *The Color of Theatre: Race, Ethnicity and Contemporary Performance.* Ed. Roberta Uno, with Lucy Burns. London: Athlone Press, 2002. 144–56.

Franco, Jean. "A Touch of Evil: Jesusa Rodriguez's Subversive Church." *Negotiating Performance: Gender, Sexuality, and Theatricality in Latino America.* Ed. Diana Taylor and Juan Villegas. Durham: Duke University Press, 1994. 159–75.

Gladhart, Amalia. "Monitoring Sor Juana: Satire, Technology, and Appropriation in Jesusa Rodriguez's *Sor Juana en Almoloya.*" *Revista hispánica moderna* 52.2 (1999): 213–26.

Kelty, Mark, and Blanca Kelty. "Interview with Jesusa Rodriguez." *Latin American Theatre Review* 31.1 (1997): 123–27.

Martínez de Olcoz, Nieves. "Decisiones de la máscara neutra: Dramaturgía femenina y fin de siglo en América Latina." *Latin American Theatre Review* 31.2 (1988): 3, 5–16.

Molarsky, Mona. "How 'Belen' Was Born." *American Theatre* 16.7 (1999): 54–5.

Nigro, Kirsten. "Un revuelto de la historia, la memoria y el género: Expresiones de la posmodernidad sobre las tablas mexicanas." *Gestos* 9:17 (1994): 29–41.

Taylor, Diana. "'High Aztec' or Performing Anthro Pop: Jesusa Rodríguez and Liliana Felipe in *Cielo de abajo.*" *TDR* 37.3 (1993): 142–52.

DENISE STOKLOS

Publications

The Essential Theatre. São Paolo, Brazil: Denise Stoklos Produçoes Artísticas, 1992.

"Excerpts from *Essential Theatre.*" Ed. and trans. Diana Taylor. *Women and Performance: A Journal of Feminist Theory* 11.2 (2000): 107–10.

500 anos: Un fax de Denise Stoklos para Cristóvão Colombo. São Paolo: Denise Stoklos Produçoes Artísticas, 1992.

Performances

Canned Cadillac. 1973.

Casa. 1990.

Circle on the Moon, Mud on the Street. 1968.

Civil Disobedience. 1997.

Des-Medea. 1989.

Elegy. 1995.

500 Years: A Fax from Denise Stoklos to Christopher Columbus. 1992.

Heavier than the Air/Santos Dumont. 1996.

I See the Sun. 1970.

Mary Stuart. 1987.

Sea Sweet Prison. 1971.

Tomorrow Will Be Late and the Day After Tomorrow Doesn't Even Exist. 1993.

The Week. 1969.

Criticism about Her Work

Capó Sobral, Suzi. "The Essential Theatre of Denise Stoklos." Master's thesis. New York University, 1992.

Damasceno, Leslie. "The Gestural Art of Reclaiming Utopia: Denise Stoklos at Play with the Hysterical-Historical." *Women and Performance: A Journal of Feminist Theory* 11.2 (2000): 111–43.

———. "'O Teatro Essencial' de Denise Stoklos." *Tramoya* 40–41 (1994): 177–85.

Nascimento, Claudia Tatinge. Review of *Vozes Dissonantes. Theatre Journal* 52.4 (2000): 555–57.

Taylor, Diana. "Denise Stoklos: The Politics of Decipherability." With selections from *Essential Theatre. TDR* 44.2 (2000): 7–29.

Performances

A flor de piel, collective creation, dir. Elena Armengod, 1995.

A flor de piel, a re-elaboration, dir. Lucy Bolaños, 1997.

Bocas de bolero, based on twenty-two classic boleros, dir. Wilson Pico, 1993.

Cuánto cuesta el hierro, by Bertolt Brecht, dir. Carlos Bernal of TEC, 1974.

¡Emocionales!, based on *For Colored Girls Who Have Considered Suicide, When the Rainbow Is Enuf: A Choreopoem* by Ntozake Shange, dir. Rubén Di Pietro, 1992.

Historias de mujeres, two poems by Bertolt Brecht ("De la infanticida María Farrar" and "La canción de Naná"), and "María M" from *Las nuevas cartas portuguesas*, dirs. Enrique Buenaventura and Jacqueline Vidal, 1986.

La cabellera femenina, collective creation, 2000.

La mandrágora, by Machiavelli, dir. Luis Fernando Pérez of TEC, 1979.

La mina, Enrique Buenaventura's adaptation of Ferenc Herzec's play, dir. Gilberto Ramírez of TEC, 1975.

Las viudas, poem by Bertolt Brecht, dir. Lucy Bolaños, 1987.

Los perfiles de la espera, collective creation, dir. Wilson Pico, 1998.

Luna menguante, written and directed by Patricia Ariza, 1994.

Macbeth, Enrique Buenaventura's adaptation of Shakespeare, dir. Helios Fernández of TEC, 1977.

María Farrar, based on a poem by Bertolt Brecht, collective creation and direction, 1984.

Misterio de navidad, dir. Héctor Fabio Cobo, 1992.

Mujeres en trance de viaje, collective creation (based on texts by Eduardo Galeano, Rigoberta Menchú, Patricia Ariza, and *Las brujas de Salem*), dir. Patricia Ariza, 1990.

No saco nada de la escuela, by Luis Valdés, dir. Guillermo Piedrahita and Jorge Herrera of TEC, 1972.

Noticias de María, based on two sections from *Las nuevas cartas portuguesas* ("María M" and "Las tareas"), dir. Jacqueline Vidal, 1985, 1986.

Sin reflejos de la luna, esplendores en la noche, dir. Héctor Fabio Cobo, 1993.

Una historia vulgar, based on poems by Pablo Neruda, dirs. Carlos Bernal of TEC and Enrique Buenaventura, 1973.

Criticism about Their Work

Martinez de Olcoz, Nieves. "Decisiones de la máscara neutra: Dramaturgia femenina y fin de siglo en América Latina." *Latin American Theatre Review* 31.2 (1998): 5–16.

Ramirez-Cancio, Marlène. "Teatro La Máscara: Twenty-Seven Years of Invisibilized Theater." *Women and Performance: A Journal of Feminist Theory* 11.2 (2000): 227–50.

KATIA TIRADO

Performances

Día 28. Third International Performance Festival, Ex-Teresa, Mexico City, 1994.

Exhivilización: Las perras en celo. Fourth International Performance Festival, Ex-Teresa, Mexico City, 1995; Carrillo Gil Museum, Mexico City, 1997; Merced Market, Mexico City, 1998.

Jálatela hasta que truene. Festival Libre Enganche, San Antonio, Texas, 1995.

Lady Luck. Bar La Perla and Epicentro Gallery, Mexico City, 1999.

Lady Muck and Her Burlesque Revue. Art Performance Festival Now, Nottingham, England, 1996.

La revolución intervenida, o inciertamente insertada en la incertidumbre. Festejos del Milenio, Mexico City Zócalo, 1999.

Miss Koatl. Katastase 90 Festival, Berlin, 1991.

EMA VILLANUEVA

Performances

Ausencia. Ninth Performance Festival of Ex-Teresa, 2000; the Red de Derechos Humanos Todos Para Todos and the Hemispheric Institute of Performance and Politics of the Americas, Monterrey, Mexico, 2001.

Clase de dibujo libre. Ongoing project since October 2000.

Have You Raped? Caja Dos Gallery, Mexico City, 2000.

Orgullosamente UNAM. Faculty of Political and Social Sciences of the UNAM, Mexico City, 2001.

Pasionaria, caminata por la dignidad. Street intervention, 2000.

Sex Art. Ongoing project of table-dance interventions since August 2000.

Todo se vale (strip-tease político). Escuela Nacional de Pintura, Escultura y Grabado "La Esmeralda," Mexico City, 1999.

Villaneuva, Ema, with Iwan Wijono. *Rebellion Pose.* Ongoing project of street interventions.

Contributors

SABINA BERMAN is one of Mexico's most important playwrights. She also has published books of poetry, short stories, and several novels, and writes scripts for film and television. Recognized nationally and internationally, Berman has received Mexico's most prestigious theatre awards for nine of her plays. Several of her works have been translated into French and English, and have been performed abroad. Her film script for *Tía Alejandra* won an Ariel, the Mexican equivalent of an Oscar. With Isabelle Taradan, Berman adapted and directed her play *Entre villa y una mujer desnuda* as a full-length film. With a degree in psychology from the Iberoamerican University of Mexico, Berman has been a visiting professor in the United States (Yale, NYU, Cornell, among others) and at the School of Film of Cuba.

MARGARET CARSON is a freelance literary translator living in New York City. She has translated novels by the nineteenth-century Mexican writer José Tomás de Cuéllar and short stories by the contemporary writers Matilde Daviu and José Manuel Prieto. Her work has also included translating the writings and dream journals of the Spanish surrealist artist Remedios Varo. She is currently working on the translation of several Latin American plays for *Stages of Conflict*, an anthology of Latin American theatre and performance edited by Diana Taylor and forthcoming from the University of Michigan Press.

ROSELYN COSTANTINO is Associate Professor of Spanish and Women's Studies at Pennsylvania State University at Altoona. She has published on Latin American theatre and film, and on Mexican women's fiction, theatre, and performance, including Astrid Hadad, Jesusa Rodríguez, Maris Bustamante, Sabina Berman, Margo Su, Laura Esquivel, Rosario Castellanos, and Carmen Boullosa. She is presently completing a book-length manuscript on contemporary Mexican women's theatre and performance—*Inconvenient Women: Contemporary Women's Performance in Mexico*.

LESLIE DAMASCENO is Associate Professor of the Practice in the Departments of Romance Studies and Theater Studies at Duke University. She teaches, does research on, and writes about contemporary Brazilian and Latin American theatre and film, cultural theory, and cultural politics. She is the author of *Cultural Space and Theatrical Conventions in the Work of Oduvaldo Vianna Filho* (Wayne State University Press, 1996; published in Portuguese by UNICAMP Press, 1994) and co-author of *Latin American Popular Theatre: The First Five Centuries* (University of New Mexico Press, 1993). She is currently working on a book on theatrical image, consumer culture, and the utopian ideal in recent Brazilian theatre.

PETRONA DE LA CRUZ CRUZ (Chiapas, Mexico) is a Tzotzil Indian who, with Isabel Juárez Espinoza, founded FOMMA (Fortaleza de la Mujer Maya or Strength of Mayan Women), the only Highland Chiapas indigenous women's theater and community organization. Actress, playwright, and community activist, de la Cruz Cruz has presented her play *Una mujer desesperada* (A Desperate Woman, 1991) in Mexico and abroad. She has spoken about her work and community in Australia, Canada, and the United States.

DIAMELA ELTIT, one of Latin America's most important artists, was born in 1949 in Santiago Chile. In *Lumpérica* (1983) and a half dozen other works, she explores the fractured personal and social identities resulting from Chile's violent coup and dictatorship. Eltit was awarded a Guggenheim in 1985 and a grant from the Social Science Research Council in 1988. In the political sphere she was appointed cultural attaché for the Chilean Embassy in Mexico during the administration of Chilean president Patricio Aylwin, 1990–94.

MARGUERITE FEITLOWITZ is the author of *A Lexicon of Terror: Argentina and the Legacies of Torture*, a 1998 New York Times Notable Book and finalist for the PEN New England–L.L. Winship Prize. She has translated numerous plays by Griselda Gambaro, including *Information for Foreigners: Three Plays by Griselda Gambaro* (Afterword by Diana Taylor), and *Bad Blood/La Malasangre*, as well as selected short fictions. Her critical essays on and interviews with Gambaro have appeared in *Theater* and *Bomb*. Beginning in fall 2002, she will join the faculty of the Literature Program at Bennington College.

GRISELDA GAMBARO is one of Argentina's and Latin America's most important playwrights. Her work has been translated into English, French, and Polish and staged around the world. A prolific writer, between 1964 and 1989 Gambaro wrote more than twenty plays, several short stories, novels, literary criticism, and essays on the role of women in literature. During the military dictatorship (1980–1982) she chose to go into exile to live in Barcelona, Spain. She now lives and writes in Buenos Aires, where her works are frequently produced in prestigious theatres.

ASTRID HADAD is a cabaret and performance artist born and raised in Chetumal in the southern Mexican state of Quintana Roo. She resides in Mexico City where, since the 1980s, she produces and manages her show. She also has produced a video of her performances, *Heavy Nopal*, and four CDs of her music for worldwide distribution. Hadad continually performs throughout Europe, the United States, Latin America, and Australia.

TERESA HERNÁNDEZ is an actress-dancer. She has been performing contemporary dance and theater in Puerto Rico for the past fifteen years. She creates her own work, which she produces under the name Producciones Teresa no Inc. In her artistic work, she employs multiple languages: theater, costumes, dance, and video. Her verbal and corporal texts have been characterized by the creation of characters that are pertinent to the everyday reality of Puerto Rico.

SHANNA LORENZ is a Ph.D. student in Performance Studies at New York University, and is engaged in two major research projects. The first project, which is a study of Latin American music in gringo films of the 1990s, examines how Latin American genres of music become mobilized in the construction of non-Latino national, gender, and sexual identities. The second project, an ethnographic study of *forró* music and dance from the northeast of Brazil, explores this genre as a living historical archive that exists in an uneasy relationship to written, official (imagined) histories of Brazil's past. In the spring of 2000 she performed her piece, "A Girl and Her Toothbrush," off-off-Broadway.

ROSA LUISA MÁRQUEZ (Puerto Rico), a director, actress, and dramatist, but above all a practitioner of theatre in education, lives in Puerto Rico. She studied at the University of Puerto Rico, New York University, and Michigan State University. She is Professor of Theatre and Drama at the University of Puerto Rico. Her courses of theatre games, socio-drama, and graphic-theatrical ventures have trained generations of theatre educators and practitioners. Márquez published her first book on her own creative process: *Brincos y saltos: El juego como disciplina teatral* (Leaps and Bounds: Games as Theatrical Discipline), now in its second edition. She has also produced a video of her work.

TERESA MARRERO is Assistant Professor of Spanish at the University of North Texas. She specializes in Latina/o and Latin American performance and cultural studies. She is coeditor of the anthology *Out of the Fringe, Out of the Closet: Contemporary Latina and Latino Theater and Performance*. Her work has appeared in the anthologies *Negotiating Performance*, *Bridges to Cuba*, and *Tropicalizations*, and in the journals *The Drama Review (TDR)*, *Latin American Theatre Review*, *Gestos*, *Ollantay Theater Magazine*, and *Revista de Ciencias Sociales* (Universidad de Puerto Rico, Río Piedras).

JOSÉ MUÑOZ is Associate Professor of Performance Studies at New York University. His articles have appeared in major academic journals, and his book *Disidentifications* was published by Minnesota University Press.

ROBERT NEUSTADT, Associate Professor of Spanish at Northern Arizona University, Flagstaff, has published two books and a number of essays on literary and cultural criticism as well as Latin American literature: *(Con)Fusing Signs and Postmodern Positions: Spanish American Performance, Experimental Writing and the Critique of Political Confusion* (Garland Publishing, 1999) and *CADA día: La creación de un arte social* (Editorial Cuarto Propio, 2001), which analyzes the work of the Chilean political art collective CADA (Colectivo Acciones de Arte).

ANTONIO PRIETO STAMBAUGH, a professor and researcher at El Colegio de Michoacán, Mexico, holds a Ph.D. in Latin American Studies from the Faculty of Philoso-

phy and Letters of Mexico's National University (UNAM), and an M.A. in Performance Studies from New York University's Tisch School of the Arts. He has been a visiting lecturer at Stanford University's Department of Spanish and Portuguese (1998–2000) and has taught theatre history at Mexico's Universidad Iberoamericana (1995–1996). Prieto has published *El teatro como vehículo de comunicación* (with Yolanda Muñoz, 1992), as well as essays in culture and performance studies anthologies, encyclopedias, and the journals *Cuadernos Americanos, debate feminista, Chasqui, Gestos, Conjunto,* and *Ollantay Theater Magazine,* among others.

TERESA RALLI, a founding member of Group Cultural Yuyachkani, is one of Peru's major theatre practitioners. She acts, creates, directs, sings, and participates in a vast repertoire of both European and Andean performance traditions. She has acted in dozens of major productions by Yuyachkani, directed theatre pieces (the all-women play, *La última cena*), and directed theatre workshops for disenfranchised women throughout Peru. She collected material for her *Antígona* by interviewing the mothers and widows of Peru's "disappeared." She continues to work actively with the country's Commission of Truth and Reconciliation.

MARLÈNE RAMÍREZ-CANCIO is a Ph.D. candidate in comparative literature at Stanford University. Her involvement in theatre began in San Francisco, where she was a member the Red Rocket Theater and Latina Theatre Lab.

DIANA RAZNOVICH is a writer, playwright, novelist, poet, and cartoonist. Her theatre has been produced and published in Argentina, Germany, Italy, Sweden, Norway, and Denmark as well as throughout Latin America. Her work has received national and international recognition and she was awarded a Guggenheim. From 1998 to 2001 she formed part of the Directive Council of Argentores, where she served as the director of the Authors in the Network project. Since 2002 Raznovich has lived in Spain.

JESUSA RODRÍGUEZ is a director, actor, playwright, performance artist, scenographer, entrepreneur, and social activist. She lives in Mexico City where, since 1990, with her Argentine partner Liliana Felipe, she owns and manages the cabaret/bar El Hábito and the adjacent La Capilla theatre. Rodríguez has staged her shows around the world including in the United States, France, and Germany. With several hundred works to her credit, from traditional-style plays to operas to cabaret shows, Rodríguez is also a social activist and contributes regularly to Mexico's feminist journal, *debate feminista*. In 1997 she received a Rockefeller Foundation grant to complete the film adaptation of the opera *Così fan tutte*. In 2000, Rodríguez and Felipe received Obies for their performances in the play *Las horas de Belén / A Book of Hours*, in which they collaborated with New York–based Mabou Mines.

DENISE STOKLOS began her career in 1968 as a playwright, director, and actress in Brazil. She received a Fulbright in 1987. Since then, she has premiered eight of her pieces at La Mama in New York. She has presented her works throughout Brazil and Latin America. Stoklos has published seven books as a poet, essayist, and playwright. She performs her plays in Portuguese, Spanish, English, French,

Russian, Ukrainian, and German. Since 1986 Stoklos has performed frequently in international events in thirty-one countries and received numerous national and international awards.

DIANA TAYLOR is Professor of Performance Studies and Spanish at New York University. She is the author of *Theatre of Crisis: Drama and Politics in Latin America* (1991)—which won the Best Book Award given by the New England Council on Latin American Studies and honorable mention in the Joe E. Callaway Prize for the Best Book on Drama; *Disappearing Acts: Spectacles of Gender and Nationalism in Argentina's "Dirty War"* (Duke University Press, 1997); and *The Archive and the Repertoire: Performing Cultural Memory in the Americas* (Duke University Press, 2003). She coedited *Negotiating Performance in Latin/o America: Gender, Sexuality, and Theatricality* (Duke University Press, 1994), *Defiant Acts: Four Plays by Diana Raznovich* (a bilingual edition; Bucknell University Press, 2002); and five other volumes on Latino and Latin American theatre and performance. She is founding director of the Hemispheric Institute of Performance and Politics, funded by the Ford Foundation and the Rockefeller Foundation.

ADAM VERSENYI is Associate Professor of Dramaturgy at the University of North Carolina at Chapel Hill and resident dramaturg for PlayMakers Repertory Company. He has written extensively on Latin American Theatre and translated plays by Agustin Cuzzani, Griselda Gambaro, and Sabina Berman. He recently published an anthology of plays in translation by Sabina Berman.

Library of Congress Cataloging-in-Publication Data

Holy terrors: Latin American women perform/
edited by Diana Taylor and Roselyn Costantino.

p. cm.

Includes bibliographical references and index.

ISBN 0-8223-3227-2 (cloth : alk. paper)

ISBN 0-8223-3240-x (pbk. : alk. paper)

1. Latin American drama—Women authors—
Translations into English 2. Latin American
drama—20th century—Translations into English
I. Title

PQ7087.E5 H65 2003

862/.6099287/098 21 2003012316